MASTERS OF NAIVE ART

MASTERS OF NAIVE ART

MASTERS OF NAIVE ART

A HISTORY AND WORLDWIDE SURVEY

by Oto Bihalji-Merin
Translated by Russell M. Stockman

McGRAW-HILL BOOK COMPANY
NEW YORK • ST. LOUIS • SAN FRANCISCO • TORONTO

Acknowledgments

In the decade that has passed since the appearance of my first book on this subject, interest in the art of the naives has become so widespread that the pressures of fashion and the market have come into play. This in turn has raised new questions which have caused me to turn to the subject once again. Dr. Dietrich Mahlov, of the Institute of Modern Art in Nuremberg, was instrumental in his recommendation that I try to formulate a clearer definition of naive art and attempt a critical evaluation of it in the light of more recent developments. But the practical impetus was given by Ljubivoje Stefanović of the Mladinska Knjiga publishers in Ljubljana, who suggested I write this book.

Many friends and connoisseurs of naive art have assisted me in this project. But always present and most helpful has been my wife and collaborator, Lise Bihalji, who went with me on all my visits to the naives, and who participates in all my deliberations.

For their courteous generosity in the sharing of information, Ektachromes, and photographs, the author and the publisher wish to thank the following persons and institutions: Director B. Bek, Dr. D. Bašičević, and Dr. Boris Kelemen of the Galleries of the City of Zagreb; Director J. C. Ebbinge Wubben and Chief Curator Reinhilde Hammacher of the Boymans van Beuningen Museum in Rotterdam; Director Mioko Fujieda and Chief Editor Yumiko Bando of the Fukuinen Shoten Publishing House in Tokyo; Dr. Louis Gans, director of the Albert Dorne Foundation in Amsterdam; José Gomez Sicre of the Organization of American States in Washington, D.C.; Director Thomas Grochowiak and Chief Curator Dr. Anneliese Schroeder of the city art collections in Recklinghausen; Karl Gutbrod of the DuMont Schauberg Verlag in Cologne; Eric Lister of the Portal Gallery in London; Dr. Eberhard Marx of the city art collections in Bonn; Milica Maširević, director of the Gallery for Lay Art in Svetozarevo; Dino Menozzi of the Istituto della Communità (Gruppo Naif) in Reggio Emilia; Modest Morariu of Editura Meridiane in Bucharest; Robert Schmitt of the Gallery of the Self-taught in the Austrian Gewerkschaftsbund in Vienna; Dr. A. Schlatter of the Kunsthaus in Zurich; Mr. N. Snodin of the British Council in Belgrade; Heinrich von Sydow-Zirkwitz of the Sydow Gallery in Frankfurt/Main; Dr. Eugen Thiemann of the Museum am Ostwall in Dortmund; Dr. Karel Vaculik and Štefan Tkač of the Slovakian National Academy, and the directors of the Triennial Exhibits of Naive Art in Bratislava; Dr. Robert Wildhaber of the Museum für Völkerkunde in Basel; The Brooklyn Museum, New York; Galerie Berry Lardy & Cie., Paris; Galerie Hilt, Basel; Metropolitan Museum of Art, New York; Kunstgewerbe Museum, Zurich; Museum of the City of Belgrade; Museum of Modern Art, New York; Philadelphia Museum of Art; Springfield Museum of Art, Springfield, Massachusetts.

I am also indebted to the scholars Dr. Alfred Bader of Lausanne and Dr. Leo Navratil of Klosterneuburg, Austria, for their professional advice; to the collectors Kurt Bachmann of Puerto Rico, Prof. Aurelio de Felice of Terni, and Hans Holzinger of Munich; to the photographers Marija Braut of Zagreb, Tošo Dabac of Zagreb, André Held of Ecublens, Claus Hansmann of Munich, Dragutin Kazić of Belgrade, and Karel Neubert of Prague; and to my friends Eva Garztecka and Ignaczy Witz in Warsaw, Ursula Rusche-Wolters in Munich, and Horst Hussel in East Berlin.

I wish to give special thanks to Vera Stojić, who has helped me with her knowledge and advice, to Dr. Anneliese Schumacher-Heiss, whose thoughts and suggestions were of help in the final draft, to Emilija Pavković who took care of translations and printing, and to Gerhard Schoenberner who read the German manuscript.

O. B.-M.

PRODUCED IN ASSOCIATION WITH CHANTICLEER PRESS, INC.
LIBRARY OF CONGRESS CATALOG CARD NUMBER 70-155880
SBN 07-005257-3
TYPOGRAPHY BY ELLEN HSIAO
PRINTED IN YUGOSLAVIA

Contents

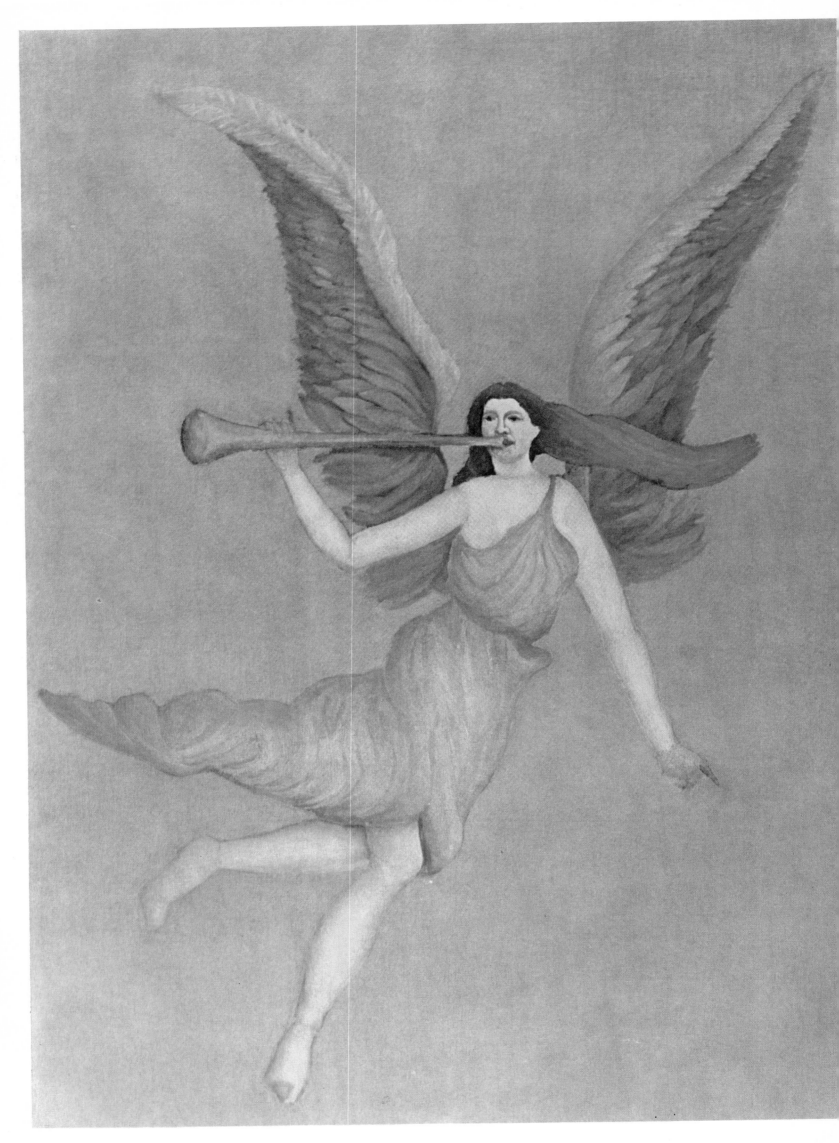

Strength and Vulnerability of Naive Art

Introduction

Another book of mine—*The End of Art in the Scientific Age?*—was published only a few days before I began working on the manuscript of *Masters of Naive Art*. Both works deal with border areas of artistic creation: this one with aspects of a manner of expression that is still preconscious or at most developing along with the consciousness of the time, the former with the realm of the transhuman and the deliberate advance of art into the magnetic field of science and technology. Both then have to do with polar forces which in classical terms are either not yet, or no longer, art. These are artistic provinces characteristic of our time in which primitiveness and refinement, preperspectivism and postperspectivism, naiveté and artifice are integrated. With a sense of the world as yet unshaken by *ratio,* naive art instinctively and with a wealth of images reflects primal observations of simple communal experience, while at the same time experiments in cybernetic art are being proclaimed as elementary forms of a coming collective creativity.

The growing wave of interest in naive art and the increasing number of artists who may be classed as naive cause one to ask whether this art does indeed stand aloof from history and from style, as we used to say, and truly shows no development. Is the popularity of naive art a sign of its durability, or is its recent ascendancy not rather a self-conscious, and by now quite deliberately practiced, variation on primitive picturemaking? Has naive art the strength to renew itself on its own, or does it cease to be itself once it reproduces its unique essence by artificial means?

A naiveté which is artificially preserved and nurtured seems somehow both grotesque and tragic, as in the case of those Indians who for tourists will play themselves, put on their feathered garb and perform ritual dances. Clearly the naive artist cannot be shut off from contact with technological civilization and with culture. Can his art nonetheless remain naive and, if so, still be art?

Should those art critics prevail who ignore the work of the naives with aristocratic disdain, who register it condescendingly as a sidetrack along the highroad to professional art, while at the same time bowing before each new experiment of the day? Or is naive art in this cybernetic age not one of the few creative possibilities offering promise of renewal in the simple human sphere? Might naive art perhaps provide a necessary balance between the technological, scientistic principle and a striving after living expression?

The multifaceted nature of the phenomenon we call "naive art" makes it imperative that one examine with utmost care all possible variations: peasant painting, rustic and urban amateurism, pseudonaiveté, and true naive art.

Yet in this realm too, classification offers only limited assistance. Many an artist whose roots are in the soil of the naives oversteps, through practice and growing self-awareness, the boundaries of the primitive. And in so doing he enters into the mainstream of the art of mankind, like Henri Rousseau, *le Douanier.* Others however—artists by profession—turn toward a more intimate and simplified world of forms in their search for creative renewal, and thereby attain a naive clarity.

The twentieth century teaches us to see in a new way. An increasing decline in psychic substance and the surrender of historical development to the gravitational pull of technology have led art to focus on primal images. In their quest for more profound

1. Henri Rousseau, "Angel of Liberty"

Detail from Liberty's Invitation to the Artists to take Part in the Twenty-Second Exhibit of the Independents, *1906*

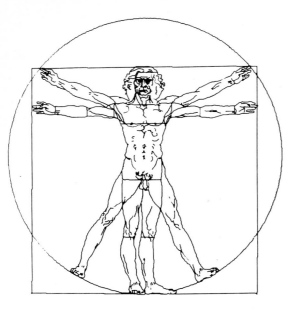

Far left:
Drawing by Leonardo da Vinci.
Computer transformation From
Circle to Square, *by Charles Csuri.*
The full visual and pictorial instru-
mentation of the cybernetic age is at
the artist's disposal. The childlike
experience and discovery of the world
through the innocent yet knowing eye
of the naive artist are in sharp con-
trast to such a synthesis of scientific
and artificial experience.

Near left:
Flying Man, *drawing by the naive*
artist Ilija Bosilj-Bašičević, 1963.

interrelationships, artists and friends of art are turning not only toward the early forms of prelogical ages, but also toward the latest forms of the primitive and naive.

Lively interest in primitive art began with Paul Gauguin's discovery of the world of forms of the South Seas. The expressive resources of primitive peoples—perhaps wrongly referred to as such—the reserves of strength in sun, ecstasy, and intensity, were supposed to refresh the exhausted wellsprings of art. Gauguin struck this mythical tone of primeval nature in his notebooks titled *Noa Noa.*

Then followed the discovery of African Negro sculpture, rooted in a tribal culture of hunters. And finally came the birth of a naive art of dreamers and poets, men living in the jungle of the metropolis and in the gentler countryside. Unencumbered by schools and traditions, they created—and continue to create—their gentle and violent, childlike, naive landscapes of feeling and the soul.

Naive artists have received a great deal of attention and have been referred to by various terms: "painters of instinct," "Painters of the Sacred Heart," *"maîtres populaires de la réalité,"* "neoprimitives," "Sunday painters," and "'insite' artists." There is some truth in each such designation, but none is completely satisfying.

If we apply the term "naive" and avoid others that have been put forward, it is simply because this concept characterizes such art better than any other.

The term "lay painting" is clearly too broad, as it includes all painters devoid of professional schooling, from folk artists and regionalists to dilettantes and amateurs of various social strata. The concept "Sunday painter," on the other hand, seems too narrow, for it suggests a mere spare-time amusement, a hobby, or a casual dabbling in art, and omits creative activity born of inner ne-

cessity, one which can be performed with just as much seriousness and intensity as are those learned in academies.

The somewhat ostentatious and sentimental term "Painters of the Sacred Heart," with its lyrical, literary overtones, encompasses properly only the first circle of naive painters, those who were assembled about Wilhelm Uhde and who by now have become classics. The concept *"maîtres populaires de la réalité"* covers only one side of the naive artist, for quite often naive painters and sculptors are the most unrealistic of fantasts and dreamers. "Artists of instinct" are not only those whom we would call naive, but also the painters among primitive peoples. One could call naive artists "primitives of the twentieth century" perhaps, and indeed they are occasionally so named. But while the art of primitives developed out of the totality of their culture and had its cult function, the art of the neoprimitives, the naives, is based on individuality; it is like an island of artistic innocence in the middle of the civilized and technological world.

The founders of the Triennial Exhibitions of Naive Art in Bratislava have proposed the term "'insite' art." Stefan Tkač is of the opinion that the word "naive," at least in the Slavic languages, has a slightly depreciatory connotation. He suggests that the straightforward borrowing from the Latin *insitus* (innate) is not so encumbered. And yet concepts change; half a century after the death of the customs official Rousseau the term "naive art" sounds perfectly acceptable.

We can also best avoid error by referring to the work of these artists in future, as has been done for decades, as the "art of the naives."

To be sure, the naive artists are as far from considering their work "naive" as is the creator of many-armed Siva-figures from calling his "fantastic." Things in themselves are never fantastic; they may seem so only when

viewed from an unfamiliar vantage point. For those who inhabit the landscape of consciousness of the naive, what they themselves portray is the only true and possible reality.

Naive painters do not constitute a movement in modern art. Their curiously simplistic creations stand removed from the intellectual manifestos of the professionals. Untroubled and spontaneous, they create out of the urgings of the heart. Kandinsky spoke of true naiveté in art as "the great Reality" as opposed to an increasing abstractionism. Its unique quality consists not only of a decorative artlessness and narrative simplicity, but even more of a symbol-laden imagery and a childlike delight in discovery. Those rare naive artists who fuse these qualities to a high degree transcend themselves; no knowledgeable person today would hesitate to place Henri Rousseau, *le Douanier,* right alongside Cézanne and Picasso as one among equals.

The revolutionary movement in art around 1890, carried forward by Cézanne, van Gogh, and Gauguin, stood in contrast to an urban civilization exhausting itself in external matters. Cézanne explored and surmounted the world-view of Impressionism. In place of vagueness he held out for a strengthening and synthesizing of composition. Intellectual substance, having thus become form, sought through the work of art a new ordering of the world. Vincent van Gogh appeared to be but an unsuccessful apprentice in the art trade, a lay preacher in the Belgian coal region, a self-taught painter with little enough schooling. But in his search for the original human condition of brotherhood, he discovered an idiom of imagery full of cosmic, yet intimate, experience of objects and—thanks to the strength of his instincts—one true to life. Artistic virtuosity was expelled from his work, and in its stead, as though in visionary discharge, an incredible intensity of color came to achieve spiritually expressive force. And through his work, his self-imposed task leads to an apotheosis of self in humble surrender to the world. Van Gogh charted here certain paths which, together with Gauguin's but unlike them, would direct the course of art in the twentieth century.

Paul Gauguin, second mate, bank teller, and—at least at the beginning of his career —"Sunday painter," despised the mechanized, urban industry of a saturated Europe. He put Paris and the bourgeois existence behind him in order to achieve a vital intensity of fresh forms and mythical imagery in the ageless world of the primitives. He sought to answer questions about the origin and purpose of man through the adventure of his own existence and of his work, as he

abandoned civilization and returned to the lost paradise of archaic community.

He bought happiness in Tahiti at the expense of forsaking Europe. When Gauguin painted them, the light of an eternal Sunday seemed to lie above the blessed isles of Polynesia. His naked figures are poised in greenish-gold shadows of paradisiacal innocence, and yet Gauguin viewed this world with a bitter melancholy. Though he painted the inhabitants of this happy island strolling under palm trees, his letters and diaries speak of human misery. His paradise was dependent on colonial powers which were beginning to destroy it in their embrace. The return to a land of legend was to remain a utopia of nature mysticism. Gauguin's paintings could only gain in mythical presence and poetic intensity under the sunlight of the primitives; today's human society, however, cannot revert to archaic communal forms.

This return to primeval sources signified a deep caesura in the art of Europe and the world. Here began the rehabilitation of early and primitive cultures and the release from the rule of classical antiquity. Primitive art brought with it the old and now revived message that the world is not what is revealed to our glance, but what the artist intuitively senses. The abandonment of imitation, the discarding of illusionist methods, meant the beginning of a new age. Once the copying of things had become hackneyed and outmoded, Henri Rousseau could emerge from the lifeless artificiality of the bourgeois world, enter the fable-land of his vision, and transform outworn things grown invisible through convention into reclaimed and reawakened images for man. In 1886, as Rousseau was exhibiting for the first time in the Salon des Indépendants, Paris saw the last group exhibit by the painters of Impressionism. Cézanne had already taken the step from an optically naturalist system of Impressionism to a nonperspectivist, abstract view. But Cézanne, who sought to transmute nature into pure form, and Rousseau, who with no theoretical program but only with instinct and grace led all forms back to the magical reality and matter of nature—both were strangers in their time and unacclaimed.

Like a sleepwalker, Henri Rousseau walked a path of concretized dreams and dreamed reality. In so doing he anticipated the modern concept of existence which posits a dialectical reality composed equally of the visible and the imaginable, of knowledge and vision. Reality is expanded to include the possible; utopia becomes an immediate experience. At Rousseau's childlike, magical touch, nature becomes the promised land, an act of creation takes place, a prodigal returns. Things condemned to be mere objects are made to live again, and a new harmony is

Ivan Rabuzin, Einstein, 1961.

Shalom of Safed. Jonas Is Delivered From the Whale.

given to men estranged from themselves.

In France, and in the world, the name Rousseau symbolizes three times over an admonition to the necessity of returning to nature. Jean-Jacques Rousseau taught that the only genuine culture would be one representing nature itself at a higher level of development. Theodore Rousseau left Paris and his atelier to settle in the village of Barbizon, where in patient study of nature he painted those first intimate landscapes which were the beginning of plein-air painting. It may be, as Roger-Marx presumes, that *le Douanier* Henri Rousseau never knew of these men who shared his name and who also caused nature to green and blossom again. Unschooled and unread, he left Paris only rarely. In his work he found a deep union with living nature. To an epoch characterized by alienation from the individuality of men and of things, Rousseau gave "the great Reality," the conformity of man and thing, of self and world.

In a thoughtful discussion of naive art, a scholar and friend once spoke to me of the responsibility we must assume in exposing it to the harsh light of our frenzied times. One must acknowledge that much which finds exhibitors and buyers is neither naive nor art. It has become necessary to distinguish between creations from the soul and creations for sale. There is an ever-present danger that skill may be applied to products merely adapted to the wishes and expectations of the buyer.

In this economy of consumption based on supply and demand is not everything subjected to the laws of the market? Can we expect more from the naives than from the schooled, professional artists; can we require of them that they resist the temptations of notoriety and wealth and keep to their peaceful little rooms?

The essential character of naive art flourishes however within a mental horizon of artlessness and simplicity. When the naive artist abandons these, he corrupts the specific climate of his art. Through years or decades of artistic activity the naive artist perfects his technique and comes to move more freely with the materials of his composition. If there is a decline in feeling and inventiveness, if he begins to repeat himself and to pass over into serial production, it can easily happen that he loses his originality and immediacy. His paintings and sculptures become more skillful, but their tension and radiance slacken.

So this book will attempt to respond to questions asked by friends of the naives and by naive artists themselves, questions that have stirred me in the past few years. Along with my skepticism regarding its vulnerability, there grows within me an intuitive certainty that this art can help to overcome the increasing estrangement of man from himself and from nature.

Below left:
Paul Klee, Small Shipwreck, *1928.*
No other artist has dredged up into the visual world of art the incomprehensible distance, the primal naiveté from the depths of time "where the key to everything is kept," as has Paul Klee.

Below right:
Matija Skurjeni, Still-Life With Spirit, *1959.*

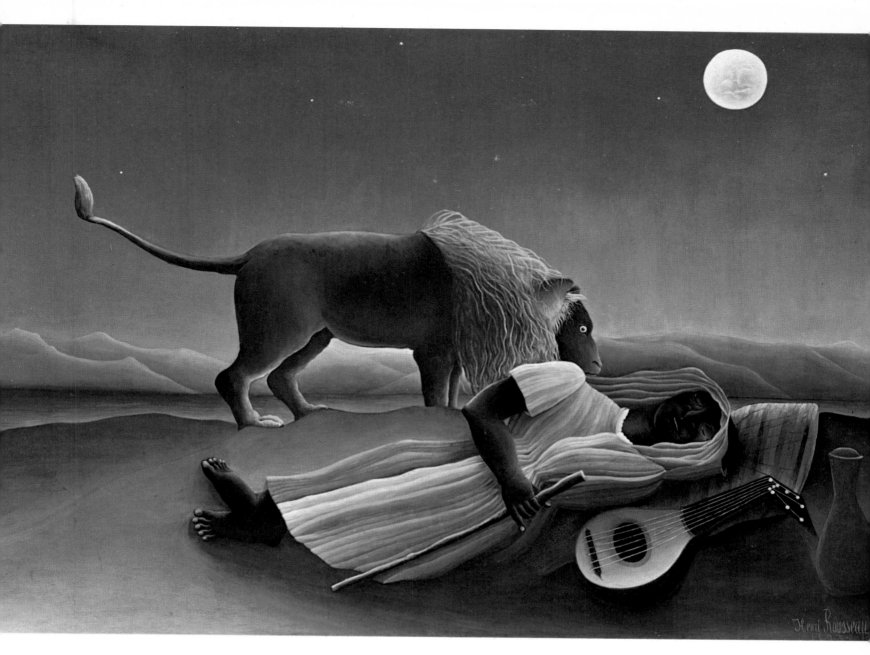

2. *Henri Rousseau,* The Sleeping Gypsy,
1897

*In the moonlit solitude of the desert lies a
dark-faced and brightly dressed woman. Can
she be dreaming under this blue night sky,
while the horrifying lion bends over her?
With unconscious mastery, Rousseau has
given form to the endless silence of the desert
and the dreamlike experience of a primeval
landscape. Jean Cocteau has said that this
woman of mystery thinks she is alone, and
that she is exposing herself to the night.
Everything is real to the primitive and the
child, and only the poetic imagination of utter
innocence could have created such a reality as
this in art. There is something of the bound-
lessness of existence in the broad depths of
this uninhabited space; the green river
between the desert foreground and the
gleaming mountains is a symbol of infinity.*

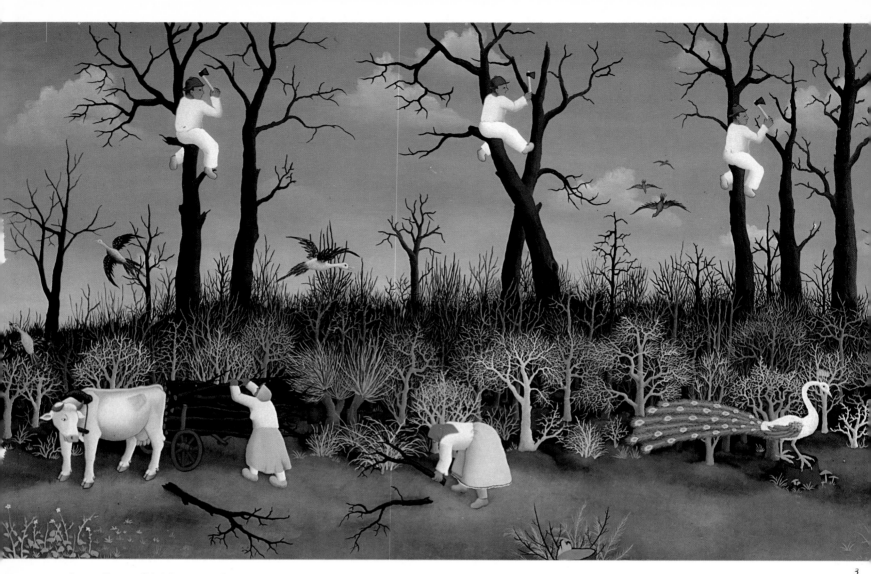

3. *Ivan Generalić,* The Woodcutter, *1959*

Instinctively or knowingly, the naive peasant painter Generalić has made use of the principle of repetition in order to transcend the actual and visible event, and to give his composition an air of symbolism through rhythmic variation. The peasant sitting on the branches of a tree and swinging his ax is depicted three times as though in mirror images. The strong verticals of the tree trunks are balanced by the horizontal lines of the oxcart and of the shimmering peacock which paces so pompously in the foreground. This is a study in simultaneity, one which echos an archaic artistic sensibility and folklore motifs, while at the same time expressing a modern blend of work and daydream. Virtuoso technique and the problematics of the composition are already signs that the naive artist faces questions which are scarcely to be met with simple innocence, but which rather lead to a dramatic creative monologue.

Part One

Early Art:
Art Among Primitive Peoples

Chapter I

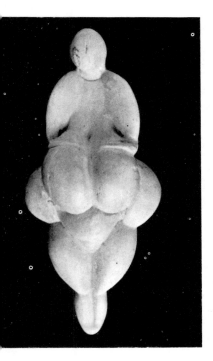

ie Venus of Lespugue, *Haute
aronne.
astic expression began with arche-
es of the mother. Typical is the
f-contained solidity of this Venus
ure with its slightly lowered head,
drooping shoulders and unde-
loped limbs. The elemental quality
fertility is clearly stressed.
imeval sculpture presents us with
nbols, not mere imitations of
ality.*

Pictures from the earliest artistic periods are the traces of a primal concept of the world. In spite of the thematic treatment of real creatures we can still recognize, paintings of animals or men from the early Stone Age are charged with magical strength, exaggerated and concentrated as they are into forms of existential experience. They fulfilled still other functions beyond the mere representation of the visible.

The degree of naiveté in archaic primitive art varies. A certain naiveté is always present when observation of nature is not overlaid with rational thought. Art first had to discover the world and to invent ways of making it perceivable. Along with visible things, invisible forces too were given form and substance and began to make their appearance. And as they achieved form they took on permanence.

The early hunters attempted to influence the chance fortunes of the hunt through magical practices. The power of magic was as real to them as the power of the stone ax they had invented. Art ensnared the form of the animal. Whenever the figure of woman appears it is as a sign of fertility; representations of men are rarer, and when they occur they show him in his role as hunter. Man does not yet look beyond the borders of existence that mark his practical life. Magic precedes the fall of man into knowledge.

It must have meant a considerable revolution in prehistoric times when man discovered that he did not have to live solely from hunting, that not only the animals but indeed all of nature round about him was full of life. Stars and seasons take their rhythms from unknown forces; a mysterious power functioning beyond human understanding, propitious or forbidding, helpful or threatening; forces of ancestors, spirits, and demons,

and forces of the departed and the coming gods.

With the transition from the early to the late Stone Age there appears the first stylistic change in art. The original naturalism based on observation and experience gives way to a geometrically stylized world of forms discoverable only through thought and speculation.

Prehistoric man, leaving behind him the life of the hunter and gatherer, invents abbreviations and pictographic signs which are no longer pictures proper but rather thought-models, reflections of his more settled existence as a beginning herdsman and farmer.

Following the late Stone Age, the art of the Bronze Age—which in Asia dates from the middle of the third millennium and which began in Europe around 2100 B.C.—contains, as does the art of the Iron Age as well, elements of naiveté and inventive immediacy side by side with highly developed, formalized compositions. The bronze sculptures of the Celts and the Illyrians are ample witness to them.

With the substitution of conceptual rationalization for more primitive, mythical explanations of the world, a kind of art arises in which objective criteria of reality and the natural laws of optics come into play. The simplicity and vividness of the naive become more rare.

The art of the period of the catacombs was informed with the naturalistic naiveté of late antiquity. In medieval Christian art, which was averse to any spatial illusions, a "moral" perspective dominated; all action was pressed onto the holy, two-dimensional surface.

While the primitive and instinctual accompanies the course of art until the Renaissance, it recedes in the face of the humanistic

concept of the world and the discovery of linear and aerial perspective. High art forsakes the realm of instinct in exchange for the province of reason.

But parallel with it, in folk art and among so-called primitive peoples, naive representation lives on.

There is a similarity of expression between the forms of the most ancient, original art and the imagery of uncivilized peoples in our own day; both strive after communication and supplication. Cliff paintings, idols, totemic figures, and ancestral monuments promote communion with otherworldly powers. Concepts of space are determined by the breadth of vision which is taken to be totality and depicted as such. It is a preperspective art, characterized in painting by the exclusive adherence to frontal posture or profile. In sculpture one consistently notes a limited outlay of form, a strict compactness, and simplifying stylization.

The artists of so-called primitive peoples belong to preindustrial cultures. They are infused with religious, mythical notions. These anonymous artists perceive themselves as links in an endless chain of generations and enjoy a sense of identity with their work. The sculptor is less inclined to represent the external form of the visible than to capture its inner significance.

African natural religion, akin to the Southeast Asian doctrine of the universal soul and to the concept of Mana among the Polynesians, inspires its artists to ritual sculpture for use in the worship of gods and spirits and in the cults of the dead.

The inscrutable restraint and taut simplicity of the broad surfaces of a dynamically subdued material give to these idols a magical strength and plastic integrity. All forms derive from the organic makeup of the material and from their spiritual function. The rhythm of nature's cycles vibrates within these figures and gives them their significance as suprapersonal, mysterious emblems.

The primitive thought-pictures of prelogical peoples were expressions of collective experience; the art of the primitives is a language of form born of instinct, a ritual rather than an aesthetic activity. Through the perfection of their design, such works are charged with the magic that will guarantee them unique powers.

Around the turn of the century many artists in Europe and America were attracted to the art of early epochs and of uncivilized peoples. Fauves and Expressionists, Cubists and Surrealists sought out perennial signs of archaic and primeval expression. Picasso

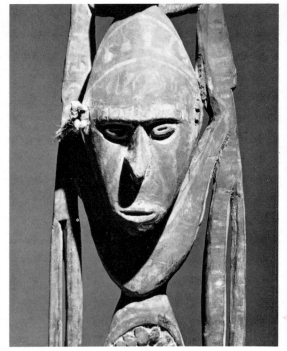

turned from the transparent classicism of his artist-figures to the magical, archaic world of Africa. Derain, Matisse, and others took inspiration from the masks of wood carvers. The sharp-edged figures from Bakota and the T-shaped stylization of the eyes on Pangore sculptures from Gabon influenced the formal vocabulary of the Cubists. Modigliani's portraits and sculpture were inspired by carvings of the Gouros of the Ivory Coast.

Vlaminck, Schmidt-Rottluff, and Pechstein owed much to the abrupt line and glaring color of primitives. Ernst Ludwig Kirchner and the painters and sculptors of *"Die Brücke"* tried their hand at wood carvings which in their blunt, exaggerated primitiveness are reminiscent of sculpture of the South Seas. Emil Nolde's paintings and masks share the dark fire and intensity of the instinctual art of the primitives: "I draw and paint and try to capture something of the primeval essence. The artistic production of uncivilized peoples are a last remnant of prehistoric art. . . ."

Also for Max Ernst and other painter-poets of Surrealism, objects unearthed from the realm of drives and instincts become building blocks of the unconscious, related to the fetishes of African pictorial magic.

While in the late capitalist world artists who had become overrefined through intellect and technology refreshed their imaginations at the wellsprings of primitive art, the peoples of Africa awoke from their jungle sleep and began to free themselves from the idols of their witch doctors and from the dominating influence of the white empires. In so doing they won freedom, but at the same time they sacrificed much of their spiritual strength.

Above left:
Amedeo Modigliani, Head, *circa 1913.*

Above right:
Head from an ancestral column from the Sepik region, New Guinea. Detail

Below:
Morris Hirshfield, "Female Nude", *Detail from* The Artist and His Model, *1945.*
This nude girl's body with its empty idealized face and ornamental curve reveals the Venus concept of the naive painter.

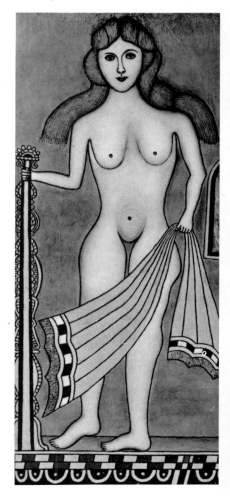

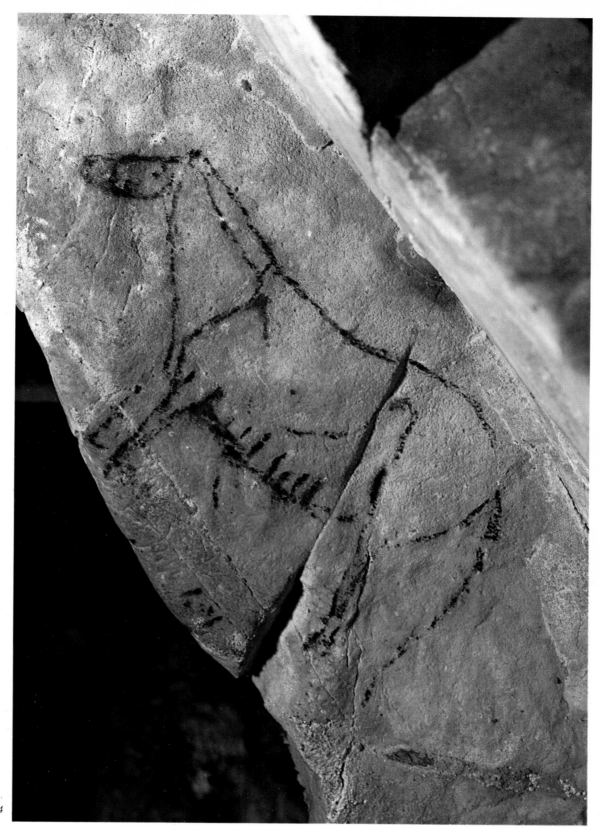

4

4. Outline figures of a horse from Las Monedas cavern, Santander, Spain, from the Pleistocene Epoch

In the thirties, during the Spanish Civil War, the people of the western side of the Iberian peninsula often sought refuge in caves. Fleeing from present-day inhumanity, they returned to the dwellings of man's earliest beginnings. Many of these caves contained precious wall paintings.

Deep in this cave, and guarded by stalagmites, is a cult shrine with pictures of all sorts of animals: mountain goats, primeval cattle, deer, bison, cave-dwelling bears, and horses. The figure of this horse is drawn with child-like simplicity and vitality, yet it is integrated into the natural structure of the stone surface. The outlines are naturalistic, but at the same time they attempt to catch the magical essence of the animal beyond the merely visible. The similarity between primeval art and that of the primitives and naives of our time consists of the simplicity of unsullied forms and the instinctive spontaneity of pictorial expression.

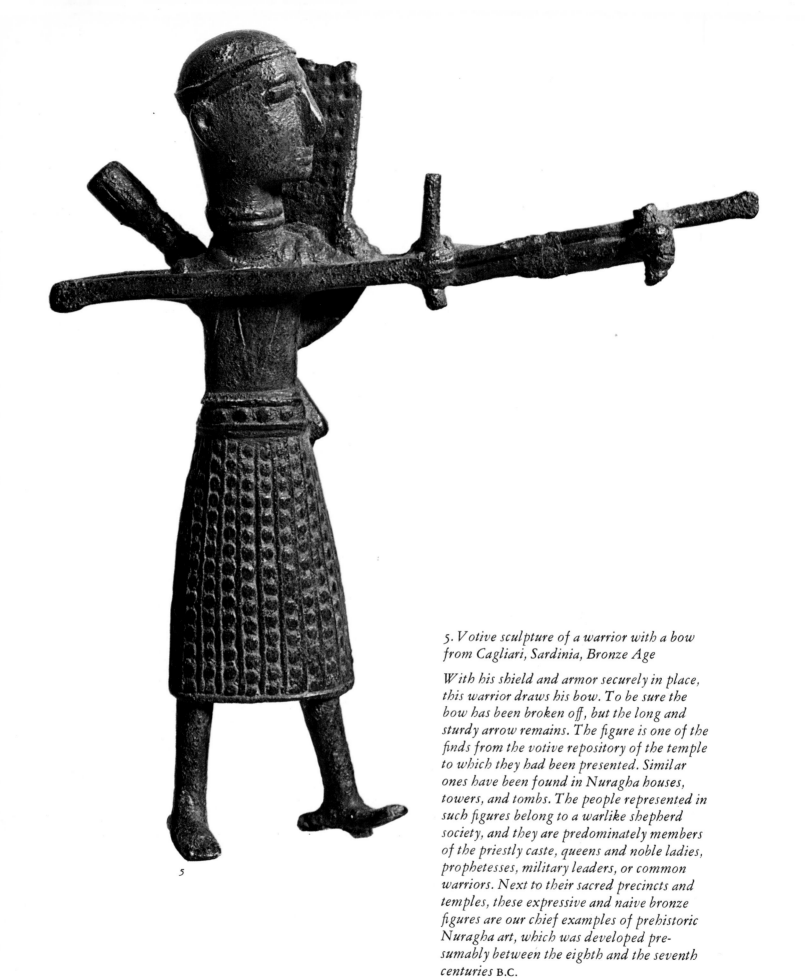

5

5. *Votive sculpture of a warrior with a bow
from Cagliari, Sardinia, Bronze Age*

*With his shield and armor securely in place,
this warrior draws his bow. To be sure the
bow has been broken off, but the long and
sturdy arrow remains. The figure is one of the
finds from the votive repository of the temple
to which they had been presented. Similar
ones have been found in Nuragha houses,
towers, and tombs. The people represented in
such figures belong to a warlike shepherd
society, and they are predominately members
of the priestly caste, queens and noble ladies,
prophetesses, military leaders, or common
warriors. Next to their sacred precincts and
temples, these expressive and naive bronze
figures are our chief examples of prehistoric
Nuragha art, which was developed pre-
sumably between the eighth and the seventh
centuries* B.C.

6. *Bogomil tombstone, 13th–15th century, from Opravdici in East Bosnia*

Portrait of the deceased with crossed arms. Some 30,000 of these tombstones are to be found in remote necropolises in the forests of Bosnia and Herzegovina. They are something quite unique in the art of the European middle ages. Figures, emblems, and ornaments have been worked into the stone with a two-dimensional draftsmanship. They resemble the chip carving of primeval shepherd and cattle-raising woodworkers. The simplicity of this world of symbols reflects not only the rustic sensibility of a naive folk soul, but also the gnostic teachings of the Bogomils. The forms of this heathen, fetishist, and at the same time Slavic Christian symbolism complement the highly civilized frescoes found in medieval cloister churches in Yugoslavia.

7. *Detail of a bronze urn from Vače, Slovenia, between eighth and fifth centuries* B.C.

These vessels from the Hallstatt period, and which belong to a culture of urn burial, are bucketlike containers once used for ritual purposes. They have been found buried in Italy, Austria, and Yugoslavia. Religious rites are represented with a naive directness in circular friezes of hammered bronze; one can see contests, feasts, processions, or sacrifices, which follow the rounded lines of the bucket in rhythmic action, with the sequential narrative of the film.

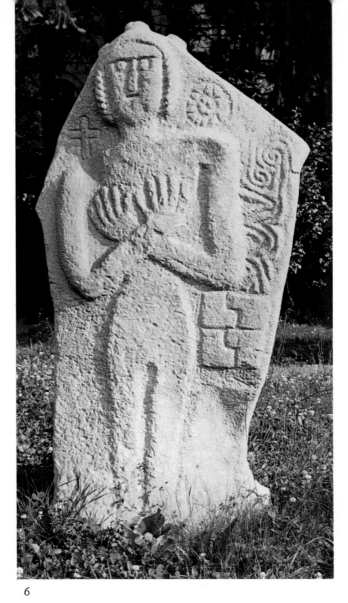

6

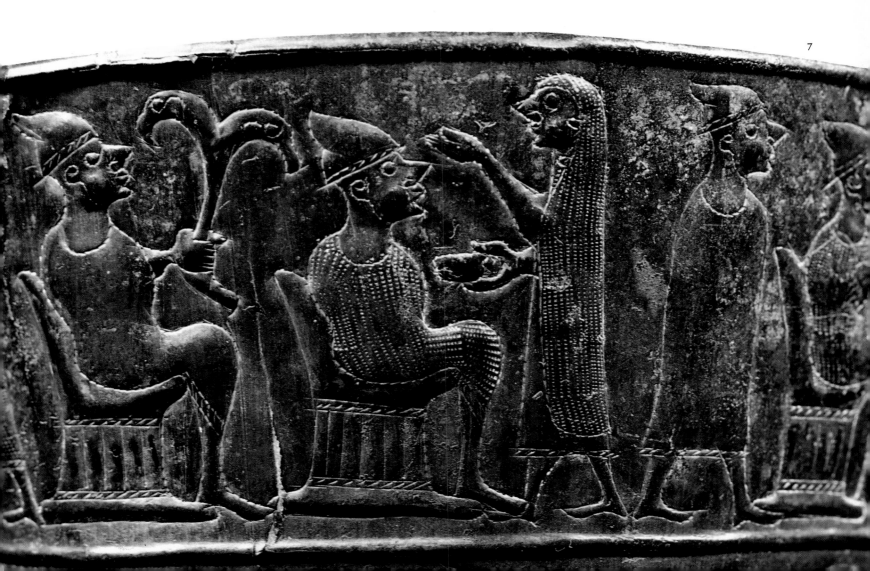

7

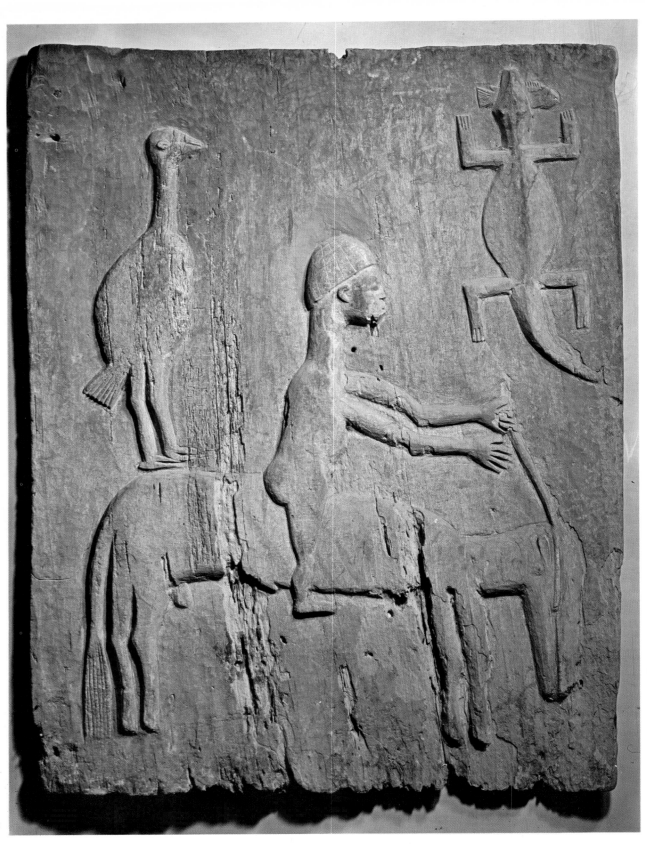

8

8. Carved wooden door of the Baulé tribe, from the central region of the Ivory Coast, West Africa

This relief in reddish wood with a patina of smoke presents a man in a helmet and a huge bird astride a horse. Balancing these on the right is a crocodile which is devouring a fish.

The solemn stylization of this naive and expressive sculpture is a unique mixture of naturalistic observation and emblematic abstraction. In its static and sacral calm, it is reminiscent of the primitive treatment of form on Egyptian reliefs from the early dynastic period. The artist has invested the wooden plate with magical powers through his formulation of human and animal shapes. The images have a mysterious affinity to their models and speak to a community of visionaries.

Art Remote
from History and Style

Chapter II

Children's Art

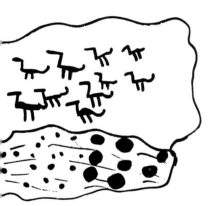

...ows in the Pasture, *drawing by the ...e-year-old Martin Vinaver, ...exico, 1964.*

...he cow-symbol which is repeated ...n times suggests the rhythm and ...rection of an unhurried movement. ...rge and small dots resemble musi- ...l notes set onto the regular lines ...the pasture. With childlike ...nplicity but a true sense of form, ...ese individual elements are com- ...ned to produce an unconsciously ...aphic composition.

...low:

...iff paintings in southeast Australia. ...line of dancers, hunted kangaroos, ...aying hands.

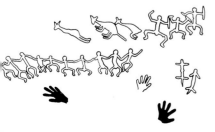

The precepts of logical thought and the limits to the conventionally accepted relationships between men and objects are as yet unknown to the painting child. Between speech and writing the signs are discovered through which one gains awareness of the world. Out of the scribbling of nearly unconscious lines the pictorial symbols of earliest perception are developed. As among peoples who have not yet invented writing, these pictorial signs are the first articulation of forms of communication emerging from the hull of the self.

The possibilities for graphic expression available to the child range from scribbling, in which no relationship to objects is yet discernible, to the structured fixation on particular forms that suggest with the simplest of means the most important feature of what is seen or thought.

Kandinsky, in his essay on the question of form (*Der blaue Reiter,* 1912), insists that the practical and effectual are quite foreign to the child, that he views every object with a fresh eye and still enjoys the unspoiled capacity to perceive the thing in itself.

As though with X-ray eyes, the child sees through walls and clothing, through all artificial barriers, and depicts what lives and breathes behind them. In the process, he alters proportions to bring things into his own scale, as though employing quite archaic distinctions between large and small, exterior and interior. Out of play and emotion he constructs his miraculous world; but when play and emotion cease, his artistry vanishes.

An understanding of cause and effect and of trial and achievement takes the place of unintentioned creation.

C. G. Jung writes: "The infinity of the preconscious soul of the child either disappears or is salvaged. Accordingly, the remains of the child's soul in the adult comprise both his best and his worst attributes, but in any case they follow the secret *spiritus rector* of our most important acts and careers, whether or not we are aware of it. It is they who take the insignificant human figures appearing on the checkerboard of life and make of them peasants or kings, take any poor devil of a father and turn him into the tyrant dominating one's life, or transform a poor goose of a helpless mother into a goddess of fate. For behind every specific father stands the eternal image of the Father, and behind every temporary appearance of an individual mother stands the magical figure of the Mother *an sich.* These archetypes of the collective soul, whose power is exalted in immortal works of art and in the fervent doctrines of religion, are also the forces which dominate the preconscious soul of the child."

Interest in archaic and primitive art has also called greater attention to the essence and meaning of children's art. Its awkward spontaneity, its candidness, its instinctive directness, could only be recognized as genuine creative values from the points of view of depth psychology and of the modern concept of art.

Both the child and the naive painter strive to shape and interpret their experience of the world in images. Their disregard for anatomy and perspective are not the result of a deliberate choice of style, but rather the stamp of a less developed level of consciousness. This perceptual limitation at the same

time favors the preservation of total expressiveness and originality of image.

An experience of space and a growing consciousness of anatomical proportions appear later and signify entry into the world of the adult. Pedagogical conventions compromise the originality of the sense of form. As the image of reality is adjusted to convention, the prerational world-view is left behind.

The child's intensity and image-making fantasy are transformd through education into intellectual conceptualizing and abstract thought. Original, total perceptions are taken apart, and replaced by logical reconstructions. The drawing of the child then ceases to reflect spontaneous experience and begins to adapt itself to the standard vision and concepts of the normal adult.

In his book *Education through Art,* Sir Herbert Read wrote of the possibility or necessity of preserving the child's capacity for perception in its pristine integrity on into the years of youth and beyond. Thus he hoped to realize in the twentieth century an idea Plato formulated more than two thousand years ago—using art as the foundation of education.

Can one construct a bridge between the improvised miracles of a child's drawing and a deliberately planned and controlled work of art? Georg Schmidt, who refused to recognize as art the creations of the mentally disturbed, was also skeptical about the artistic expression of children: "A child's art ends, however, precisely at the moment in which he enters into conflict with his time. Before this moment, the child lives in purely natural circumstances. Therefore children's art may well display aspects of true artistry, but as an expressive whole it is not art."

If we can consider children's artistically valuable and expressive achievements and withhold from them the honor of being called art because the creativity behind them is of a transient kind and a factor of biological development, we should recall that many artists produce works of importance only in a given period—generally in their youth—but later lose their creative imagination.

In these closing years of an epoch, when intellectual assumptions and aesthetic standards are changing radically, the drawings of children which have fertilized and affected the art of our times should be included in any consideration of the dimensions of the total phenomena of art.

In order to escape the circuit of outworn, traditional forms, many artists of the second half of the twentieth century have surrendered themselves to the impetus of play; play-art has been the frequent motif of contemporary exhibits. Playful activity which is undertaken without any conscious aim and which happens of itself out of sheer pleasure belongs to one of the early stages in man's development. Free play serves as the child's active preparation for life; repetition of experience eases the unconscious attempt to enter into harmony with the basic structures of one's surroundings. What is lasting in art, however, is hardly achieved through the exercise of unintentional functions, but rather from the creative will to give shape to an interpretation of the world.

While Gauguin sought renewal from sources of nature in the South Seas, Paul Klee found his own manner of expression not in primitive perception but in observation of archetypes. Psychoanalysis and a knowledge of past ages were his prerequisites for the journey into the realm of origins and of childhood. But the drawings of children also provided Klee with visual documents which, when deciphered, helped him discover a miraculous region of unintentional poetry: ". . . There are ultimate origins of art, you see, that one is more likely to find in ethnographic collections or at home in the nursery.

Paul Klee, Sick Man in a Boat, *1940 This highly cultivated artist once spoke of the primal beginnings of art that can be found in the nursery: "Children can do it too, and there is wisdom to be gained from that. . . The sick man and the boat, rendered with childlike and at the same time refined lines, may suggest the last voyage across the river of forgetting.*

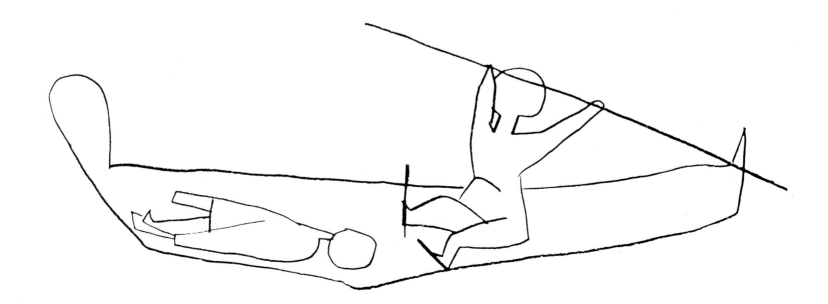

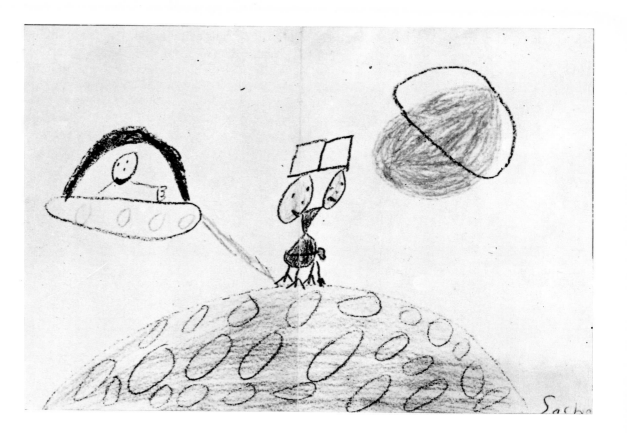

Space Traveler, *a drawing by the six-year-old Sasha Powers, Truro, Massachusetts.*
Scarcely any other voice could communicate so honestly the new and special events of our time. The child artist shows us man on his dangerous and adventuresome journey into cosmic space.

Don't laugh, Reader! Children can do it too, and there is wisdom to be gained from the fact that they can." (Paul Klee, 1912)

From early historical times to the primitives bordering upon our own, the works of painters and sculptors have sustained a fetish quality of magical power. Picture-magic still survives to a degree today in the art of children and of the mentally disturbed. The child believes he has the things themselves in his images of them, and also for the mentally sick painting is a way of taking possession of things. In the twentieth century a variant of object fetishism has arisen in the art of Dada, in pop art, and in Surrealism. Forms and objects function as the bearers of meaning in a disoriented world.

A view of art that no longer looks for imitation but rather for primal images will not hesitate to recognize the artistic utterances of psychotics as creative expressions. Our outworn and comparatively lifeless culture in this atomic age occasionally courts impulses of renewal by conjuring up the primal and archetypal. It also takes an inter-

est in the crippled powers of the psychopath: "The borderline cases of 'schizophrenic art' or of *peinture naïve* call attention to the scientific discovery of the unconscious and of archetypal regression as a distinctly supra-individual factor at work during the genesis of the work of art, which in turn can contribute just as much to an understanding of the art in its time as do external historical factors bearing on it . . .," writes Peter Gorsen in his study *The Painting of Schizophrenics as Art.*

If deep similarities are evident when one compares the work of children and naives, there is nonetheless a constant divergence to the point of separation between the permanence of children's creations and of those of the naives. The child's artistic output is ephemeral; as he develops, his instinctive powers are reduced and the creative act is generally supplanted by deliberate and rational conceptions.

The work of the naive artist has a chance at permanence; the art of the child passes away.

Artistic Expression of the Mentally Ill

The art of the mentally ill, like that of children, lies outside of any historical development along the course of human progress. It too shatters the mesh of logic, negates the restraints of civilization, and ignores all established relationships between man and things. It too can achieve no continuity, since the calligraphy of terror, the distorted forms of madness, receive their stimulus from a sickness which precludes any conscious, continuous creative production.

"The person who is mentally ill can only develop the forms and figures residing in him, while the naive painter freely chooses his motifs. The further the process of disintegration of the personality has advanced, the more the work of the patient loses structure—the structure that is preserved by the naive painter, no matter how bizarre the representation, how crude the rendering, how ornamental and decorative the style. The sick mind works spontaneously and uncontrollably, while the naive painter procedes with much deliberation." (Dr. L. Gans, at the Hlebine Symposium, 1970)

The precise boundary between normality and madness, between health and illness, may always have been difficult to draw in the field of art. In modern art it is scarcely any longer discernible. The present-day artist, in contrast to the man of the Renaissance, no longer feels himself to be a *homo universalis* in harmony with the order of the world and the cosmos. He makes use of the language of the absurd and the fantastic in order to portray the nightmares and hallucinations that oppress him; visions of terror, insecurity, and isolation thus find expression. Hell is no longer a distant threat remote from earthly existence; it is all too present in our world. The disruption of the relationship of man to his surroundings, once a characteristic of mental illness, has nearly become a standard ingredient of the modern sense of life. As such it finds expression in images of a decomposed and transposed world, as ours has come to be represented in modern art.

In his study of the painting of the mentally ill (1922), Prinzhorn wrote by way of analysis of one patient's drawings: "Tulip blossoms and children's heads are spread out in rows like apples in a pantry. The children toward the back have become somewhat bigger than those in front. It is only striking that the ground is cut off horizontally at the top, for the dark row of firs that reaches from this horizontal into the sky tempts one to seek other points of perspective. As one looks carefully at one after another along these stiff rows of heads, one can perceive directly an evident compulsion toward stereotyped repetition. There is a touchingly childlike objectivity in this mass scene composed with the obligation to build up the concept of plurality through dogged enumeration. This is surely a sign of the mentality of a child, expressing itself so openly here only as a result of the illness. One thinks of peasant painting and of the customs official Henri Rousseau, who one day became a painter and fascinated even the experts with the utterly simple composition of those contemplative pictures projected out of his charmingly childlike being. His pictures and his life story make it highly probable that one would have to classify him as a benign schizophrenic. His engaging gentleness and his alienation coupled with visionary experience suggest as much quite persuasively. . . ."

Today every contemporary art exhibit shows us the suspension of the laws of perspective and anatomy, the dislocation of foreground and background, and that stereotyped repetition akin to ornament which the scientist could identify as the product of compulsion. These belong to the vocabulary of modern painting, easily enough explained as symptoms of the spirit of technology and the mass psychology of men in large cities. It would be absurd to try to apply the concept of schizophrenia to all artists who alter the classical standards of visible nature and expand the inventory of form in accord with their inner vision. Art has never been limited to the catalogue of observable reality, and today it can be so less than ever. Often it must leave the boundaries of custom behind

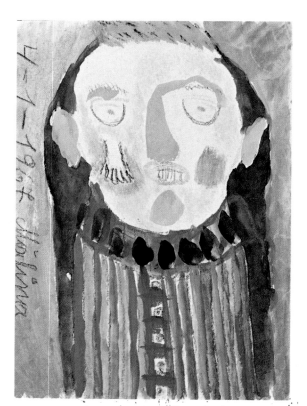

Portrait of a Man With a Hand on His Cheek, *by the mental patient Malina, Bratislava, 1967.*

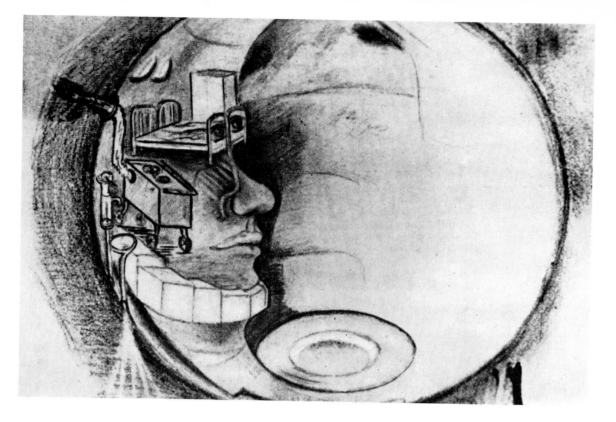

Head of a Man, *by a patient S. K. in the University Neurospychiatric Clinic in Pécs, Hungary. The man's head is drawn in severe profile, and as though enclosed in a glass sphere. An electric shock-machine—which is simultaneously a kitchen range—takes the place of his ear. Glazed eyes peer through the iron rails of two bed-frames which are balanced on the bridge of his nose. The patient had attended an art school.*

and plunge into an uncontrolled fantasy world in order to find itself and to find truth.

In his study *The Painting of the Mentally Ill: A Mirror of the Human Soul,* Alfred Bader writes: "There is no psychopathological art in the truest sense, for the phenomenon of art—or for that matter the creative act—is basically uninfluenced by mental illness. . . ." Bader proceeds to complain that the earlier theory developed by Lombroso about the relationship of genius and madness had placed a false aura of sanctity about the works of the mentally sick. Mental illness, he insists, presupposes no inherent creative ability; the works of patients which might be of artistic interest beyond the merely clinical are few indeed. There are sick persons, to be sure, who have never tried their hand at painting before their illness, but who begin to draw during the course of their psychosis and suddenly reveal a hidden talent: "In such cases the mental illness may serve as a catalyst and assist a gift to break free of the restraints which had hindered its development. Those schizophrenics who are only stimulated to graphic expression through their illness are self-taught in the truest sense of the word. Their isolation in the world of mental illness, one so utterly different from our own, causes them to express themselves with a pencil or a brush quite free of preconceptions. . . ."

Inborn talent is just as all-important among the mentally ill as it is for the healthy artist. Mental illness cannot produce artistic genius, but it can activate latent talent and set free a creative spontaneity productive of works of art bound by no convention and by no style.

There are no pictures so produced which are well thought out in advance and conceived in accordance with a deliberate plan. The sick person does not explore, but rather projects into the outside world the vision he has experienced and survived; this vision breaks forth in an unchecked stream of the unconscious and is developed with a spontaneity familiar to us in the art of the twentieth century in the essentially similar manifestations of "sequential painting," "incarnation of the sign," tachism, and "informal painting."

Among the specific trademarks of the painting of schizophrenics belong a fixation on sexual motifs, autism, hallucinatory and acoustic experiences, a tendency toward anatomical deformation, lack of depth, and the absence of shading and shadow. This is no intentional stylization, but rather a metamorphosis rooted in the illness and lying outside the logical world. But even such designations are inadequate; the metamorphosis and hybridization of men, animals, plants, and stones can be found in the work of archaic and primitive artists. Toward the close of the Middle Ages they take on increased importance in the symbolic paintings of Heironymus Bosch and his contemporaries; they occur in the works of the Mannerists and in countless variations in our own time in Picasso, Max Ernst, Paul Klee, Joan Miró, and others.

In contrast to the works of these artists who summon their visions of figures apprehensively out of the depth of the soul and release them into their work, the painting of schizophrenics is the reflection of a world in which the soul of the patient is confined.

Lévy-Bruhl, in his book *The Primitive Mentality* (1922), wrote of the preconceptions of primitives as based upon their belief in magical forces: "In the collective imaginings of the primitive mentality, objects, beings, and phenomena can be both themselves and something other at the same time, in a manner incomprehensible to us. In an equally incomprehensible way, they radiate forces and receive them; 'virtues,' qualities, and mystical effects may become noticeable in their surroundings, though the objects remain in their original locations. . . ."

The hands of artists among primitive peoples are guided by spirits and ancestors; for many naives—especially in the ritual painting of Haitian artists—the work is often felt to be a suprapersonal commission from the deities. In the case of the mentally disturbed there are medial forces of the soul which move the brush.

I asked the naive wood carver Bogosav Živković how he came to create his fantastic hybrid figures of men, animals, and plants. He replied: "They are contained in the log. They live there. I liberate them by simply removing the covering material."

Séraphine Louis, the painter of astonishingly ecstatic, fecund bouquets of flowers and fruit-seeds, worked in a condition of trancelike obsession. Somewhere between religious transport and erotic longing, her paintings emerged as dispatches from a paradisiacal dream world.

The two-faced forms of the gifted peasant painter Iliya Bosilj—these angels, heroes, demons, and cosmonauts struggling out of his divided soul like the hallucinatory revelations of Trillhaase's religious fixation—show signs of schizophrenia. The weird scenes of Friedrich Schröder-Sonnenstern, dictated by a sexual compulsion, are also rooted in the dark soil of psychopathology like the images of Edmund Monsiel, forms projected out of fear and isolation and surrounded by the thousand eyes of God.

Jean Dubuffet tells in his publication *Art Brut* about the spiritist suggestion that led the miner Augustin Lesage to transmit his fate-haunted pictures as messages from another world. For Dubuffet art shares nothing in common with knowledge and culture; the original, untainted language of the artless picture is in complete contrast to all canons of beauty. He finds his models in primitives, in the works of children and psychopaths—but not in art.

Professor Hans Steck compares the magical thinking of primitives with the utterances of schizophrenics. The painting of the mentally ill does not correspond to a conversation with the surrounding world, but is rather a lonely monologue nourished by inner conceptions, directed within, even though from time to time it addresses real or imaginary personalities: the attending doctor, the spirits of the deceased, or even God. "The magical power and meaning adhering to the name or the picture of a being or thing are typical examples of the quality of primitive thought. There is a concern for concretization such as one encounters constantly among schizophrenics. . . ."

The patient is at one and the same time himself and another. There are tabooed words for him which as among primitives are charged with fateful meaning. The primitives, in their fear of invisible forces, protect themselves with the help of taboos and magical ceremonies. The schizophrenic has similar defenses. As the paleolithic hunters attempted to charm their game by depicting it on cavern walls, gifted and solitary schizophrenics project the ideas of their madness in pictures and gain thereby, in the fusion of rhythms and forms, a new and integral image of bodies contending with existence; they thus manage to conquer their own fragmentation.

One need not be of the same opinion as Dubuffet in order to take interest in children's drawing and the painting of schizophrenics. Such art, though it has not yet reached the threshold of purely aesthetic experience, touches us today no less than that other marginal manifestation of cybernetic art which is produced outside the human sphere. The border between the "healthy" and the "sick" in the realm of art has begun to blur.

The art of schizophrenics can include genuine masterpieces when a creative gift is at work.

Naive artists share with children the distinction of being the last people in our civilized world who can still be moved to awe, and who can lend form to the miraculous.

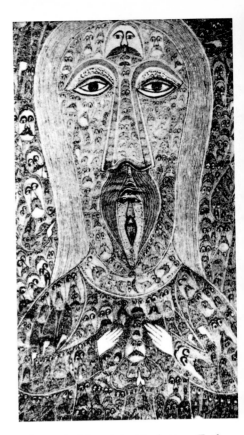

Edmund Monsiel, God the Father, *Poland, 1956.*
The boundaries between health and sickness, fantasy and madness, between high art, naive art, and the work of mental patients occasionally blur.

Below:
Friedrich Schröder-Sonnenstern, The Moral Mule-Driver.

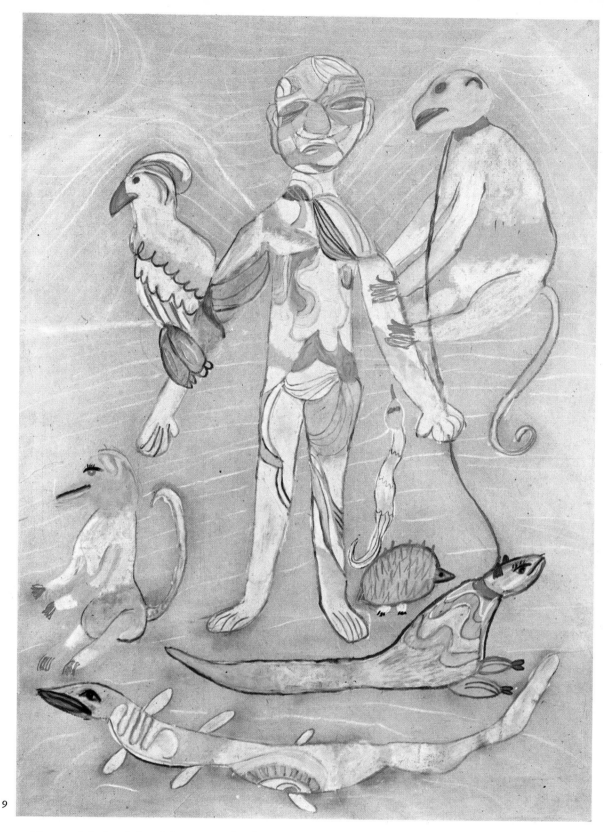

9

9. Man and Animal (1969), *watercolor by Jasmina Krašković, age 12, House of the Pioneers, Belgrade*

The schoolgirl artist Jasmina has painted a picture which we can appreciate as being well-nigh perfect. She has nearly transcended the limitations of children's art. Will she manage to preserve her degree of penetration and her sensitivity in spite of the rationalizing influences of schooling and of life in general? This picture of the communion of man and animals is done in light and gentle colors.

A man with a round, bald head provides a resting place for a parrot and an ape. At his feet are a hedgehog, a crocodile, and a cross between a dog and an ape. Jasmina has used a pastel blue, shell pink, lilac, and saffron yellow against a cool, misty gray background. It is a peaceful world. We do not know whether this man is taming the animals, or whether he gathers them around him because he too belongs to their kingdom. His face, with its large nose and angular eyes, suggests a dreamlike state.

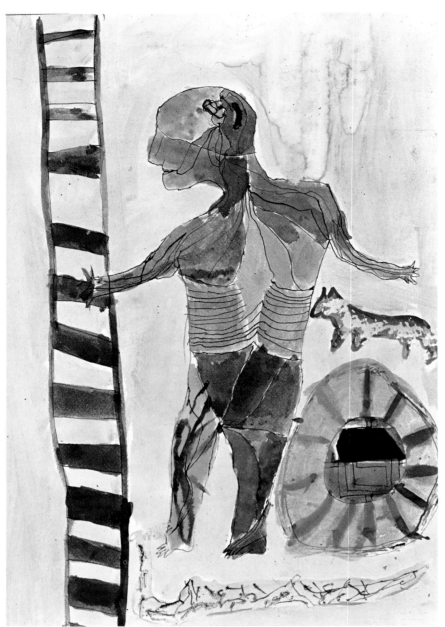

10

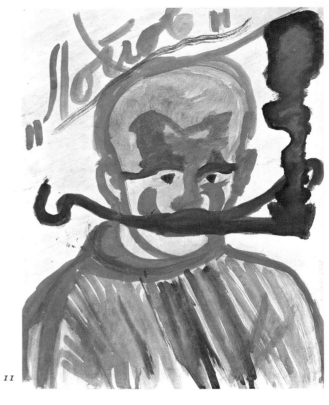

11

10. Man in the Factory (1969), *drawing and watercolor by Tomislav Ratković, age 9, House of the Pioneers, Belgrade*

The nine-year-old boy Tomislav has chosen a man, a ladder, a wheel, and an animal as the pictorial elements for his concept of life in a factory. The human figure seems to have been stripped of its skin, so that one senses the mechanics of the body between the rhythms of the ladder rungs and the spokes of the wheel. Shimmering and iridescent color give the picture a certain mystery. We are struck to see how a child is able to paint so expressively what is given to his inner imagination.

11. The Thief, *watercolor by a 22-year-old patient called Milutin*

Milutin painted this portrait with swift and strong brush strokes. The same evening he lost his cigarette holder,

12

13

14

15

and was convinced that it had been stolen. The following morning, in a rage, he added a smoking cigarette holder to the picture and called it The Thief. Afterwards, having punished the thief via the picture, he calmed down again.

12. My Friend (1969), *chalk drawing on paper by Murali, age 7–8, Isidora Sekulić Grammar School, Belgrade*

13. Children Feeding the Birds (1969), *watercolor by Savica Kocović, age 7–8, Isidora Sekulić Grammar School, Belgrade*

14. Portrait, *chalk drawing by a patient called Toma, age 19*

On his own, as though following an inner urge, Toma began to draw with chalk on paper with swift and violent motions. He will produce twenty or more pages of drawings in succession before a given spurt of activity is ended, and he is then exhausted and calm. The dynamic and bold lines of his drawing reflect a confused poetic spontaneity.

15. The Burial, *watercolor by a patient called Kumbla*

16. César (1948), *drawing by a patient called Aloyse*

Aloyse was born in Lausanne in 1886, with severe psychic derangement inherited from her mother. In 1918 she was placed in a psychiatric clinic. She was visited by cosmic visions of madness, and she wrote religious texts which she then illustrated with pencil drawings of flowers of an obvious sexual symbolism. Though her speech was nearly unintelligible, her means of expression in art developed a considerable beauty and intensity. In his Miraculous World of Madness, Alfred Bader has written: "There is no doubt that unsatisfied sexual desires have had a great effect on Aloyse's pictorial production. . . . Her lascivious figures, whose breasts are often transformed into flowers (symbolic of fertility), provide her a chance to realize her frustrated drive at least on paper, and a certain compensation for her suppressed craving for love. . . ."

16

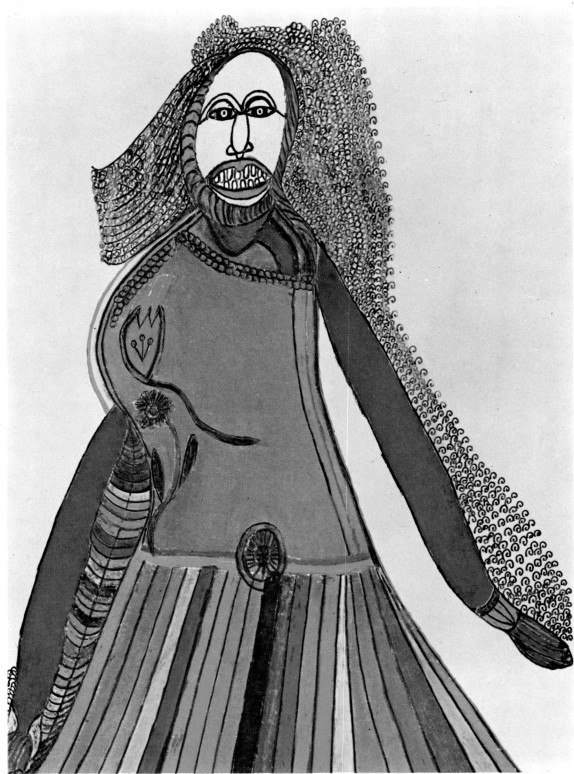

17

17. Female Figure (1960), *chalk drawing by a patient called Hans*

Born in 1926, this patient was admitted into a sanatorium at the age of seventeen. In his thirty-fourth year he turned to artistic activity in a psychotic condition for the first time. This opportunity for expression proved helpful even after his acute psychosis. The portrait of a woman which I include here was made shortly before the resolution of a manic phase. The manifold contours of the upper body and the masklike rigidity of the face with its paranoid expression show recognizable symptoms of schizophrenia. The rainbow-colored drawing is everywhere exciting, but especially in the abundance of precisely drawn spirals of her hair lies the eternal fascination of the feminine.

Folk Art
and Regional Creativity

Chapter III

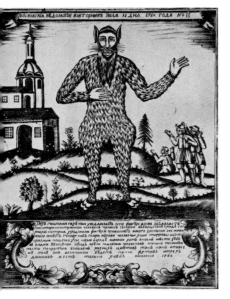

Picture of a Miracle Man, *from a portfolio of Russian engravings, Moscow, 1760.*
Portfolios in the "scullery" style, as was called, were first produced by Russian monks in the seventeenth century. Both secular and religious themes were utilized. Beggars peddled these "Lubki" prints at markets and fairs.

In folk art, cult and magic are supplanted by tradition and community opinion. The peasant carriers of the regional heritage are no longer sorcerers and mediums of secret conspiracy with cosmic powers, but rather respectful custodians of the clearly defined and established rules of form of the community. The concept "folk art" is associated with the culture of agrarian society; regional boundaries and backwardness preserve this social structure.

Folk art implies long history and inheritance; it rests not on the achievements of individual taste, but on the conceptual world of custom and tradition. It lives as long as the necessary social and psychological community is unchallenged. In modern civilization the old social structures are surely dissolving. Folk and peasant arts are losing their original inner substance and are becoming merely decorative coverings for a lost message.

Peasant art was only recognized for what it was late in the history of art. Only in the twentieth century did there develop a new feeling for its beauty, expressiveness, and integrity. Until that time it had been considered only with benign indulgence as one aspect of ethnography.

To be sure, nineteenth-century Romanticism had concerned itself with folk art; it did so chiefly because of its preference for indigenous poetry and music which appealed more directly to its concept of life. Painting and sculpture as produced by the peasants could not attract the attention of the Romanticist. The immediacy of this art, like that of the primitives, was only appreciated much later by the Expressionists and Fauves, who saw in it an achievement of their own professed aims. The poetry of the rustic, primitive and naïve, the vital metaphor of inner agitation, fascinated the modern artist.

In folk art there had never developed that gradually increasing distance from the taste and tolerance of broad masses of the people which we witness in professional art. Between "producers" and "consumers" of folk art there exists complete accord. Folk art itself bears the stamp of a common mentality; it never leaves the framework of local custom nor stands in conflict with the communal sensibility.

Rootedness in tradition allowed folk art only limited freedom of movement, little chance to alter its stock of inherited forms. A strict canon prescribed the forms, and allowed them to reflect historical changes only after a considerable lag. Folk art in every epoch has meant the repetition and rebirth of the artistic impulse inherited and accepted from previous generations.

Such changes as can be noticed in folk art, in spite of the seclusion of country life, derive generally from the influence of the church, the court, and the manor house, as well as of the culture of the town.

Prehistoric, historic and contemporary motifs blend together, as any object of folk art shows: pots with the neolithic designs of the spiral and the meander or with colors and ornaments echoing Roman ceramics; the *siurelles* of Majorca, those primitive figures of riders on horses or cows, still displaying the Punic heritage; anywhere and everywhere a pre-Roman dependence on line, a Gothic sense of space, the feel for proportion of the Renaissance, the love of movement and ornament of the Baroque, the repose and sense of order of Classicism, the emotional substance of Romanticism.

Since the objects of folk art were not oriented toward particular epochs or stylistic periods, it is often difficult to date them. In

an altered, simplified, and outdated form, they reflect the progress of taste in the outside world. Folk art does not recognize the distinction between the artistically significant and the practical. The aesthetic self-function of the work of art which since the Renaissance has led to the development of an art for collectors and museums, but for no specific demand, is simply unknown to it. By its very essence it is applied art, and it functions within the realm of what is useful. Accordingly, its value is not in its uniqueness, but rather in its faithfulness in the reproducing of previous models. It knows variation in quality, but not variations of subjective expression.

The practical folk artists seldom shape true-to-life copies of visible nature; they simplify, exaggerate and deform the represented object. In that they work under their own emotional tensions, they communicate the experience of their locality to the world.

An important element and characteristic of folk art is its feeling for materials. Simple objects woven from rushes or made of iron, wood, clay, plant fibers, husks, willow sprigs, palm leaves—whatever the material, harmony and beauty are the natural result. Objects correspond to the landscape, be it sand, shore, cliff, sea, or pastureland, and to the men who made and used them: hunters, shepherds, fishermen, farmers, and craftsmen. All of these were determined through the conjunction of the individual character of the artist and the collective sensibility of the people.

Alexander Jackowski speaks of peasant sculpture in his book *Polish Folk Art:* "These define, in part, the character of this art: the close adherence of form to material, nonnaturalism, a compactness and simplicity of forms (the reduction of description to a minimum; geometric severity), the renunciation of individualization of the object represented (as different as the styles of individual carvers may be, still the various figures from one and the same artist will be remarkably uniform), strength of expression within a static and symmetrical composition (balance of the material in larger compositions), predominance of frontal orientation, preference for the development of rhythm especially in the treatment of the surface. . . ."

In his *Philosophy of Art History,* Arnold Hauser takes pains to deny that there existed a soul of the people, unchanged throughout the past, which with a kind of collective improvisation has produced folktales, folksongs and sagas: "Every product of folk art, every folksong and every lyrical motif has had its moment of origin, its birth place and its creator."

This excessive emphasis on individual creativity may be forgiven as the antithesis to an idealist, metaphysical definition as handed down by the Romanticists, who considered folk art to be the pure creation of the spiritual strength of the people. But though the romantic interpretation—in its enthusiasm of discovery—has put excessive stress on the unconscious collective power of the folk soul, Arnold Hauser's rational and individualist denial of the effect of the community is in its own way insufficiently conclusive in explanation of the phenomena of folk art.

Industrial mechanization, modern means of communication, new materials, products, and pigments threaten the things and forms of folk art. They dissolve the contemplative, patriarchal life, and they are changing the relationship between the craftsman and the consumer as well. Folk art is ending in the assembly-line manufacture of mass products for tourism. A local art of little distinction, one oriented toward the requirements of the market and of fashion, makes its appearance as ersatz folk art.

The disappearance of authentic folk art is not only the end result of technological development, but also the closing act in a complex historical and social process.

The anonymous forces which created folk art continue to survive in our time underground, and as the collective breaks apart they press for individual rebirth. The disintegrating folk art flows into a layman's art which combines the last influences of the collective and the original with the timeless need for play, and with the eternal, childlike, human will to create—into the art of the naives.

Here it will be shown that in the real world of art clear categories seldom stand, and that in our era of penetrating optical and acoustical mass-media cross-forms are predominant. Naive art, as well, will be unable to shut itself off completely from these influences and metamorphoses.

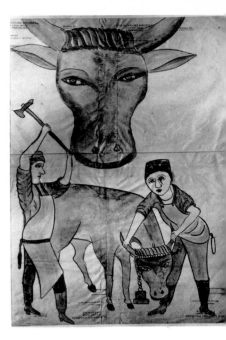

Alexander Salczmann, sketch for a butcher's sign, Prague.

Sign of the blacksmiths' guild from the Haute Vallée de la Seine, France 1878.

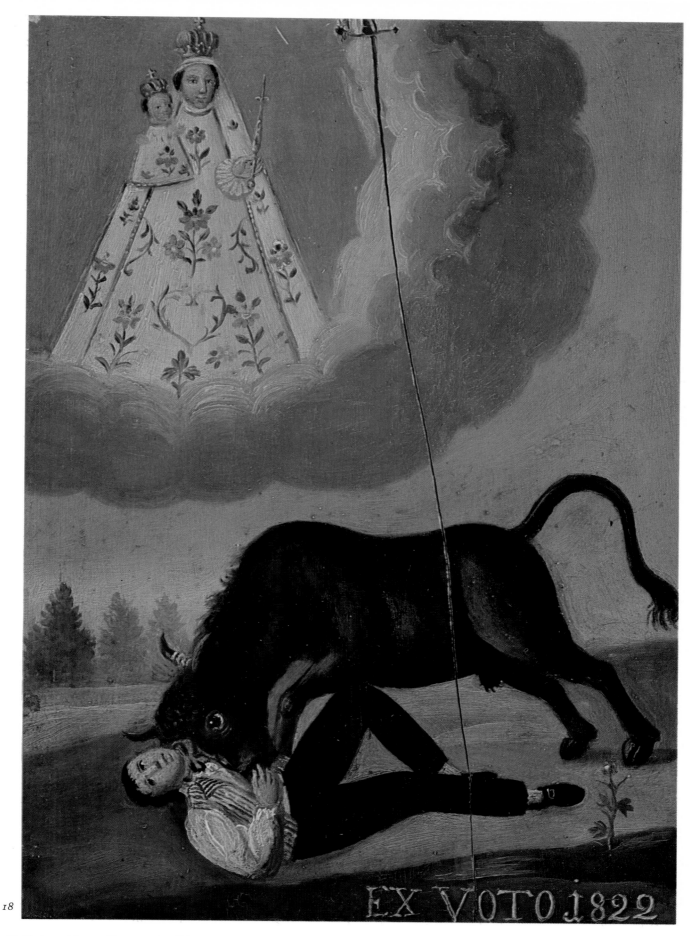

18

EX VOTO 1822

18. Bull Attacking a Farmer, *Ex Voto, 1822*

One can find a vast collection of popular naive art in votive churches, cloisters, and cemetery chapels, with their ex votos and martyrs which have been painted, embroidered, hammered, or carved, and dedicated to a guardian saint. These are but the remains of an ancient tradition of testimony and gratitude for one's salvation from extreme danger.

The dramatic event which here clearly did not end in tragedy, a horrible attack which nonetheless was averted, is presented with the precision of a photograph and the magic of a typically anonymous artist with a deep faith in miracles. The actors and the costumes have changed, but an antique and heathen feeling remains. Catholic and Orthodox patron saints have often appeared in portraits of charming grace and childlike simplicity on the stage of popular peasant painting.

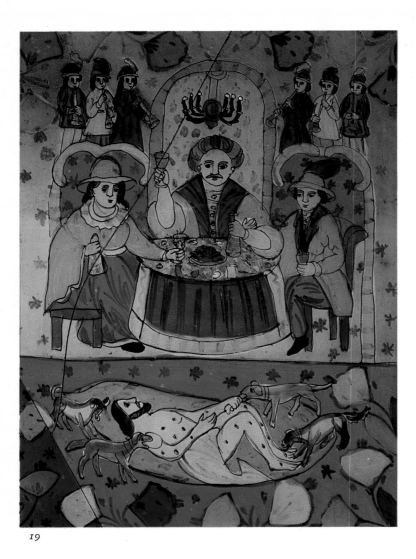

19

19. The Parable of the Rich Man and the Beggar Lazarus, *Polish painting behind glass*

20. The Prophet Elijah Driving a Fiery Chariot into Heaven, *early nineteenth-century painting behind glass from Rumania*

Through the course of centuries, tradition-bound artist-monks have developed painting schools and workshops in which not only the rules of composition are firmly fixed, but coloring and painting procedures as well.

In medieval icon painting the circle of painters became even more extensive, and naive elements are also apparent. During the sixteenth century, icon painting clearly became a branch of true folk art. The metaphysical landscape of these legends of saints took on a new vitality thanks to the cheerful palette of a folklorist naiveté. A primitive, simplifying use of line, a dynamic sense for composition, and a glowing and expressive range of color united to create a uniquely expressive popular art.

The rustic art of painting icons behind glass was developed in many places on the Balkan peninsula, but especially in Rumania. Aurel Rodeanu, the master of the Sorrowful Mother, *and this unknown painter of the ascension of the prophet Elijah were able to create color harmonies of extreme subtlety; the glow of their palettes and the delicate and poetic drawing produced works of exceptional naiveté and beauty.*

The anonymous Elijah-painter created an epic narrative full of adoration and an awesome sense of flight in radiant color. A street of clouds like a rainbow bears the mounting quadriga of the saint into an abstract infinity. The enamel-blue sphere of the world is spread beneath a golden sky, and further below one can see the praying figures kneeling in an earthly landscape.

The peasant painter Rodeanu portrayed the Virgin draped in black with only the subtlest colors and with a sparing use of form. A sorrow without pathos radiates from the abstract juxtaposition of gold, scarlet, and Delft blue.

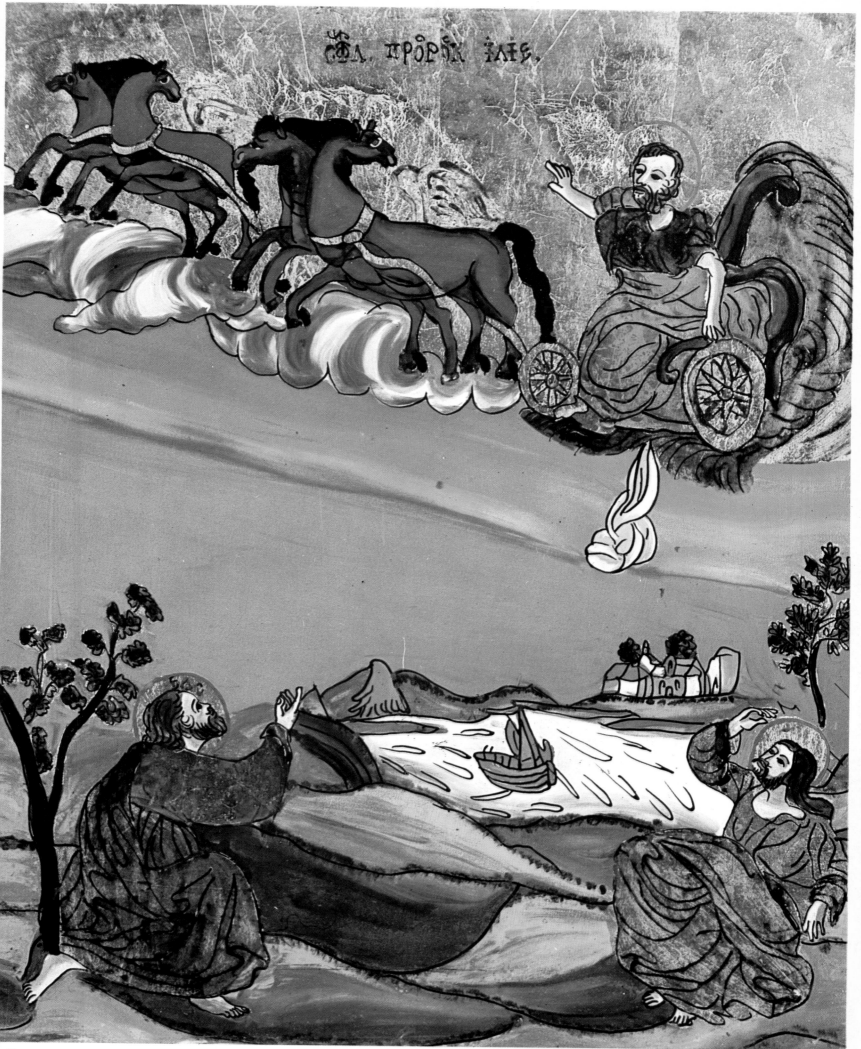

СѲЛ. ПРОРѺКЪ ІЛІЕ.

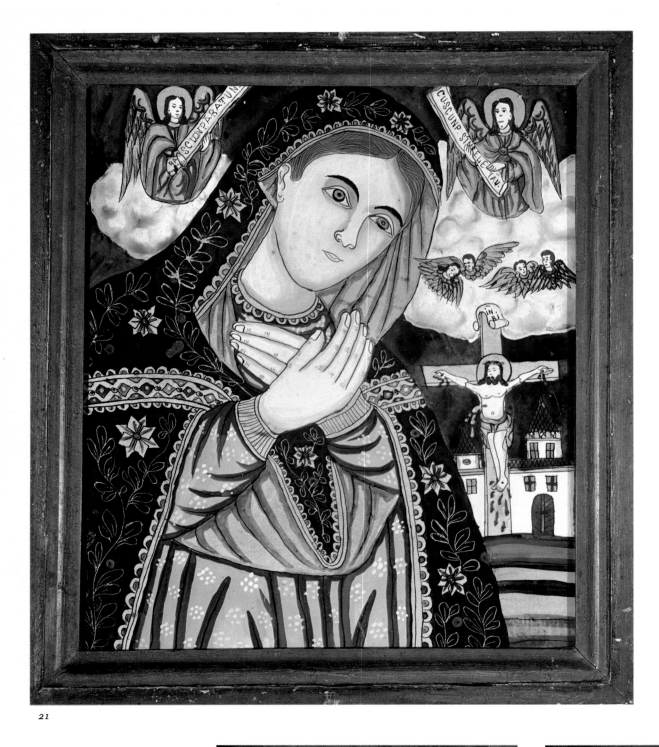

21

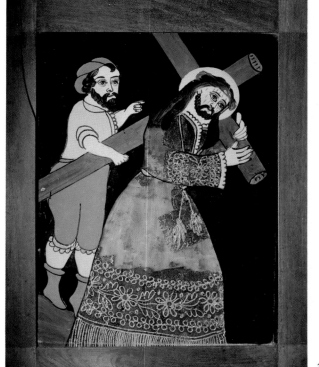

22

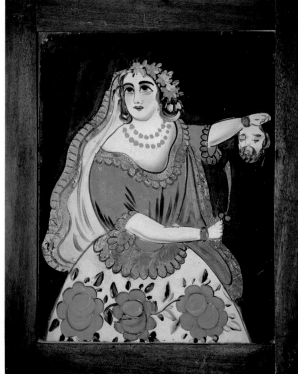

23

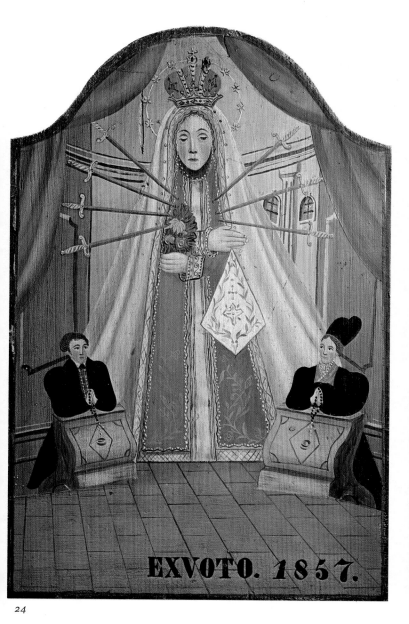

24

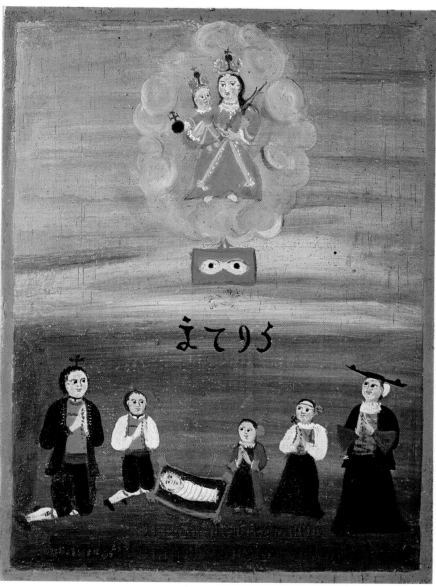

25

21. *Aurel Rodeanu,* Our Sorrowful Mother, *early nineteenth-century painting behind glass from Rumania*

22: Christ Bearing the Cross, *nineteenth-century painting behind glass from Seville, Spain*

23. Salome, *nineteenth-century painting behind glass from Seville, Spain*

Inspired by the import into Spain of paintings on glass from Oberammergau and from Austria and Bohemia, artists in,this genre established themselves in Andalusia, borrowing the traditions of Alpine countries. These paintings, with their specific Spanish influence, are charming examples of naive painting behind glass.

24. Peasant Couple Plighting Their Troth Before Our Gracious and Sorrowful Mother (*1857*), *Ex Voto from Lower Bavaria*

25. Praying for a Sick Child, *Ex Voto, 1795*

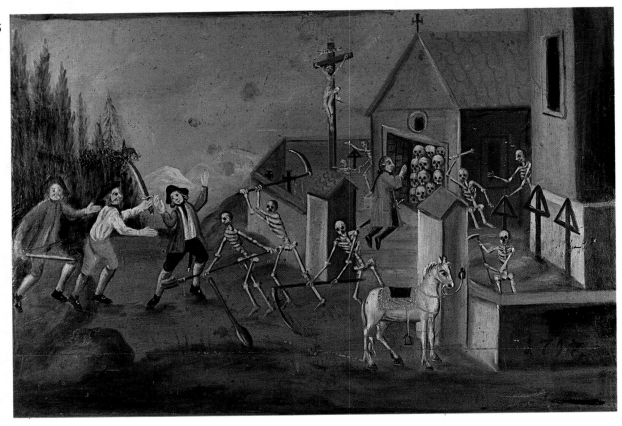

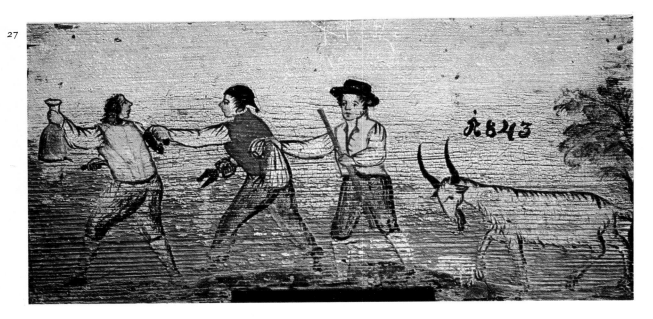

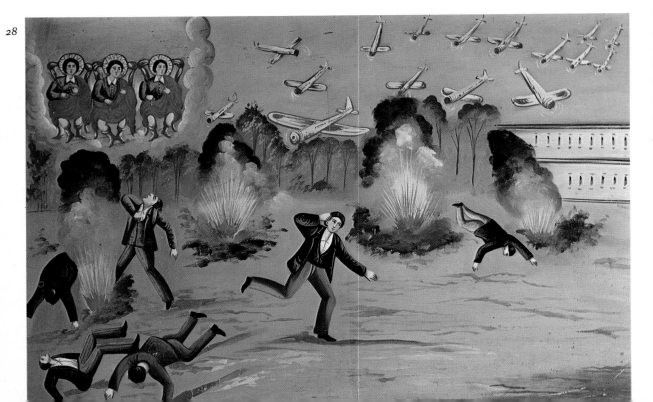

26. Attack by a Band of Robbers (1797), *votive painting from Mühldorf/Inn, Bavaria*

Peasant artists revived the art of painting behind glass around the middle of the eighteenth century, and it developed into a folk art of uncommon expressiveness through their reworking and variation of inherited motifs and their splendid sense for color. Behind this picture of the dead rising out of their tombs to bring help to the praying victims of a band of robbers is a legend that has also been illustrated in the Très Riches Heures *of the Duke of Berry, and which has seen many variations in many places in Germany and Switzerland. In the twentieth century, this art has again lost its intensity and expressiveness, and has sunk into the mass production of schematic motifs.*

27. Painted Proverb on a Slovenian Beehive, 1843

The paintings on the boards of beehives in Slovenia were done between the middle of the eighteenth century, which was the time of the highest flowering of peasant culture, and the turn of the twentieth century, when that culture died out. In Slovenia, these painted beehives came to reflect the prestige of their owners in the same way as did their cupboards, bed-frames, and chests. There were a number of professional peasant craftsmen who took up the formal tradition of the late Baroque, and who produced these various motifs from the local iconography with naive earnestness, with fantasy and humor, often making use of prints from Epinal or elsewhere.

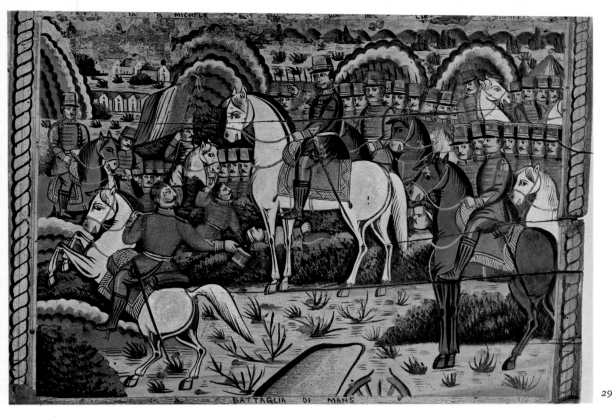

28. Bombing Attack on Catania, *1944, Italian votive painting*

Industrialization and the cheap reproduction of oil paintings have brought an end to the widespread practice of painting behind glass, which is done now only in isolated communities. But before the First World War the painters of the Blaue Reiter *school rediscovered the process. Just as the previous generation had been influenced by the art of the South Seas and of Africa, the genuine and simple feeling of these rustic painters was to have an effect on Kandinsky, Franz Marc, August Macke, and Alexej von Jawlensky.*

29. The Battle of Le Mans, *on the sideboard of a Sicilian cart*

Among the craftsmen of Italy in the last century, particularly in the smaller cities, there were people to be sure, but who composed idealized representations of their milieu with great passion, whether in portraits, family groups, landscapes, genre scenes, or mythologizing celebrations of the national struggle for emancipation. In the provincial museums one can find tradesmen's signs, or plaques from inns and carnival booths which give ample testimony to this pictorial narrative talent. Sicily, Sardinia, and Calabria are especially rich with naive religious and secular lay painting. Popular motifs are love scenes, historical occurrences, great tragedies, and scenes from courtly romances. With vitality, pathos, and a vivid expressiveness, these paintings display the balladlike simplification and the exaggeration of color which were the fashion of the eighteenth century.

30. The Tiger-God in the Form of a Holy Moslem Rider, *circa 1930, by an anonymous village painter from Santal, Parganas, in the state of Bihar, India*

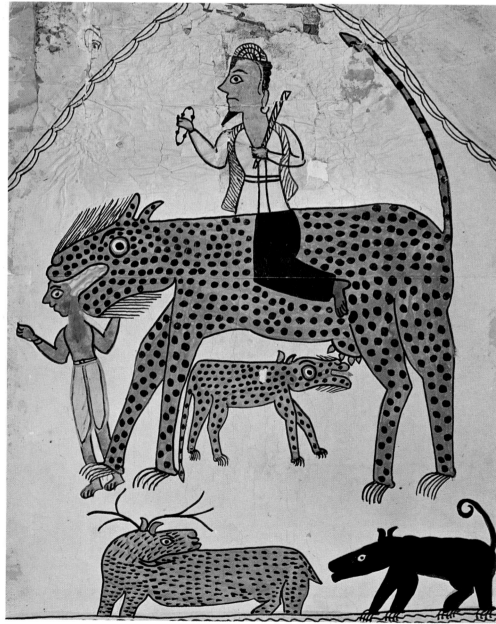

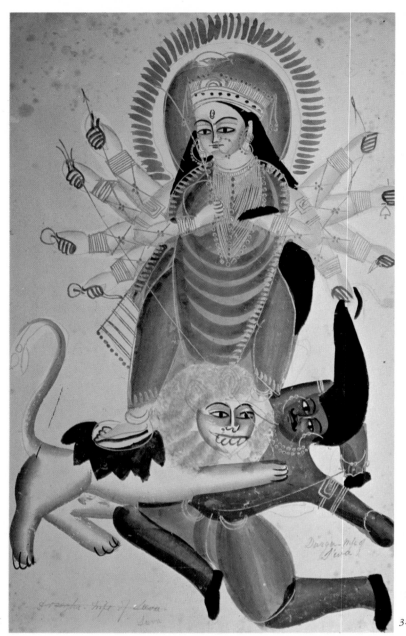

31

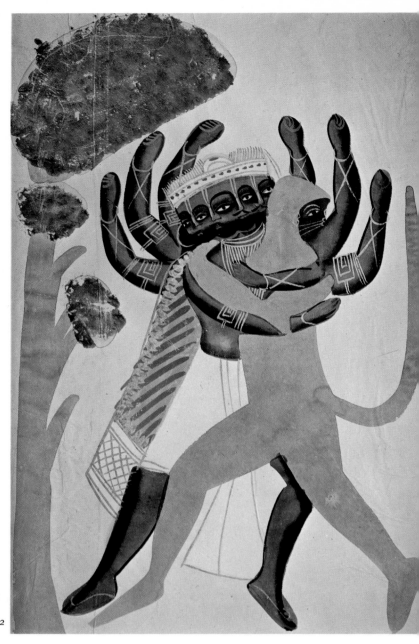

32

31. The Goddess Durga on Her Lion Kills the Demon Mahishasura, circa 1880, by an unknown artist of the Kalighat school, India

32. The Demon Ravana Fighting With the Ape Hanuman, circa 1880, watercolor by an unknown artist of the Kalighat school, India

The Popular Art of Indian Bazaars (Nos. 31 and 32)
The art of Kalighat has served the pilgrims to the temple of Kali near Calcutta for some 150 years, furnishing souvenirs for sale in front of the shrine. First there were wooden dolls and earthenware figures, and later watercolors of gods and goddesses were added. The artists have been Bengali Hindus of the Patna sect. In florid and determined brush strokes, they portrayed Krishna, Radha, Shiva, Durga, and other gods and goddesses.

Since the pilgrims were very humble people, the prices of these votive pictures also had to be very low. These Patna painters worked until roughly 1930, when printing replaced their handiwork. As early as 1888, Mukharji, of the Indian Museum in Calcutta, predicted that lithographs would bring about the demise of Patna painting. In 1870, they had begun to be quite critical of their own art, and English and European culture began to have an influence on it. The pilgrim art of the Patnas began to be thought of as old-fashioned, and schematization, simplification, and formal corruption were the predictable results of this confrontation between traditionalism in a naive popular art with the techniques and procedures of modern civilization. Beautiful, though somewhat banal, these popular illustrations of sacred legends had to give way to cheap color prints.

Folk Art, Limners,
and the Art of the Naives
in the U.S.A.

Chapter IV

Baby in a Red Chair, *by an unknown American painter, painted between 1800 and 1820.*
Though nothing is known of the painter of this portrait, it touches us deeply because of its air of dreamlike innocence.

Until the first decades of the twentieth century, North America's intellectuals suffered a certain sense of inferiority, fostered by the prevalent Europe-centered assumption of the superiority of ancient Mediterranean cultures and of the great European styles in art. They felt themselves to be in a cultural vacuum which could only be overcome as America's self-consciousness was strengthened through extension of her economic and political power. The discovery of cultures buried in the soil of North America, the uncovering of pre-Columbian gods, the rediscovery of Indian totem poles, of Negro sculpture and music, gave them in place of a classical heritage a unique and independent art free of preconceptions.

"For a quarter of a century the newest movements in radical art have come out of New York; in New York *the* artistic climate is created, from action painting to pop art, from 'environment' to cybernetic art.

"Perhaps the new continent is that space in which all heterogeneous forces of the time come together, the modern primitives and the technocrats, the urban nomads and computer engineers. (O. Bihalji-Merin, *The End of Art in the Scientific Age?*)

Three centuries before pop art there existed a popular art which led, as it turned out, to the forms of artistic expression which one can call the beginnings of a naive art in the United States.

The art of farmers, craftsmen, and housewives was so close to the unique spirit of the new nation precisely because it did not imitate traditional art. After the colonies had freed themselves from the European colonial system, the cultural ties binding them to the past of the old continent were loosed as well. An awakening desire for artistic expression found adequate form in the painting of amateurs or unschooled professionals. This art was the spontaneous answer to the need for recording, entertaining, and earning a living.

The precursors of naive painting in North America did not formulate a view of the world in opposition to the mainstream of art history, as was the case in France; they themselves belonged to the social sphere of those pioneers whose houses they painted, whose portraits they produced, and whose tastes they shared.

In most European countries, amateur art stood under the influence of the dominant artistic styles. Its painters called themselves *dilettanti,* and with inadequate materials and little skill they painted the same things as did the official artists—only imperfectly.

In America the contrast between dilettantishness and naive painting was from the beginning only slight. Many men and women painted in order to beautify their surroundings, to preserve the features of their relatives for the future, or to capture personal or historic events of their times. Portraits, memorials, landscapes, still lifes, genre pictures, and allegories comprise the gallery of the local painter; preachers and teachers decorated marriage and baptismal certificates, ladies painted arrangements of fruit, bouquets, and portraits of the deceased. Female seminaries trained their students in the art of watercoloring and painting on silk and velvet, just as they gave them lessons in reading, penmanship, and dancing. Here were combined a genteel, somewhat Romantic artistic habit on the part of amateurs and the professional practice of self-taught painters. Certain subjects—lifelike portraits, farm panoramas, and what-have-you—done to suit the taste and purse of the person who commissioned them, were the work of self-taught professionals. These artists were gen-

erally craftsmen—cartwrights, cabinet-makers, plasterers, sign painters—whose work had made them familiar with the rudiments of painting. Their art was hardly a hobby, but rather the source of their livelihood. There existed no visible distinction between handicraft and art. Most works from the close of the seventeenth and the early eighteenth centuries are unsigned. Without artistic training each painter relied on his own ingenuity, his skilled hands, and his artistic gift. He worked on his own; no patrician, no Maecenas supported him. He lived among the people with the unfailing approval of those whose needs in life he helped to satisfy.

From the seventeenth century on, painters of this sort, called "limners" (presumably from "illuminators," the painters of manuscripts and engravings), like the painters of the Middle Ages, worked anonymously.

The limners, like all craftsmen in America's pioneer era, took part in the hard life that came from the opening up of the continent. They scarcely dreamed that their art would become the object of intense interest in a later century.

The wandering limners traversed the broad countryside, decorated the farmers houses with stencil work or with free-drawn landscapes and frescoes, and painted their "likenesses" of farmers and city folk. In the winter months they often prepared the backgrounds of their portraits, painting clothing, jewelry, arms, and even hands in advance, so that only the face would have to be added later. For this reason the portraits of the limners tend to have something of the simple and typical about them. At the same time there were portraitists who worked directly from life. But in their work too one sees stereotyped poses and conventional gestures reinforced by the stiffness and austerity of the drawing, the unbroken, opaque use of color, and the instinctive urge for comprehensive simplification and schematization.

In the New England states of the East Coast, as in Pennsylvania, New York, and New Jersey, the small towns were the centers of primitive art. These states were the focus for a bustle of commerce, trades, and handicrafts. But while the large cities ordered their art "from abroad," the small country villages were the consumers for the primitive painters. Until the middle of the eighteenth century, portrait painting predominated. There followed landscapes and later genre pictures and historic scenes, which by the middle of the nineteenth century had achieved great popularity.

The limners of the second half of the seventeenth century are known, in spite of the quality of their work, only by the name of the person who commissioned their work or by its subject matter. The painter who was active around 1670 and who painted a portrait of Mr. and Mrs. Freake with their baby is simply known as "the Freake limner." The portraitist of the same period who painted the Mason family has entered cultural history as "the Mason limner." The sternly puritanical and austerely naive portraits of adults and of those charmingly stiff miniature adults, their children, look out at us from the context of their century with the delicate, remote expressions of sepia-toned daguerreotypes.

For two centuries the limners fulfilled the functions of the as yet uninvented camera. They created in this period those unique ancestral galleries of simple people which were later supplanted by photograph albums, which strayed up into attics to grow dusty and be forgotten until an age tired of technology and mechanization discovered them anew.

Joseph H. Davis of Newfield, Maine, who painted around 1856, was known by the nickname "Pine Hill Joe" because the beginning of each spring thaw found him following his wanderlust out into the woods and mountain wildernesses. He covered the countryside, collected commissions, and painted those almost silhouetted, rigidly profiled family portraits which he would occasionally sign: "Joseph H. Davis, painted with his left hand." Today we know of more than a hundred of his watercolors.

At roughly the same time, in Springfield, Massachusetts, there worked a painter by the name of Joseph Whiting Stock, who at eleven had suffered an accident and, being lame in both legs, could not take up any normal trade. He advertised himself to the public through newspaper announcements and found a great demand for his work. He produced more than a thousand portraits. The delicate, poetic pictures of deceased and living children touch our hearts with their rigid grace. The words of Thomas Wolfe echo within us: "A thousand voices, voices of his father, voices of his brother, voices of the child that he had been, and the voices of hundreds of other lost and vanished people whispered. . . ."

William Matthew Prior was one of the wandering portrait painters. In a newspaper announcement in the year 1828 he offered his services to the public: "Whoever prizes verisimilitude, and at a very reasonable price, should apply at once. Profiles and pictures of children at reduced rates." His finest quality paintings—including the frame—cost thirty-five dollars, a price which he tried to minimize at the close of his advertisement: "Anyone wishing only a flat picture without shading can have it at only one-fourth the cost."

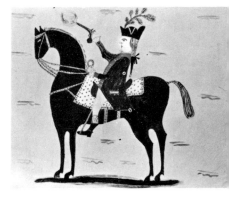

Mary Ann Willson, General Washington on Horseback, *circa 1820.*

Prior died in 1873. Thirty years had passed since the physicist Arago of the Academy of Sciences in Paris had explained Daguerre's photographic technique. With the arrival of photography, the profession of the portrait painters, the limners, began to languish. The camera replaced it.

Among the local painters who made up their own compositions, Edward Hicks is certainly the best known. He was born in Attleboro (now Langhorne) in the state of Pennsylvania, ended his apprenticeship as a cartwright at the age of thirteen, and opened his own shop at twenty. He traveled through many states preaching as a Quaker and painting pictures which with their charmingly archaic dignity praised peace among men (illus. 36).

Hicks loved grandiose historical compositions. The picture of *Washington on the Delaware* which was painted in 1835 and which served for a time as a sign on a bridge belongs to a series of them, as does *America's Declaration of Independence,* from 1845. Particularly successful however are his pictures of animals, regardless of whether he combined them in allegories, as in *Noah's Ark* (illus. 37), or chose them for farm portraits directly from the observable context of the everyday.

His *Cornell Farm,* painted in 1848, shows a herd of cattle grazing across softly rolling plains. Each individual animal can be counted, admired, and judged in its beauty and vitality: lively horses and comfortably fat cows, black and well-fed pigs, and the foal being stroked and protected by its mother. All are perfectly recognizable, like the faces in multiple portraits of guilds done by Dutch miniaturists. The viewer constantly comes upon new details: tiny figures in high hats, men in conversation about the harvest or a sale, plowmen, sheep, a garden fence, the red roofs of sheds and houses, and countless more.

After historical pictures and religious compositions, scenes of daily life were especially favored, pictures of men at work or on holiday. From Linton Park to Grandma Moses runs a tradition of the painter's dependence on the activities of the farmer and of the patriarchal society of the village.

Linton Park, presumably born in western Pennsylvania, lived from 1826 to 1906 and painted spirited representations of working men, genre pictures, and farms set carefully into the landscape. Among his most important pictures is the *Flax Scutching Bee* (illus. 38) from about 1860, which depicts the varied activities of the country folk with the realistic humor that comes from a droll love of life.

The painter combined the motif of labor with grotesque anecdotes and small glimpses of situation comedy into a lively genre picture set in a lyrical landscape. Against the sepia-colored background of the fences and log cabins a group of people move in a line, staggering to the unsteady rhythm of joyous festivity, from the main house on the right, across the foreground, and toward the left side where a fire has been built. Perhaps it is something in the manner of the narrative, the costumes of the women—their long dresses,

Edward Hicks, Cornell Farm. *Detail, circa 1848.*

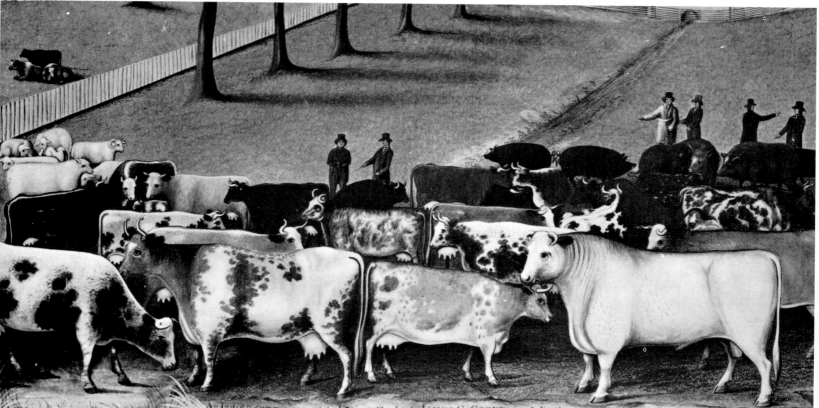

their head scarves and aprons—or possibly even the men in their gray and black top hats, which calls to mind Dutch genre painting. *En face,* in profile, or seen from behind, men and women are sitting on logs, dancing, singing, or following an old custom which allows the women to flail at the men with sticks, once the work is done, as they might the flax. The view of the landscape in the background with its trees, its ocher-colored haystacks, and its grayish-blue sky finishes off the naturalistic rural narrative with an attempt at aerial perspective. Any heaviness and clumsiness in the painting is compensated for by a respectful concern for order and an original talent for narrative. The easy sincerity and joyous, enthusiastic portrayal reveal an American Biedermeier sense of humor which lends depth to the rustic movements and simple situations and provides with a touch of creative naiveté this ragged chain of figures done in saffron-yellow, smoky blue, violet, and red-orange.

Around the middle of the nineteenth century, Thomas Chambers created his romantic landscapes of the Hudson River, the cascades of the Genesee, and of the dramatic, visionary Niagara Falls. About 1840 R. Costa, who is presumed to have been originally a ship's cook, was painting on wood his small and quite primitive pictures in which he records the life of the whale hunters and which call to mind Melville's Moby-Dick, "the all-destroying, but invincible whale."

Scarcely any other writer has carried within himself the sense of identity, the continuum of self and events, so unconsciously and suggestively as did Melville. The force of his legend of reality, in which men and things are refined into archaic symbols, places him in the close fraternity of *le Douanier* Rousseau.

With Edward Hicks, Linton Park, and Thomas Chambers, the boundary of amateurishness was shifted further in the direction of naive art. Let us try at this point to define the identity and the dissimilarity of amateur art and the art of naives.

The amateur painter tries to copy the appearance of visible reality. In doing so he achieves his effects less through the study of perspective and anatomy than by the imitation of finished details from the work of professionals. We can also recognize the desire of the naive painter to adapt for himself the style of the academic artist, but his manner of approach toward the revelations of nature is somehow more rooted in feeling and directed by instinct.

Amateur artists align themselves in the wake of the professional art to which they feel they have some claim. Accordingly they carefully and hesitantly follow the stylistic changes of high art and give their works the flavor of Classicism, Impressionism, or Expressionism, or elements of the surreal or the abstract.

While the naive painter attempts to represent the essence of things and appearances out of his own experience regardless of the breadth of his knowledge or his capabilities, the amateur artist tries to master traditional modes or even newer styles and, by borrowing from his models, to appropriate their perfection. The naive artist, filled with his private visions, and concepts, dares to tackle even the most difficult themes and achieves, through the tension between his technical ignorance and his inner truth, between intellectual simplicity and visual invention, that integrity of creative expression which distinguishes him from all other artists. Deformations and metamorphoses of appearances are for him not a matter of stylistic intent, but reflections of that inner truth.

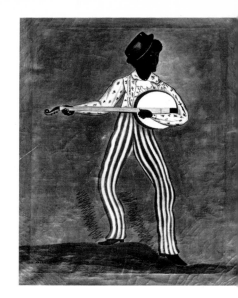

D. Morrill, Negro Singer With Banjo, *circa 1860.*

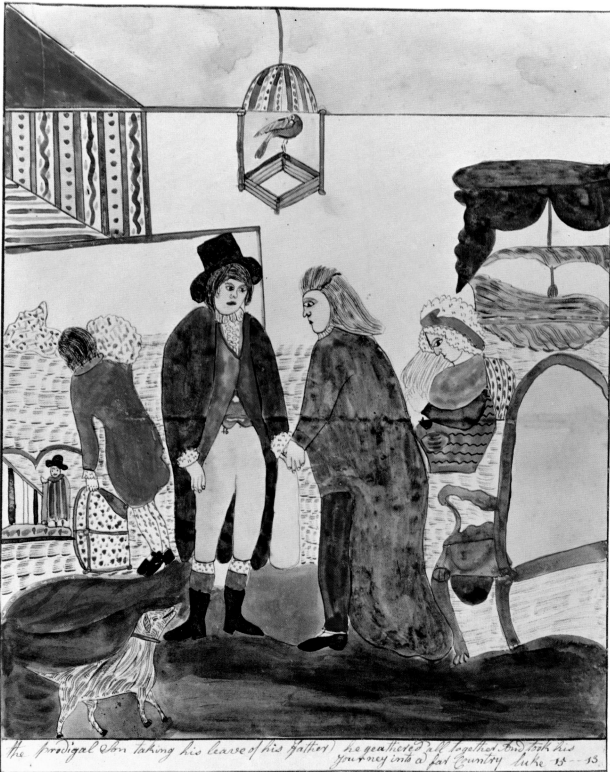

the prodigal Son taking his leave of his (father) he geathered all together And took his Journey into a far Country luke 15--13.

33

33. *Mary Ann Willson*, The Prodigal Son Taking Leave of His Father, *watercolor from circa 1820*

With training and inspiration, a schooled painter is able to suggest the ineffable and legendary in form, but the lay painter Mary Ann Willson manages to achieve the same results with utter simplicity. Inspired by delicate prints, she transposed the biblical theme of the prodigal son into a series of watercolors of permanent and up-to-date validity. The prodigal son says goodbye to his father, leaves his home and family, his bird and his dog, in order to follow an

obscure inner need to set off into the unknown: "And not long afterwards the youngest son collected all his things together and set off for a distant land, where he soon squandered his fortune . . ."

The departing son already has his hat and coat on, and his bags are packed; the painter portrays him in gentle colors—brown and blue, orange and pale green. The scene breathes a certain sadness, rising from the synthesis of childlike spontaneity and instinctive pictorial sense.

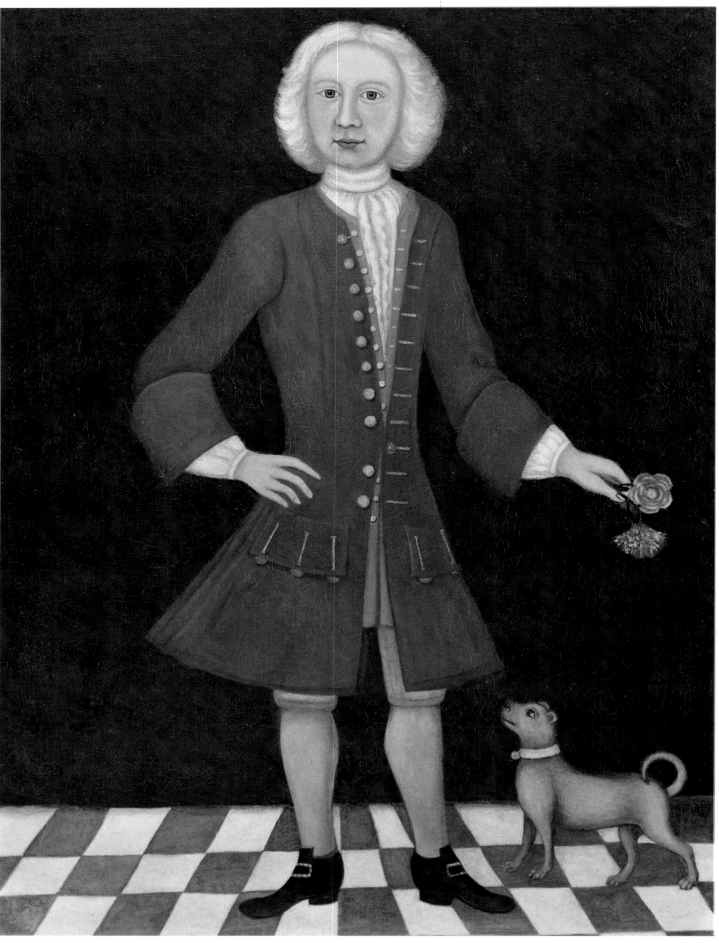

34

34. Portrait of Jonathan Bentham,
artist unknown, circa 1710

*This portrait of the young Jonathan Bentham
was painted around 1710 by an unknown
painter. Dressed as a page, he stares with
large child's eyes framed by whitish blond,
wiglike hair. He stands erect on the blue*
*and white checkered floor tiles, his right hand
on his hip, his left holding two pinkish
flowers, and with a little dog at his feet.
Everything is carefully placed and ordered, a
bit stiff, but nonetheless charming in front of
the dark blue-green of the background.*

35. The Sargent Family, *artist unknown, 1800*

We do not know who painted this portrait of the Massachusetts Sargent family either. The scene probably portrays the joyous reception of the returning father, who stands at the left in front of a half-opened door, still wearing his top hat and cutaway. Clean-shaven, and in a self-conscious posture, his right hand at his lapel and his left extended toward his daughter who welcomes him, he represents the comfort and ease of the American bourgeoisie of that period. His wife sits on the right,

also dressed in a dark color, with a baby on her lap and another child pressing against her knees. For the sake of symmetry, the fourth child is placed in the middle of the picture. It is playing with a ball on a string which a small dog is trying to catch. Bird cages are hanging on the pale green wall patterned with roses, and below the carefully draped window curtains, we can see a neatly framed bit of landscape. This is a picture of simple and warm family comfort, captured by an experienced limner—a painted photograph which antedates Daguerre.

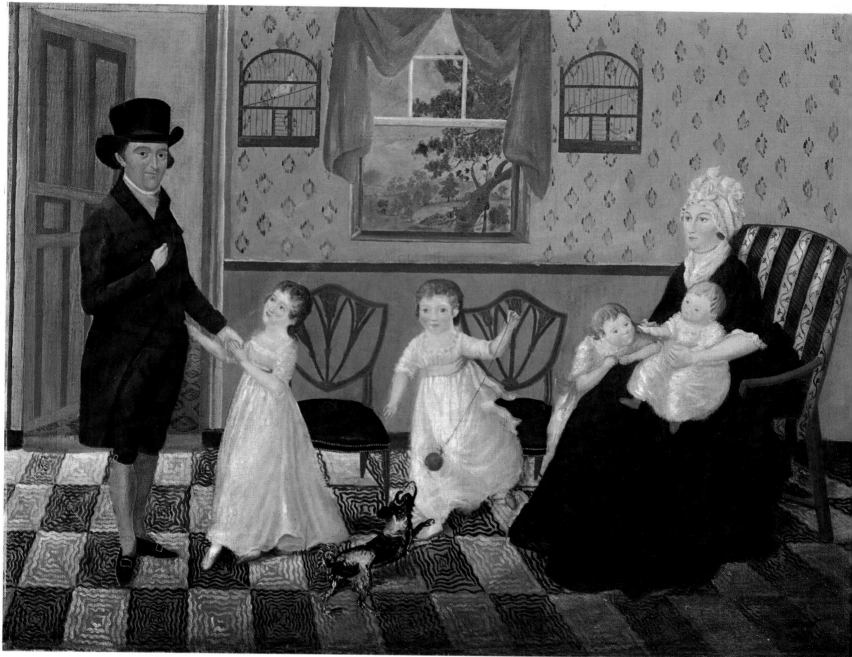

35

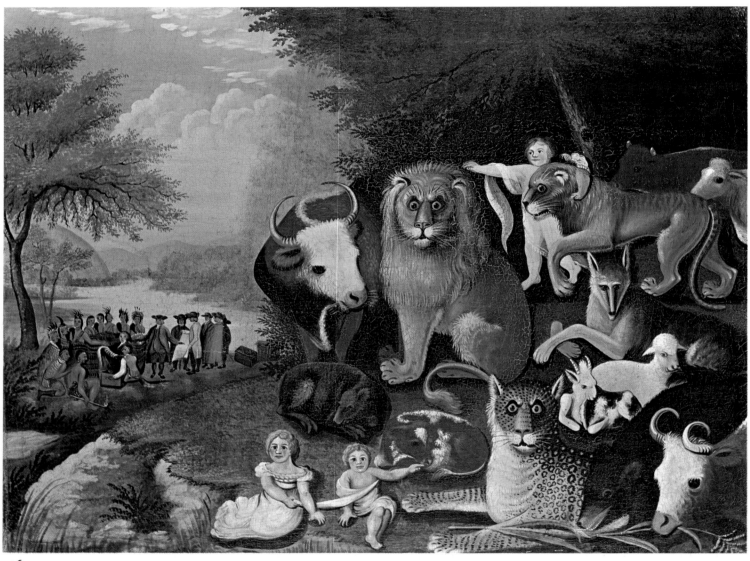

36

36. *Edward Hicks*, The Peaceable Kingdom, *1830–40*

*Edward Hicks, a cartwright and painter and Quaker preacher
(1780–1849), often took Bible stories as his themes. He
preached and wrote, and as a self-taught painter portrayed
landscapes, farms, Old Testament and historical compositions,
dreaming all the while of a land of peace among men and
animals.* The Peaceable Kingdom—*like* Noah's Ark—*gave him
a chance to paint a variety of animals in the context of one large
composition.*

*This picture is both naive and romantic, and he produced several
variations of it. A rosy-cheeked child embraces his friend the
lion, while goats and a cow and a lamb mix fearlessly with
predatory beasts. In the background is the statesman William
Penn with his friends, renewing a treaty of peace with the chiefs
of the Indian tribes. Behind him there are mountains suffused
in a bluish light and a pleasant lake.*

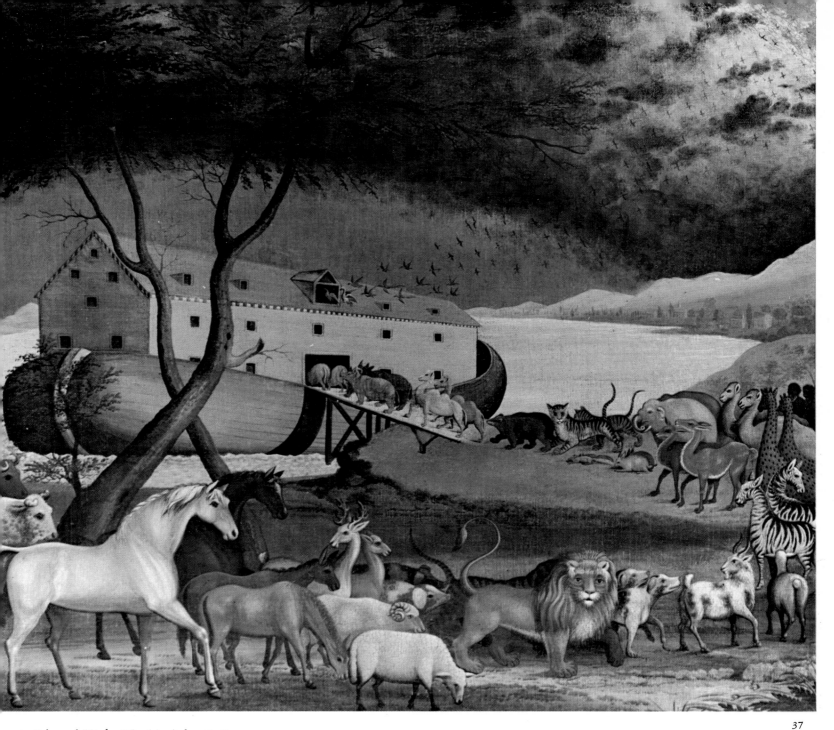

37. Edward Hicks, Noah's Ark, *1846*

Noah's large house stands on a broad hull which is already afloat. Animals are boarding the lifeboat by twos, some already on the gangplank, the rest in an orderly queue in a broad curve across the picture. Hicks not only loved men, but also included animals among the most beloved of God's creations. He rendered the trees and the greenish-brown earth with grace and warmth, just as he did the line of animals, including lions and zebras, camels and giraffes. Hicks, who was influenced by the lithographer Currier, chose to leave out men and apes in this inventory. Birds are descending out of the threatening storm clouds and taking their places on the roof of the ark. You can still see houses in the background, for the water has not yet begun to rise.

Overleaf:

38. Linton Park, The Flax-Scutching Bee, *circa 1860*

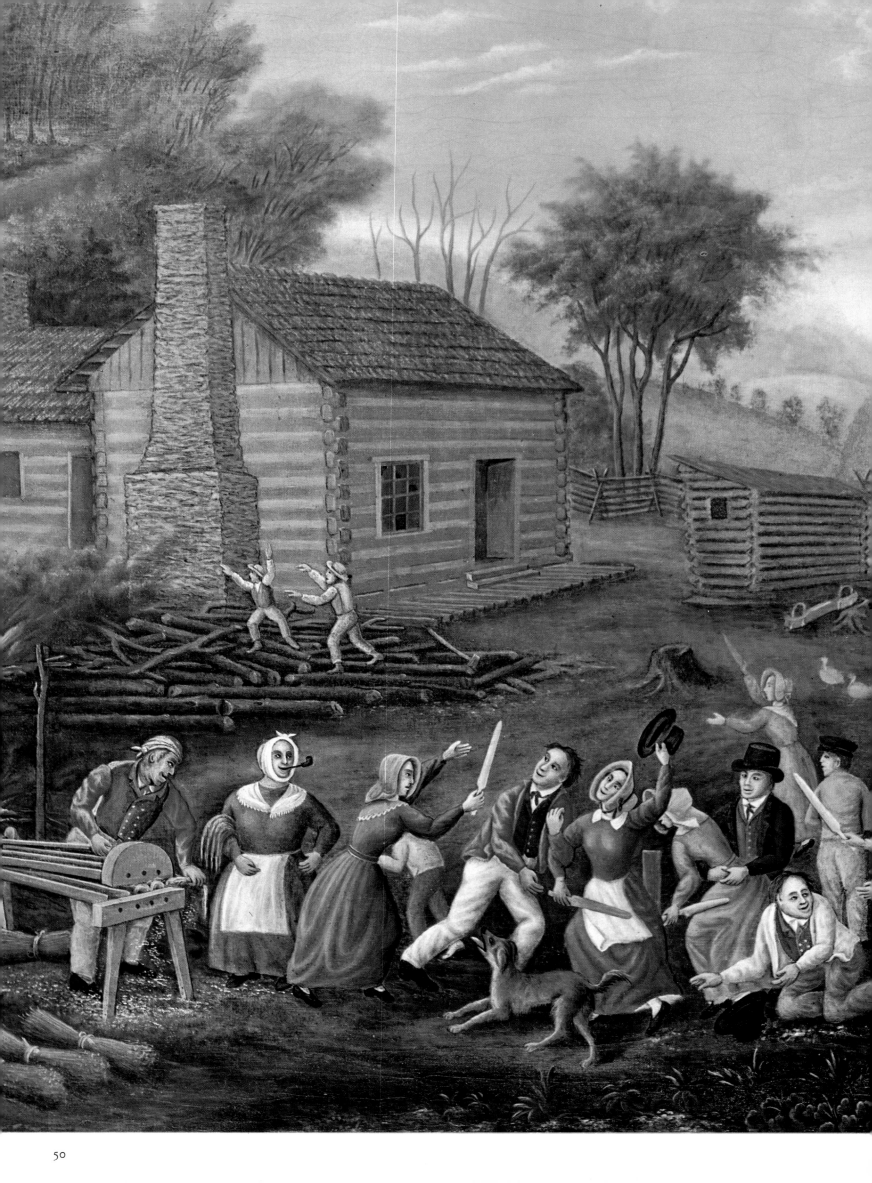

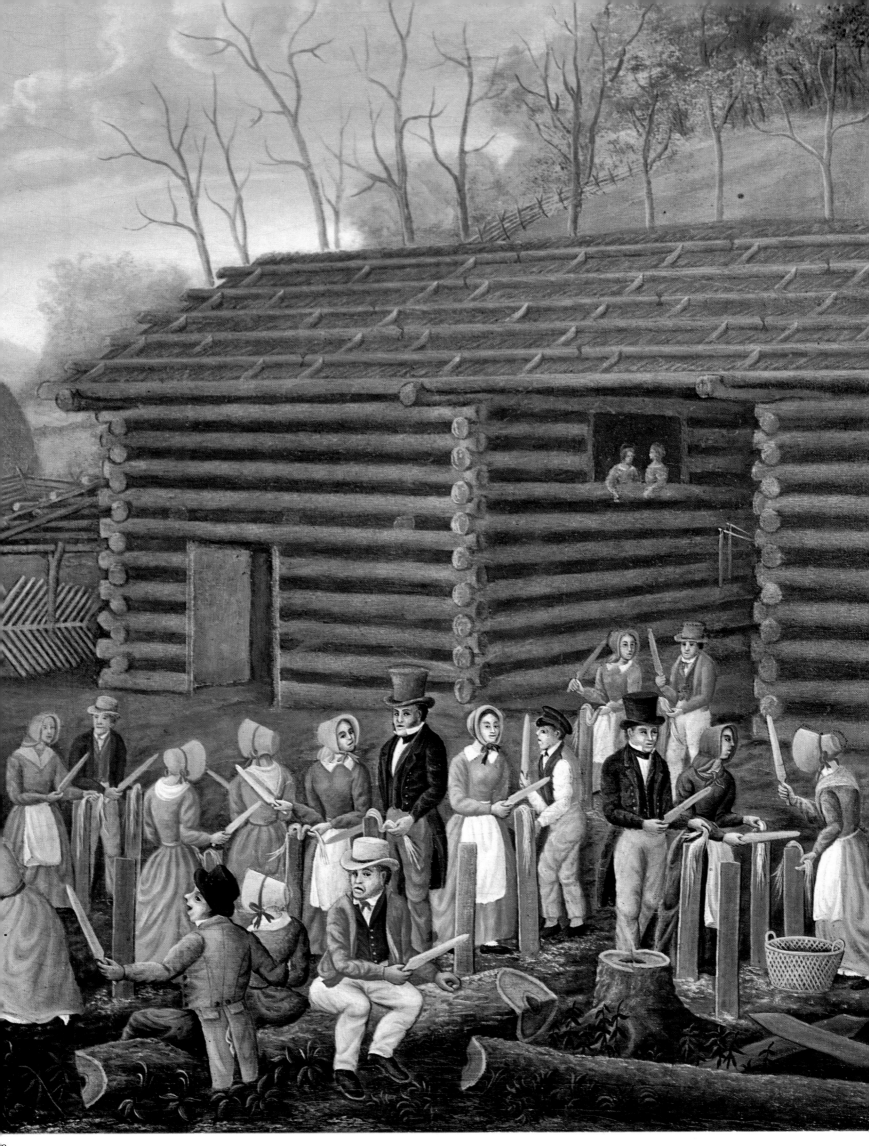

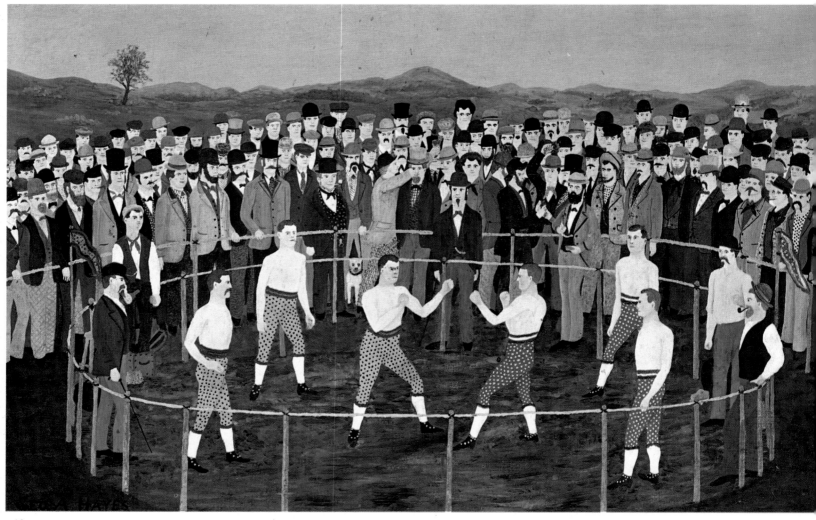

39

39. *Georges A. Hayes*, With Bare Fists, *circa 1860*

*Two pictures painted in the middle of the nineteenth century
are somehow symbolic of the culture of the American continent,
one of Negro music, and one of boxing.*

Around 1860, D. Morrill painted his Banjo-Player, *a Negro boy
with a gray hat balanced smartly on the back of his head. His
skin is dark, his curly hair black; his legs in his brown and
red striped trousers seem ready to dance in front of the pale
green wall. His moon-shaped banjo gleams as it vibrates with
the rhythm of what would later become American jazz.*

*Georges A. Hayes painted one of the earliest sporting pictures
in his* With Bare Fists. *The boxers stand in the ring stripped to
the waist, wearing knickerbockers and white stockings, and
surrounded by the referees and the public. The rigid faces of the
bystanders are a pasty flesh color; though frozen in
astonishment, they communicate an atmosphere of sporting
excitement and participation.*

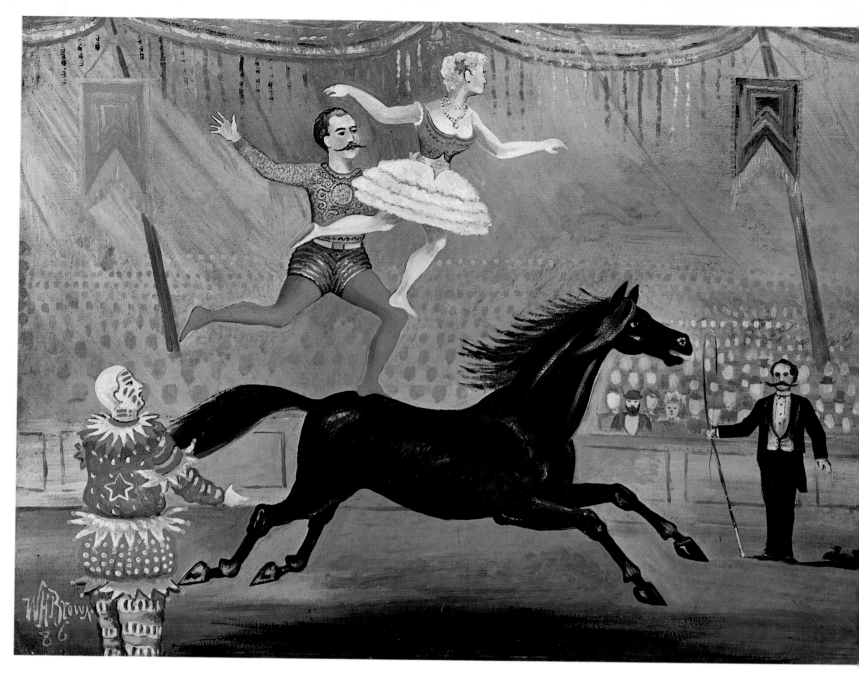

40. *W. H. Brown*, Bareback Riders, *1886*

40

*Like a ballerina, a young girl with ash-blond hair is balancing
with outstretched arms, in a violet bodice and white pleated
miniskirt, on the knee of her partner, who rides on one leg
around the ring, wearing a suit of gold brocade and cinnabar-red
tights. The artists and the horse are frozen in their movement,
while a clown addresses the audience and parodies their
brave performance. The circus director, with a dapper mustache,
stands proudly holding his whip and pointing to the
achievements of his stars. The public is only suggested by pale
dots in the background.*

*This is the period in which theater, circuses, and cabarets were
also flourishing in Paris. Brown's naive picture is but a primitive
prelude to Seurat's bareback rider, the clowns and acrobats of
la belle époque and of Picasso's Blue Period, and the radiant
circus riders of Chagall. We can hear the fanfare of the brass
band at the climax of the act, and can see the play of the
spotlights. The spectacle is both touching and breath-taking.
With childlike courage Brown has attempted to represent the
movement of the galloping horse which has risen full of youth
and grace from the mythic depths of his imagination.*

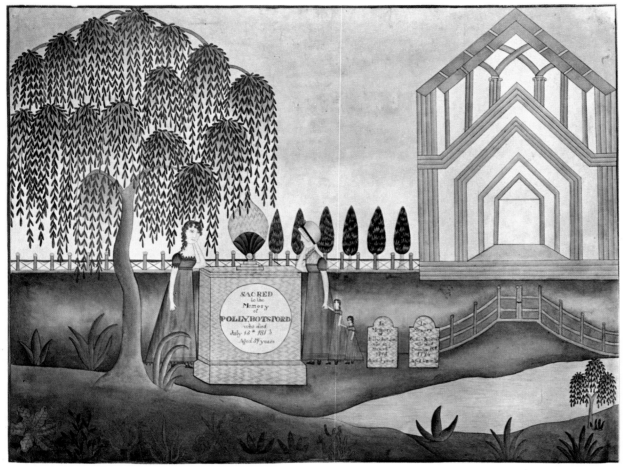

41

41. Polly Botsford and Her Children, *memorial plaque
by an unknown artist, 1813*

*Plaques such as this were often commissioned by the
survivors of a family, just as today one has death notices
printed. Alice Ford tells us that this was an art practiced
in female seminaries, where women and young girls
created such pictures in watercolors or embroidery on
paper, cloth, glass, wood, or canvas. Their motifs were
tradition-bound and like stage sets. A lyrical mood filled
these pictures of mourning with a delicate charm.*

*This memorial with a cemetery temple was dedicated to
Polly Botsford, who died at the age of 39 on July 18,
1813. The cemetery is surrounded by a fence and stylized
cypresses; its chapel is but a single geometric and
stylized plane. To the right and left of the tombstone
are gentlewomen, one with her small daughters near
a pond symbolic of tears and the other by a weeping
willow, the leaves of which hang down in lines of
melancholy and resignation.*

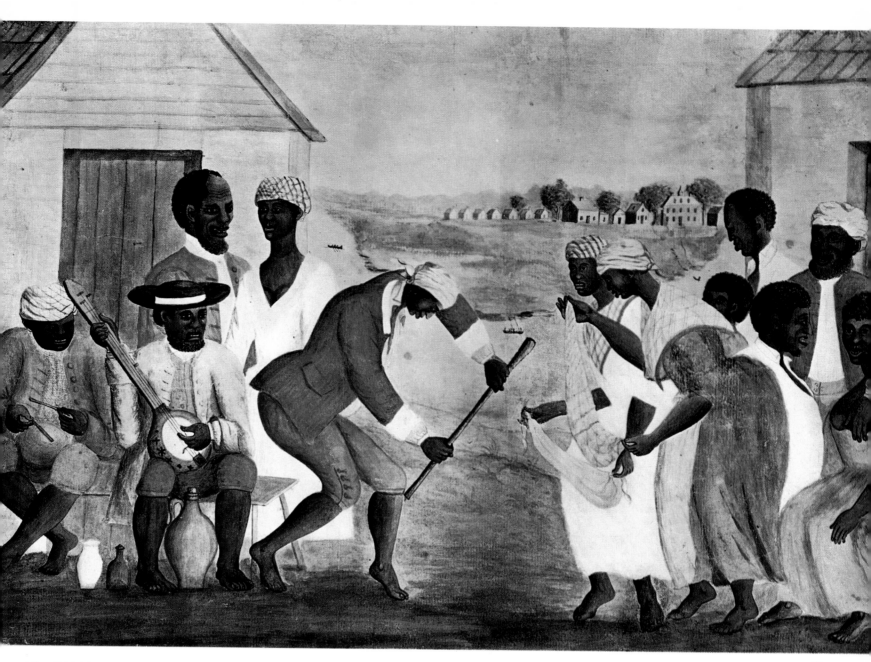

42. The Old Plantation
artist unknown, circa 1800

In European countries, anonymous folk art and popular painting were primarily concerned with religious themes before the development of the individualized art of the naives, but American folk artists chose themes from history or from everyday life for their compositions.

Around 1800, an unknown artist created this fascinating picture of life on a plantation. With it we have a unique documentation of the survival of African cultural tradition in America, as we observe a group of slaves on a plantation in South Carolina.

Recognizable as descendants of the Yoruba and Hausa peoples brought as slaves to America from the north and southwest of Nigeria, these Negroes belong to the same groups as do those who developed an

important naive art in the Negro republic of Haiti in our century.

The faces of the dancing Negroes are splendidly characterized. This may be a slave wedding, one of the rituals of which is the business of jumping over a stick which we see portrayed. The stringed instrument that looks like a banjo is an African molo, and the Yoruba drum is called a gudugudu. The rhythm of the dancers' bare feet, the turbans, and the drinking jars show the continuation of African tribal customs, while the rest of their clothes and the architecture behind them are of local origin. In the distance we can see the master's house with its farm buildings and the huts of the slaves. In muted shades of salmon-red, orange, pastel blue, and olive green, the unknown painter has created a legendary picture from man's history.

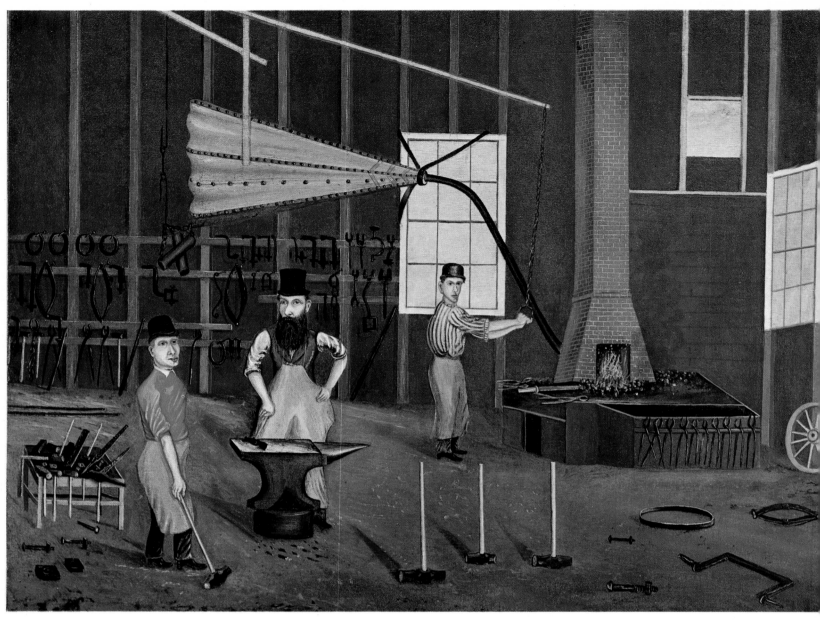

43

43. Studebaker's Blacksmith Shop, *artist unknown, circa 1855*

*Occasionally the naive artist's imagination is not able to compose
a unified picture out of photographic details. The total effect
of this particular childlike narration is one which nonetheless
gives us a poetic and profound insight into the social and
spiritual realities of the American continent. There are painters
who are known for only one picture, and who with that one
work have managed to express something unique and
noteworthy. This fascinating picture of Studebaker's
wheelwright shop is attributed to H. M. T. Powell. To the
viewer it appears that Studebaker, in his top hat and with his
black beard, together with his bowler-hatted apprentices, is
singing a ballad which tells of the coming victory of industry
and technology over the work of craftsmen like himself.*

Part Two

cocks.

113. Castera Bazile, *Farm Scene,* 1952.
114. Fernand Pierre, *Cock-Fight.*
115. André Pierre, *The Voodoo Divinities Dambala l'a Flambeau and Jean Dantor and the Goddess Erzulie Dantor,* circa 1965. Oil on cardboard; 91 x 76 cm. Kurt Bachmann collection, Costa Rica.

LIST OF SCULPTURES

Numbers in italics indicate black-and-white pictures

Chapter X

116. Bogosav Živković, *Dreams and Thoughts,* 1965. Detail of a wooden column; height: 2.35 m. Possession of the artist.
117. Erich Boedeker, *Modern Society Considering the Fruits of the Quarrel Between Adam and Eve,* 1970. Multiple sculpture in painted concrete; height: 96 cm. Gallery of Primitive Art, Zagreb.
118. Djordje Kreča, *Jefimija,* 1969. Front view of wood sculpture; height: 77 cm. Possession of the artist.
119. Petar Smajić, *Head of a Peasant Woman.* Wood; height: 20 cm. Private collection, Belgrade.
120. Petar Smajić, *Adam and Eve,* 1957. Wood; height: 57 cm. Gallery of Primitive Art, Zagreb.
121. Bogosav Živković, *Axle,* 1962. Wood.
122. Milan Stanisavljević, *A Family,* 1969. Wood; height: 99 cm. Possession of the artist.
123. *Woman With Snake,* from Toba-Batak, Sumatra, Indonesia. Wood; height: 39 cm. Rijksmuseum, Leyden.
124. Totem pole from New Zealand. Von der Heydt collection, Zurich.
125. Milan Stanisavljević, *Wedding Dirge,* 1967. Wood; height: 2 m. Possession of the artist.
126. Bogosav Živković, *Novice,* 1963. Wood.
127. Lavoslav Torti, *Self-Portrait.* Stone. Gallery of Primitive Art, Zagreb.
128. Head from a Bogomil tombstone from the necropolis at Radimlja, Herzegovina. 13th–14th century.
129. *The Deceased With His Children.* Bogomil tombstone from Radimlja, Herzegovina; 13th–14th century.
130. Face of a weeping woman in black, red, and white. Basket of woven straw in human form; height: 10 cm. R. Bravo collection, Cafayate, Argentina.
131. Ladislav Jurovaty, *Madonna,* 1969. Wire sculpture; height: 65.5 cm.
132. Sculptures in wood at the entrance to a Rumanian farmyard.
133. Bust of the Serbian patriot Rade Domanović, early nineteenth century. Detail from a tombstone in a peasant cemetery.
134. Adam and Eve on a tombstone in Rumania.
135. A circle and cross combined to form a portrait of Tanasko. Serbian peasant tombstone, 1863, in Studenica.
136. Bust of Lastomir Petrović. Detail from a Serbian peasant tombstone.
137. A group of Serbian peasant tombstones collected in Kalemegdan park, Belgrade.
138. Figures in iron and stone by Bogosav Živković in the artist's garden in Leskovac.
139/140. Bogosav Živković, sculptures in the garden in Leskovac.
141. Abbé Fouré, cliff sculptures at Rothéneuf near Saint-Malo, second half of the nineteenth century.
142. Ivan Jurjević-Knez, portrait bust in the artist's garden. Stone. Korčula,

Dalmatia.
143. Fernand Cheval, head of a figure from the west front of the *Palais Idéal.* Stone. Detail with Arabic characters.
144. Fernand Cheval, the *Palais Idéal,* 1905–14, in Hauterives, Drôme, France.
145. Fernand Cheval, large grotto with three gigantic stone figures in the *Palais Idéal.*
146. *European,* by a folk artist of Ghana, West Africa, early twentieth century. Black and white painted wood; height: 31.3 cm. Museum für Völkerkunde, Berlin.
147. *European With Pad and Pencil,* by a Yoruba artist in Nigeria, nineteenth century. Red and black painted wood; height: 54 cm. Museum für Völkerkunde, Berlin.
148. Neculai Popa, *Lute Player.* Stone; height: 38 cm.
149. Erich Boedeker, "The Sheriff," 1970. Painted figure from the group sculpture *Modern Society Considering the Fruits of the Quarrel Between Adam and Eve,* Gallery of Primitive Art, Zagreb.
150. Adam Zegado, *St. Cecelia,* wood. Collection of the Folk Art Institute, Warsaw.
151. Leon Kudla, *Councilman,* painted wood. Collection of the Folk Art Institute, Warsaw.
152. Leon Kudla, *Pietà,* painted wood. Collection of the Folk Art Institute, Warsaw.
153. Jedrzej Wawro, *The Troubled Christ,* wood. Collection of the Folk Art Institute, Warsaw.
154. Leon Kudla, *Leon Kudla's Wedding,* painted wood. Collection of the Folk Art Institute, Warsaw.
155. Mato Generalić, *The Bride,* 1970. Wood; height: 97 cm. Possession of the artist.
156. Dragiša Stanisavljević, *Cosmonauts,* 1967. Wood; height: 130 cm. Possession of the artist.
157. Milan Stanisavljević, *Wedding Dirge,* 1967. Wood; height: 2 m. Possession of the artist.
158. Milan Stanisavljević, Detail of *Wedding Dirge,* 1967. Wood; height: 2 m. Possession of the artist.
159. Petar Smajić, *My Family,* 1960. Wood; height 46 cm. Gallery of Primitive Art, Zagreb.

LIST OF ILLUSTRATIONS INCLUDED IN THE TEXT

Part II, Chapter V

p. 59—Henri Rousseau, *I Myself; Portrait-Landscape,* 1890. Oil. Detail. National Gallery, Prague.
p. 60—Henri Rousseau, *The Artillerymen,* circa 1893–95. Oil on canvas. Solomon R. Guggenheim Museum, New York.
p. 61—Henri Rousseau, *Portrait of Pierre Loti,* 1891–92. Oil on canvas. Kunsthaus, Zurich.
p. 62—Henri Rousseau, *Portrait of Joseph Brummer,* 1909. Oil on canvas. Private collection.
—Henri Rousseau, *The Poet and his Muse,* 1909. Museum Pushkin, Moscow.
—Henry Rousseau, *Present and Past,* painted before 1890, reworked sometime later. Oil on canvas. Louvre, Paris.
p. 63—György Stefula, *Parents in Heaven,* 1958.
p. 64—Henri Rousseau, *The Jungle,* 1908. Detail of a tiger attacking a buffalo. Oil on canvas. Cleveland Museum of Art.
p. 65—Pablo Picasso, *Play With Balloon.*
—Henri Rousseau, *Ball-Players,* 1908.

Oil on canvas. Detail. Solomon R. Guggenheim Museum, New York.
p. 66—Henri Rousseau, *The Merry Jesters* (Les joyeux farceurs), 1906. Oil on canvas. Philadelphia Museum of Art.

Chapter VI

p. 71—Séraphine Louis, *Tree of Paradise,* circa 1929. Oil on canvas. Detail. Musée National d'Art Moderne, Paris.
p. 72—Louis Vivin, *Venice,* 1926. Oil. Musée National d'Art Moderne, Paris.
p. 73—Camille Bombois, *Carnival Athlete,* circa 1930. Oil. Detail. Musée National d'Art Moderne, Paris.
p. 74—André Bauchant, *King Louis XI Orders the Planting of Mulberry Trees,* 1943. Oil on canvas. Detail. Musée National d'Art Moderne, Paris.
p. 75—Jules Lefranc, *Ships' Propellers at the Dock.* Oil on canvas. Musée Municipal d'Histoire de l'Art, St. Denis.
p. 76—Miguel G. Vivancos, *Flowers in the Window,* 1961. Oil on canvas.
—René Rimbert, *The Window of Le Douanier,* 1957. Oil on canvas.

Chapter VII

p. 85—Nikifor, *Self-Portrait.* Watercolor.
p. 86—Niko Pirosmanashvili, *Beauty from Ortachal,* 1905. Oil on oilcloth. State Museum of Art in Tiflis, Georgia, USSR.
p. 87—Niko Pirosmanashvili, *The Old Servant,* 1905. Oil on oilcloth. Museum of Peoples' Art, USSR.
p. 88—Kiyoshi Yamashita, *Yucca,* 1938. Collage by a sixteen-year-old.
—Suma Maruki, *White Birds.* Oil on canvas.
p. 89—Joseph Pickett, *Coryel's Ferry,* 1914–18. Oil on canvas. Detail. Whitney Museum of American Art, New York.
p. 90—John Kane, *View from my Window,* 1932. Oil on canvas.
p. 91—Morris Hirshfield, *The Coquette,* 1941. Oil on canvas. Detail.
p. 92—Alfred Wallis, *The Bellaventure of Brixam.* Portal Gallery, London.
—James Lloyd, *Feeding the Horses.* Detail.
p. 93—Louis Delattre (1815–1897), *The Ascension of Prince Baudouin.* Detail. Franz Hellens Collection, Brussels.
p. 94—Micheline Boyadjian, *In Expectation.*
p. 95—Micheline Boyadjian, *The Easel.*
—Bernardo Pasotti, *Chastity.* Oil on canvas.
p. 96—Bruno Rovesti, *Landscape With Sea.*
p. 97—Adolf Dietrich, *Two Rabbits,* 1902. Charcoal drawing.
p. 98—Adalbert Trillhaase, *The Witch of Endor.* Oil on canvas. Clemens Sels Museum, Neuss.
p. 99—Joseph Wittlich, *Vast Battlefield.*
p. 100—Friedrich Gerlach, *Train Station,* 1965. Municipal Gallery, Recklinghausen.

Chapter VIII

p. 113—Ivan Generalić, *Woman With Candle.* Painting behind glass.
p. 114—Ivan Generalić, *Still Life With Landscape,* 1953. Painting behind glass.
p. 115—Ivan Generalić, *Seated Peasant Woman.* Drawing.
—Ivan Generalić, *Rustic Conversation,* 1959. Detail of painting behind glass.
p. 116—Ivan Večenaj, *John the Apostle,* 1969. Painting behind glass.
—Mirko Virius, *The Day-Laborer.* Oil on canvas.
p. 117—Mijo Kovačić, *Peasant Woman With Geese.* Tusche drawing.

—Franjo Mraz, *Team of Horses in the Village,* 1944. Drawing.
p. 118—Janko Brašić, *Battle Between Serbs and Turks,* 1955–56. Oil on canvas. Gallery of Naive Art, Svetozarevo.
—Milosav Jovanović, *The Shepherdess,* 1967. Detail. Oil on canvas. Gallery of Naive Art, Svetozarevo.
p. 119—Ondrej Venjarski, *On the Way to Work,* 1960. Detail. Oil.
p. 120—Sofia Doclean, *Women in the Cemetery,* 1964. Detail. Oil.
p. 121—Juraj Lauko, *Christmas Eve,* 1962. Oil.
p. 122—András Süli, *Train Station,* 1935. Oil.
p. 124—Michail Kasialos, *Palm Sunday,* 1967. Detail. Oil.

Chapter IX

p. 145—Copper disk with two faces, northern Argentina, before 1500. Museum of the American Indian, Heye Foundation, New York.
p. 146—Antonio José Velazquez, *View of San Antonio de Oriente,* 1957. Detail. Oil on canvas. Collection of the Organization of American States, Washington, D.C.
p. 147—Ezequiel Negrete, *Lunch in the Fields,* 1958. Detail.
p. 148—José Guadalupe Posada (1851–1913), *Calavera Zapatista.* Lithograph.
—Ritual mask of the Songe tribe, Congo. Institute of the Tropics, Amsterdam.
p. 149—Shop sign for the "New African Barber," signed Willy Arts, Oshogbo, Nigeria.
—*All for You.* Painting behind glass from Ikorodu, Nigeria. Ulli Beier Collection, Prague.
—Shop sign for a portraitist, stamp maker, and bookbinder in Nigeria.
p. 150—Asiru Olatunde, *Scenes From the Life of the Yoruba.* Detail of a hammered aluminum triptych. Naprstek Museum, Prague.
p. 152—André Pierre, *Linglinsou, Bassin Sang.* Demonic voodoo being painted in a scraped gourd.
p. 154—Salnave Philippe-Auguste, *Three Women.* Oil on canvas. Private collection, Belgrade.

Chapter X

p. 163—Mijo Smok, *Head of a Girl,* 1959. Wood.
p. 164—"Raised Hand," detail from a Bogomil stone from Radimlja, Herzegovina.
—Anthropomorphic shepherd's staff. Yugoslav folk art.
p. 165—Fernand Cheval, west gate of the *Palais Idéal* in Hauterives, Drôme, France.
p. 166—Bogosav Živković, *Axle.* Detail of a small wooden column.
p. 167—Bogosav Živković, *Head of an Old Man,* 1969–70. Stone sculpture in the artist's garden in Leskovac.
p. 168—Bogosav Živković, *Bust of a Farmer,* 1969. Wood.
p. 169—Milan Stanisavljević, *Wedding Dirge,* 1967. Wood sculpture.
p. 170—Petar Smajić, *Mary and Peter,* 1963. Wood.
—Petar Smajić, *Night of the Shepherd,* 1963. Wooden column depicting a man, his wife, and his son who is reading on horseback.
p. 171—Georges Liautaud, *Crucifix,* 1959. Forged and hammered iron; Haiti.
—Erich Boedeker, two figures from the composition *Modern Society Considering the Fruits of the Quarrel Between Adam and Eve,* 1970. Painted concrete.
p. 172—Bogdan-Boško Bogdanović, *Man and Wife,* 1969. Beechwood.

Rousseau and the Great Reality

Chapter V

Henri Rousseau, I Myself; Portrait-Landscape, *1890.*

Between Life and Legend

In the northwest of France, in the village of Laval, a son was born to the master tinsmith Julien Rousseau and his devout wife Eleonore Guyard on May 20, 1844. He was given the resounding name Henri Julien Félix. Is it not possible that the shiny tin monsters in his father's shop caused him to experience the everyday, even from the beginning, as a world of fable? The black, sooty atmosphere, the salmon-colored tongues of flame from the forge, the insistent clang of the hammers, the silver effrontery of slender roof-hatches, pointed-nosed funnels, and dully shimmering lanterns. Tin gleams like platinum if you wish, but you can also paint it to look like marble. A hollow palm tree made of papier-mâché can become a jungle; the green velvet armchair a lion about to spring.

Uhde was probably correct in doubting the truth of Rousseau's military exploits in Mexico. Though of course Rousseau had spoken of them himself, the exotic glory of the Mexican expedition probably belongs among the fantastic fabrications with which the painter tried to disguise the humdrum reality of his bourgeois suburban existence. From the perspective of his debilitating poverty he spun childlike daydreams of beauty and fame. He experienced his dream world so intensely and vividly that in the half-light between certainty and conjecture he overstepped the bounds of reality and even convinced himself that the President of the Republic had invited him to a soirée, but that a rude doorman had turned him away on account of his ragged clothes.

From time to time the circle of Rousseau's friends used to capitalize on his naive willingness to distort the lines of reality in order to draw him into their grotesque and tragic deceptions. Once they presented someone to him as Puvis de Chavannes, who then praised Rousseau's painting with condescending interest. Another time a man was introduced to him who bore a resemblance to the National Secretary of Fine Arts then in office. Rousseau received this sign of recognition from the state authorities with delight, while the directors of the crude skit amused themselves at his expense.

The famous evening in Picasso's atelier in the rue Ravignan was one of these pretended celebrations of his false fame mixed with equal parts of good will and condescending mockery. There are several somewhat conflicting accounts of this banquet which began in the Bateau Lavoir one evening in November 1908.

Picasso had bought a painting of Rousseau's from the art dealer Père Soulié, a portrait of a woman quite likely depicting *le Douanier's* first wife. He had paid five francs for it. In celebration of his purchase, an evening in honor of Rousseau was carefully arranged.

Picasso's wife of this period, Fernande Olivier, has written in her memoirs: "The plan delighted his friends who were fond of making fun of the poor customs man." Maurice Raynal and Gertrude Stein have also recorded their memories of this event. In their journals one senses the atmosphere of these years, the insolent whimsicality of these artists of *la belle époque.*

In a café next to the Bateau Lavoir countless guests collected to begin the evening with an *apéritif* or two before going up to

the atelier. Among them were Georges Braque, Marie Laurencin, Guillaume Apollinaire, Max Jacob, Gertrude Stein, André Salmon, Maurice Raynal, art lovers, collectors, and pretty young women.

The guests arranged themselves around a long table improvised out of planks laid across saw horses. The decorations were all ready; leafy garlands curled around columns and beams and trailed across the ceiling. In the background at the spot destined for Rousseau a kind of throne had been constructed out of a chair placed on a box and set off with flags and paper lanterns. On the wall hung the painting of Rousseau's wife which Picasso had bought, and above it ran a wide strip of bunting "In Honor of Rousseau."

Raynal relates: "In the midst of the tumult someone knocked softly at the door three times. The noise immediately ceased and it grew quite still. When the door was opened the customs official stepped in with a soft felt hat on his head, his cane in his left hand, his violin in his right. It was certainly the most touching sight of Rousseau I ever had. He looked around. The paper lanterns seemed to delight him, and his face began to glow. . . ."

After two hours, when dinner had still not arrived, someone remembered that the order had been wrong, that it had been made for a different night. Everyone immediately began to concentrate on turning up something to eat. Picasso was well supplied with things to drink. Some sardines were discovered and everybody was happy. Rousseau played his violin and sang his ballads. People danced, and Rousseau performed his waltz *Clémence*. Wax from the candles and the lanterns dripped on his head. Apollinaire was at that time devoting himself to his "correspondences" and on the spot composed a poem for Rousseau which he then recited:

Tu te souviens, Rousseau, du paysage aztèque
Des forêts où poussaient la mangue et l'ananas . . .

Rousseau thanked him; he was deeply moved and delighted. He sat on his throne, which had been thought up for him by Picasso, and basked in the flow of recognition.

"For a long time he cherished this banquet, which he in good faith took to have been a celebration of his genius, as one of his most beautiful memories," reports Fernande quite openly, thus confessing that this whole occasion was again nothing but a joke.

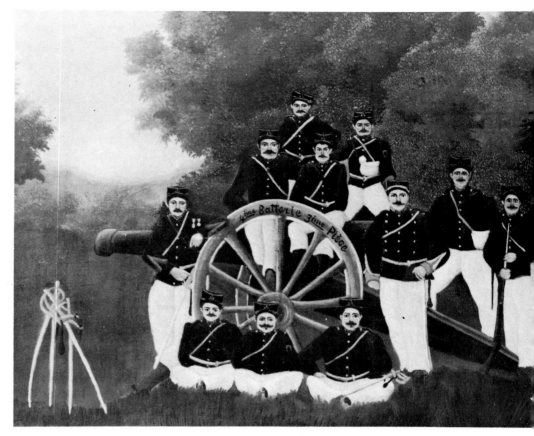

Rousseau had actually participated as a sergeant in the campaign of 1870–1871. One of his paintings, *The Artilleryman*, points back to this time, as does perhaps the picture of *War* (illus. 233), both painted in 1894 and 1895. Discharged from the army, he married Clémence Boitard. At this time he was employed by a trial lawyer, but it is recorded by his niece, Madame Jeanne Bernard, that it was unbearable for him with his gentle nature to have to mark the furniture of debtors with stamps of distraint. One of his wife's cousins then found him a position as a second-class regular with the Paris import customs. At this job he may not have shown himself to be too capable, for he was soon given less demanding duties. Nonetheless, Rousseau was convinced that his superiors had made this adjustment out of kindness, to allow him more time in which to paint. Near the city gate of Montrouge, next to la Porte de Meudon on the Tournelle bridge, he was left alone with his job; and it was there that he made sketches for many of the landscapes which we now value so highly. He was supposedly quite reticent and only a very few people knew him well.

Eight of the nine children borne him by his tubercular wife died young. Only one daughter survived him. Around 1884 he received a pension which allowed him to devote himself completely to his artistic endeavors. Many of the naive painters who have come after him were also enabled to pursue their creative dreams only after their retirement.

Henri Rousseau, The Artillerymen, *circa 1893–95.*

The Double Life

On Rousseau's door in the rue Perrel No. 2A could be read: *"cours de diction, musique, peinture, et solfège."* In this small apartment an odd double life was lived, the life of a small, awkward, and shy man seemingly lost in the bustling indifference of the city. Though he was mocked, made the butt of intrigues, and ironically praised, he kept to a strict schedule of creative activity and remained unshaken in his faith in his calling. Below the life-size portrait of his dead wife Clémence he played the violin or the flute, composed, and wrote poems and plays. And painted. With deep seriousness he brought all the streams of his emotions together in his pictures. Into this apartment came the daughters of the craftsmen and merchants of the Plaisance quarter to receive instruction in violin or in recitation. Sometimes too, though less often, came schoolboys who wished to learn to draw.

In this apartment too he agreed to the piece of naive chicanery with the swindler Sauvaget which would involve Rousseau in a criminal affair and land him in detention at la Santé. Rousseau's letters from prison allow us a glance into this period of disruption in his life, and at the same time provide the art historian with invaluable material.

Today, when the works of Rousseau are treasured in the Louvre, it is not easy to grasp in retrospect the miserable poverty and loneliness which were his life. Rousseau's compositions based on his everyday world and on his fantasies, the mysterious backdrops of his enchanted landscapes, and the magical stillness of his figures are today so much a part of us that we can scarcely comprehend how critics and public alike could

once have dashed them beneath a wave of derision.

One of the two pictures Rousseau exhibited in 1885 in the Salon des Champs Élysées was slashed with a pen-knife by a disgruntled viewer. Usually his pictures were hung somewhat apart or in the corners because the jury—wishing to be anything but a jury—was ashamed of them. The cynical devotees of Rousseau would track them down, however, and make much fun of them when they found them.

More sensitive and perceptive artists, to be sure, could appreciate the peculiar qualities of these singular pictures. Signac, one of the founders of the Salon des Independants in Paris, invited—together with Maximilien Luce—*le Douanier* to join their group; from 1886 until his death, Rousseau exhibited, with but one brief interruption, with this circle. Pissarro, Redon, and Gauguin were among the first to notice him. When several members of the Salon moved for Rousseau's expulsion in 1890 it was Toulouse-Lautrec who defended him.

During the year in which Gauguin set sail for Tahiti, Rousseau painted the portrait of Pierre Loti as well as his first exotic picture, *Storm in the Jungle.* The outstanding biographer of Rousseau, Henri Perruchot, is quite correct in his insistence that we link these two paintings together. Loti, a member of the French Academy, was the troubadour of exoticism. Can Gauguin have been moved by his novels to undertake the journey to Oceania? The longing glance toward distant lands and seas, the escape to the sources of originality as formulated by Loti, meant the negation of that barren and conventional social reality which the artist so fervently hoped to forget.

Rousseau did not proceed from such intellectual considerations. He painted Pierre Loti, the purveyor of dreams of his time, whose face he knew obviously only from pictures in the newspapers and journals. To the solid bourgeois features he gave a significance which far outshone the natural character of the writer.

With a plastic severity and childlike directness, the poet and the cat, bearded and earnest, gaze out at us from this picture. The pinkish face under the red fez is tricked out with a jauntily twirled mustache. Gentleman and cat in dark suits; hers striped with white, his set off with white collar and cuffs. The hand with rings on the fingers and holding a cigarette is raised in a portentous gesture as a kind of counterpoint to the cat, just as the acacia tree in a transparent sky is balanced by the organ pipes of the factory smokestacks. The famed and admired contemporary, with exotic touches to his clothes which recall the substance of his novels, is here portrayed

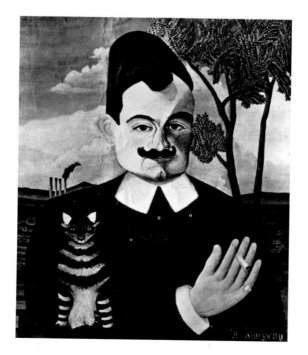

Henri Rousseau, Portrait of Pierre Loti, *1891–92.*

with respectful precision. The rigid propriety of the portrait lets one sense at the same time the eternally vain features of the naked man behind the frozen dignity of the mask.

Georges Courteline, the playwright and satirist, purchased this picture for his gallery of spoofs, for he could appreciate only its grotesque and comic elements.

The man who undertook to fight for Rousseau was Alfred Jarry, the author of *Ubu Roi*. Jarry was then only about twenty, an extravagant young man who loved the dream-worlds of Rimbaud and Lautréamont, and who seized upon the illogical pictorial alchemy of Rousseau as being appropriate to the spirit of his rebellious and grotesque invectives. Like Rousseau, Jarry had come from the village of Laval. The simplicity and artlessness of this former customs man who painted incredible pictures and insisted on exhibiting them impressed Jarry more than the purely painterly qualities of the artist, for which he probably had but little understanding. But precisely because almost everyone laughed at Rousseau, he chose to defend him with his brusque enthusiasm and, in order to show his contemporaries how independent his tastes could be, he even had himself painted by Rousseau with his favorite animals: an owl and a chameleon. The picture

was shown in 1894 in the Salon des Indépendants. Jarry found it boring, however. He snipped only his head out of it, and the rest of the ruined canvas was lost. Francis Jourdain, the consummate expert on the period, suggests that Jarry, who had a passion for revolvers, used the salvaged head as a target and filled it full of bullet holes.

The portrait of Pierre Loti already possesses those specific qualities which Rousseau displays at the end of his career some sixteen years later in the portrait of the art dealer Brummer. This likeness also leads us beyond the personality. Trapped in a cane chair and shaded by the ornament of fantastic broad-leaved trees, Brummer seems enthroned in pensive numbness, like an eleventh-century Byzantine Christ. Another related painting is the double portrait of the poet Apollinaire and his muse done in 1909. With emblematic finality Apollinaire is here depicted as the poet *an sich*. In his hands he holds a quill pen and a roll of parchment, while his muse, the painter Marie Laurencin, seems to guide him with a prophetically extended hand. They stand in grass under the trees; symbolic carnations, pink, white, and red, grow straight about them and protect the poet from the world.

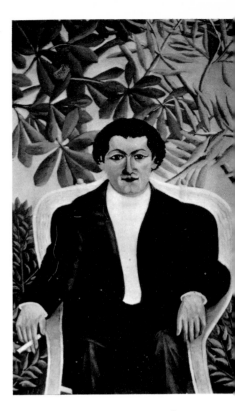

Henri Rousseau, Portrait of Joseph Brummer, *1909.*

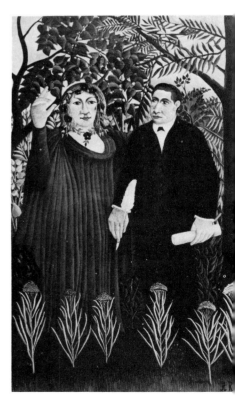

Henri Rousseau, The Poet and His Muse, *1909. Museum Pushkin, Moscow.*

Women

Wilhelm Uhde reports that Rousseau used to seek encouragement and strength in his hours of exhaustion and resignation by standing before the portrait of his first wife Clémence. In her wide-sleeved velvet dress, her right hand on her hip, a parasol in her left, at her feet a tiny house-cat playing with a ball of yarn, Clémence stands like a monument, a fixed landmark in Rousseau's life. Life is narrow, and dreams are so much more spacious—especially the dream of love.

He also immortalized his second wife, Rosalie Joséphine Noury, who tried to support them by working in a stationery shop. The two of them stand behind blossoming shrubs in the garden, dressed in deep and somber black, the painter stolid, his wife sullen and submissive. But above the couple, on a higher plane of eternity, so to speak, hovers a second pair of portraits: Rousseau changed a bit and with an outmoded cut to his beard, and Clémence, his first wife, who now gazes down out of a remoter day, out of

the commemorative present of all that is lasting, as though the concept of *vraie durée* had here come into its true incarnation.

After Josephine's death, quite late in the painter's career, came the touching middle-class melodrama with the forty-year-old shopgirl Léonie who worked in a warehouse. The ardent heart of the aging man needed the nimbus and warmth of love. But the father of the chosen one was against the marriage. It was not only the little pensioner's poverty that worried this stuffy man, but even more his useless and foolish dabbling in painting and the arts. This was the situation which caused Rousseau to ask for that now-famous testimony to the respectability of his profession and the value of his works from Wilhelm Uhde and Vollard. In spite of this, the hour which had been scheduled for the wedding and his victory turned out to be a Chaplinesque scene of dashed expectation.

Still one more woman's name cropped up in Rousseau's life: Yadwigha! Dream or actual confrontation?

In 1910, when he exhibited his painting *The Dream of Yadwigha,* he attached this poem to the frame:

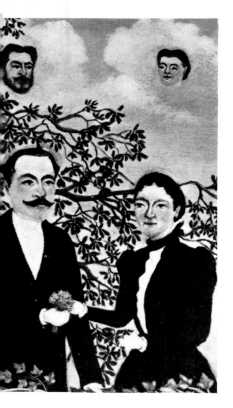

Henri Rousseau, Present and Past, painted before 1890, reworked sometime later.

György Stefula, Parents in Heaven, 1958.
With humble indebtedness to the great master, Stefula conceived of his dreamy, childlike scene of stylized innocence as a tribute to Henri Rousseau.

Yadwigha in a lovely dream
as sweetly soft she slept
heard piping from a shepherd's flute
on which a kind magician played.
And while the moonlight's silver gleam
lay on the streams and leafing trees
wild serpents basked and listened
to those blissful melodies.

While Tristan Tzara is convinced that Yadwigha was actually a woman of Slavic origin close to Rousseau who inspired him to write the drama about the revenge of a Russian orphan, Perruchot feels she is just as much a wishful fabrication as were the jungle landscapes of Mexico. Were Yadwigha an imago of Rousseau's first wife Clémence, which Perruchot considers to be likely, *The Dream of Yadwigha* (illus. 212) would doubtless have taken on a different appearance.

The loveliest picture of a woman Rousseau has given us is surely the *Sleeping Gypsy* (illus. 2) done in 1897. This is no genre picture, no narration of an event; it is a reading of primal symbols, the emancipation of a dream.

"The mystery thinks herself to be alone and removes her clothes," says Jean Cocteau, "the gypsy sleeps with eyes half opened. . . . I think of Egypt, which has known how to keep its eyes open even in death, like divers under the surface of the sea. . . . Where does such a vision come from? From the moon? . . . Moreover it is perhaps no accident that the painter, who never overlooked a detail, indicated no indentation, no trace in

the sand around the sleeping feet. The gypsy has not come here. She is here. She is not here. She is in no place known to humans. She inhabits the mirror. . . ."

Neither the woman nor the lion has entered into this taboo-charged landscape from without. In the depth of space is held the limitlessness of being, and the green river streams like infinity between the desert and the moonlit range of mountains. Like an island, the figure lies in the inner monologue of its existence between the desert of the sky and that of the earth. The totality of the vision demands, however, two materialized symbolic forms in their supernatural concreteness: the jug and the mandolin. The two of them will haunt the dreams of the Surrealists and the spaces of the Cubists from this point on.

In order to understand completely Rousseau's desire for distance, for the discovery and invention of landscapes never seen and never entered, one must try to imagine the middle-class confinement, the frustrating poverty, the conventional wasteland of his home and of his life. The miserable repertory of pictures from illustrated magazines, family albums, advertisements, catalogues, and botanical books were often enough the stimulus or point of departure for his imagination. And thus he simply sailed away from the drab setting of his existence and landed at the imaginary jungle's edge. He listened to the secrets of the tropical hurricanes, to the death struggles of savage beasts, and to the peace and the chatter of the wilderness.

The Utopia of the Exotic

Some twenty years before Picasso's Negro Period began, Rousseau had demonstrated the wealth and original force that might be got from simply looking at photographs. It is not the geographic or ethnographic strangeness of his landscape which is crucial to the meaning of his work. Delacroix, Fromentin, Ingres, and Matisse have also depicted African and oriental motifs.

He did not create merely a paradise of gentle peace and pious contemplation. In the depths of the jungle of his vision a terrifying

battle of the species is taking place. For Eve and the serpent, sin and temptation are present in the lush garden of eternity. In the magical panopticon of his imagination beasts of prey steal without a sound through towering ferns. The powerful lion flays the gentle antelope (illus. 46). A Negro is attacked by leopards; an Indian struggles against a gorilla. The cries of apes and of flocks of flamingos blend in with the thousand dissonant shades of green. And the sharp tone of the flute puts the forest under a spell.

For Rousseau, the exotic simply meant poetry. He paints detailed factuality, but his trees and flowers belong to no particular species. And it is probably immaterial whether he observed them in the Jardin des Plantes in Paris or on the Angers tapestries. For Rousseau copies and imitates neither the

Henri Rousseau, The Jungle, *1908. Detail of a tiger attacking a buffalo.*

forms of art nor those of nature. His proportions do not correspond to the visible world; they are modules of his own essence. Detail is for him a function of the whole composition. With harmonious monumentality he arranges his flora into a decorative, stylized, unexpected landscape of his own invention.

Rousseau's exoticism is not necessarily confined to his themes. Even his French landscapes and street scenes bear the mysterious stamp of an archaic strangeness. The trees on the promenade of Vincennes rise up in magical enchantment, bare and unmasked by the veil of light the Impressionists threw over them. The nature in his *Paysage des Fortifs* functions like a composition of conscious construction with its geometric severity. In his *Quarry* the naked stumps of the walls tower like lightning rods of emotion into the clouded, sorrowing sky. In the *Landscape of the Suburbs with Viaduct* the facts of reality are altered to conform with an inner prejudice; the play of line in the trees and in the feathery branches is no less "contrived" than that of his exotic jungle. In the grand painting of *Summer* (1906), there is, aside from the instinctive artlessness of the vision and the detailed precision of the execution, something of that elemental compactness of form which shortly thereafter was to become the aim of the Cubists. Behind and beneath the unconscious or barely conscious revelry of form lies a legendary harmony of men and beasts and nature.

Rousseau loved men as he loved things. A feeling of fraternity bound him to the most humble everyday objects: a lady's hat, a parasol, a gas lamp, a vase, a lantern—all have about them something miraculously special beyond their normal appearance. The painter gives to these paltry, motionless things a solemnly grotesque and poetic expressiveness. Out of simple, profane objects which would seem to be impotent and dead, he built a world of magic in which the contact between men and things was restored.

The painter also loved the proud, miraculous discoveries of technology: graceful montgolfiers, confidently cruising dirigibles, and the scudding, puffing double-deckers of the Blériot epoch. But these machines, like motorized angels, hover with the indecision of slow-motion against a benumbed sky. Rousseau transforms their movement into an astonished changelessness. The smugly passing convertible, a charging horse, airplanes, dancers, ball-players—they are all trapped in a moving moment, absolutely against the classical rules, frozen as though a painting of light and motion had never been developed. The *Ball-Players* of 1908—often wrongly called *The Football-Players*—a unique document for the history of culture, is fascinating in its almost spectral treatment of an everyday activity. In the clearing—or is it a specially laid-out playing field?—are four men, perhaps only half of the whole team, dressed in zebra-striped jerseys and concentrating on their game. It is claimed that Rousseau included two portraits of himself in this picture. The ball hovers above the players who with strange contortions seem intent on catch-

ing it. As though with a flash camera, the men at play are caught in mid-air. In the midst of the dynamic action the faces with their roguish mustaches and their carefully glued-down locks are described with the breathtaking accuracy of a slow-motion sequence. The chord struck by the tobacco-brown trees and the bright blue sky is repeated in the men's clothing, and structures a beautiful space in which the cheerful game becomes at the same time the dignified ritual of our age.

Above:
Pablo Picasso, Play with Balloon.

Right:
Henri Rousseau, Ball Players, *1908.*

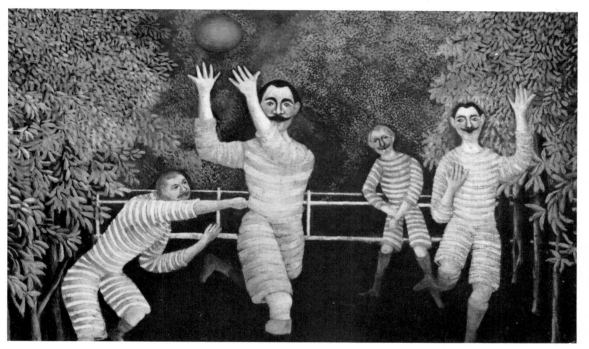

Motionlessness and Poetry

Rousseau possessed a rigid bourgeois conscience. It comes to the fore whenever the painter records the dignity of the simple man, the propriety of his own milieu, the world of the lower middle class. His republican patriotism and his all-inclusive cosmopolitanism are expressed in the simple, straightforward compositions of social events: the *Centennial Festival of Independence,* the *Portrait of Freedom,* the *Portrait of War,* and finally in the painting titled *Peace.*

Why did the customs man Rousseau paint war in 1894? Did he know anything about that remote war that Japan was then waging against China over spheres of influence in Korea? He was probably painting no particular war, but war *an sich.* We do not know what inspired him to do this picture. He once wrote about war that "it moves over us with chilling force, everywhere leaving behind despair, tears, and ruin."

Rousseau's picture of war was given its spiritual complement in the work from 1907 called *The Representatives of the Foreign Powers Bring Greetings to the Republic and Sign the Peace.* The actors in this piece of statecraft line up together standing properly at attention as though reporting for calisthenics. The Frenchmen, decked out in mustaches and imposing sideburns, dressed in their bourgeois nineteenth-century best, and greeted by the angel of peace with palms or olive branches, are themselves holding symbols of peace in their hands. Sovereigns in uniform, as the occasion demands, wear their decorations across their chests; Nicholas of Russia, Wilhelm II, Edward of England—or was it George V?—and many more. Then come the bojars and kings from the East in their pointed hats, their turbans, and sombreros. All have assembled to declare the peace. And even the heraldic lion is there. Around a bronze monument the contented citizens are dancing, Chinese in long pigtails and simple people from the suburbs of Paris, delighted as can be about this holiday of peace on earth and love among men.

Many critics speak of an artistic progression in Rousseau, as it is common to attempt to trace such a development in painters. Surely there can be noted certain technical accomplishments in Rousseau's later works, a freer brand of painting than was evident earlier. But that implies no essential change in his work and does not insure greater profundity or perfection. As early as in the landscape at the edge of the woods called

Promenade in the Woods (illus. 47) which he painted between 1886 and 1890, everything which is optically superfluous has been consciously left out. Visible nature is enriched and transformed by the urges of poetry. In the portrait of the painter's wife in the garden from 1890, and in the *I Myself: Portrait-Landscape* (illus. 182) of the same year, the same elements of metamorphosis of visual sensation into a simpler and more profound image of being are present which are so impressive in the portrait of Joseph Brummer painted in 1909. To be sure, the *Snake Charmer* (illus. 195) of 1907 and *The Dream of Yadwigha* of 1910 are masterpieces of his old age. The same magical force and poetic urgency, the same somnambulant assuredness

in the composition and its objective plasticity can however be found just as surely in *War* from 1894 and in the *Sleeping Gypsy* of 1897.

His specific signature, the clarity and rigor of the material from which men, animals, trees, or leaves are carved, is noticeable from the beginning. Objects and people are not experienced as phenomena of light and movement. Inwardly felt appearances as well as those visible to the eye are elements of his inspiration. Like the icon painters of Byzantium, Rousseau identifies his images derived from color and form with the things themselves. Rousseau carried the picture of his world ripe and secure within himself from the first time he undertook to create.

Epitaph

Henri Rousseau died in 1910, poor and alone in Necker Hospital in Paris. Robert Delaunay and Rousseau's landlord Queval bought his tombstone. With a stylus, Apollinaire wrote an epitaph on it which the sculptor Brancusi and the painter Ortiz de Zatate carved into the stone three years later, following the hand of the poet:

Kind Rousseau, do you hear us?
We send greetings,
Delaunay, his wife, Monsieur Queval,
* and I.*
Let our bags through the gates of heaven
* duty-free.*
We will bring a brush, paints, and canvas
So that you can paint in the blessed leisure
* of the true light*
As once you did my portrait
The visage of the stars.

Since then much has been written about Henri Rousseau. At first he was but a curiosity for writers, but while his works were being secretly or publicly derided, the legend of the disarming innocence and childlike faith of the gentle old man grew. He was the angel of Plaisance, celebrated by none less than Apollinaire.

Only a true poet could initiate such a legend, and Apollinaire is largely responsible, since in 1914 in his poem "Memories of *le Douanier*" he sang these fond and touching verses:

A very tiny bird
On the shoulder of an angel
Sang in praise
Of gentle Rousseau

The motions of the world
The memories surface
Like a boat on the wave
A sorrow in the soul

Kind Rousseau
You are this angel
And this bird
Full of your praise.

Feeling and innocence, not knowledge and deliberate form-giving, were the attributes which suited the concept of the archetypal in modern art. To this concept the features and qualities of the painter Rousseau were appropriate. In the legend founded and circulated by Apollinaire and his circle Rousseau had become the genial medium that, filled by the stream of material from the collective unconscious, created the man's work for him.

Recently an opposite view has gained strength, one which would like to see Rousseau set free of that nimbus of genial artlessness which makes of him the shepherd to the flock of those painters of the simple soul so that he can be ranked among the masters of art solely on the basis of his painterly qualities.

Rousseau is neither one nor the other; he is both together. For a long time he was the hero of a legend which was seen as a marginal phenomenon running alongside the historic development of modern art—and one requiring apology. But the brilliance of his painting does not consist solely of the perfection of its optical expression, but also of a visionary spirit. He not only anticipated the line of development of modern painting in France and the rest of the world; he opened new landscapes for man.

Henri Rousseau, The Merry Jesters (*Les joyeux farceurs*), 1906.

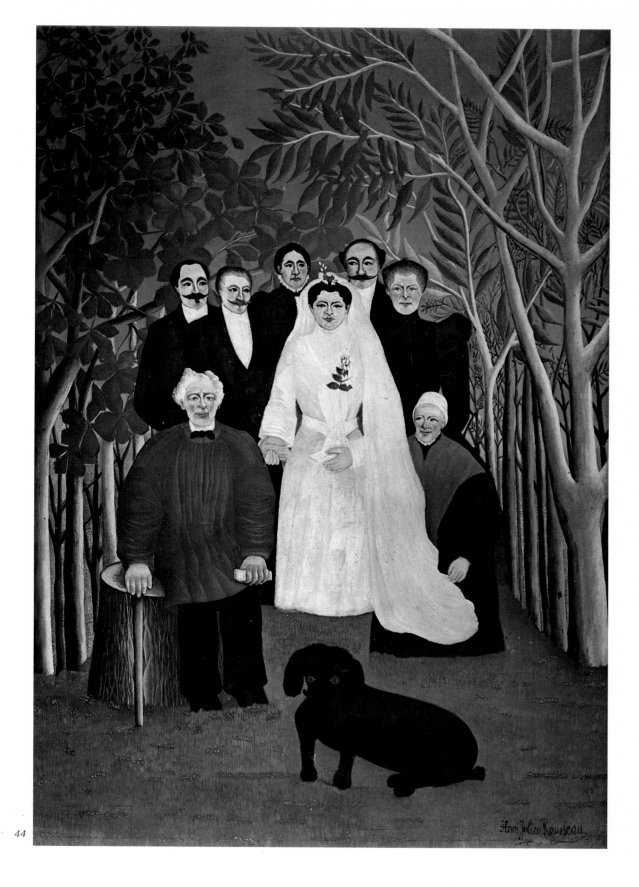

44

Henri Julien Rousseau

44. *Henri Rousseau*, Wedding in the Country, *1905*

The strange and magical world of the supreme primitive reminds us of Giotto and Uccello. The eternal present of a pure and childlike humanity and the unquestioned unity of objects and the world find expression in the paintings of le Douanier. I introduce this chapter on the naive artist Rousseau with this touching and masterful wedding ceremony.

The family is portrayed under pleasant trees, chestnuts whose foliage looks more like fig leaves, and acacias which the painter is said to have found in the Jardin des Plantes. The bride, the bridegroom, and their siblings stand, while the parents sit. All are freshly starched and ironed. The father displays the marriage contract, and the mother touches the bridal dress which she has possibly made herself. Everyone is in his Sunday best, and is looking straight at the camera as he is supposed to, and as the simple man and his new bride would want it. There is magic and incomparably sincere poetry in the factualness of this solemn and banal occasion.

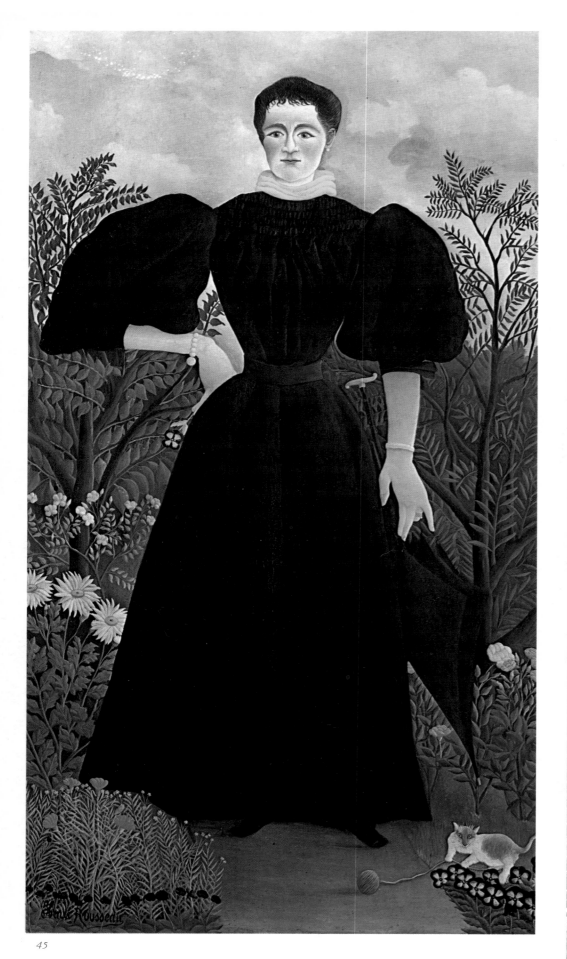

45

45. *Henri Rousseau,* Portrait of a Woman, *1897*

Even in his earliest pictures, Rousseau achieved a singular perfection through his combination of fantasy and love. His being and his work are defined by these two concepts. The poet Paul Eluard wrote of him: "What he saw was love, and for us it will always seem a miracle. . . ." This explains the painting that shows his first wife Clémence, who died much too soon, surrounded by flowers on a garden path.

46

Rousseau was the Columbus of naive painting, and the world he discovered is a primeval paradise. Plants, fabulous beasts, men, and sky—all rise out of the childlike imagination of his simple and poetic soul.

Rousseau tried to explain the puzzling contents of his pictures through the addition of short texts which read like stage directions. He presents the sequence of an action which must be rendered as a single moment on his canvas: "The hungry lion tears at the antelope, the female panther waits for a share of the booty, the bird in the tree is already holding a piece of meat it has snatched in its beak, the suffering animal sheds a tear. Then the sun goes down." So much for the story. A suffering creature is killed, and behind the jungle trees the sun is glowing red.

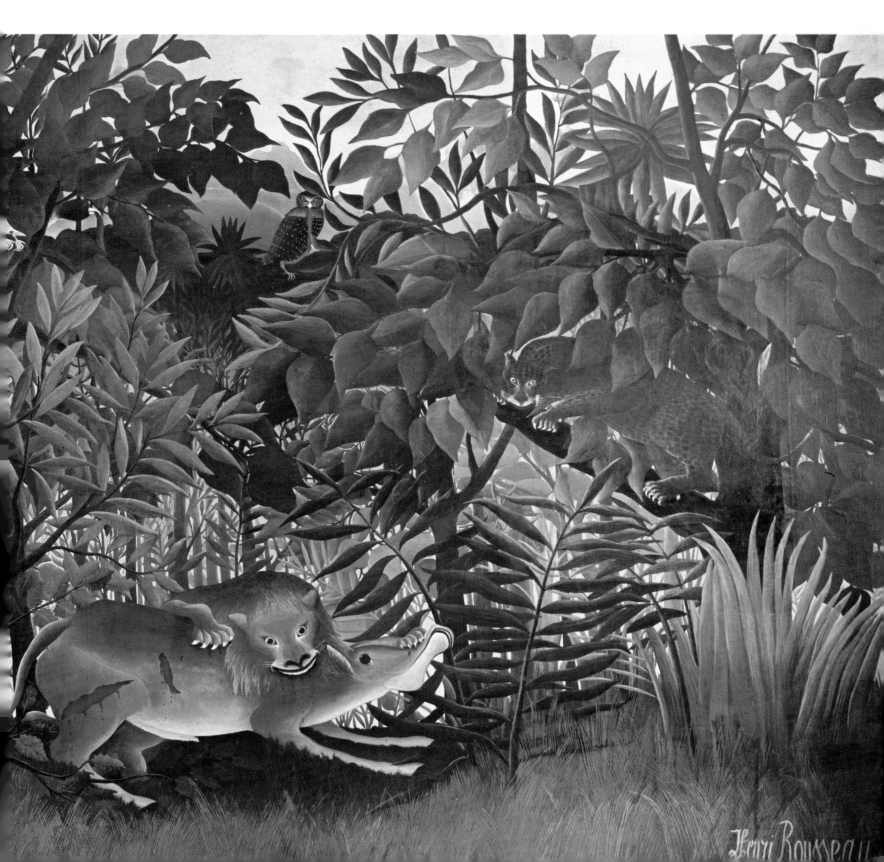

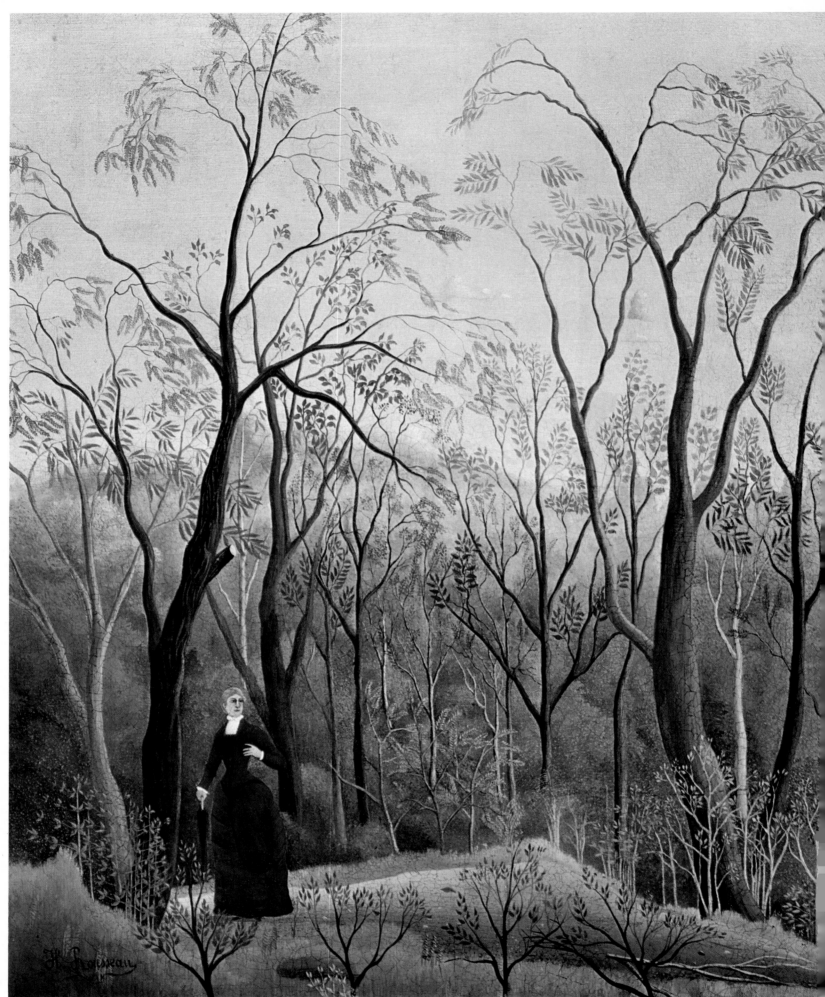

47. *Henri Rousseau,* Promenade in the Woods, *1886*

The painter Rousseau feels and appreciates the quiet growth of nature with a direct sensitivity. A delicate figure of a woman in a long, reddish-brown dress is standing beneath the slender, rhythmically swaying trees.

Their fragile foliage stands out against the transparent blue of the sky. The woman is painted with utter tenderness, care, and devotion, for she is a wishful composite of women he has seen and others he has only dreamed of.

French Overture

Chapter VI

The Painters of the Sacred Heart

Séraphine Louis, Tree of Paradise, *circa 1929.*

Why are we moved by the outlandish other-wordly flowers of Séraphine, the flaming bouquets embroidered with the colors of ecstasy, that glaring yellow, alarming serpent green, reassuring autumnal wine red, and naively confident, radiant turquoise?

Séraphine Louis, often called Séraphine of Senlis, learned painting neither in her child-hood spent as a sheep-girl nor later as a housemaid. When did she begin to capture her dreams and intimations of desire in color and form? Why did she do it? We know but little about the inner drama of her modest existence. Perhaps we would know still less about her art if a fateful coincidence had not brought her into contact with the very man who, once caught by the spell of Rousseau's imagination, was to accompany the course of the modern primitives.

In 1912 Wilhelm Uhde had retired to Senlis in order to bask in the stillness of the old village in the île de France, close to Paris and yet remote from its bustle. Every morning an elderly woman came to straighten up his rooms. Uhde scarcely noticed her. Then one day in the house of some strangers in Senlis he saw a still life of an apple which attracted him. He asked the name of the painter and was told: "It is your cleaning woman Séraphine!" Until then fate had led blindly, but now Uhde could insure that the rapturous bouquets of flowers would grow into prodigious trees of fantasy. He provided her with the large canvases which Séraphine

had so long wished for. And from now on, in endless variations, were repeated those strangely demonic bouquets and gloriously lascivious fruits of the paradise dreamed of in Séraphine's room (illus. 57, 221).

Uhde mentions that Séraphine jealously guarded the secrets of her painting. No one was allowed to watch as she painted, to see how she mixed her colors or prepared the canvas just so, so that everything was carried out with professional competence. In cloistered seclusion she seldom left her little room in which the eternal light of the Virgin burned on the mantlepiece.

Small, withered, with darkly burning eyes in a pallid face, she painted in a kind of trance, like a mystic gardener, the flaming bushes behind which lies hidden the temptation to all that is holy. Fleshy plants with heavy-lidded fruits, ornamental foliage made of precious, pastel feathers in whose shimmering whirl eyes open and close; a weird interweaving of whispering, covetous branches with ropes of pearls made of berries from the shrubbery of tenderness; starry umbels from the garden of desire.

Where do these bouquets come from, which sprouted so luxuriantly and compulsively in her fantasy? Perhaps they had been inspired by the cloying, lustrous, artificial wreaths and bouquets made of wax and celluloid in provincial chapels and churchyards? Perhaps she had included in her pictures the sight of the cosmos through the glass windows of the church of Senlis? For though the pictures Séraphine painted may also be manic repetitions of decoratively stylized leafy and flowery ornaments, they are also arabesques of an inner revelation, hieroglyphs of chalices ultimately comprehensible to herself

alone and to that God for whom she composed and consecrated the sacred and ecstatic testimonials of her love in the handwriting of her painting.

All the smoldering lights of her dreams were one day extinguished. She then wandered from house to house preaching the end of the world. Her mind had become empty and distorted. In 1942 she died in the nursing home in Clermont.

The precincts of ecstasy were foreign to the postal inspector Louis Vivin. He only communicated with the mysterious voices of the beyond during spiritualist séances. When he stood at his easel he painted the factual world even more factually than he found it.

Through many years of his life he had traveled through the landscape in the mail car of a train. In this office on wheels he had constructed a minutely accurate map of all the postal districts of France, a piece of work for which he was rewarded with an advancement. Vivin's life's work too was doubtless nothing more than a geographic survey of his mental wanderings. His business was the registration of the memorable.

In the twilight of his age, when as a postal pensioner he was at last free for his chosen profession, he felt his way back to all the streets he had walked, the squares he had crossed, and the bridges of his existence.

With tortuous vigilance he went into each detail. Not just the ensemble of the houses, but each brick; not only the bridge as a whole, but each steel column; not just the tree, but every leaf was worthy of being enumerated and noted down.

Uhde somewhere mentions that Vivin especially loved the painter Meissonier. In this artist too he saw a keen sense for detail. Vivin hated the summed-up generality; this was a basic trait of his being, that nothing should be left out in his inventory of reality. Everything that was there had to be sorted and registered, like the letters in the mail car. What had been experienced and imagined, what had once been perceived, is stamped in his artistic undertaking. Without this accountant's compulsiveness in the precise appraisal of the world, his experiences would have grown desolate and become dispersed.

In his dull apartment the postal inspector Louis Vivin sits like St. Jerome in his cell. Resting on his maulstick he paints day after day on his copy of the world. Often he works from post-cards, as did Utrillo and the Yugoslav Feješ. But everything real is reworked by his insistent, stubborn soul, be it the Trianon, Venice, or the streets and squares of Paris. They resemble the originals, but the architect and city planner Vivin has added a touch of his own style. With the shaky, spidery lines

Louis Vivin, Venice, *1926.*

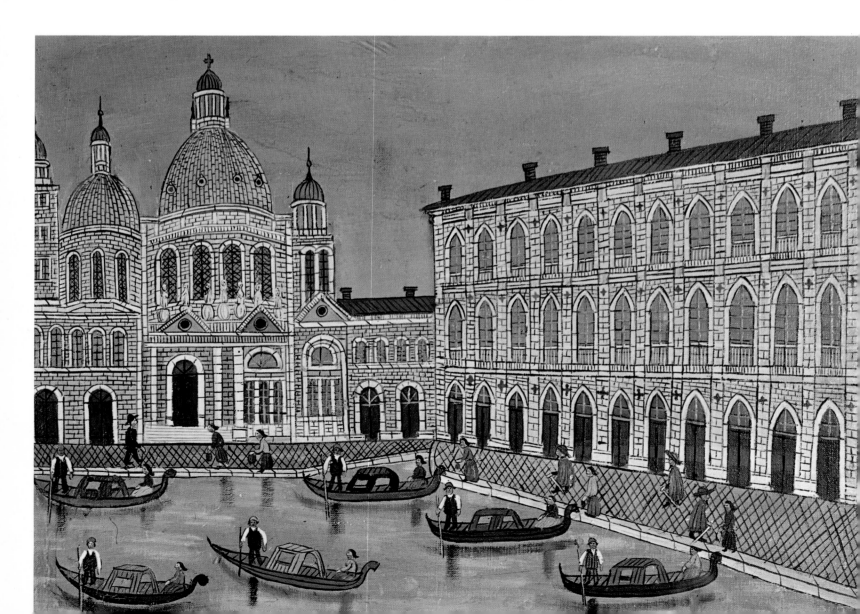

Camille Bombois, Carnival Athlete,
circa 1930. Detail.

of his pointed brush and with fanatic naiveté
he builds up ascetic pictures; systematically
he places stone upon stone and shows us
Place Châtelet, the Jardin des Plantes, Sacré
Coeur and Notre Dame, the lions of Belfort,
and the mill at La Galetta. Constant are the
subdued brick red of his walls, the bitter
ashen gray of the sky, the blue-black of the
Soldiers' Memorial, and the hopeless color-
lessness of the façades. But behind the litany
of these rows of houses there vibrates the
secret of an indefinable existence.

In this painting there is no depth of space;
everything is two-dimensional foreground,
painted from the front like figures in the
burial chambers of Egypt—perhaps because
another landscape must be kept from show-
ing behind his cautious, graphic enumera-
tion. The childlike shrewdness of the aging
painter has created this world ignorant of the
laws of materials and of perspective, inno-
cent of any sort of pact with authority or
with conventions of fashion and style (illus.
52).

"The world created by such a spirit has all
the symptoms of reality. Each stone is an
urgent assurance that here the banal truth is
intended. But behind these regular and seem-
ingly objective façades lies uncertainty, mys-
tery, and sadness. This painter is anything
but the Canaletto of modern Paris."

With Wilhelm Uhde's words one could
round off this portrait of the artist Vivin. But
in Vivin's genius there is yet one other
aspect: the world he invented is supported by
a framework of true relationships and pic-

torial harmony whose rhythms and modula-
tions are upheld by the spirit of conscious
abstraction.

Uhde had in part discovered Rousseau,
Séraphine, and Vivin. Bauchant and Bombois
were always two of his closest friends.

What is striking in Camille Bombois is the
ingredient of folk art deformed into colpor-
tage and injected with unconscious surreal-
ism. Bombois gives to everything he makes
something of the abundant strength of his
vitality. Landscapes and objects have their
own plastic existence, and the spaces the
painter leads us through, the bridges we
cross, the tree-lined boulevards stretching
into the distance, have a unique depth result-
ing from their brightness, the long shadows,
and rapidly disappearing lines (illus. 49).
But man stands in the foreground of his
interest. Wrestlers, weight-lifters, clowns,
sword-swallowers, fire-eaters, fat ladies in
jerseys or in the nude—the mysteries of
human elasticity are displayed and exploited
(illus. 53). It is the spell of the fair and of
carnival booths, of the exhibition of abnor-
malities, the false but ravishing glamour of a
bare-back rider accompanied by the tragic,
heroic blare of a brass band. Folk-song art, or
rather folklore of the exotic—a splashy,
rustic fantasy, mechanized to the point of the
loud-speakers and the orchestration.

This is self-portraiture and inner land-
scape. Bombois was the son of a bargeman.
His childhood was spent living on boats
along the canals of the Côte d'Or and central
France. He was later a farmhand, road

builder, athlete, and typographer.

At sixteen he begins to draw. He keeps at it in spite of the most taxing jobs. In 1922 he shows his work on the sidewalks of Montmartre. The journalist Noel Bureau is enthusiastic about his pictures and calls attention to the newly discovered talent in the little magazine *Rythme et Synthèse*. The discerning art dealer Mathot begins to buy Bombois's work, and Florent Fels and Wilhelm Uhde encourage him. And so Bombois, who had waited for this moment with passionate certainty, can devote himself wholly to his painting.

He paints with the strong man's delicacy. Everything visible is precisely defined and set off from the indistinctness of light and movement. Objective straightforwardness, poetry of sobriety at times bordering on the look of cheap colored prints, occasionally close to the frontier of kitsch. Bombois loves the massive darkness of the weights that he lifts and of the black paint he uses so heavily. He adores the billiard green of tufted draperies which frame a dancer's pinkish thighs (illus. 214), the velvet red, the strong yellow, the saccharine violet of circus posters and the interiors of bordellos. They correspond to the crude objectivity of his drawing.

André Bauchant was a gardener like his father. He remained one as long as he lived. Even when he painted, he caused the myriad trees and fruits of his native Touraine to bloom (illus. 50). His mountains of stone, men, and animals all have something of rank vegetative fecundity about them.

As a soldier in the First World War Bauchant went to the Dardanelles and to Greece. Later he served in Reims as a surveyor and was praised for the accuracy of his survey drawings. In 1912 he exhibited sketches for a panorama of the Battle of the Marne in the Salon d'Automne, a vista of Châteaurenault, his native town, and a picture of the burning of the temple at Ephesus.

Le Corbusier, Ozenfant, Lipschitz, and the art dealer Jeanne Bucher took notice of him. Sergei Diaghilev commissioned him to do the stage decorations for Stravinsky's *Apollon Musagète*. In 1927 Madame Bucher introduced Uhde to the painter Bauchant, "a tall thin man with a mustache who was dressed stiffly in a dark suit like a peasant going to a wedding or a funeral."

What was it that moved Diaghilev to order stage designs from this Bauchant who knew neither his ballet nor Stravinsky's music? It was doubtless his mixture of sublime antiquity with the everyday present. This fragmentation and simultaneity of myth and irony which also occupied the *pittura metafisica* was part of the spirit of the times.

André Bauchant expressed the same thing

without knowing it, and without conscious ironic or grotesque intent. He peopled his grandiose historical scenes with simple Bauchants dressed as Greeks, Romans, or Germans. The *Apotheosis of Homer* painted in 1927 breathes just such a spirit. In a setting of gray and craggy mountains, groups of men are sitting, lying, and standing in pinkish-red and orange tunics that look like outmoded bathing suits around Homer, who lies outstretched in the foreground singing of the great deeds of the Greeks and the Trojans. Above the mountains, high among the clouds, can be seen a vision of the events he relates. The picture of Neptune painted in 1929 is also based on this conceit. As though practicing on water skis, Neptune skims across the gray-green waves which look like a fresh permanent. The short-legged god in a red robe carries his trident in his right hand, and holds the reins of his woolly-maned horses in his left. He is accompanied by bearded men. In front of him glides another team with cupids and gods in wigs and blowing robes. Shell ornaments enhance this touching, ridiculous, but still somehow magical schoolbook illustration of the gods and heroes of antiquity.

Where on earth did he discover these legendary compositions, these heroic, utopian decorations composed of charming ruins, glowing alps, and secret magic? Bauchant does not work from life as does Bombois; his visions are borrowed from historical museums in his dreams in which the past sits retouched in gold (illus. 51). They are the reflections of antiquarian wisdom mixed with the sham of the pedant, with the plush exoticism of the nineteenth century, and the rhetorical pathos of dead languages. These

André Bauchant, King Louis XI Orders the Planting of Mulberry Trees, *1943. Detail.*

family portraits draped and disguised as history (illus. 107) were not produced out of an aberrant taste, but rather out of a childlike love of inventing stories. Wherever the vale of his mysteries may lie, it is in reality his native landscape of the Touraine, and all the heroes and actors of remotest times are but the bourgeois neighbors of the village in which he was born, only projected back into history.

After his historical compositions came those of his late period: flowers and birds, peasant scenes, and landscapes. With velvety colors as lusterless as pastels he shows us the rustic world, metaphors of an enchanted reality of dreams. Bauchant the gardener—a painting Anteus—delights us with the flowery masquerade of his daydreams which are rooted in the fertile soil of a trusting fantasy.

These are the "Five" whom Wilhelm Uhde exhibited for the first time in the Galerie des Quatre Chemins in Paris under the name "Painters of the Sacred Heart," and whom he taught me to see and to understand. It is true that when we talked about the modern primitives in later years he no longer insisted on this designation. By now it had become all too laden with emotion, and the evaluation of the naive painters no longer seemed to rest solely on their human purity, but also and above all on the artistic qualities and creative originality of their works.

Nonetheless I prefer to place the old phrase at the beginning of this chapter if only to thank the discriminating man and critic Uhde who, though a German by birth, so loved and appreciated the soul of France and its naive interpreters.

Since that time new primitive artists have come to light in France as well as in other countries and on other continents. Yet in a certain fundamental sense these "Five" paved the way.

Jules Lefranc, Ships' Propellers at the Dock.

Successors in France

Urban painters generally belong to the working class. Their finicky pedantry is blended with utopian symbols and optimistic wishful thinking, and occasionally too with religious, mystical vision. In France, the land of an uninterrupted artistic tradition and of the first discovery of modern primitives, the naives have mostly come from this urban sphere.

Like *le Douanier* Rousseau, Jules Lefranc came from Laval, and by profession and by birth he worked with iron and tinware. In his mind these were to become elements of poetry just like Séraphine's fantastic flowers. The clattering gesticulations of mechanical objects, the flashing of semaphores, the rhythm of machines and contrivances inspired him. He did not take the harnessed mechanism of the industrial world as a starting point for his compositions, however, but transposed it into a kind of still life, into a panopticon of mechanical things. His picture *Trolley with Eiffel Tower,* with its parallel wires stretched across the shafts of the streets like strings on a zither, and with the coquettish steel dancing doll of the Eiffel Tower in the background, already has the romantic look of a folklore of the machine.

The typographer Dominique Peyronnet drew the ice-covered landscape of his desires, his seascapes, sections of forests, and river views like a poet of virtuoso banality (illus. 54). With a razor-sharp pencil he formulated his world; the tossing waves of his sea in their magical motionlessness are as though cut of glass, the leaves and ferns of the woods are lined up together like threaded strands of pearls. He felt the need to reproduce nature and the human drama with the same precision as that required of him in the printing shop when preparing for color work. Only some thirty pictures of his still exist.

Émile Blondel was born in Le Havre, sailed the seas for many years, and later drove a bus through the streets of Paris. In precise miniature and with a pointed brush he paints pictorial syntheses of journeys near and far in which he recalls suppressed and forgotten moods of land and sky and sea. The *Benediction of the Sea, Belle-Île,* portrays a procession along the shoreline. The faithful and their priests with crosses, in long blue robes, white dalmatics, and red caps, hands folded for prayer. Boats decorated with flags draw near with their sails furled; the pennants flutter, the approaching sailors wave joyously. Everybody rejoices in the spectacle; the harbor with its deep blue waves is contained between jetties.

The shepherd and mountaineer Dominique Lagru began to paint at seventy. On the imaginary pasture land of his declining years he collected uncommon herds of prehistoric reptiles. The cheerfully delineated forms are done up in bright azure shades. The landscape and the fauna, supplied from the painter's zoological texts and his daydreams, are a simple delight for the viewer.

Jean Eve—miner, trainman, mechanic, and revenue officer—hiked along the rivers of France and captured in an easy, old-fashioned manner the curtain of landscape of his homeland with true-to-life, childlike devotion (illus. 169).

In the pictures of Jean Fou, who sold knickknacks, post-cards, and picture frames in the Paris Flea Market, one can hear the charming hubbub of the street and the cynically humorous patter of the suburbs. *The Rag-Market in Mouff* breathes of the periphery of the metropolis; stands and booths are heaped high with the junk and used goods from house and shed. Advertising posters can be seen on the walls. Diverse people wear fezzes or military caps. Buyers and sellers, women with baby carriages or dogs, old men, children playing leapfrog. Old stoves, pots, furniture—treasures for the naive observer in his poverty. A colorful miscellany drawn with a fine brush and full to the edge of the frame.

A winter scene with Christmas trees on the street, and with people greeting each other and exchanging best wishes. An open church door pouring forth a rich light. A village or small-town scene with houses embraced by mountains; the dark and cloudy sky above new snow. And there goes the painter with his sketchbook under his arm to make a picture of it.

André Demonchy's picture *Dinan* shows a street scene with tall buildings under a cloudless sky, many people crossing the street, and a traffic accident. Someone has run into the red sled. Another picture, *The Eiffel Tower,* painted in 1955, shows the red Coca-Cola balloon rising, surrounded by small children's balloons with numbers on them. Visitors stand on the familiar sculpture of the Eiffel Tower watching the event. Under the lowest arch of the tower one sees pedestrians, and behind them the buildings of the city. Trees in the park frame the picture on the right and left.

Chicago-born Gertrude O'Brady began to paint in Paris before the war. Her art was an attempt to give meaning to an aimlessly lived life through work. What stirs her is lost time. Not only the future, but also the past can be invented. One of her pictures, *A la bonne Galette,* which she painted shortly before the occupation of France and her period of suffering in a concentration camp, represents the famous restaurant with the windmill vanes. In the green frame of the garden the bright red carousel is circling. On yellow gravel paths couples stroll in the costume of the *fin de siècle.* A chaise with a white horse glides past. A lady in a violet robe holds the reins and drives with elegance, while a gentleman in a top hat makes conversation. A society in the enclosure of the past, full of melancholy and quiet grace.

Another picture of Miss O'Brady's, *Anatole and Mino* (illus. 55) done in 1939, portrays Anatole Jakovsky, who has performed a great service in tending to the naives in France. The subject is lying on the sofa, one hand in his pocket, the other holding a pipe. The painting is like a miniature. In the sleeping niche hang several pictures: naives, a Mondrian, and a Toulouse-Lautrec poster. The room is decorated with a garland of fans and a chain of suspended pipes. The patterns in the rugs on the floor and on the couch and the square tiles give the space a well-ordered rhythm.

René Rimbert loves intensity of vision, the penetration and rousing of things in the endless stillness of the material (illus. 56). His streets, squares, and façades are painted in the light of transience. The painter portrays them and obscures them at one and the same time. People are included, yet they are almost never visible. They have just passed by, with one foot only in this street, this world. Half of the face of Rousseau, the greatest of the naives, can be seen gazing out the window. He is holding his palette in his hand as in the self-portrait which hangs in Prague, and his one astonished eye looks out from the picture. Rimbert calls this little painting *The Window of le Douanier Rousseau.*

Still others belong to the obscure community of naives in France: André Bouquet, whose city-scapes resemble faded maps; Jean Schubnel, who rebuilds the palaces of the past with naive romanticism; Germain Vandersteen with his generously structured, red-violet cathedral and his archetypal portraits of cats; Emma Stern, who describes scenes from our time with direct emotion and poetic color—the exodus, the deportation of the Jews by Hitler's fascists, burned-down houses, lines of people, a dead girl carried along.

Among the countless naives of the present day there are many who inhabit the dangerous zone of self-consciousness. Jacqueline Benoit's graceful thoughts incline more toward the harmless illustrations of children's books than toward the simple, uncomplicated world of the naives. Raymond Riec Jestin and Nina Barka's nymphs with butterfly wings, decked out with appliquéd velvet and set-in pearls—these Venuses with fashionable hair-dos and languid, kitschy eyes—belong to the warehouse of bad taste. These are pseudo-naives standing on ambiguous conscious footing. They have misplaced their unaffectedness.

Miguel G. Vivancos, Flowers in the Window, *1961.*

René Rimbert, The Window of Le Douanier, *1957.*

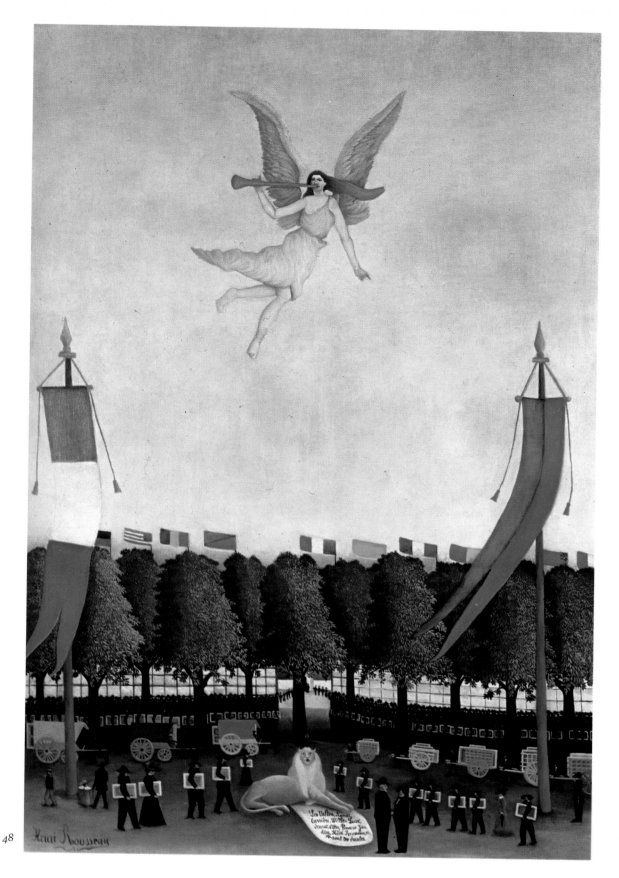

48

Henri Rousseau

48. *Henri Rousseau,* Liberty's Invitation to the Artists to Take Part in the Twenty-Second Exhibit of the Independents, *1906*

The only picture that Rousseau painted in the style of folk art, this is a profane votive plaque, a contribution in honor of the day on which le Douanier *was accepted into the society of the* Indépendants. *The door of the gallery was at the same time the portal to recognition. Just as the Mother of God appears in the sky on pious votive pictures, so does the Angel of Liberty appear in this one. He hovers in front of a translucent blue and blows triumphantly the trumpet call which will open the exhibit. The endless rows of painters are ready for their formal entry into the hall. Women are among*

them, for in this period they were already considerably emancipated. The wagons carrying the large canvases are parked symmetrically to the right and left of the door. In the center of the foreground, the strangely emblematic, fairy-tale lion lies watching the splendid occasion. To his right, le Douanier *stands conversing with Odilon Redon.*

An important moment in the life of the artist, and an important one for the history of art; it was the sign of a new beginning when Rousseau, the great naive, was accepted into the ranks of the modern painters. A primitive, original, and naive art takes over from a fading folk tradition.

49

50

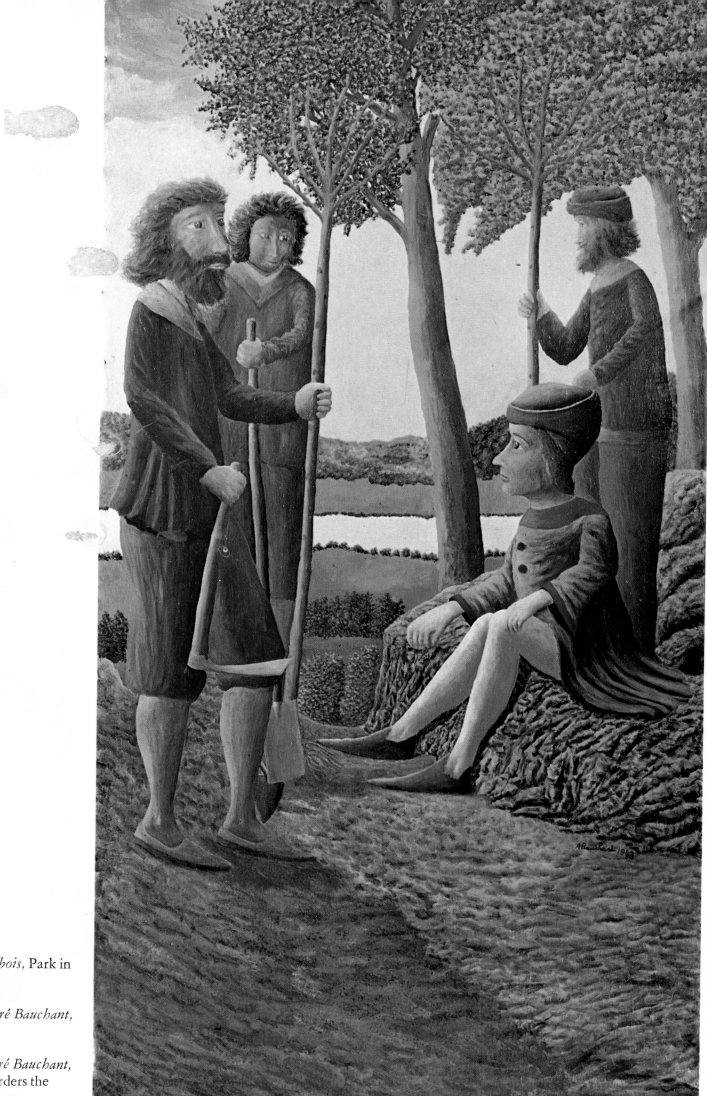

49. *Camille Bombois*, Park in
Autumn

50. *Auguste-André Bauchant*,
Flower Garden

51. *Auguste-André Bauchant*,
King Louis XI Orders the
Pl of Mulberry
 43

51

52

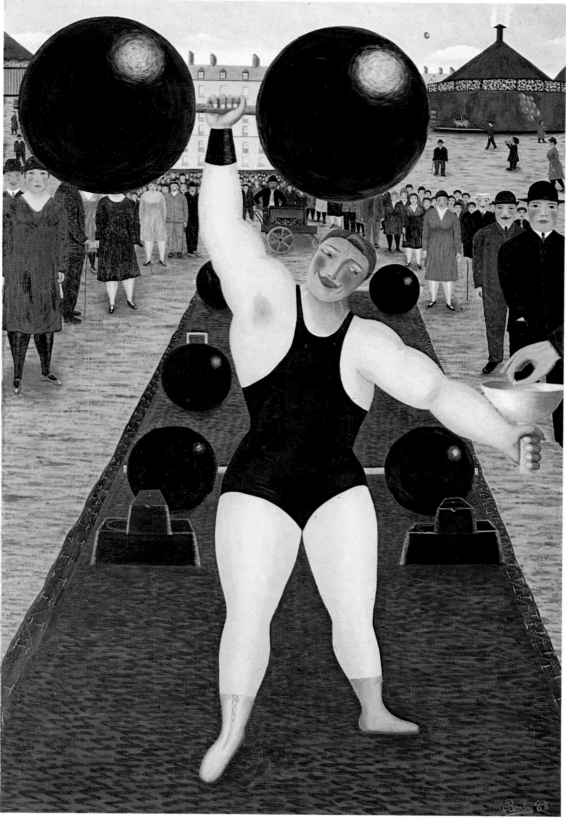

53

52. *Louis Vivin,* The Cathedral
at Rheims, *about 1923*

*Brick by brick, the postal
inspector Vivin rebuilt the
streets, squares, and churches he
had explored through his
long career with fanatic
patience and stamina. The
finished products are like
enchanted ornaments through
which the figures move as in a
daydream.*

53. *Camille Bombois,* Carnival Athlete,
about 1930

*Bombois painted as vigorously as he lived.
Standing on the blue carpet of grandeur,
he lifts massive weights. Fame wafts about
the hero's powerful muscles, while an
army of admirers stands in rigid rows
behind him with faces full of dumb-struck
astonishment.*

54

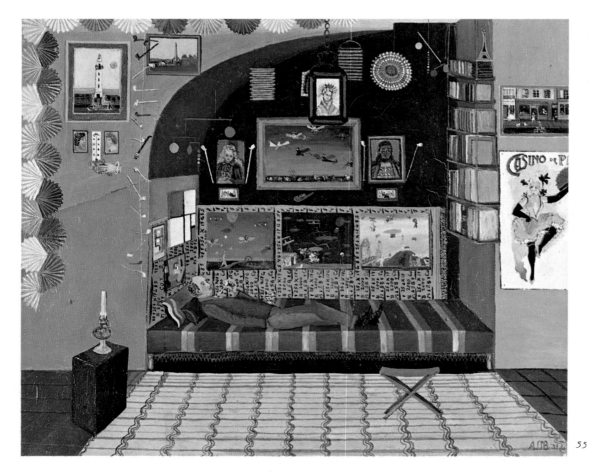

55

54. *Dominique-Paul Peyronnet,*
The Forest Clearing

55. *Gertrude O'Brady,*
Anatole and Minou, *1939*

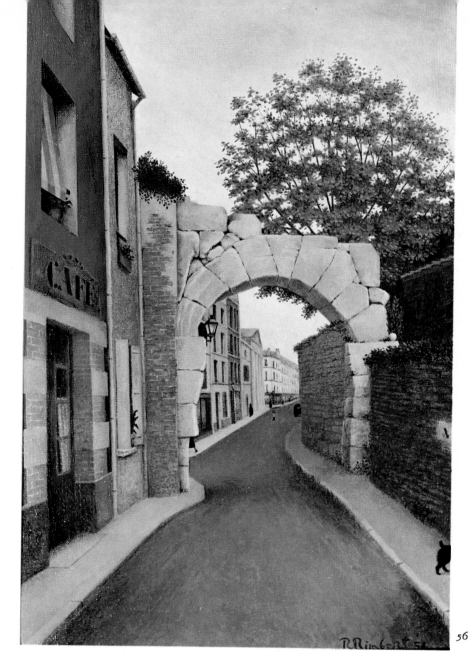

56

56. *René Rimbert*, Street Scene in Autumn, *1954*

There are few painters who have charmed such a sensitive harmony of color out of the unpromising reality of dilapidated and decaying walls as does Rimbert. In the generous simplicity and severity of his architecture there is a meditative attentiveness and considered control. The studied groups of people and single figures which appear in the shadows of doorways and draw back again, and which vanish in the depths of the street, are occasionally hidden by a jutting piece of architecture or cut off by the frame of the picture. Rimbert's magical and brooding intensity suggests that something invisible

is taking place behind his walls. The old city, in which life is almost totally concealed, is here displayed in mellow autumn colors. We see golden brown foliage, an inviting coffee house, a length of street through a ruined archway, a little dog sneaking out of the picture, and just a bit of a red skirt and a woman's leg being withdrawn. Like Vivin, Rimbert was a postal clerk. It is uncertain just how much his simplicity and originality might let him qualify as a naive. Rimbert himself does not believe in such distinctions. He possesses the lyrical spiritedness of an inner vision, and at the same time he carries within himself the great French painting tradition.

57. *Séraphine Louis* (*de Senlis*), The Red Tree, *1927*

The Great Expansion

Chapter VII

Nikifor, Self-Portrait.

Eastern and Asiatic Naives

In honor of Wilhelm Uhde I gave the last chapter the sentimental title "Painters of the Sacred Heart." But the phrase could also be applied quite appropriately to the destitute, unfortunate, and truly inspired painter Nikifor.

Nikifor came from the Polish village of Krynica, though he forgot his family name and the beggarwoman who had been his mother. He had a speech defect and chose to communicate with his surroundings through the strokes of his brush. The written characters of his world are screaming semaphores, rampant bridges, swaying streets, or even saints in fur hats driving along in carriages of eternal life.

Nikifor's story is similar to that of Kiyoshi Yamashita, who also only began to develop his artistic talent in reaction to the loneliness and contempt he found in the world, and who also led the life of a wanderer and beggar.

He sold the little products of his brush and pencil in the streets and parks of the spa Krynica. With simple schoolboy colors he painted on pieces of cardboard from the bottom of cigarette packages, on wrappers from chocolate bars, or lined pages from school notebooks. On these one finds his odd architectural mixtures of fantasy and reality, the melancholy impressions of his wanderings through the villages of Galicia with towers and cupolas of little churches set against the blue and greenish-black background of his dreams (illus. 62).

A sense of his own doom and the world's destruction together with specific depressions regarding the war and occupation may have caused Nikifor to resort to drawing as a bridge toward people or as an expression of his spiritual needs. Art was essential to his existence; it could not only reproduce the world in a new way, but also redirect his own thought accordingly.

Often he painted pictures of himself: Nikifor reading or painting, Nikifor as a judge or a scholar, as a prince of the church, a saint, or occasionally as a lonely wanderer (illus. 58).

In this way the simple painter compensated for his limitations and assured himself of a place among the wise men on earth and the saints in heaven. With his native love of storytelling he managed to banish all rational complications and recreate the world.

He painted tirelessly. Some ten thousand of his paintings and drawings have been dispersed throughout the world. Many of them bear inscriptions, but they are meaningless; Nikifor never learned to read or write.

He began selling his little pictures for a few pennies each when he was thirteen. They were simple drawings done in watercolors. The firm outlines have an hallucinatory clarity; the statement is simple and yet kept in the background like a consciously constructed metaphor. They are gently secretive, nonperspective compositions of childlike hope. The artist's gaze is directed toward a happy landscape unlike that of the here-and-now.

As one penetrates further into truly Eastern culture it becomes increasingly difficult to distinguish between folk art and high art. In Asia, the art that has developed out of tradition is less affected by the fragmentation of

consciousness attendant on technical civilization.

The art of the Georgian painter Niko Pirosmanashvili combines an inherited conceptual world of folk custom with the actual life of people in his region today.

Just as the rhapsodists at princely tables in antiquity would sing of the deeds of gods and heroes in exchange for food and lodging, Pirosmanashvili glorified in the legendary and the prosaic life of Georgia in the cafés of the city of Tiflis and its surrounding villages. His almost monumental pictures, expansive but simple, were made for wine merchants, innkeepers, peddlers, officials, diners, and drinkers who populated cafés and bazaars.

He had taught himself to read and write as well as to paint, and a streak of romanticism caused the painter to immerse himself in the poetry of Georgian literature. Above all others he loved Vaska Pshavela, who taught him to appreciate the suffering, the pride, and the yearning for independence which characterize the Georgian people. Inspired by Shota Rustaveli's epics and the poems of Tshakhuradse, the painter included in his compositions the figures of folk heroes: Georgi Saakadse, the brave Czar Irakly II, and the wise Czarina Tamara.

Remarkable in his palette are the colors of Georgian folk art. His themes are taken from the country life and its round of work and celebration, as for example the wedding in Kakhetia and the festival in Bolnissi. Pirosmanashvili also loved to paint men eating and drinking. Feasting and carousing are portrayed with an intense detail and easy humor as though they were ritual ceremonies (illus. 61).

His monumental still lifes, these luxurious fruits of the Georgian soil standing out radiantly from the dark canvas—orange gourds and indigo grapes next to sizzling *shashliks*

and mouth-watering fish—possess the symbolic power of a longed-for abundance in life. "In his representation of them the painter takes possession of them, which may also be the case with the beautiful women of Kakhetia that the artist, who lived in unrelenting poverty and privation, sets before us in a creative effort more magical than real. Utopia thus becomes a matter of his immediate experience, and nature is restored as a promised land," writes Gert Clausnitzer of this artist (illus. 59, 60).

Pirosmanashvili painted the Tunguska tributary Emut as well as the landscape of Batumi with its sea, its harbor and mountains, and a toy train edging along the coastline. In its dark, strong colors the landscape of Georgia generally provides only a background for compositions of figures. He painted not only people, but also the animals of his world that he loved: deer, goats, lions, and eagles. They are creatures from fairytales and at the same time they are his own; his night-wandering bear is given a halo of moonlight, and a wounded stag evokes his sympathy.

Through the years his painting becomes surer, his technique freer. From the beginning, however, there persists in him a spontaneous and experiential, epic and optimistic vision of the world. His chromatic scale is restricted to an alabaster white, a shell pink, a matt blue, rust, and the various vegetable greens which gleam against a consistently dark background. These generous and solid compositions occasionally display the names of shops or inns in Cyrillic or Georgian script. Today these have the effect of pictograms, as though the painter had deliberately used the letters as calligraphic forms.

Pirosmanashvili was born in 1862 in Mirsaani, a small village in Kahetia. His parents were peasants and died in his early youth. The boy was to hire himself out as a

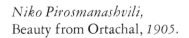

Niko Pirosmanashvili,
Beauty from Ortachal, *1905.*

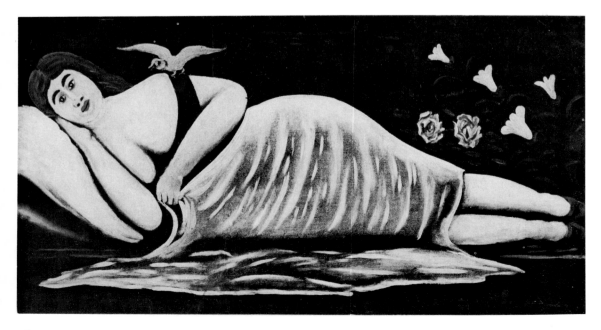

86

Niko Pirosmanashvili,
The Old Servant, *1905.*

shepherd, a house servant, and as part-time help on the trans-Caucasian railway. For a short time he ran a shop selling milk and cheese, and later a small paint store, but all of his financial undertakings ended in bankruptcy. He managed to support himself only from the signs, frescoes, and pictures he did as a wandering painter.

Around 1916 the professional painters of Georgia took notice of him for the first time. But his pride and sensitivity prevented him from accepting their assistance. He felt himself slighted, and interpreted the interest of trained artists as condescension. He lived alone and exposed, without relatives and friends, and died unnoticed on May 5, 1918. No one knows where he is buried.

Only with the resurgence of interest in primitive and naive art did people begin to collect his works. Today they are prized in the national museum in Tiflis. There are doubtless many people of the region who feel that Pirosmanashvili has captured more of the life and dreams of Georgia through the simple candor of his talent than have the "official" artists.

Kiyoshi Yamashita was born in Tokyo in 1922, the son of an alcoholic. A devastating earthquake forced the family to move to Niigata on the Sea of Japan when he was quite small, but three years later the boy began to go to school back in Tokyo. After his third year of school it was clear that he was mentally retarded, and Ryuzaburo Shikiba, who has written about the life and work of this naive Japanese painter, reports that Yamashita had an I.Q. of about 68.

Reacting against the disrespect he sensed in others, the child developed a severe inferiority complex which was manifest frequently in outbreaks of violent rage during which the boy threatened with knives anyone who came near him. At twelve he was separated from his home and his mother, and was taken in at a succession of private charitable institutions, first the Yawata Home and later the school in Bokke. There, encouraged by good teachers, he learned how to make Japanese *hari-e* collages, pasting pictures made of bits of colored paper which are either torn or cut with scissors.

On occasion he would escape from the institution and the constraints that oppressed him and set out to wander. He was at this time still wild and had a compulsion to steal. He worked variously as a farmhand, a dishwasher, and a babysitter; later he hired out to a blacksmith and worked for a fish merchant. Often he would beg for food, sleeping in train stations and walking the whole length of the country. With a peculiar directness he has described the experiences of his wanderings in ten notebooks. During the whole time he continued to perfect the art of the collage,

and was to develop a remarkable skill in it, using his own techniques. When he returned home in 1949 he began to paint in oils. He made his first oil paintings by squeezing the paints directly from the tube onto his board or canvas. The result resembled the *hari-e* with their spots of color, or perhaps in a purely formal sense the pointillist pictures of van Gogh.

Kiyoshi and his pictures did not remain unnoticed for long. The press began to call him the van Gogh of Japan. It seemed as though the recognition scarcely penetrated to his consciousness, however, and he performed his new role with a quiet, hesitant reserve.

An essential characteristic of Yamashita's work is the spontaneity and freedom in his representation of scenes which are otherwise generally avoided. He is completely uninhibited in his drawing, whether he shows us nakedness, or sex, or people urinating. Through the vitality of his pictures he could break out of the isolation imposed on him and communicate with the world. His sense of himself as a painter compensated for his social inadequacy.

Though he is self-taught, the simplicity and order found in Kiyoshi Yamashita's pictures are a part of Japanese tradition. His work does not display so much his simple-mindedness as it does a pure and genuine feeling for rhythm and proportion, an urgency toward discovery like that found in children (illus. 66, 235). Driven by his sense of estrangement, he sought a compensation for the loneliness of his life and a means of self-realization. He found it through his determined conquest of the *hari-e* technique; in the art of collage he discovered a way of expressing himself completely.

For me the name Suma Maruki is associated with the picture cycles of the horrors of Hiroshima. Through years of concentrated effort, the flash of the atom bomb, the scorched earth under a colorful rainbow of the ashes of death, have been drawn and painted by Iri Maruki and Toshiko Akamatsu. I do not know whether the naive Suma Maruki has any connection with these painters of Hiroshima. Only this is certain: she herself survived the destruction of the city.

I have tried in vain to find a similar life story in the annals of art. Suma Maruki was born into a peasant family of many children, she never attended school, and she remained illiterate. As a child she simply did not like learning; she preferred to set off for the mountains and the woods where she could occupy herself with games of her own invention. When she was grown she married a farmer and had to slave for her huge family.

She was sixty when she first tried to draw. Desiring to send some kind of picture of her

own to her youngest son who lived far away, she took an uneven stone and painted it black, then made prints from it on paper. The result rather resembled a mouse. All she had to add by hand was the nose and tail. The painter was to confess this first attempt to her daughter-in-law Toshi Maruki, who also relates how a second picture came about.

The bomb had been dropped on Hiroshima, the war was over, and a hard, depressing life had begun again among the ruins of the city. Suma Maruki was seventy-four when the whole family was able to gather in her house again for the first time. Such a portentous reunion needed to be celebrated by some kind of group effort, and her son and daughter-in-law, both painters, suggested the group paint a picture; each member of the family would paint a portion assigned to him. Suma Maruki doubted she could do it. Apprehensively she took up the brush, for she had no idea how to hold it.

She also had no idea what she would paint. But a fish that had been bought for the festive dinner was lying on the table, and she simply studied it for a long time and then began to paint it. She did not use any lines; she did not know what drawing meant. Dot by dot she placed a little red, green, and other bright colors on the canvas, and in this way slowly built up the form of the fish. When the finished picture hung on the wall, all could see that the fish was certainly the best part of the group project. From that day on, Suma Maruki worked intensively at painting. She painted more fish, and also cats, dogs, and everything else around her. She would only paint with dots, somewhat like the Tachists. Only later did she learn to make lines.

She created in her pictures the scenes of nature and the life of her village, her own experience and her acquaintances. Her picture of a large dog called *Ron* (illus. 65) was done in 1945. The painter stands with her two children in front of her house and looks, almost terrified, at the huge animal that has just been given her. On either side of the wooden fence the children of the neighborhood have gathered to admire the dog, which looks, incidentally, like a wild boar. Birds of various kinds sit about on the trees. The surface of the picture is broken up into sections, and the huge Ron stands in the middle of the scene like a golden calf of mythology.

Another picture from 1945 is called *The Cattle-Dealer Comes* (illus. 63). Every fall at about this time, this man comes to sell his cows. He leads a dark brown one on a rope, while holding a spotted one by the tail. The autumn earth is a rich brown; ripe orange fruits larger than life hang decoratively from the trees in the upper half of the picture. In the background, to the right and left, stand the village houses with their low-hanging roofs. Most of the figures in her pictures have large heads and small bodies; only from the content of the narrative can one determine which ones are adults and which ones children.

A photograph of Suma Maruki shows us the old painter's beautiful face, its touchingly fragile softness, its half-closed eyes, and a mouth compressed with sorrow. The branching wrinkles around her eyes, these furrows of her years, give her a look of repose and withdrawal suggestive of inner vision. She is standing with a teacup in her hand in front of the large picture of animals and plants which she chose to call *The Bright Hair-Clasp* (illus. 64). Done in 1955 near the end of her life, this picture measures 110 by 180 cm. It is her largest and doubtless her best piece of work. She has assembled many of the companions of her long life in the melancholy, dreamy garden of this picture; there are snakes, cats, chickens, ducks, songbirds of various kinds, and miraculous trees, shrubs, and fruit.

Maruki's palette boasts countless variations of green. Through the muted jade of tree leaves and the bright green of ferns shimmer pastel blues, a smoky pink, an alabaster white, and the lilac glow of flowers. Chicks and ducklings are a flaxen yellow.

The imposing plumage of birds blends in with the colors of the leaves. A triad of snow-white, dovelike birds stands out against the orange glow of sunlight vibrating behind the rhythmic lines of branches. A soft and shimmering glow infuses this place.

These are not the flaming, frenzied bouquets of desire of Séraphine Louis. Nor are these blooms closely related to the spirited art of the American farmer's wife Grandma Moses, who in gentle idealization of her past painted noteworthy scenes from memory. Suma Maruki's compositions belong neither to memory nor ecstasy. They are the creative expression of a childlike faith in life and its future—in spite of Hiroshima.

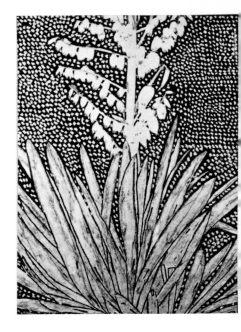

Kiyoshi Yamashita, Yucca, *1938. Collage.*

Suma Maruki, White Birds.

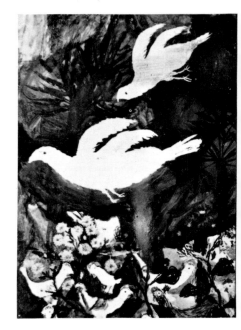

Within the Magnetic Field of Industrial Civilization

In 1938, the Museum of Modern Art in New York put together the first large exhibit of European and American "folk-painting." Since that time, art historians and collectors have brought to light much of the history of this genre. A great number of exhibits have presented the art of the naives and have called particular attention to a few individuals. In many places talent which had been unnoticed up to that time has been encouraged, and many works have found their way from provincial museums into the great art galleries. With their modest work the naive painters have also doubtless exercised a subtle influence on their "colleagues," the professionals. We can say that the most important American painters of our century are Joseph Pickett, John Kane, Horace Pippin, Morris Hirshfield, and Grandma Moses. But perhaps it is still too early to choose from the large number of primitive painters those who will be remembered in the future.

The carpenter Joseph Pickett traveled with a circus in his youth. In summer he would set up his shooting gallery at a fair and decorate it with landscape backdrops he had painted himself (illus. 163). After his marriage he opened a grocery store and painted, when he found time, in the storeroom at the back. He made his paints from berries he collected in the woods and his brushes from cat hair. Since Pickett worked on each of his pictures for months or even years, he produced but very little. The works from his hand which are known today come from the last years of his life, and they were bought at auction after his death for only a dollar apiece.

He painted *Coryel's Ferry* (1914–1918) not as he saw it before him, but as he imagined it must have looked a hundred years before. To be sure, it is the same landscape in the same summer green as today, with a water wheel turned by the little stream, but the pedantic craftsmanship of the house fronts on either side is now completely gone. Above the roofs extends a densely crocheted forest in which the onetime owner of the place, in eighteenth-century costume, looks at wildlife through his spyglass. Red deer are mirrored in the water, ducks swim in neat rows, a white horse stands obediently close to the mill waiting for its rider. As is often the case with lay painters, the artist has tried to enhance his colors with the addition of bits of other materials. Here the white crests of

the waves have been raised for the sake of illusion with little blobs of something like plaster. As in oriental miniatures, all elements have been arranged according to plan and assembled in order. The heavy hand that lingered over details has nonetheless created a whole, a poetic vision of the passing and permanence of a landscape.

One of the most outstanding painters of the United States, and the most important among her Negro painters, was Horace Pippin. A schooling in piety and patriotism had presented him with ideals in which he believed, although in the depths of his being one can sense an undertone of rebellion. But even in protest, sensibility and a feeling for rhythm and color prevailed. Something of the sentimental tone of *Uncle Tom's Cabin* sounded in him as well. His work is a graphic spiritual of the black man who took Christianity more seriously and felt it more deeply than did white Christians grown indifferent.

Educated Negro painters berated Pippin for refusing training in spite of certain opportunities he had had, and for remaining "only" a naive painter. Pippin did not think much of the experience to be got by schooling. In his autobiographical notes he says: "My idea of art is that one must have a love for it, for I think a man paints from his heart and from his imagination. So it would seem to be impossible to teach art to another person." At seven, Horace Pippin began to draw with a pencil or in ink. He lived with his mother in the town of Goshen in New York State, where they had settled after leaving West Chester, Pennsylvania. At ten he began to paint religious pictures; he knew the Holy Scriptures, and their themes inspired his work. Many of his biblical pictures are reminiscent of the fervent, innocent scenes in the film *Negroes Read the Bible*. At the age of fifteen he left school and became successively a coal shipper, a bellboy, an iron smelter, and a junk dealer. During the First World War he went as a soldier to France, where he was seriously wounded. The war remained his most definitive experience; in his sketchbooks and pictures he portrays its inhumanity and the horror and despair of destroyed cities. Back in America he occupied himself chiefly with painting. He did pictures from the life of the Negroes, landscapes, religious scenes, still lifes, and memories of the war.

In his monograph on Horace Pippin, Selden Rodman relates the life of this important painter with obvious sympathy. His room was supposedly full of religious calendars, displayed together with his marriage certificate, his military discharge, and faded photographs, in one of which one could see the painter himself in his army uniform. His

Joseph Pickett, Coryel's Ferry,
1914–18. Detail.

room enjoyed little natural light, so he usually painted at night in the light of a 200-watt bulb. He held his wounded right wrist in his left hand, and so supported the movements of his fine brush.

In 1937 he was discovered, like Grandma Moses, by Christian Brinton, and the actor Charles Laughton bought a picture of his displayed in a shop window. Only a year later, the Museum of Modern Art showed several of his paintings.

Among the most powerful of his works is the *John Brown Trilogy* (illus. 67). John Brown, who espoused the cause of the liberation of the Negro and was accordingly punished with death, is a transposed Christ figure.

The picture of *Uncle Tom* has about it something homely and familiar. The pathos of the scene is outweighed by the honesty of the emotion and the intensity of its expression. The colors are laid on thick in order to strengthen the poignancy of this depiction of a white child seeking help on the lap of the good black man. The figures in the interior of a Negro dwelling in *Sunday Morning Breakfast* are particularly sympathetic and true to life. The workingman sitting on a broken chair is accentuated in strong colors, his undershirt red, his shirt bright blue. In front of a yellow door one sees the checkered apron of the mother. In spite of the heavy labor personified in the portrait of this man, an air of warmth and happiness lies over the scene.

In his last pictures, Pippin reviewed everything he loved to paint: childhood memories, the milkman in Goshen, Christmas mornings, Sunday evening baths, interiors (illus. 68). For his colors he went back to those of the John Brown cycle, grayish-brown values and a black and white palette.

Then came success. His pictures found their way into many museums, and he sold everything he did. The leading magazines *Vogue, Life,* and *Glamour* were clamoring to reproduce them.

But he was old now, and his wife lay in the hospital with a nervous ailment. He felt alone and indebted. His last picture, *The Park Bench,* must serve as our parting view of him. He sits quite alone on the bench, holding to the back of it as though it were difficult for him to get up again. A tree lowers its branches and leaves above him. The man on the bench is gazing tiredly at nothing in particular: the homelessness of his race, his estrangement from people, and possibly most of all his deep loneliness. On July 6, 1946, he died of a heart attack.

John Kane was a naive painter with a proletarian conscience. If it did not ultimately find political expression, the private world that he painted was nonetheless that

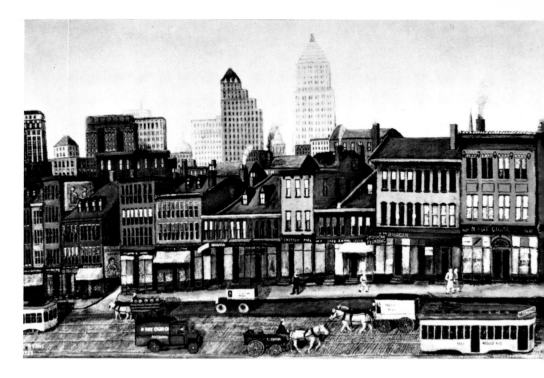

of a critically minded industrial worker. Born in Edinburgh in 1860, John Kane landed in Pittsburgh at nineteen. He worked as a miner, cabinetmaker, and steelworker, and during the last years of his life as a house painter. "I used to have to paint new steel things," he writes, "and that is when I learned to use paints."

He painted houses and train cars; he colored photographs of communions and weddings, producing keepsakes that were then very popular. He tinted black-and-white photos and at times he even painted right over them. This latter habit brought him into conflict with a Junior League group that had wanted to sponsor him until they caught him at such imitations. Still, he had no sense of guilt about his copying, although later he tried to be more "inventive."

Kane painted portraits, interiors, celebrations, landscapes (illus. 164), and above all the city of Pittsburgh in which he lived. The sooty black factories in which he had worked, the gloomy cobbled streets, and that mixture of classical architecture ornamented with columns with the cold strength and practicality of concrete skyscrapers and steel bridges.

Kane loved to paint the streams of smoke rising from steel factories. He had worked in those factories, had helped lay the tracks for one of the oldest streetcar lines, and had the sense of being one of the builders of those bridges, waterworks, and industries of the city which he painted. "When I look at Pittsburgh, I see it both as it is in my memory and as it looks today. And so I see it double: once as God made it, and once as man has changed it," Kane used to say.

He painted with much patience and precision. A multitude of detail was held together by a strong sense for total composi-

John Kane, View from My Window, *1932.*

tion. He was as he represented himself in his self-portrait (illus. 179): a powerful, masculine figure with a thoughtful face and strong fists ready to strike. But these fists could also guide a brush and paint sensitive pictures.

The Carnegie International Exhibition in Pittsburgh accepted his pictures in 1927. Kane was the first primitive painter to be recognized in the United States. Still, his art brought him little material gain, and he died in poverty in 1934 of tuberculosis.

One of the strangest phenomena in modern primitive painting is Morris Hirshfield. Born in 1872 in a small border village in what was then Russian Poland, he came to the United States as an eighteen-year-old. He worked in a clothing store, and later became the owner of a wholesale house dealing in bedroom slippers. When he retired from the business after a severe illness in 1937 and began to work at painting intensively, visions from his cutting room kept breaking through into the substance of his pictures; his landscape, people, and animals are childishly finished as though for the ready-to-wear counter. But behind the forms there vibrates something irritatingly unreal, a challenging absurdity, a dream-laden soul which manifests itself in the sensuality of color and the hypnotic surrender to form (illus. 215, 216).

His work was first displayed in the Museum of Modern Art in 1939 in an exhibit arranged by the collector and first-rate connoisseur of primitive art, Sidney Janis.

In the following year, Hirshfield painted his *Tiger.* He took as his model a cheaply realistic print he had found in a children's book. But he transformed the banal original, changing it into a fabulous animal with delicate feet and love-struck eyes, purring at its newfound magical existence. While the tiger is dressed in a well-cut striped suit, his later *Lion,* wandering cautiously in a garden so as not to step on any of the flowers, wears a splendidly groomed topcoat with a lush fur collar.

Sidney Janis relates how the round eyes of the *Angora Cat* stared out of the darkness of the picture at him with such magical power the first time he saw them. He was reminded of a sequence from the film *Duck Soup,* in which Groucho Marx comes upon his unexpected reflection in a mirror and retreats in fright, while his strange double stands perfectly still. In such a way, the eyes of this cat resting with a languid, proprietary air on the sofa can hypnotize.

When Hirshfield painted, he first drew the outline of his object. He then felt the application of color to be a sensuously impulsive act of creation. In order to achieve the structure of the lion's mane exactly enough, he took a comb and stroked the strands on the

Morris Hirshfield, The Coquette, *1941. Detail.*

picture into waves. These gentle, erotically hesitant, dapper but dangerous wild animals from children's books and from his own fantasy betray something of the ecstatic vision of his Eastern childhood. But the feverish dreams are controlled and compressed into an objective artistic image; each of his figures is the representative symbol of an inner world, a sign of power, possession, fear, and temptation.

Hirshfield created out of psychological, subterranean springs of instinct. By contrast, Anna Mary Robertson Moses—called simply Grandma Moses—turned without reserve to the reality of the visible. She presented the small cosmos of the farmer's life, idealized only slightly in her recollection of the past. An art of unhurried contemplation, this is a survey of and last visit to the abundant life she knew was running out. Things that were lost and buried were made visible again with unnatural clarity. What remained was the earth and the life that springs from it. With the farsighted eyes of old age, she drew close again the events of her distant childhood, working days and holidays, settled motherhood, and the wanderings of a long life. These are her subjects: a celebration to which friends and relatives come from far away; a festively decorated room; the steaming tubs of clothes on washday; the long-awaited arrival of the overland mail; the color and smell of fresh-plowed ground; the thousand shades of green in the landscape of Cambridge Valley, with its meadows, woods, and hills under a lilac sky (illus. 165); the highly polished country roads sparkling with ice as old-fashioned sleighs trace light gray tracks along them. "When I paint I test again and again to see how it looks in the daylight," Grandma Moses would say.

The charming winter landscapes of Grandma Moses have naturally been compared with Brueghel's pictures of winter. But while the Flemish master composed a rhythmic interplay of color and space out of generous formal elements, Grandma Moses arranged the facts of her world side by side with pedantic neatness and trusting naiveté. Following her sense for decoration, she inserted figures or scenes wherever an empty space offered room for them. For this reason she could better be compared to the illuminators who used to fill their allegories of the months and seasons with an endless variety of human activity.

An inner composure surely allows one to achieve and to express a feeling of harmony with self in old age. But one needs a gift before one can set into the world this joy, the sounds of one's affirmation of life in the fullness of experience. Grandma Moses reached into the diary of her memory, extracted the best things she could find there,

then displayed them—following the habit of her countrymen—with a friendly smile and complete with a "happy ending."

"Why paint a picture if it doesn't show something nice?" she said. "I think back very hard until I remember something really pleasant. Then I paint it. I like to paint things from long ago. Historical buildings I used to see, bridges, mills, hotels, old family houses—a few are still standing, but they'll soon be gone. I paint them from memory. They're mostly daydreams . . ."

European Resonances

While in the United States a tradition of lay painting developed on its own apart from tradition and the academies, in Great Britain it was a phenomenon closely associated with official art. Aristocratic young ladies, statesmen, secure members of the middle class—by no means outsiders like those in France, but rather cultivated amateurs—painted poetic watercolors, moody landscapes, flower arrangements, and occasionally still lifes with animals and character portraits with delicate taste and feeling for form. When the eyes of art lovers in England were opened to a kind of painting without tradition and schooling, it turned out that there too there were naive painters by instinct and with an immediacy of perception working among the people. To these belong the fisherman and shopkeeper Alfred Wallis, the farmer James Lloyd (illus. 93) whom Herbert Read discovered, and the country dweller A. W. Chesher (illus. 95).

Alfred Wallis, the fisherman, was found by the painters Ben Nicholson and Christopher Wood. Characteristic are his bold draftsmanship and subtle colors. He deforms his landscape dramatically. His *Bridge* was painted with crude and strong brush strokes on a piece of wood. A viaduct looms out of a depth of night; the thin line of a train creeps off the upper margin of the picture. The few crass and bulky lines of the diagonal bridge supports and arches have about them something of the rigor and strength of the life of sailors and fishermen of the north.

Shows of naive art often include Scottie Wilson, the son of a Glasgow workingman. Can one still call naive his calligraphic visions which lead into those abstract and subterranean spheres which Klee explored in his analysis of reality? If the realm of things and "the great Reality" find rebirth in the art of the naives, Scottie Wilson has severed the umbilical cord binding them to the visible things of this world.

The London painter E. Box approaches the circle of the conscious naives. Experiences of surrealism give her pictures an atmosphere of daydream; poetic irony and genuine understanding lead to a blend of childlike grace and meditative romanticism. We will speak later of Patrick Byrne.

Any mention of "primitives" in Belgium or Holland causes one to think automatically of medieval Flemish painting. The fateful heaviness, the introspective faces, the vividness of the realism, and the last remains of a Gothic habit of life—one acknowledging the nightmare of the world behind the visible—these qualities are nonetheless absent in most of the work of the neoprimitives in the Netherlands. Perhaps Louis Delattre, born in Ghent in 1815, was an early promise of what was to come. Delattre led a peculiar, restless life. He was a machinist, house painter, banker, photographer, inventor of a sadly unworkable flying machine—and painter of pictures. Around 1865 he made several unsuccessful attempts to fly, but his neighbors called him "the flying man" regardless. He painted pictures full of a unique imagination: *The Birth of the World, The Friday Market in Ghent* (in which he included his own portrait down in the right-hand corner*), and *The Ascension of Prince Baudoin.* The latter records an obscure gathering of nobles and high dignitaries of Europe in 1891 together with God's heavenly representatives. One wonders whether Delattre did not paint it so realistically with a certain secret irony.

The assembly in mourning is arranged around the pompous sarcophagus out of which, borne by pink cupids, the dead prince rises in gala uniform triumphantly toward heaven. Our puzzlement could doubtless be a

Alfred Wallis, The Bellaventure of Brixam.

James Lloyd, Feeding the Horses. *Detail.*

* The painting hangs in the collection of M. Raymond Moerens in Brussels.

Louis Delattre, The Ascension of Prince Baudouin. *Detail.*

The Dutchman Jan van Weert, born in Hertogenbosh, was a stable owner, horse breeder, and equestrian. At seventy, after the Second World War, he took up painting "out of boredom, and because I don't have anything else to do anymore." He loved the streets and canals of Amsterdam, windmills, sleighing parties, and riding pictures; the diary of his recollections. He worked directly in childlike color, with the romantic touch of old age.

The Amsterdam baker Sipke Cornelis Houtman, too, began only at the age of sixty to recreate himself and his world with his simple drawing and a gift for naive observation. A self-portrait shows an inner gentleness and a heavy hand. The bird in a cage is perhaps a symbol of the beauty trapped in man until art opens the cage. His *Garden at the Old Age Home in Amsterdam,* seemingly experienced in only two dimensions, appears to be a design formed of the crossed and ordered paths of our lives.

The Dutch diamond cutter Sal Meijer (illus. 71) painted canals and the stone furbelows of Amsterdam architecture. The roof tiles of the houses glisten, the cool green light of the early morning vibrates like faceted petals in the soft sea wind. His placid cows as well seem to live in the aquarium of time. Trusting and ruminating, they look out of the strings of pearls of their black eyes. The simple painter has arranged them all in a row—as did old masters when painting group portraits of guilds and corporations—so one can properly admire them. Some of them look directly out of the picture at us in a friendly way while chewing their cud. They may not be sacred, but for all that they are useful companions to man, and the painter loves them, perhaps because of their patience.

The retired tram driver Pieter Hagoort paints geometrically ordered farms, meadows, windmills, canals, small bridges, and an electric train that moves across the land and on into the sky through the air. He chooses to paint the places and ways that he has known, country houses surrounded by green and with storks' nests on their chimney tops (illus. 92), all as precise as though drawn with a ruler. Small figures of horses, cows, and men are scarcely more than specks, the people often in the white collars of long ago. A horse-drawn tram and its tracks, painted quite flat, has the look of a child's toy train. As it moves through this tiny world we see boats on the canal, green plantings, streets paved with red bricks, a blackish-red station through which the tram wagons come and go.

The innkeeper Johannes Smits paints small, intimate scenes with psychological insight. His *Night Refuge* breathes poverty;

matter of today's point of view, however. Delattre painted a genre picture of mourning in the taste of his time. The surrealist components of actual and metaphysical spheres, the coupling of anachronistic events possible only in his fantasy but nonetheless rendered with the realism of a documentary photograph: these were faithful to his imagination, and only unintentionally do they produce a striking effect of alienation.

Leon Greffe, born in Charleroi in 1881, was a miner in his Belgian homeland until he left to work in Les Halles in Paris. Later he was a doorman in a building from the sixth floor of which he looked out upon the Quai des Bouquinistes, the Palais de Justice, the Pont Neuf, and other landmarks which figured in his work. An impressively vigorous feeling for the idiom of color is characteristic of him. Houses and people take their places in the picture with the cheerful abandon of children's drawings; folk dancers against a golden ocher background, black-suited citizens on green grass in the foreground.

Camille van Hyfte was a farmer born in Ertvelde in 1886. In later years he owned a horse slaughterhouse in a Paris suburb for a time, before becoming a jockey. Anatole Jakovsky praises his intense sensitivity to the atmosphere of his surroundings, the slate-colored, deep-hanging sky, the fairs of the common people, the multicolored sandstone of the Belgian façades. Particularly his interiors tell of an intimate, old-fashioned world in controlled brush strokes and gay spots of color.

bearded figures at a bare scrubbed table with an empty bottle lying on it. Men staring silently and with deep concentration into emptiness.

Resting in Front of the House shows us a man and his wife sitting on chairs, beside them the ubiquitous bicycles of Holland, with brick walls of a brownish red, and garden walls painted with advertisements. Smits takes many details from the storeroom of reality, and builds out of them the quiet, naive snapshots of his observation.

The housekeeper Anna Zomer (illus. 170), the innkeeper Jentje van der Sloot (illus. 171), the furrier Willem Poelman, the porter Leonardus Neervoort, the wigmaker Daan Keuning, the press photographer Abraham Doorgeest, the mason Willem van den Berg, and others are naive artists collected and encouraged by Dr. L. Gans for the Dutch Albert Dorne Foundation.

There are historians who consider realism the essence and aim of naive art. The detailed representation, that abundant accumulation of particulars comprising the surface of a total picture, seem to them the true stamp of realism. But the concept of realism can only be applied to the art of the naives to the degree that one is willing to consider the cave paintings of paleolithic times realistic as well.

Naive artists present an instinct-laden image transposed into experience. Together they form a community in the sense that they all stand at a remove from tradition. Naive art neither presupposes a line of stylistic development nor stands in conscious opposition to one. The naive painter lives and works outside of historical categories. If in the works of individual naive artists there are visible stylistic influences nonetheless, this only shows that there can be no absolute insulation in art today, and that visual and acoustical mass media are able to penetrate even into the isolation of these people.

Two Belgian naives testify to this symbiosis of innocence and an unconscious, intuitive experience of form. The furniture maker Aloys Sauter, who portrayed in his philosophical compositions naive and somewhat grotesque aspects of life, touched without knowing it upon the territory of the surreal.

Hymn to World Peace is the name of one of Sauter's pictures in which the painter places his wife into the compressed landscape of his backyard. She stands there in a black lace dress, holding a page of her own poetry in her round right hand and a red fall aster in her left. With an expressive, masklike face, she is reciting her verses. In the background are some small stone steps, an arched garden bridge, and luxurious roses. In the foreground are assembled the animals of the house, cats, dogs, and a parrot, listening to the reading. Madame Sauter is speaking from the depths of her soul. She is bracing one leg against the arm of a chair as a provincial soprano might, and in a manner which the painter considered genteel. Above her head hovers the legendary dove of peace with his palm branch in his beak. In a picture of his shop (illus. 69), the painter portrays himself twice; once in profile with a chisel, and a second time precisely full face holding a plane.

Micheline Boyadjian's multiple pictures are not inspired by pop art. Her thoughts are turned toward the past and possibly affected by her childhood memory of a stereopticon, whose twin images, when seen through the proper lenses, produce an illusion of depth. In her search for times now lost, Micheline Boyadjian rediscovered this charmingly innocent childhood adventure and captured it. Her family tree shows three generations: the tinted photographs of grandparents on branches with stylized leaves, above them the parents' generation in its several branches, and above these the younger-still generation of the granchildren.

Sometimes Micheline places a chair or a table in a long picture, with drapes and curtains behind; the table highly polished, the flowers dried—lovely but lifeless—a vase sitting on a wicker chair that might have belonged to one of our grandmothers—everything from the past transfigured! In the background a fireplace with a clock and pictures or with old teacups and knickknacks, as in every proper Dutch parlor.

Micheline Boyadjian told me in a letter of January 10, 1970, that she was born in Saint-Jean Hospital in Bruges, where the marvelous paintings of Memling can be seen, and that perhaps therein lay the beginning of her calling. These are ambitious words, but it is true that there is something of Memling's inner stillness of figures in space in the small and charming province of Micheline's painting.

Her gift for precise observation does not stop short at the external and visible limit of things; it is often accompanied by a memory, a consciousness of the endangered beauty of the world in which we live. We can now see in her pictures the small, delicate girl that Micheline may once have been, standing apart from the difficult things of the world of adults. The well-behaved little girl appears again and again: playing the piano, going to school, walking in the rain, standing quite alone, or enjoying a band concert. The theme that fascinates Boyadjian is one's confrontation with self, the duplication or perhaps even the suspension of personality (illus. 70).

The girl stands in deep space in a simple

Micheline Boyadjian, In Expectatio

94

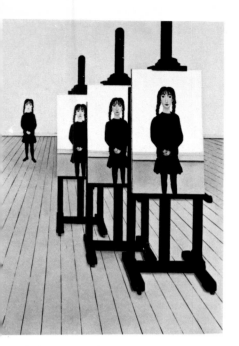

Micheline Boyadjian, The Easel.

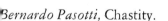

Bernardo Pasotti, Chastity.

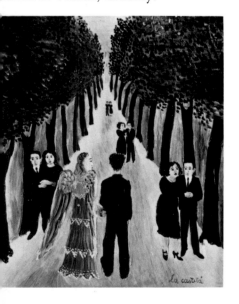

black dress, her narrow face framed by braids, her large eyes turned toward us. In front of her are three easels, graduated in size according to precise rules of perspective, and on each easel we can recognize the same painting: three identical portraits of the same girl. When we then look back from the foremost painting, we are touched by the frailty and isolation of the original model.

In 1959, the peasant painter Ivan Generalić produced a rhythmically ornamental multiplication of images in his pictures *Deer Courting* (illus. 75) and *The Woodcutters* (illus. 3) which corresponds to the serial pictures Andy Warhol did in 1963.

The Italian artist Bernardo Pasotti occasionally does a narrative sequence of paintings like the scenes of Gothic masters which in separate phases relate a story of life and suffering from the Holy Scriptures. Pasotti's sequences of faith and of everyday city life can lay equal claim to piety. His gift consists of an ability to waken lifeless things. He has transformed the pompous squares and ugly streets of the poor quarters of Italian cities through the patience and intensity of his art (illus. 174); in the dark light of his melancholy they take on beauty and radiance. The day-to-day lives of people become mysteriously remote. It is almost a matter of course to the pairs of lovers strolling along a tree-lined boulevard that an angel stoops to take the hand of one solitary young man. It is the painter himself in a rendezvous with his genius on this street full of languishing love and sighing couples. His guardian angel leads him through the streets of the suburbs, through poverty-stricken hovels, into glowing houses and splendid palaces, into dilapidated hospitals and somber schools, and into mass processions; he leads into a heaven where angels and zeppelins hover.

Pasotti is no innocent. He studied art at the Brera; he has tasted the fruit of the tree of knowledge. Nonetheless he succeeded in preserving the childlike shyness and the trusting openness to discovery which are the hallmarks of naiveté.

Italy's air is heavy with the glow of the past. Only rarely can the pathos of antiquity and the harmony of classicism be drawn off into the provincial and made primitive. The influence of works of high culture is everywhere. Among the painters of Italy there are some, however—especially in the smaller towns—who, though without training, compose passionately idealized portraits of their surroundings and of their own existence. In provincial museums one can find craftsmen's emblems, tavern signs, and display window posters whose banal poetry attests to the suggestive narrative power and talent of the people.

The strangest and most important naive painter of Italy was the master shoemaker from Terni, Orneore Metelli (illus. 184, 185). He leads us through the frozen stone architecture of his home town and celebrates it in the rhetoric of the born storyteller. Time and space are caught in his pictures as in a static trance. The generosity of his palette and the subtlety of his forms derive from an optimistic love of life; the revolutionary spirit of the Garibaldian shoemaker is softened by his gentle devotion to art. His self-consciously honest and naive compositions belong in today's gallery of classics of naive painting.

Metelli's son Ezio writes: "When he was fifty, his inclination toward artistic beauty led him to take his attempts at painting more seriously. He did this in quite a simple way, without special calculation and without pretensions, quite alone and for his own pleasure. . . ." In his pictures is the same honesty and originality with which he undertook to give new life to the events of his past and to the streets of the town of Terni.

Metelli shows us, for example, a *Procession near the Cathedral of Terni.* We see a moving train of priests, church flags, crucifixes, pictures of the saints, and sculptures—all in festive colors. Everything is ordered; his secure skill is in control. The people are pressed close together; police in black uniforms and shiny helmets seem larger than life. Metelli's *Design of Vittorio Emmanuel Square in Terni* is equally ordered and classic. An ancient Roman in his white draped toga stands with the solemn rigidity of a monument; silhouettes are framed by classical doorways; everywhere columns, cupolas, crenellated walls, and roof sculptures. A ghostly emptiness of the square suggests sirocco. The idea of rhetoric is apt; the naive painter is elevated through his art into a mood of solemnity. Just as in Central and South America the Spanish ecclesiastical and folklore heritage lives on in naive art, not only in its architecture but even in its costumes, hats, and the cut of cloaks, the political and cultural past of Italy and the imposing grandeur of her cities flow into the painting of her naives.

Metelli places his scenes of celebration or confession, his opera productions, and interiors into such a framework. One always senses the regional element as well, the contemplative life of the small town and a rustic populace. His Terni does boast of an orchestra, however, and Metelli was a member of it. When he stopped playing the trumpet he took up painting. We do not know much more than that.

Since he was then free and no longer had to go out to rehearsals, and since his doctor had forbidden him to drink too much wine

and he could no longer meet his friends in the tavern, he spent his long evenings at home, fussing with his paints and brushes. He enjoyed it so much that he never really put them down again until his death.

He had wanted to paint for a long time; talent he had, he only lacked training. But the charm of his style was sufficient. His pictures took shape out of his love, his passion for beauty, out of his capacity for transfiguration. None of his works took shape accidentally; all of them bore the stamp of his talent, his "genius." His world was well organized and precisely rendered, full of humanity and simplicity. In addition to his earnestness and humanism he displayed a certain sense of irony and mood of protest, but these found scant expression in his pictures. And so he found his own place in the art of his time; his interpretation remained within the sphere of the common man and the tastes of the people.

Aurelio de Felice feels that Metelli unconsciously continued certain old Italian traditions. He sees the same influences of the city, of architecture, and culture which moved Pasotti, though Metelli came from a different milieu. He notes that in many of his landscapes one can experience the grace and lushness of the Umbrian landscape and the richness of its tradition. Felice goes so far as to suggest that many of Metelli's pictures are reminiscent of Perugino or Pintoricchio.

Unconsciously he had the ability to create art. It gave him pleasure to paint, and he loved it so much that he often neglected his sleep—and quite probably his trade. It is for this reason that his works are so full of life. He felt the great satisfaction of telling of the life of his town with the help of colors.

Like a figure in one of Henri Rousseau's paintings, Metelli played the post horn on high holidays, and he played first trumpet in the theater orchestra. He was no friend of militarism; he loved his musician's uniform, but not the soldier's.

He painted on canvas, cardboard, wood, and even on sheets of metal. Some 250 of his paintings exist. His observation was clear, and he knew just where something should be included in his scenes. Of the classics, it is known that he was familiar with Giorgione. The city that surrounded him was rich in classical architecture and sculpture, and even more in examples from the Baroque period. He found his motifs in the backdrop of Terni, and he arranged his compositions in front of it like an opera.

His colors were full greens, velvety reds, a pale pink, and the grayish yellow of straw. Even the base of the painting is full of light and expression. Earthy forms, hilly shapes, provincial moods, comparable to folios of pictures from Epinal or illustrations for a novel. Folk art and regional painting are his inheritance and his legacy.

P. Courthion speaks of the "magic" of Metelli's compositions, of his pinpointing of space and time. In a compressed form, specific moments are caught forever. He drew and painted his world, which was Terni; to the viewer it could be anywhere in Italy.

He worked indefatigably, only interrupting his painting in order to drink a necessary cup of coffee. He would paint late into the night and again very early in the morning, before he had to face his day's work as a shoemaker. When death came in the wintry November of 1938, he was painting at five in the morning on his picture *After the Performance* (illus. 176). This, his last work, remained unfinished.

During the sixties in all parts of Italy new naive talents and painters striving toward naiveté have been discovered: Antonio Ligabue, Irene Invrea, Nell Ponzi, Pietro Ghizzardi, Bruno Rovesti, and others.

Bruno Rovesti's landscapes and street scenes are a synthesis of memory and observation. The material from experience is modified by a strong and poetic fantasy; the impressive red walls of the city hall under a blue-black sky with great dark birds at ornamental intervals have the look of embroidery. The excitement of a southern city lies over this square with its teetering monument, its blossoming boulevards, and its ecstatic people.

We will come to speak of the general folk tradition in the painting of Switzerland in connection with the art of the peasant naives. Here we must add to the portraits of Nikifor and Metelli some mention of the one most important naive artist of Switzerland, Adolf Dietrich.

Coming from a small-farm family, Dietrich took jobs as a day laborer, worked on road crews, and in factories. In spite of this heavy and exhausting work he preserved a sensitivity which allowed him to reproduce the narrow world in which he lived with such microscopic precision and childish delight that it mirrors the world as a whole.

Dietrich's biographer Karl Hoenn says that as a boy the artist "read in the book of nature, studied flowers and herbs, birds and caterpillars, and the whole treasure-house of mother earth like a biologist, but drew them to his heart like an artist. . . ." Gardens, fruit, stuffed birds, martens, mice, and men are formulated in his work with the plastic intensity of the Quattrocento and the immediacy of the primitives. Dietrich can only be classed under the somewhat outmoded rubric "primitives" if one is willing to include as well the pre-Renaissance artists Giotto, the Flemings, and the older Germans. He is an

Bruno Rovesti, Landscape With Sea.

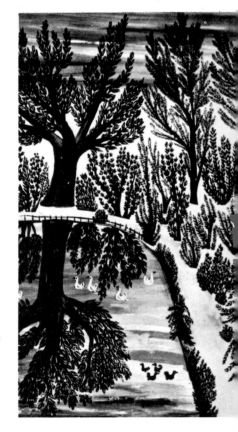

Adolf Dietrich, Two Rabbits, *1902.*

artist of untouched simplicity and at the same time a master of detail, a chiseler of forms. For him, the detail is an integral part of the whole. With staunch perseverance and a musing love of work he built up from his parts a perfect whole.

Dietrich worked with fine, thin brushes and a cautious application of color. "He does it almost unconsciously," writes Karl Hoenn, "like one whose hand and brush are led by an inner voice, just as an inner vision enables him to paint from sketches made long before, since in the eye of his imagination the experience of the past is still a part of the living present."

His flower still lifes, aquariums, animal pictures (illus. 73), self-portraits (illus. 186), and renderings of children (illus. 187) and young women have the precision in drawing of the old masters and the delicate feeling, the muted palette of the German Romanticists.

One can hardly point to stages of development in his work. Quite early he already had a sure sense for the delineation of surfaces and for living space. Still there are successes and failures both in his early work and in that of his last years. It is in the essence of the naive painter that his ability outdistances his creative criteria.

Adolf Dietrich was a naive painter who painted with faith and instinct. He had perfected his craft through years of patient dedication; a solemn awe at the magical self-sufficiency of things, a preference for small things, bound him in brotherhood to *le Douanier* Rousseau. His striving for harmony and beauty in sympathy with the music of nature made him a pantheist poet of life.

In an attempt to formulate a definition of lay painting, N. Michailov reminds us of the work of the schoolmaster Oluf Braren, born on the North Sea island Föhr in 1787, whose pictures he calls the most splendid achievement of early lay painting in Germany.

Braren was a precursor of naive painting in Germany, where one can also find lay painters of sensitivity and simple intuition in the provincial museums if not in the great collections. Only a few of Oluf Braren's pictures are known. His work shows elements of creative immediacy, depth, and sincerity.

Oluf Braren, the son of a blacksmith, became a teacher against his father's wishes and married against the wishes of his heart; he lived, however, with another woman who bore his children. In 1822 he lost his teaching appointment and lived from then on estranged from society and in poverty, dependent on the help of his brothers and on occasional work as an agent. He died at fifty-three of tuberculosis. Possibly the restrictions and bitterness of his life accentuated his ex-

pressive ability and concentrated his intensity on his painting.

He collected and studied plants, rocks, and shells, and so discovered the beauty and order of things. He drew leaves with a botanist's care. He painted portraits and a very few compositions with figures in which there is a stiff grace and a strength of color. It is as though he had transposed the inspiration taken from shells, plants, and ocean cliffs into his view of men. In his portraits and pictures of groupings, especially in the two versions of *Home Wedding* (illus. 222), there is a crystalline clarity and a coldly precise definition of nature; the painter draws his faces as though they were flowers or rocks. The frozen monumentality may only derive to a degree from the classicist influence of the time; it seems to be much more the sign of an inner relationship to Baldung Grien and Lucas Cranach.

In Germany, lay art has been a matter of quite eccentric, spirited, and whimsical talents. Perhaps the strangest of the naive painters in Germany after Braren is Adalbert Trillhaase, born in Erfurt in 1859. Trillhaase was a dreamer remote from reality, who tried in vain to lead a practical life after having been trained to be a merchant. Attempts to manage a linen factory and an ironworks were miserable failures. At sixty he began to paint, mostly historical pictures or illustrations from the Old Testament (illus. 202, 203). The primitive, fantastic fable world of his compositions, reminiscent of Bauchant, whom he, however, did not know, has nothing to do with the folk tradition of small-town artistic schoolmasters. His pictures are unconscious attempts to capture dreams on canvas and to interpret them in line and color. In spite of their epic retelling of well-known biblical motifs, these pictures have about them something that seems ghostly, disoriented, and strangely hallucinatory. Abraham stands with his bared knife above his first-born: the large, bearded, expectant face of the patriarch is raised in vision; the unconscious protest of his heart and the instinctive hesitation of his conscience coalesce into the angel commanding him to stay his hand.

Cain, who has just committed the horrendous murder of his brother, stands transfixed with raised hands and a tortured face, for he has set into motion for the first time the ceaseless seesaw of destruction and revenge.

Here is the Witch of Endor, who summons forth the spirit which foretells death for the proud King Saul. Abraham, Cain, and the old prophetess, though placed into group compositions, remain nonetheless completely isolated, and carry on a conversation on the side, above and beyond themselves, with God, with conscience, and with fate.

Jephthah's Daughter is dancing in front of the palace. The witnesses, in oriental white turbans, are arranged from top to bottom as in a strip of motion picture film. Jephthah wears the costume of a knight and carries a sword. His daughter carries a garland in her hands and moves and leaps in her dance. All of the faces have long noses, the eyes are almond-shaped, the hands tremble in ecstasy. A soft green and dark red dominate the picture; gray mountains lie in the background.

In *The Sermon from the Sea,* many of the faithful are arranged together with Christ as though for a group photograph. People sit on a bench at the front, behind them stand others of the audience partially overlapping each other. An old man limps toward them, leaning on his stick. Long idealized robes of the sort one is accustomed to see on biblical figures, but of a cut uniquely Trillhaase's. With a gently dissonant palette, Trillhaase tells the traditional, somewhat neglected story.

Awkward and unschooled, obscure and allegorical, these pictures are ultimately a strange blend of faith and superstition, aggressive illustrations for a demonology, as though created in a trance and dictated by a voice heard only by the artist.

In her intelligent and informative monograph on the painting of Adalbert Trillhaase, Juliane Roh writes: ". . . the pictures are not only a kind of self-analysis manifested in symbols. They are genuine works of art in that aggression is sublimated in forms which compose a solid pictorial structure, and dissolves into colors which produce a harmonious whole. . . ."

The pictures painted by Friedrich Schröder-Sonnenstern have a certain similarity to these of Trillhaase because of their hallucinatory character. But in the magic mirror of his vision there is nothing of childlike innocence. His eye is that of a voyeur. Free of all restraints, these pictures impress one as the erotic delusions of a feverish young boy (illus. 217, 218). Yet out of this blighted soul there speaks a naive imagination about sin, existence, and death. He forms a grotesque, fantastic world of forbidden dreams in his primitiveness, by instinct, and yet with a true gift. Schröder-Sonnenstern's career was responsibile for the distortion in the landscape of his soul. He was a letter carrier, spiritist, gardener, wandering preacher, smuggler, and street singer. He also spent time in prison and in asylums. It is quite clear that his artistic signature shows traces which scarcely belong to naive painting, but come from quite different borderline regions. And yet it is precisely this style which can shed valuable light on the whole complex of the problem of primitives in our century. The intensity of his expression, the language of

his instinct insure him of a particular and unchallenged place in its history.

The development of the well-known ophthalmologist Dr. Waldemar Rusche and his transformation into the painter Paps is not without symbolic significance. One day, when the inertia of a long career of hard work was halted, a wise and knowing providence placed a brush in his hand. Hesitant, astonished, and delighted, he began—like Louis Vivin and Morris Hirshfield before him—to brighten the twilight of advancing age through recollection of long years full of experience. He evoked landscapes and street scenes from remote places that he had visited in his youth in the operatic style he loved so much. Travel impressions from France, Bel-

Adalbert Trillhaase,
The Witch of Endor.

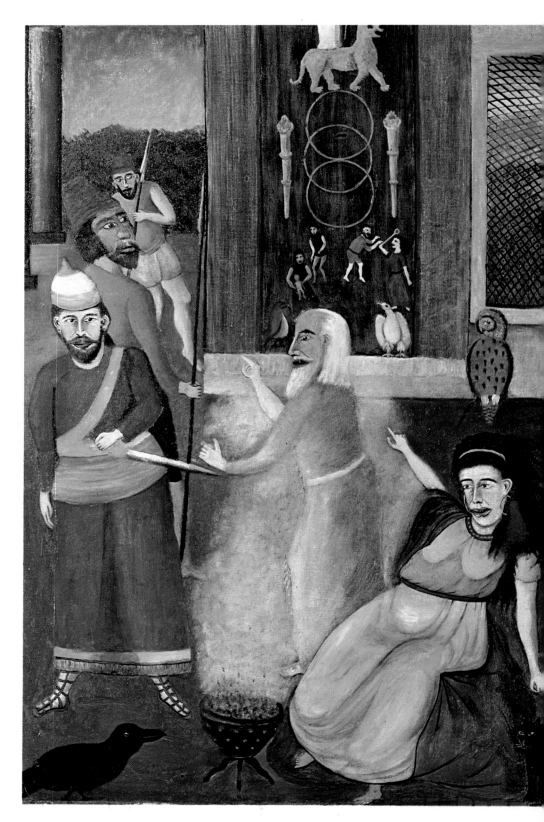

Joseph Wittlich, Vast Battlefield.

gium, Holland, America, Japan, Morocco, and Italy filled the spaces of his paintings in oil and tempera.

Bright colors and soft ones; he conjures up parks (illus. 166), shipyards, boats, circus performances, and local fairs. Here he sits at his easel, painting the carousel in a festive picture. Even his tiniest figures are expressive. In order to paint them, he puts on the magnifying glass with the help of which he had performed cataract operations for so many years. Delicate marionettes take on a life of their own on the canvas, placed into a silent flurry of existence by the brush of their creator, enlivened by a scenic assuredness and cheerful accuracy, and moved by narrative inventiveness.

Time is caught as a breath of life, as a tonal harmony, as the wafting scent of passing years (illus. 72).

Paps is an intellectual and at the same time a childlike man full of warmth and dignity. Something about him reminds us of Theodor Storm and the atmosphere of the North Sea, a delicate restraint and inner measure, qualities which encourage the beautiful preservation of all that is old.

It is as though he has understood the great art of giving a solid substance to old age, and can find new value and fulfillment in place of some simple activity producing nothing of real permanence. We can only conjecture whether there might be tragic aspects behind the brightness of the colors and the operatic scenes, whether there is behind his idyll a sense of helplessness that he is determined to overcome, just as he conquered through creative work the sorrow and sickness he repeatedly met in his career as a doctor, when often even the hand of the surest oculist could not salvage a patient's eyesight.

In this North German man there is, so to speak, something of the Mediterranean; we know of no composition constructed in a closed space; all are under the open sky, in front of houses in the light and air. Never is there the darkness of sorrow and blindness. It may be that living in the painter Paps is the knowledge that light is the greatest of man's treasures; light, color, and with them the joy we must never surrender.

With the farsighted wisdom of age, he takes the best from the chronicle of life. His memory fortunately has the necessary richness, for Paps cannot paint directly from life. He opens for us the naive and intimate flower-edged window of joy onto the miraculous landscape of existence.

Naive artists or artists close to the naives have appeared in many exhibits in Germany in the past few years; lively, humorous talents, at times with a bourgeois drollery, which confuse the childlike with the childish. At the same time, the workingman-painter

Joseph Wittlich, who has been encouraged by Thomas Grochowiak, seems to me a man of genuine and uncommon gifts. He creates mass scenes and single figures in paint or collage with powerful outlines and garish psychedelic colors. His themes—history, war, parades—are taken from illustrated books and magazines, and unmask the pompous, patriotic, and hypocritical ceremonies of life and society. Wittlich's themes, transposed into banality, resemble comic strips, and are the fascinating pop art expressions of a naive (illus. 194).

Karl Eduard Dazmierczak once worked as a metal worker in the August Thyssen shops. In spite of his scanty artistic abilities, he has a vital capacity for observation. His picture *Paradise* (1961) shows bathers in a summer landscape. Is he painting the biblical legend of Adam and Eve or a modern, everyday, summertime experience? The naked man has put the woman on his shoulders, and she is picking fruit for him from the tree. Squirrels peek through the leaves and fish surface from the water, while storks step up on long legs to watch. Both nudes, as seen from behind, are perfectly unerotic and even slightly grotesque.

Both the German and Austrian trade unions have undertaken the deliberate sponsorship of lay art. In Recklinghausen, the artist and director of the art gallery Thomas Grochowiak receives such support. In Vienna, the painter Robert Schmitt organizes shows of self-taught artists from various social strata, but particularly workers and apprentices.

The body mechanic Heinrich Schilling, who used to work for Krupp in Essen, paints pictures of the landscape of industry with primitive, basic colorful elements.

The switchman Johann Mis of the ERIN mining concern paints scenes from his daily work with a considerable feeling for the separate life of things.

The mechanic Franz Klekawka in Dortmund portrays a demonstration against the war in Viet Nam. Sharp colors and banners protesting atomic-age death. In the background are blocks of stores.

The furniture maker Hans Strygel from Baden bei Wien and the file cutter Franz Spielbichler from Lilienfeld in Lower Austria paint naively deformed portraits and appealing landscapes.

Among the informative presentations at the Hlebine Symposium in 1970 were the thoughts of the onetime miner Friedrich Gerlach, now retired. He spoke of the perceptions of the world one forms while working in the darkness of a mine shaft. A life in the mines is but a modern form of slavery. Through forty years of it there formed in the consciousness of this naive artist an endless

succession of unrealized images of longed-for light, as witness *Night Candles* (1963). Flowers that open in the dark. A wanderer, perhaps Gerlach himself, strolling along a river; a field of yellow flowers and a train trestle. The stroller with his walking stick, whom we see from behind, is facing the landscape with the flowers.

The Dream (1969) shows a large masked figure in whose coat the dreamer is entangled and a street of barracklike buildings which could also be prisons. The frightening figure blocks the street between the buildings. One must nonetheless pass. A small dog runs away in fright. The night space is illuminated with gray and green.

Daemon (1970) is a huge industrial complex being consumed by flames. Airplanes with bared teeth have been produced; rockets, gigantic cannons, terror, and menace.

Train Station (1970). The picture of a sleepwalking woman approaching the tracks; two men follow after her to hold her back. Intimations of fear in the darkness of the night. The train tracks are painted in precise perspective. A larger lamp illuminates this mood of nightmare. The pictures of dreams and terror transposed into visual images are severely rendered and sparing of color. A man who saw no light for a long time, and whose sense of color is atrophied. A brooding German with an introverted image of the world; a private preacher seeking comfort and delivering his message in his pictures.

Train Station, *Friedrich Gerlach, 1965.*

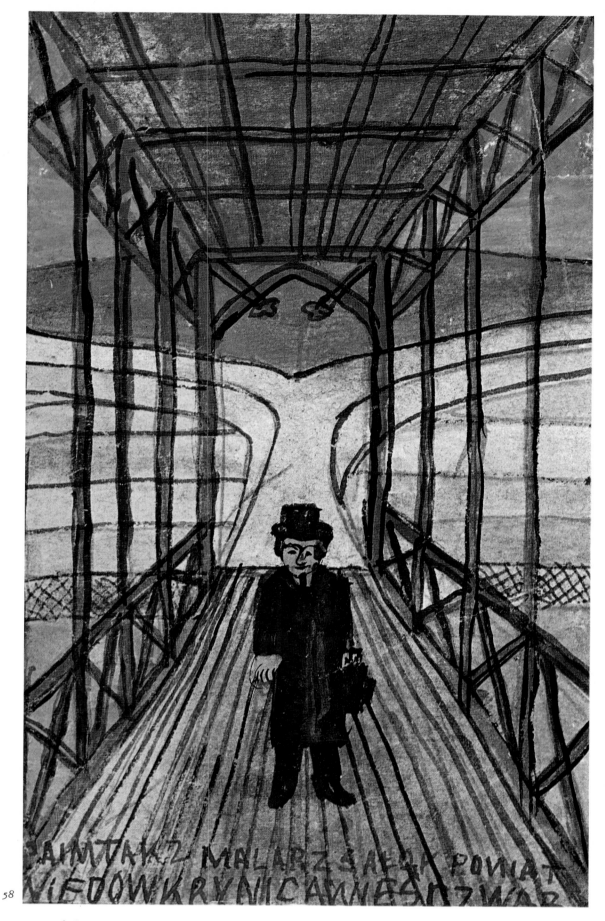

58. *Nikifor,* Nikifor on His Way, *1939*

A man is coming toward us, reaching the spot where two paths meet. In long curves they advance out of the background until they join into a single and dominating street. It leads across a wooden bridge covered with a sort of canopy, and it is on the bridge that we see Nikifor walking in his black clothes, with a black hat, and carrying a black bag in his hand as though he were a doctor.

One is accustomed to seeing roads diminishing in the distance, but here we are astonished to see them expand instead. The approaching figure is placed directly in front of the viewer, whom he stares at boldly. Nikifor is the sort of man who walks right up to people. He may demand money of them, but he gives them the priceless gift of art.

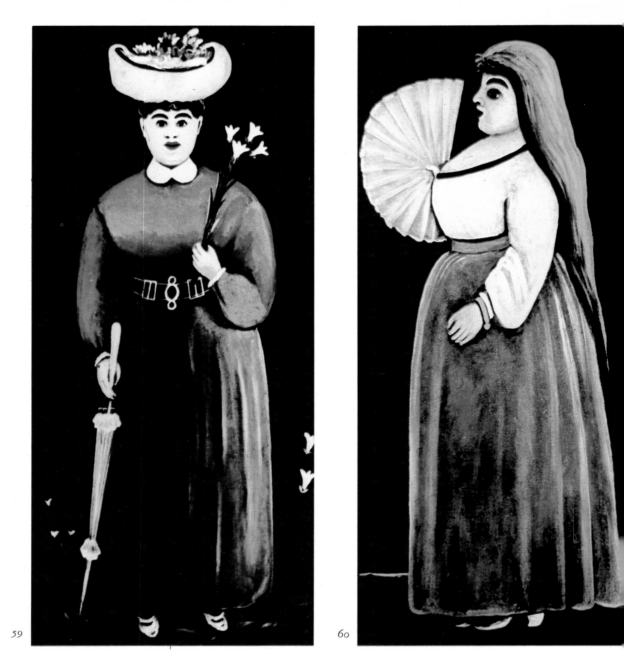

59

60

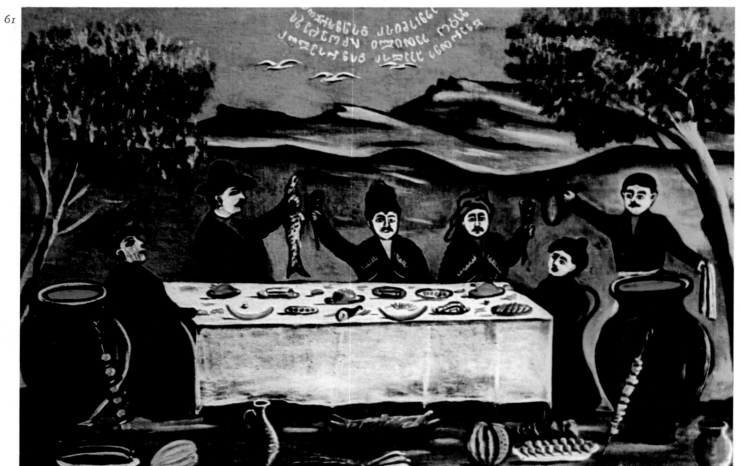

61

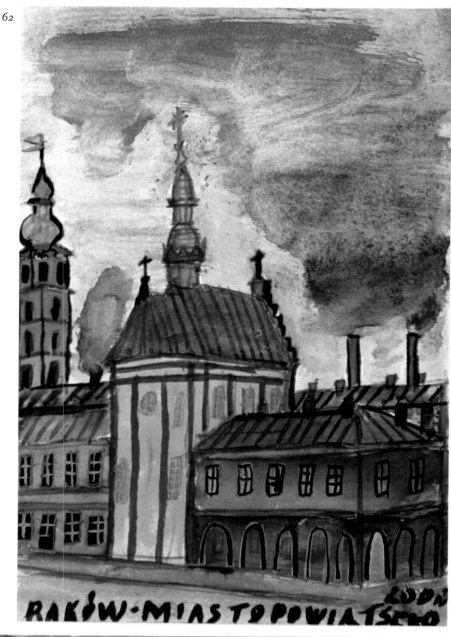

59. *Pirosmanashvili,* Lady in a Hat With a Lily

60. *Pirosmanashvili,* The Beauty From Ortachal
With a Fan

61. *Pirosmanashvili,* Bego Greeting His Guests

*In his frescoes, in tradesmen's signs, on cardboard, on
tin, and even on black oilcloth, Pirosmanashvili has
blended the legends and the past of Georgia. In addition
to the celebrated and celebrating princes and boyars
which he painted, he created an all-inclusive portrait
gallery of his time, including night-club owners, and
innkeepers, acrobats, street sweepers, actresses, and the
beautiful women of Ortachal for whose favor one might
have to fight with a knife. All these likenesses have that
concentrated factuality which we designate as the
"Great Reality" of the naives.*

62. *Nikifor,* View of a City With a Church

63. *Suma Maruki,* The Cattle Dealer Comes to the
Village, *1945*

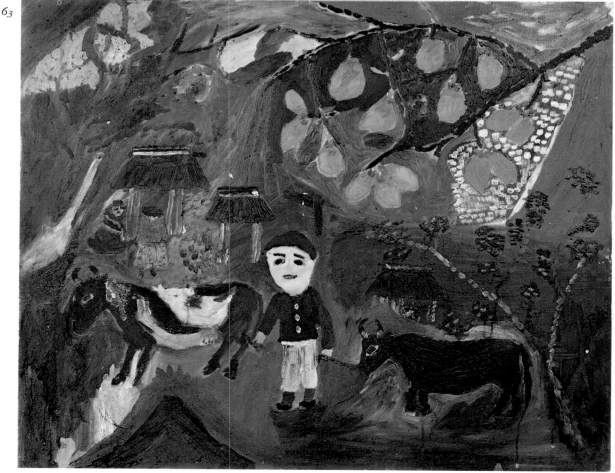

64. *Suma Maruki,* The Bright Hair-Clasp, *1955*

65. *Suma Maruki,* The Dog Named Ron, *1945*

Like Grandma Moses, Suma Maruki began a new and creative life in her old age. When asked, she would admit that it was the better half of her existence. Suma Maruki simply became a painter, without having learned to draw or paint, and even without a table on which she might have placed her canvases. She painted some fifty pictures, and she achieved honor and fame.

66. *Kiyoshi Yamashita,*
Toshogu Shrine in Ueno, *1939*

*Kiyoshi Yamashita was
seventeen when he completed
this collage. The gleaming red
shrine stands at the end of
a path in the center of the
background. The paving stones
have become a priceless carpet
of decorative patterns. A
slender, dark red pagoda and
ocher-colored trees lead the
pilgrims whose heads are just
visible above the lower edge of
the picture. A procession is
just leaving the sacred precinct
and coming toward them.*

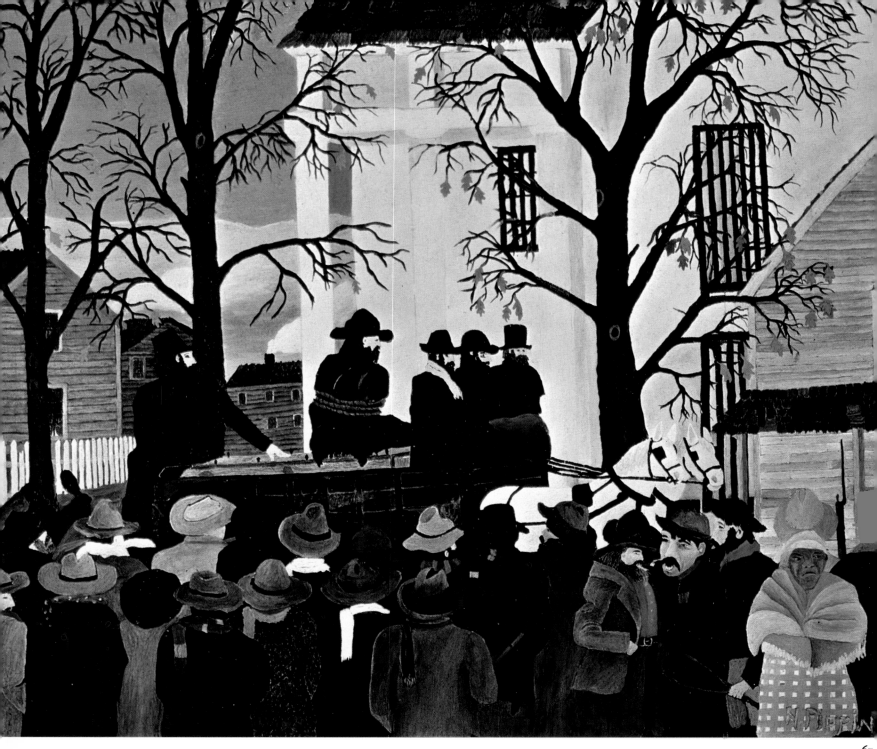

67. Horace Pippin, John Brown Going to His Hanging, *1942*

Among the most important pictures Horace Pippin created is the John Brown trilogy, dedicated to the history of the suffering and the revolts of the blacks in the United States.

Like Lincoln, John Brown was an enemy of slavery, but his struggle was premature. In October 1859, with eighteen of his people, the preacher, surveyor, farmer, and abolitionist stormed the arsenal of Harpers Ferry in Virginia. This was supposed to be the signal for a general rebellion of the slaves, but it proved to be only a tragic prologue.

The first picture shows John Brown standing before his twelve jurors, so wounded and abused that he has had to be carried into the courtroom on a stretcher. It is the figure of a savior close to the end of his days. The second shows him in a cell, awaiting his execution. He is holding a Bible in his hands, and his eyes are piercing and full of fire. It is a gloomy picture in which the red glow of a candle points up the bars even in the pattern of the curtain. Unconsciously, Pippin composed the history of this martyrdom in dark and heavy colors. Anecdotal and pathetic elements have a profound import thanks to the honesty and faithfulness of his manner.

The third painting in the series, the trip to the gallows, is the most successful, and this picture has the simple air of a ballad about it, like the lines sung by the Negroes on their long marches:

> *John Brown's body lies a'moldering in the grave,*
> *But his soul is marching on . . .*

This last scene is set in the sad and dismal street of a town. The group of men stand in cruel relief against the chalk-white of the buildings in the background. As in early Christian painting, each person is identified by a single telling attribute, and John Brown is here furnished with a length of rope. His friends accompany the wagon in silence. It is a cold December, and they are all wrapped in cloaks and shawls. Three figures huddled on the right side of the picture are looking away from the procession, preferring not to be witnesses or even to think about it. An obvious simplicity and intensity reveal this painting to be genuine naive art. The tragic movement, the simple picturesqueness, and the drama and rhythm of this saga of hopelessness have musical parallels in the spirituals of the American Negroes.

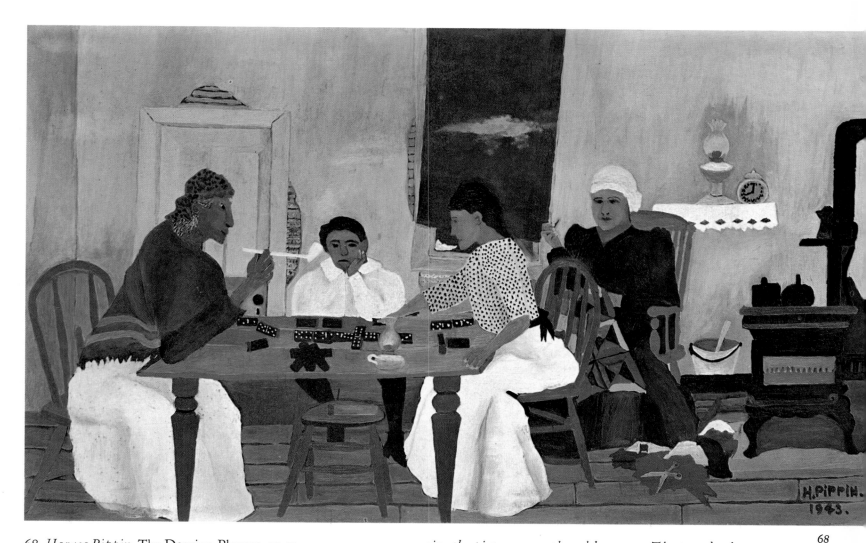

68. *Horace Pippin,* The Domino-Players, *1943*

Although Horace Pippin only intended to reproduce reality by painting the atmosphere of a given scene, he penetrated— perhaps without realizing it himself—beneath the level of the externally visible, and arrived deep in the realm of the psyche.

Two women are here sitting at a long wooden table, the older one with a red head scarf and black shawl, the younger— perhaps her neighbor—in a polka-dot blouse, both in long white skirts. A boy is sitting between them, watching the game with his elbows on the table. The black dominoes in a row across the table comprise a line of tension between the two players in their studied concentration. Behind the table, a woman in black is embroidering a bright coverlet. Little accents of red

give the picture warmth and harmony. The pastel colors— dusty brown, smoky blue, muted olive green, whitish gray—are well tempered and pleasant.

The conventional interior is transformed into something special by the breathing proximity of its inhabitants and their simple naturalness. One can feel the warmth of past and present life in the room. Its quite humble objects—a stool, an alarm clock, a coal scuttle—become symbols of a permeating poverty as well as of a melancholy atmosphere of brotherhood. Plaster is flaking off the walls. The posture of the seated figures in the warm light of this idle hour is expressive of the natural dignity of the blacks.

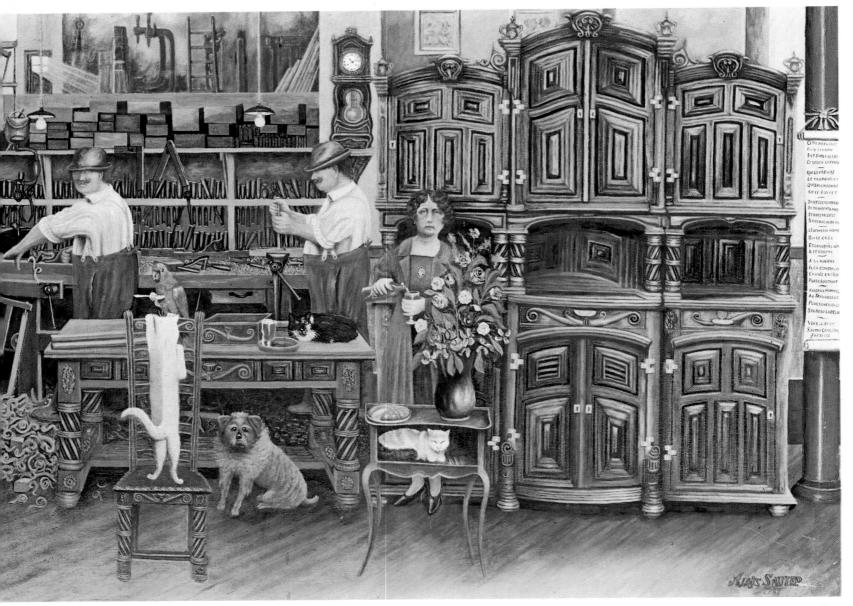

69. *Aloys Sauter,* The Furniture Maker's Workshop, *1931*

Just as Henri Rousseau revealed a strongly bourgeois conscience in many of his works, it is also possible to recognize in Sauter a devotion to bourgeois craftsmanship and industry. In this well-known picture of the workshop that belonged to the Sauter brothers, the dining-room buffet clearly dominates. The cabinetmaker who proudly admits to being the creator of such monumental pieces of furniture is portrayed in separate postures as though in two separate frames of a film strip, once with a plane, and once with a chisel. The painter's wife, Mme. Sauter Castellier, is pouring red wine from a decanter into the glass in her hand. One wonders whether she might not be reciting here as well the hymn to world peace that she had written, and which her husband had already portrayed. She is wearing a stunning green dress, though a large bouquet of flowers in a blue vase partly obscures her quite presentable figure. The pets of the household, her dog and cat and parrot, feel perfectly comfortable in these surroundings; their presence is naturally required to complete this portrait of an industrious existence.

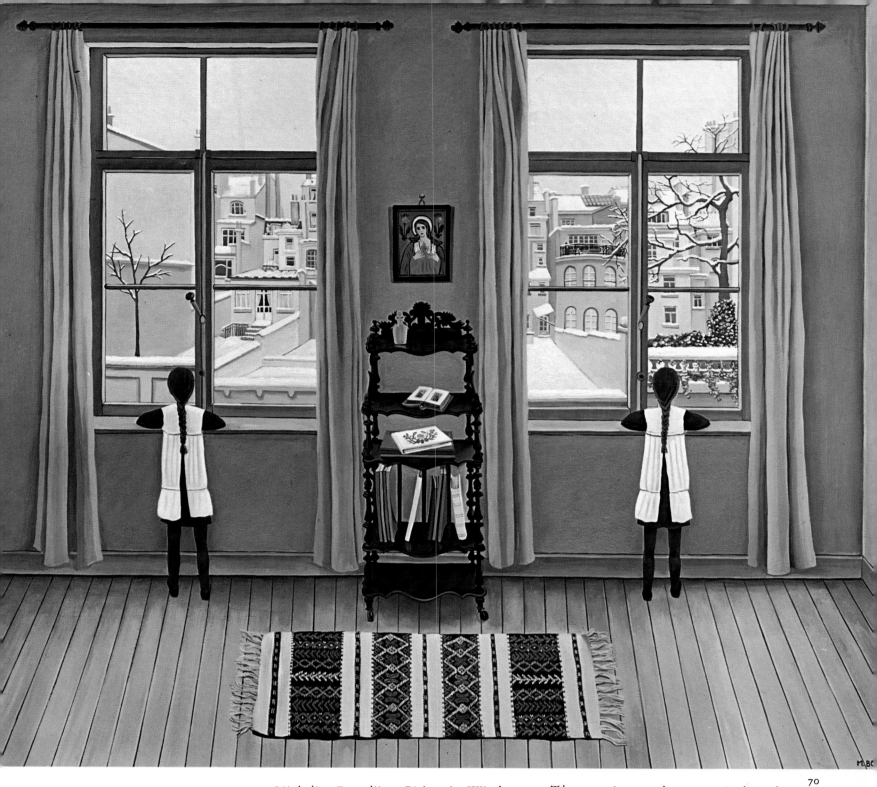

70. *Micheline Boyadjian, Girl at the Window*

*We see a little girl with a long braid twice
in the same comfortable room, each time
gazing out a large window at the
snow-covered city, down into the street where
such a well-bred child is apparently not
allowed to play. Each window opens upon
a different section of the street. Quite well-
behaved and proper, with a polka-dot smock
over her blue school dress, she is literally
doubly striking. Is she an only child who
has chosen herself as a playmate on this
lonely afternoon?*

*The room is severely symmetrical. In the
middle stands an old-fashioned stand from
her grandmother's time, carved and black,
dividing the room into two spaces, one for
each person. The books on it do not tempt
her from the window. On the top shelf is a
small pink crystal bottle. A gay runner is
lying on the floor; soft colors in a carefully
muted pinkish gray. Is it simplicity or
refined naiveté which thus underlines the
lovely tragic grotesqueness of life with the
melancholy and quiet irony of a Françoise
Sagan?*

*Solemn and motionless, a white and brown cat leers at us through narrow eyes.
Though comfortably settled, she still seems ready to leap out of her comfortable
nest at any moment. She considers us challengingly and with a certain mistrust.
The picture is ordered and symmetrical, and so precise that on the cloth
below the box one can even see the outline stitches worked into the pattern.*

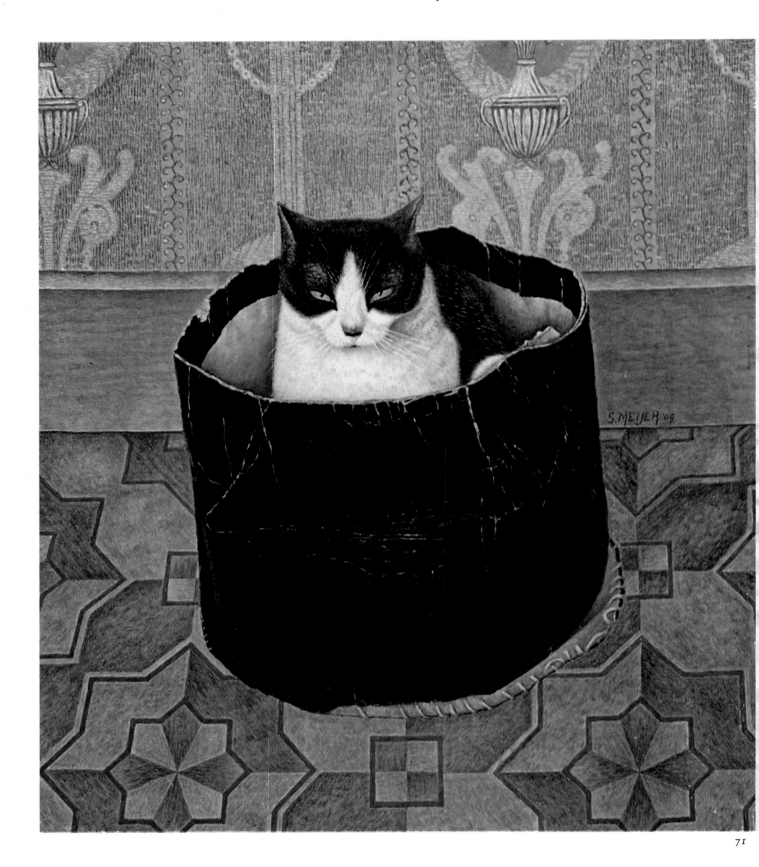

71

*The parquet floor has a geometric pattern, and the wallpaper looks like the
old and lovely stamped leather wall coverings in Dutch palaces.*

*Sal Meijer painted animals with delicate feeling, presenting us with Dutch
interiors done with the modest art of a craftsman. In their warmth and
faithfulness, his pictures are charmingly sincere.*

72. *Maler Paps,* Birthday Flowers, *1961*

*Late in his life, when he began to work with a palette and
brushes instead of a scalpel, the painter Paps discovered that
light and color could be a source of great pleasure. The flowers
he painted are rooted in the blessed earth of fantasy. A bouquet
of dewy-fresh pastel colors, faded rose, lilac, wheat yellow, and
gleaming white; a vibrating chord of Pompeian red,
Bordeaux red, and the scarlet of poppies. This is an ornament
rich with heavy scent, framed by the dark green of the leaves.*

73

73. *Adolf Dietrich, Beagle, 1939*

Dietrich was a friend to animals. He painted the flight of birds, knew how a rabbit lies, and how weasels, foxes, and mice can run. With a penetrating vision and attentive spirit he formed likenesses of animals as carefully as he did portraits of people.

This dog sits diagonally in the picture, his front legs supporting him while the back legs rest casually on the pastel

yellow carpet of grass. His soft and glistening white and rust-colored coat is given life by the addition of careful blue shading.

Dietrich does not try to express the animal soul symbolically, as would Franz Marc, but rather by means of a humble empathy and understanding of the fate of animals in the whole of living nature, as did the master painters in Dürer's time.

The Peasant Naives

Chapter VIII

Ivan Generalić, Woman With Candle.

Ivan Generalić, the School of Hlebine, and Others

In this age of artificial suns and plastic hearts, in our yearning for a warm and true spark of life, we are here migrating toward a land of direct images untouched by history, the appealing art of the naives. Such a region is the already legendary village Hlebine.

Ivan Generalić is the central figure of the Hlebine school, which came into being after the sixteen-year-old peasant Generalić first met the Zagreb painter Krsto Hegedušić. In 1929, the latter had founded, together with a number of Croatian painters, the group of artists called *"Zemlja"* (Earth). A social and artistic program bound them together. They wanted to bring art closer to the people in a time when it was growing more and more difficult to understand in its irrationality and decomposition. Hegedušić did not only meet talent in the village of Hlebine, but also those vital social impulses which come of bondage to the earth. The peasants Generalić and Mraz formed the nucleus of a group of painters which was joined by Mirko Virius and later by the younger Dolenec, Gaži, Filipović and Večenaj. A contemplative community of peasants developed which believed that not only the real fruits of life but also those created out of the dream of art should be the stuff of our daily bread. Hlebine—the painting village—became a Mecca for pilgrims to naiveté and with faith in art.

It is usually sufficient to immerse oneself in an artist's work if one wants to understand it. But the life and work of the peasant naives form an indivisible unity. Their domain is life. What they paint is a sequence of pictures of their activities, their work and their festivals, their baptisms, weddings and funerals, the calendar of their revolts, and their surrender to all that is earthly. Their language is full of crudeness, lurking peasant craftiness, and unsuspected poetry.

From the time that Ivan Generalić was able to walk along behind the pigs in his charge, he carried a pencil and paper in his pocket in order to note down quickly what he felt or saw or thought. His early pages have something of the unexpected rhythm and severity of children's drawing. Sharp lines ignore logic. Things he has seen become confused with things of his imagination. The swineherd and the dog, the gloomy woods, men, and animals stand side by side as equally simple aspects of creation.

Most of the pictures by Generalić are done on the back of glass. This technique, in which—even after many years of practice—there is always an element of the unexpected and accidental, the artist has mastered to perfection. Color becomes for him a reflection of the heart; the dark green shimmer of the carpeted fields, the matt yellow branching of strange trees, the soft off-white of shepherds' cloaks, and the sensitive differentiation of tonal qualities, from gold brown to brick red. A mood of autumn and a rich feeling for space and proportion; naked trees resemble coral. In spite of the precise representation of reality the well-known landscape is given a poetic atmosphere as though thrown into a new and unfamiliar light.

Harvest pictures of abundance and affirmation of life; grape picking, hay mowing, grain harvest. The strong rhythms of work, the swinging of the scythe and the well-earned rest after heavy work in the hot sun. In front of the damask curtain of the uncut wheat a man and his wife sit down to rest at midday. The farmer will take a drink of cool water from the gourd she is holding. Bread, apples, and a crock with some sort of stew; peace in the attitude of the people and in nature. How can we fail to recall when looking at this noonday rest the great Flemish master Pieter Brueghel? Even though Generalić may never have seen Brueghel's illustrations of peasant proverbs or his harvest scenes, he was influenced indirectly by him through the pictures of Krsto Hegedušić's Brueghel Period. His hardy closeness to nature, his brand of narrative with its sharp definition of detail, and his positive delight in color strengthen the similarity.

Cattle markets, church festivals, weddings —compositions full of heavy drinking and practical love-play. Though care seldom ceases just at harvest time, celebration most certainly begins. The dance on the village green; men and women not in a round *kolo* but in pairs, a bit heavy and a bit gross. The harvest bride is being chosen. Musicians with a bass fiddle and cymbals, the young men as yet undecided, and the expectant girls. The dancers leap and hop and court each other as centuries-old tradition prescribes. With the startling precision of shameless staring, he analyzes these farmers at the mercy of rhythm, as though caught forever by a flash camera in the motion of their dance, frozen in the strained gestures of abandon.

The fruits of the field and garden are also gathered into concrete still lifes with child-like directness and plastic rigor. It is as though the peasant painter had taken into account his personal experience of the natural processes of budding and growth, of invisible procedures, in his pictures.

Generalić's themes include not only the blessings of the earth, but also threats from the natural elements, as in his representation of floods, blizzards, and fires.

A number of times fire is presented as the symbol of village catastrophes. Night lies around the place like a cloak of black velvet. The salmon-red eyes of the fire flare threateningly out of the windows of the house; people pass along buckets of water; men on ladders, women screaming or dumb with fright. Terrible misfortune and confusion. A story told with robust strength and poetic composure.

But man as set into the landscape is the basic theme in this powerful and distinct treatment of the story of work, of fear, and of country pleasures. The compositions

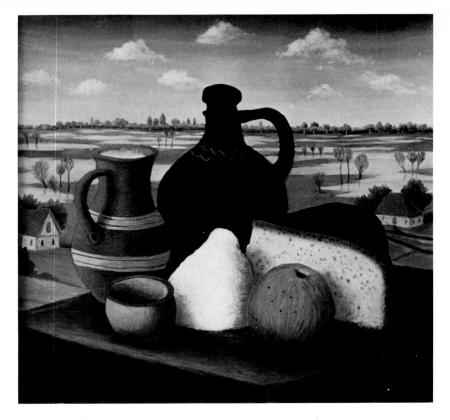

Ivan Generalić, Still Life With Landscape, *1953.*

which include many figures are held together by the rhythm of community; something of tradition and archaic collectivity continues to echo in them.

In the peasant painter Generalić, the anonymous forces of folk art, which have dissolved in our modern civilization, have come to life again in a single individual. He is interested in the community, to be sure, but also in himself. He paints the faces of fields as well as men. He has created a series of compelling compositions which present man in the tragic as well as the comic situations of life.

Under a low-lying sky goes a procession of people in their simple faith. On the peasant faces lies a ray of sadness and disorientation. Naively realistic and at the same time allegorical figures of existence. *Fasching Parade:* five men dance through the village, bedeviled sorcerers. The masks, the solemn and horrifying foolishness of their gestures have more than a touch of the primitive to them. Peasant phantoms, kobolds of the people unexpectedly appear and walk about. Beneath the marvelous hats and masks one can recognize mockery, alienation, and things impossible to explain.

In many of Generalić's pictures appears the strangely monstrous and at the same time lyrical figure of the rooster (illus. 74). Something powerful and awesome accompanies the entrance of this fabulous animal into the everyday country life. Is he an emblem of struggle, of the intensity of life, or of Eros, the artist's unconscious sign for the shrill dissonances of existence?

One can watch a fight between two cocks happening on the roofs of the houses. Through windows and doors one can see

Ivan Generalić,
Seated Peasant Woman.

Ivan Generalić, Rustic
Conversation, *1959. Detail.*

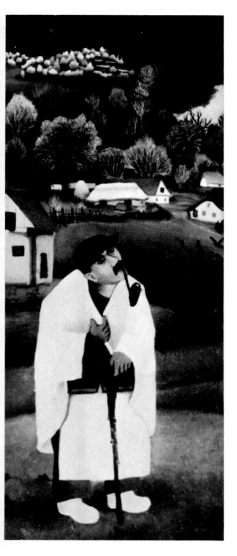

women; the cows are in their stall. The farmer comes with a long switch to separate the raging giant roosters that are eager to tear each other to shreds. Are they his cocks attacking each other up there like heraldic beasts?

In another instance the monumental rooster stands crowing on the peak of the roof. Does he have something to proclaim? Someone has set fire to the shed, while the farmers go about their tasks of making butter or whatever in the yard. An evil autumn.

Stranger still is the *Country Conversation.* A man who is well wrapped up against the cold stands under a dark tree and looks about with uncertainty, listening with his head held to the side, as though the outsized cock in the tree might be crowing something at him. An astonishing, fairy-tale event.

From this cycle we should also mention the rooster with the gleaming plumage who stands guard next to the dead Mirko Virius. *The Death of My Friend Virius* (illus. 79), who was his friend and was murdered in the war, affects us deeply. He lies there like a martyr, wrapped in a dark robe on his native earth. His large hands are folded, his equally naked feet peep out from the cuffs of his trousers, and a kind white cloth covers the eyes and brow of the dead man. He seems to have come home from far away, and now here he lies with candles placed around him. His friends come out of his house deeply shaken and full of sorrow. Hesitantly they advance out of the depth of the picture. Next to the body stands the rooster with his glowing feathers and his griffinlike claws. Is he looking for grains lying just here, or is he pronouncing his inner animal and village word on this lamentable occasion when the peasant painter Virius, who so loved justice, had to die?

A spiritual tension turns the experience of the picture into a folk tale. The simplified lines of the drawing are based on close observation. Generalić's colors are suited to the somber motif. A mild, sparing green encircles the dead Virius; the bitter darkness of the robe and the harsh white of the cloth on his pale face are given with a sensitivity for their values. The distracting vividness of the rooster in his radiant shades of cinnabar, earth brown and bluish green, and the gently receding distant rhythms of the hills conspire to insure a compositional unity.

Anyone who has visited the farmer and painter Generalić in Hlebine must understand that the village is not for him mere bucolic decor. After many years I find him calmly and patiently bent over the pane of glass which will become his picture. He can no longer choose uncritically from the fullness of his experience. Something new has taken its place alongside the unconscious ele-

ment of his work. With the peasant's dogged endurance he weighs the capacity of a given reality to bring together naive observation and intuitive knowledge. A critical rigor tightens his mouth; he has tasted of the apple of understanding. He puts questions to himself which are hardly any longer the questions of a naive, but rather belong to the dramatic monologue of any creative artist.

An attempt to return to the unique style of his earlier years, a conscious archaism, cannot fully satisfy him. In the past, only technical divergences existed between imagination and reality. These have been surmounted. The perfection of a craft lightens the work of creation and makes it more difficult at the same time.

The naked coral-like trees had taken shape out of an unconscious groping for expression; he had progressed out of the somnambulant security of naiveté into the dream landscape of his own.fantasy. Now he multiplies the coral trees and combines them into a mysteriously rhythmic landscape. The *Deer Courting* (illus. 75) in the ghostly land of his most florid period is reproduced to form an ornamental row of white deer. The principle of repetition explodes the definition of reality and gives the composition a slightly miraculous quality. In the picture *The Woodcutters* (illus. 3) this new-found method of ornamental repetition of the theme is further developed.

On this borderline between primitiveness and experience, Generalić suffered an inner crisis. He managed to overcome it with an artist's gift and to transmute it into creativity. However we might classify his painting, a legendary strength lies in the descriptions from his brush. While creating he becomes at one with man and nature in his village—and thereby in the world (illus. 183).

Mirko Virius preferred painting on canvas over Generalić's method of working on glass. He loved his materials; he sensed the fullness of life and wanted to capture it with penetrating verisimilitude. He identified himself closely with the things he painted. This sense of participation as well as his clear social commitment lent a dramatic, realistic force to his style (illus. 193). He was a gifted draftsman, and his drawings have a greater social consciousness than do those of Generalić. The clear, unshadowed tracing of his pencil formulated the events and conditions of the farmer's existence: a vagabond begs from the farmer's wife; three homeless men sit by the side of the road while the farmers head toward their fields with their equipment; a common man in court will finally talk straight to the judge. The latter may be Virius himself speaking the truth.

The colors in Virius' pictures are generally muted. He portrays processions, harvest

workers (illus. 78), farm people plowing, mowing, binding sheaves. The faces are stiff, strong, and furrowed, the hands powerful and efficient.

In Virius we discover the painfully inescapable farmer's reality. A candid style has here presented with passionate substance the fate of the Slavic farmer as he sees himself.

Often a heavy moodiness hangs in his sky. A threatening tone of reflection and revolt causes us to sense his tension; protest against social injustice and against his lost years as a war prisoner, perhaps even a presentiment of the limit to the time remaining for him. Virius was killed in 1943 in the concentration camp in Zemun.

Younger painters were to grow up in this village touched by art, or to come from the villages nearby to learn from the master Generalić. Franjo Filipović paints his descriptions of the repertory of the everyday life of the peasants with a cheerful folklorist palette; simple, spontaneous, in flat planes of color as though cut from shiny paper and pasted on.

Dragan Gaži produces colorful planes of landscape and portraits of old men and women (illus. 192), using the technique of painting on the back of glass. His village festival, however, is a pure peasant's composition. Under the low ceiling of the inn are couples dancing and heavy drinkers with their wine and pitchers; the men in their powerful bodies and the bride in a white veil.

It is pleasant to recall the awkward, pleasing pictures of the young Ivan Večenaj. Blue-white snow; a ponderous sky above cadmium-yellow farmhouses. The multicolored aprons, scarves, and horse blankets give the stark scene the cheerful vitality of peasant embroidery. Man, horse, and calf display the identical startled look of innocent stupidity.

After many years I have revisited the village Hlebine to see the painters living there and in nearby Gola. They have become famous in the meantime, and several have acquired a certain wealth. Art lovers and dealers travel from distant places to visit these villages of the Podravina.

The walls in Večenaj's house are hung with prints instead of paintings. Apologetically he explains: "The art dealers have taken everything!"

His pictures of the last few years which I have seen exhibited still bear the stamp of the Hlebine school. The main elements are still derived from the composition and the palette of the master, Ivan Generalić. Nonetheless, Ivan Večanaj has grown beyond the school; infused with a spirit of natural mythology, his presentation of people eating, drinking, and dancing with an uncontrollable intensity of life is well organized in its

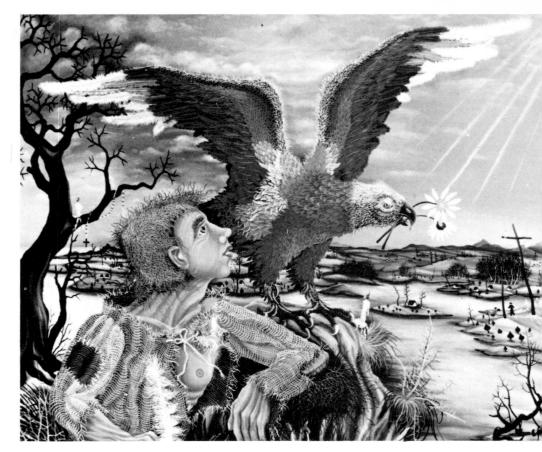

proportions and rhythms, and done in cruel, burning colors. The virtuosity of the drawing and the hallucinatory brilliance of the colors tend toward a neosurrealism (illus. 76).

Večenaj's skillful painting lies between the late Dali and the early Generalić. Has it already forsaken the realm of naiveté?

The farmer Martin Mehkek from Novacki near Gola painted the men who make wooden troughs and tubs, figures which themselves possess the wooden numbness of the carved objects. His newer pictures are more skillful, possibly more gentle, but with no decline in intensity and inventiveness. Like many of the naives he paints too fast, and has geared himself, perhaps without noticing it himself, to the demands of the market. Still his pictures continue to display the childlike directness of his character.

The years have also changed Mijo Kovačić. Earlier he used to paint the green landscape of the village as a pleasant idyll, a man of the country under a tree, ocher-colored sheaves, a cow on the part of a field that has been harvested, and next to it the ripe standing grain in its full glory; a time of ripeness and prosperity. Now the draftsmanship in his populous compositions has grown more secure, and he presents a backward peasant world in which the old ghosts and darknesses dwell. The image of nature becomes a mythical parable (illus. 77). A mastery of detail and plasticity of the objects are also obvious in his still lifes of the produce of the land. Here and there it is the world of Ivan Generalić in one of its inspired variations.

Ivan Večenaj, John the Apostle, *1969.*

Mirko Virius, The Day-Laborer.

Mijo Kovačić,
Peasant Woman With Geese.

The professional skill we can witness in certain painters of the school of Hlebine has led them a bit beyond naiveté, and encouraged them to borrow forms from the art galleries; their original tension and vitality have been left behind. The mannerist compositions of Mijo Kovačić in their Gothic clarity of outline and Baroque fullness, the works of Ivan Večenaj with their refinement of composition and their demonic energy— these works inspired by the ecstasies and lamentations of faith bear the symbolic force of another time and another place into the territory of the naives. The ragged figures remind one of *The Beggar's Opera,* of the fantasy-filled drawings of Callot and the minutest paintings of Dali.

One of the younger artists of the school of Hlebine is Josip Generalić, the son of the master Ivan. In the times of highly developed artistic skills it was common for talent and artistic sensibility to be handed down from father to son, and for whole families to be in command of the inherited knowledge. The Generalić family has just such a gift; father and son, the father's brother and his son all show characteristics of the school of Hlebine. Thanks to his quick comprehension, Josip Generalić was early able to absorb the forms and the range of color in his father's painting and begin to vary them. One had to study their pictures carefully to perceive the essential differences behind their superficial similarity. Josip also paints the peasant milieu and the landscape of the Podravina. But he does so now from the point of view of the city dweller. His pictures are not the reflection of the actual sphere of the life and fate of the peasants. They are, rather, decorative reminiscences and rustic idylls (illus. 220).

From time to time I am able to observe the secret drama of gifted naive artists, to feel empathy with their unconscious awakening of consciousness. They are aware that with the perfection of their skill and their easy virtuosity something of their intensity slips away. I can observe how they strive to re-

discover the awkward but inventive early forms of their artistic development.

True talent and naiveté are not easily lost and they do not necessarily disappear forever. For that reason it is important to pierce through the façade of the successful artist and, by pointing out the pitfalls to him, to ease his return to his homeland and his roots.

The school of Oparić, as it is sometimes called, is a small circle of Serbian peasants close to the naive artist Janko Brašić. Their mutual contacts are less close. These farmers are by nature individualists; each ultimately works and paints for himself. Rural, self-taught painters, they have injected a trace of the archaic ring of their racial epic into their painting.

Oparić: a Šumadijan cluster of fields, several houses, a courtyard, and the studio. A garden full of flowers. Inside works "Uncle" Janko, as the painter is called, slender, with a mobile old face and bright, gentle eyes. The large peasant family still lives on his farm; those of the younger generation already in high school are eager to leave the village.

Janko Brašić's picture *Battle Between the Turks and the Serbs* covers a whole wall. This realistic, detailed composition shows an inner desire for monumentality; across its broad surface one witnesses stabbings, throttlings, blood and hate, mutual killing with knives, sabers, pitchforks and bare hands— brutality in color and in form. He is the only naive painter of Serbia who favors such a large format. Human faces look out from his pictures into the world with expressive eyes (illus. 190); landscapes, animals, and movements are formed with sensitive feeling. Pasty colors show an understanding for the life of things. His farmer's eye captures men scuffling in a tavern (illus. 84), soldiers frozen while on watch, people at the village well, and the portrait of a city park.

The works of his pupil, the farmer Miroslav Marinković, look like wall hangings done in cross-stitch. Their decorative modulations of colored surfaces are contained within simple, strong outlines. Woods, clouds, human faces and herds of sheep are elements of equal weight, woven together into a tapestry.

The peasant painter Milosav Jovanović succeeds, in the artlessness of his temper, in making lively arrangements with à total disregard for perspective. In his most recent works he constructs his pictures like mosaics out of minute dots of pigment which range through only a narrow scale of harmonizing colors. Paintings like tapestries, in which the shimmering texture of lines and points compose a story rich with ornamental flora and fauna.

With childlike urgency, Dušan Jevtović

Franjo Mraz, Team of Horses in the Village, *1944.*

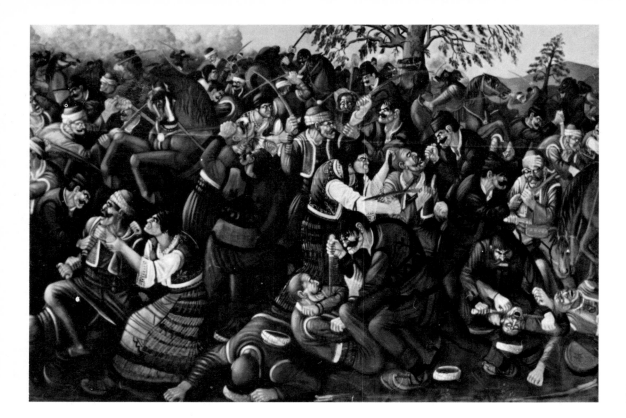

Janko Brašić, Battle Between Serbs and Turks, *1955–56.*

portrays a world somewhere between fairy tale and dream. Incidents which are not completely explicable are placed in sequential pictures; they belong to the milieu of popular fable, and yet they have been touched by a surreal sense of time. The ambiguity of the tale, which takes place in a natural setting, takes its particular charm from the minutely realistic depiction of the unreal.

Milan Rašić oversteps the bounds of peasant naturalism with his self-willed and private imagery, although his themes are generally limited to the landscape and the life of a village. His lively, epic representation has a picaresque abundance which relates the life of the village in separate sequences, like a film. Life is presented with the precision of a miniaturist on the nonperspective plane of his green and ocher-colored canvas, where foreground and background are identical. He lives at the edge of a provincial town, but he describes the village as a life's dream: spring and summer—less often winter—in the village; work in the vineyard and in the fields, plowing, harvesting; the return of the farming family in the evening; the abundance of earth and nature (illus. 89, 91). The main event he paints and describes—the funeral, wedding, or church festival—takes place as though experienced personally, scene after scene as in a film strip. A road and path lead past many details into a natural, yet decorative village landscape bright with flowers, contained within low walls and little bridges which span the Morava; all is brought together into a tapestry portrait of the sense of home.

Like groupings of colored pins, dove-gray bunches of flowers, velvet-green bushes, and soft pink trees are placed in a midday summertime landscape of geometrical fields, glowing, in turn, with tiny spots of rich ocher.

In the hope-filled landscape of Milan Rašić even a cemetery can become a cheerful stop on one's return home. In his contemplative, philosophical manner, the painter tells me: "There is no sorrow in the village. Even death is an occasion for drinking, visiting, and celebrating. The sorrow in my pictures comes only from the recognition that words and paints are inadequate means of expressing beauty and happiness. . . ."

Hlebine is not the only painting village in Yugoslavia. Not far from Belgrade, in the village Kovačica in the Banat, a group of Slovak peasants and country-dwellers gathered who translated their lives, their troubles and dreams into color and form. They built themselves a gallery, where their charming pictures hang on the walls.

While high art increasingly tended to lose its national characteristics from the middle of the nineteenth century on, until all traces of them were gone in the climate of modern art after the beginning of the twentieth century, naive art, especially that of the peasant, folklorist sphere, has preserved them undiminished. So it has happened that the naive painters of Slovak and Rumanian origin living in minority communities in Yugoslavia retain, precisely because of their isolation, their customs, language, and traditional forms longer and with greater purity than do the peasants of their homeland or those of the country in which they live.

The art forms of the peasants of Kovačica are rooted in tradition; the range of their

Milosav Jovanović, The Shepherdess, *1967. Detail.*

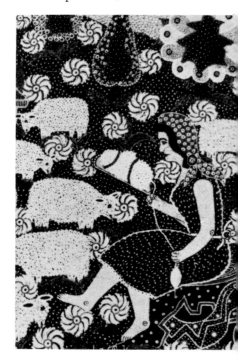

colors recalls especially the rhythmic and brightly colored heritage of Slovak folk art. Because the population of these villages distinguishes itself as an ethnic group from its Serbian surroundings, the community seems stronger and more impervious to change. The painting of these farmers has the joyous and vital idiom of simple souls. Their manner of representing the visible world causes their pictures to appear at times stiff and awkward. But even this stiffness is an aspect of their childlike innocence.

Martin Paluška, machine mechanic and one of the founders of the circle of painters in Kovačica, paints the fragrance and color of fresh earth. The green of his palette is like the green of his village, on which bleached linens are spread out to dry.

The farmer, mason, and painter Jan Strakušek builds with paint as he does with bricks. His work is vigorous and strong, with peasant humor and uncomplicated technique; farmers on galloping horses as though carved of wood, the blue-white light of the snowy landscape, and the odd activities of the farmyard.

Jan Sokol worked together with Paluška in organizing the first peasant painters of the village. The gingerbread faces of his men and horses seem unmoved and timeless.

Jano Knjazović painted working scenes and depictions of dancing and love with an innocent delight in storytelling and with conspicuous pleasure. In his *Children's Dance* (illus. 83), the boys swing the girls around, while one pair quite reduced in size sits under the huge ultramarine-blue tile stove and watches quietly. The postures of the dance steps seem caught as though by a spell in frozen motion.

A few years ago, Martin Jonaš was still painting rustic genre pictures. Below the bright line of houses and the temporary market awnings, horses and cows are being offered for sale. Farmers with waxen faces stand beneath their pointed fur hats in colorful leather vests and long sheepskins reaching to the ground. Jonaš painted the texture of the materials, the patterns of embroidery and lace, and the bright peasant flowers on the skirts and aprons of his lively women. His more recent works use the figures of people in folk costume as decorative elements, telling stories in the manner of comic strips with carefully drawn people clearly influenced by Disney.

The two brothers Jano and Ondrej Venjarski also show a realistic humor and great love of life in their paintings. Ondrej's span of oxen with the generous curves of the rhythmically crossing horns is reminiscent of the cave paintings of Lascaux.

In the past I had almost overlooked Mihail Bireš. Now it is clear that he has remained

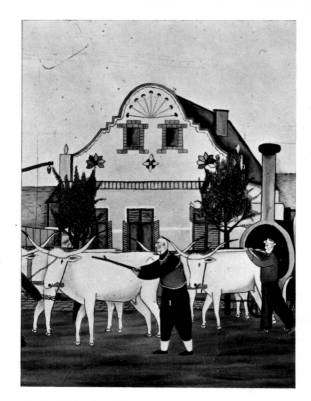

Ondrej Venjarski, On the Way to Work, *1960. Detail.*

true to himself, while many of the others have learned to paint all too well. He shows us men in front of the farmyard, ducks and geese all about, a stork on the roof, a mother with her children, a farmer smoking his pipe in the doorway—everyday things and yet with an effect of timelessness, the rural past which is so transitory (illus. 191).

Some fifteen kilometers from Kovačica lies the village of Uzdin. Its people immigrated from Rumania more than a hundred years ago, settling in this fertile spot because it offered grazing land for their sheep. Their national identity insured that they would adhere to tradition more tenaciously than do other naives.

Art in Uzdin is in the hands of the women and is accordingly perhaps gentler than that of Kovačica. The pictures done by the women of this village are like the colorfully woven tapestries which were their inspiration. The line of development led from the herd of sheep to wool, from wool to loom, and from loom to painting in an array of colors.

Years ago, Anuica Maran once went into the nearest town to get something she could copy woven designs with. In the shop she saw people buying oil paints. "I bought a few tubes myself and brought them home," she relates. "At that time I didn't know how to use them. The schoolteacher Adam Doclean showed me the technique of working with canvas, paints and brushes, and then I began to paint. . . ." Since then many others have joined the first six farmers' wives who began to follow Anuica's example (illus. 80, 189).

Anuica Maran is able to show the girls and

boys she paints throwing themselves into a dance; she can feel the inner rhythm of their movements herself, and can know the pull of sex between them.

Florica Puia paints a circle dance: men in colorfully embroidered white costumes and their ample wives nimbly leading the bright circle through the snow to the admiration of the row of people watching under a blue sky.

Maria Balan shows a group of people celebrating while riding in haycarts. Red, green, and yellow horses pull wagons full of singing, drinking, and music-making. They are accompanying the bride to her new home. Full of enthusiasm, the painter gives strong, dissonant color to her ideas.

Marioara Motorojescu (illus. 82) portrays herself in the blue-black shawl that sets off her delicate face and the white blouse with blue embroidery. Though she may not have learned anatomy, she knows how to observe it well enough. The patches of light on the dark shawl are painted with great care, the eyes and lips drawn with a touch of mystery. With almost romantic feeling she paints herself and the fantasy-landscape of the dark forest and the gleaming gold field.

Desanka Petrov comes from a neighboring Serbian village, but was close to the Uzdin group for a time. She knows nothing of the handicraft tradition of the Rumanian weavers. She will paint a church with a wall of icons in the passionate colors of her memory of her first visit there, or a round dance the way it was in her youth. The abundance of forms and colors she envisions can barely be ordered into a picture, and for this reason she writes an explanatory text for each painting: dancing in green streets after the rain to the sounds of a bagpipe and a flute and the girls' singing; off to the side of the dancing and festivity, the genteel people of the town stroll under feathered hats and parasols of refinement (illus. 85).

Sofia Doclean's picture of women mourning in the village cemetery in their black and ultramarine blue expresses much of the helplessness of man in the face of the inevitability of death.

Though they are at times quite similar, the pictures done by Florika Chet, Anuța Dolama, Viorica Jepure, and Staluța Țaran can be distinguished one from the other, nonetheless, without reference to the signatures of these naive women painters. Developments in the last few years have not led to the consolidation and crystallization of these talents, however, for increased production designed to meet a growing demand has compromised freshness and immediacy.

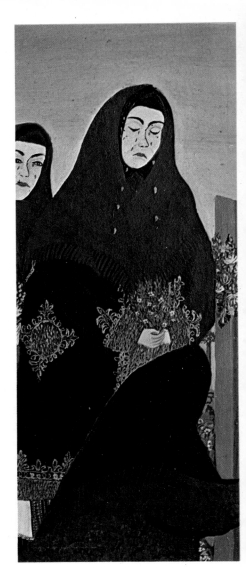

Sofia Doclean,
Women in the Cemetery,
1964. Detail.

Further Dimensions of Rural Painting

The sources of inspiration for the naive artists of Czechoslovakia are quite like those of their Yugoslav colleagues. A broad and colorful current of Slavic peasant art carries the store of remembered customs, forms, and symbols into the present day. The anonymity of patriarchal village life has here, too, been left behind, but the innocent, exploring hand of the peasant painter has not always achieved consciousness of the creative self.

The two Triennial Exhibitions of Naive Art in Bratislava showed that in Czechoslovakia, Rumania, Yugoslavia, Hungary, and Poland a naive peasant art derived from folklore is predominant. At times we see relics of archaic faith and superstition side by side with the symbols of a new social collectivism.

Ludmilla Prochazkova is firmly bound to the life forms of the village. Her pictures are related in form and color to those of the Slovak painters in the Yugoslav village of Kovačica. The old rhythm of communal festivity in her *Peasant Dance* is at the same time the expression of anonymous, collective composition. The wreath of faces is impersonal, each identical to the next and interchangeable. The men are distinguished from the women only by their mustaches and their hats topped with rooster feathers. The childlike simplification achieves decorative perfection, especially in the paintings on glass. In her compositions, the ocher of the ripe grain, the fresh green of the meadows, the soft blue of the transparent sky, the red of flowers and of the threshing machine form a glowing palette rich with contrasts. Unconsciously the artist Prochazkova has based her composition on the simple shapes of the circle and the square, and has imposed these on the surface of her work. In the nonperspective space, her people and trees have become symbols of life in general (illus. 96).

The imagery of Nathalie Schmidtova has been reduced to the very simplest of forms, expressive and joyous. She paints a field as a farmer is moving across it with his plow, and mountains, below which the lakes gaze up at the sky like mirrors. In one of her pictures, a woman spinning simply sits and turns her hand spindle. A strand of yarn lies around her neck and across her breast. Against a bright blue background, solemn, tall women are standing around a long table.

Along with the folklorist, peasant elements, we can already sense here the civilized atmosphere of the city. The hand may still be clumsy, but the eyes of the painter have learned to see in the new way.

While Prochazkova's elementary and almost unmixed colors correspond to folk embroidery with its flat colored shapes, the palette of Juraj Lauko is menacingly ghostly; poisonous green, burning orange, bitter ashen gray, and a saccharine shell pin are placed next to each other with blurred brush strokes. The sky above the world of this painter and sometime sausage salesman is dingy and obscured. His nightmares are rooted in the soil of peasant superstition, and are condensed into his paintings; a fortuneteller reading the cards, the devil and a witch, owls, skeletons, bats, and magic number squares. A burial scene: the mourners dressed in black around the open grave, the reddish-brown dirt, the gray gravestone against the living green of the trees—the

hallucinatory memories of an introverted artist.

The milliner Cecilie Markova paints spiritist landscapes and strange moods under a red, violet, and yellow sky. She scratches rhythmic markings into the thick layers of paint with her brush handle.

Zuzana Viraghova draws the vision of her pictures, like Grandma Moses, out of her past. She paints farmers and shepherds, idealized into genre pictures, inspired by popular novels and illustrated magazines, but with a poetic undertone; her work is constantly on the borderline of banality.

The undertone of the paintings of the housewife Ana Lickova is gentle and lyrical. People with round, astonished eyes gaze about in an enchanted world. Dancing, lovemaking in the woods, and an unusual catch while fishing; children, grown-ups, animals, and flowers in one larger fraternity; earth and sky sensed as one.

The painting of Ondrej Steberl reveals a unique, autistic, inward vision. He often paints Bible tales or renders his subjective interpretation of a simple, friendly, at times mysterious world. He paints in only two dimensions, without perspective on a rhythmic plane, ignoring gravity as well. In his *Crucifixion* (1967) Mary embraces the suffering Christ on the cross. Mary Magdalene sheds tears at his feet. Christ wears a pointed beard and long curly hair; simultaneously earthly and otherworldly as in

Juraj Lauko, Christmas Eve, *1962.*

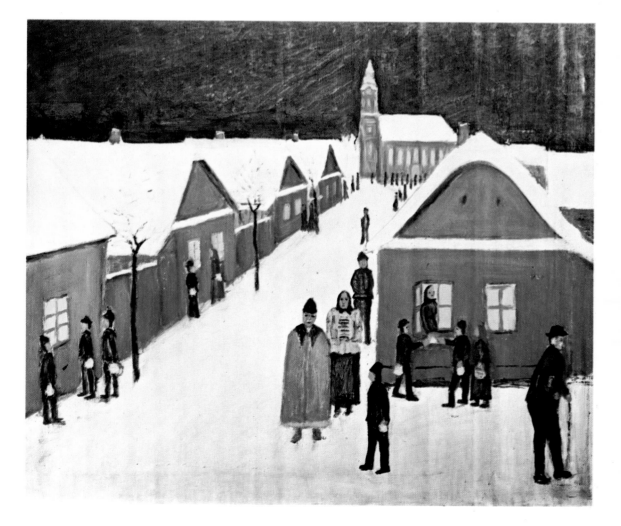

Buñuel's film *The Milky Way*. The faces are motionless in dreamy reality like icons.

The Good Samaritan (illus. 81) : he kneels beside the sick man lying in a flowery field. The Samaritan is dressed in a turban and a Bedouin cloak; the invalid, however, lies naked on the bare ground. As though asking what is to be done, the kind man raises his black-bearded face; oblivious, the people go their way untouched and unmoved. Only one girl pauses among the decoratively spaced flowers—we do not know whether out of sympathy or curiosity.

In *The Last Judgment* (1968), a cemetery is divided into small parcels. From each of the graves a figure rises, men and women wrapped in sheets. Tall crosses enclose the dwelling of the dead. The archangel Michael bends out of heaven to blow the trumpet of resurrection, like Rousseau's cavalrywoman. The faces are stiff and hard, the lips brightly painted; the eyes are circled with black, full of wonder at the miracle.

In the flat order of these compositions, the people, animals, stands of trees and cemeteries are uniformly simplified and united in their emblematic power, mirroring a naively perceived mythology—a sensitive *arte povera* of naiveté.

In the naive art of some countries, as in Czechoslovakia and Yugoslavia, the confrontation of the archaic and the modern is revealed in the conflict of social forces. Here we discover the simultaneity of highly contrastive social systems; patriarchal ways are challenged by planned socialism and the resulting friction can doubtless provide a strong stimulus to the artist.

These naive artists are both troubled and stirred to creative activity by their chronological and social point of view between the fading tradition of the community and the announced advance of a socialist collective.

Though generally unconscious of it, the naive painters of Hungary are also able to draw from the subterranean streams of a disappearing folk art.

Margit Vanko's pictures look like nineteenth-century baptismal certificates and obituary notices. In their decorative forms, they become naively ornamental metaphors of her feeling.

Julia Dudas paints the pleasant, traditional portfolio of faith and of the sad and joyous moments of the rustic way of life. What she paints is a popular, peasant representation of work, love, and death.

Elek Györi shows in his pictures the disappearance of the boundary between city and countryside. Out of his experience and in a faithful, naturalistic manner he portrays weddings, fairs, grape harvests, and village dances with farmers, soldiers, and musicians. His picture of a ride in an old-fashioned carriage is totally rustic, but nonetheless seen from the point of view of one who is returning home from the city.

The most important Hungarian naive, I would say, is the farmer from Algyö, Andras Suli. He loves nature, and inspired by it he often paints sequences of pictures on the same theme. But in contrast to folk art, each of his variations is new and expresses a different mood. His palette, with its light gold, citrus color, its variety of greens, its deep wine red and pale blue, is exciting, at the same time echoing the familiar colors of Hungarian folklore.

Train Station (1935) shows locomotives, railway employees in their offices behind the windows of the station, and on this side of the tracks people strolling or posing for their portrait. There is a village pond with ducks and willows at its edge; automobiles cross the bridge painted diagonally across the picture, and farm women in broad, pleated and polka-dotted skirts, with scarves and aprons, carry their shopping bags. Bright rustic colors, everything visible quite carefully registered. He has even added the printing on the train cars for its calligraphic interest. The travellers in the passenger train are done with great precision; in the background rise the red roofs of the village.

Suli painted all of the works we can see today in an inspired frenzy in the brief period between 1933 and 1939; the streets and squares of his own village, autumn promenades along the river banks, childish trains crossing the landscape, the parlors of farmhouses and the *Interior of the Church* (illus. 88). It is astonishing how Suli was able to differentiate between natural space and architectural space. His formal strength

András Süli, Train Station, *1935.*

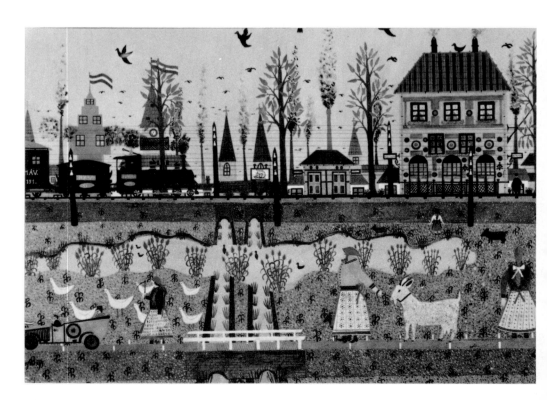

and color values are unconsciously but harmonically ordered. The inside of the church shows a considerable depth, in which women and girls with bright aprons and dark scarves stand with their backs to us under church banners, rigidly facing the altar. Two small ministrants are kneeling; everything is bright for the sabbath, and a mild sky awaits the faithful. His is a naive realism with clear definition of the world of things and a touch of folklorist ornamentation. He has a strong feeling for linear rhythms which gives his work a decorative solidity.

When after several years of intense painting Suli could find no acceptance of his work, he burned many of his pictures in the barnyard of the farmer for whom he worked. He left the village and abandoned his painting. He was forgotten without a trace. After thirty-one years in which he had not painted a single picture he was rediscovered. In 1966, his pictures were shown in the First Triennial Exhibit of Naive Art in Bratislava.

Occasionally one can see the work of Tibor Csontvary in naive art shows, a painter who was a remarkably creative person. Nonetheless, we cannot call him a naive. The fantastic sense of life and the post-Impressionist quality he displayed at the beginning of his artistic career were adapted to several successive twentieth century styles until he achieved a synthesis dominated by a symbolic expressionism. His childlike honesty and spontaneity give his work a touch of naiveté still.

Rumania's naive painters are oriented more toward the city than to the countryside. Though folk art is gradually disappearing in Rumania too, it still exerts a subtle influence which can be seen in the work of the naives. Those exhibited in the Second Triennial in Bratislava—the seamstress Adriana Bordea, the cashier Maria Linculesco, the dentist Joan Grigoresco, the forester Gheorghe Negru, the miner Alexandru Roth and the cooper Marin Vaduva—portray life and the world directly and with expressive primitive forms. Their nonprofessional awkwardness, together with their sensitivity to rhythm and color, suggests a rich background in folklore. Their work, regardless of their personal idiosyncrasies, is based on experienced reality, but thanks to its concrete expressive strength it transcends the merely anecdotal.

A survey of the naive art of Poland reveals a certain shift toward more obscure reaches of the spirit. There is the art conceived of as a magical and ceremonial activity by a primitive, unquestioning peasant faith; there is the emotional, popular religious painting represented by Maria Lenczewska and Franciszek Janeczko; there are works which seem to be compulsive reflections of inner tension bordering on psychosis, as in Edmund Monsiel who felt himself constantly watched by the thousand eyes of God; there are the theosophical fantasies of Teophil Ociepka with their rampant primeval beasts and their portrayal of nightmares (illus. 200) which may well be echoes of wartime experiences; and finally there is that most important Polish naive Nikifor, who formed with earnestness, from the most wretched of materials and the most banal of motifs, a compromised reality and the hope of his soul.

In the mountain villages of Slovakia, the dense forests of the Carpathians and in the Alps, there are remnants of the ancient art of shepherd peoples.

In Switzerland at the end of the eighteenth and the beginning of the nineteenth century, a local naive painting developed in connection with the ornamentation of peasant utensils, cupboards, and chests, which began to leave anonymity behind.

The painting of Swiss dairy farmers still preserves aspects of age-old shepherd art. In his study of peasant painting in the vicinity of Appenzell, Rudolf Hanhart notes that the "formal delineation of animals whose number probably once corresponded to the size of one's herd" is a conventional pictorial language, just like the one used quite early in the representation of animals in cave painting. Portraits of farmers and shepherds came later, pictures of shelters on high meadows, alpine landscapes, and grazing herds.

Bartholomäues Lämmler was the most celebrated of this circle of lay painters. His narrative presentation of the shepherds' lives shows a sense of rhythm, color, and form. Arranged in long strips of painting as in Egyptian friezes, his black cows and white sheep dot the green carpet of a meadow. In the nineteenth century, this type of painting was transformed into a pseudo-naive souvenir art.

Sibylle Neff comes from the Swiss town Appenzell and takes up the tradition of Lämmler. With delicate, childlike feeling, she paints her experiences and her memories, an outing of the country school or the transfer of the herd to the high meadow. There is pleasant movement and painterly vision in the sincere and patient work of this gifted, emotional naive painter (illus. 94).

Cultures overlap each other on the island of Cyprus. Influences from Egypt and Mesopotamia, from the culture of the Aegean, from Crete and Mycenae—all have left their traces. In the forms of Cyprian folk art one can find parallels for the oriental love of ornament and color, the hieratic motifs of Byzantium, the exaltedness of the Gothic style, and the harmony of the Renaissance.

A reflection of the ancient and manysided cultural heritage of the island can be found in the picture cycles of Michael Kasialos.

Although Kasialos comes from the country, he developed a sense for artistic beauty and for a long time contented himself with copying ancient works of art. He ran an antique shop until he began, only in 1960, to paint his astonishingly lively pictures (illus. 86).

Kasialos' compositions have an archaic severity and unity which gives them a certain resemblance to Byzantine icons of the Orthodox church. The rich ocher background of his harvest pictures and working scenes reminds one of the gold of images of the saints. We respond to these works as though they were naive cult paintings, in which knowledge and intuition are interfused. In spite of the movement of the events he relates in his pictures, there is in them a strange stillness; all of the figures seem solemn and benumbed. The sequence of pictures first exhibited at the Second Bratislava Triennial in 1969 provided an ample view of the landscape, life, and culture of the island of Cyprus.

The painter Kasialos from Cyprus no longer belongs entirely to the sphere of the peasant naives. The rural and folklorist element in his painting has been incorporated, though hardly consciously, into the synthetic landscape of epochs and styles.

Still other rustic naive painters in and outside of Europe could be included in this survey, painters in Latin America, and especially those of Haiti. They will be treated elsewhere.

Are there actually five hundred naive painters in Haiti, as Sheldon Williams reported at the 1970 Hlebine Symposium? And how many more on the American continent? It would not be difficult to list hundreds of names.

I have been in the homes of many peasant painters, and I know their lives and their natural gifts. Every day new talents knock at my door, show their pictures and ask for recognition. Talent is infectious. The seeds of it are everywhere that man continues to live close to nature. It develops in the climate of nature's affirmation. Are not most if not all children blessed with talent? The signs and forms with which they codify the world are full of magical immediacy. The gift and talent of children decreases through contact with rational knowledge. The naive artists resemble children in this; often they too lose the original integrity and unsullied purity of their expression through practice and increasing self-consciousness.

The naive art of peasants is also threatened in another way. Cultivation of the land was one of the earliest activities in which men engaged. Crop growing, cattle raising, the use of the wheel, potting, spinning, and weaving—these were the things with which we first conquered nature, and they live on today veritably unchanged in the villages.

Although more than a fourth of the earth's land surface is still devoted to agriculture and worked by one half of mankind, the life of the peasant faces drastic economic and social changes. The influences of the mass media, of modern communications, and of the mechanization of agriculture are supplanting the store of experience passed on from father to son, the instinctive worship of ancestors, and the habitual fertility rites in connection with sowing and harvesting. Everything is conspiring to alter or abolish the original forms of rural existence. And so it is that everything which the peasant naive painters draw forth and portray from the stock of their experience seems to us an echo and reminder of early world-views and styles of life and work.

Though it may yet take a considerable time before the original peasant life has been fully abandoned, it is nonetheless inevitable that such a change will occur. The art of the peasant naives seems to us all the more significant as the unconscious last reflection of a time when men, animals, plants, and the whole round of life enjoyed a feeling of unity in nature.

Michail Kasialos, Palm Sunday, *1967. Detail.*

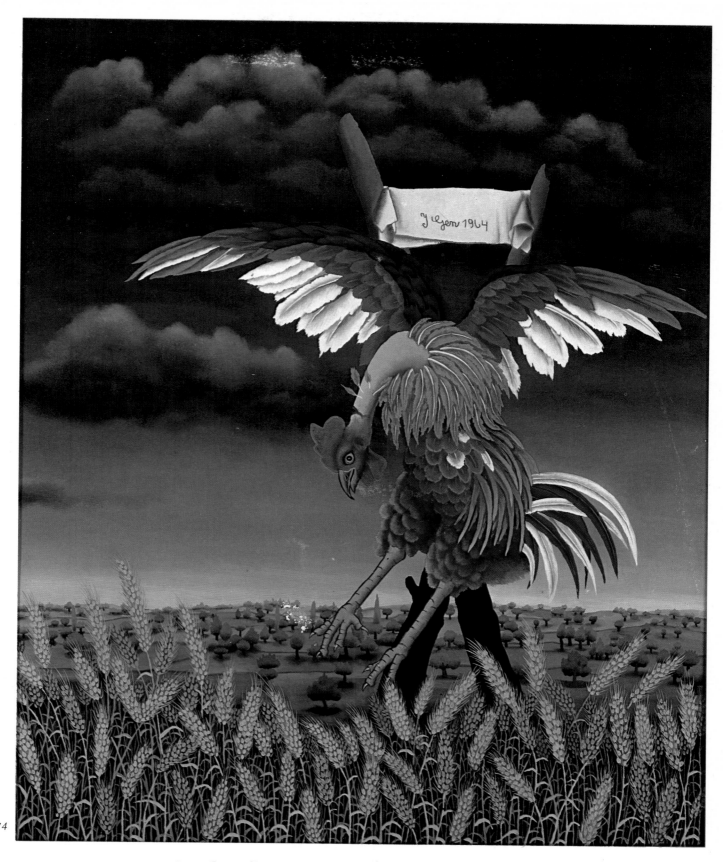

74

74. Ivan Generalić, Crucified Rooster, *1964*

The rooster, this fabulous animal from the workaday world of the peasant, appears in many of Generalić's compositions. Often he is the focus of our attention, even if he is not portrayed so grandly and tragically as he is here in a picture which the artist calls "the Immortalized One."

The purple wings nailed to sticks, the hanging head, and the frozen feet remind us of every crucifix. Its bright plumage is still glorious, but its body is contorted, and its eye gazes as in a last and sorrowful bird's-eye view of familiar villages, fields, and trees.

Nailed to the crossed sticks against the deep blue clouds of a mournful sky is a band with an inscription. Where we would expect to find the name of the crucified figure, we discover instead the painter's initials and the date of the painting.

Generalić's cycle of rooster paintings is more than a presentation of peasant life; it is at the same time a message from deeper spheres of human existence.

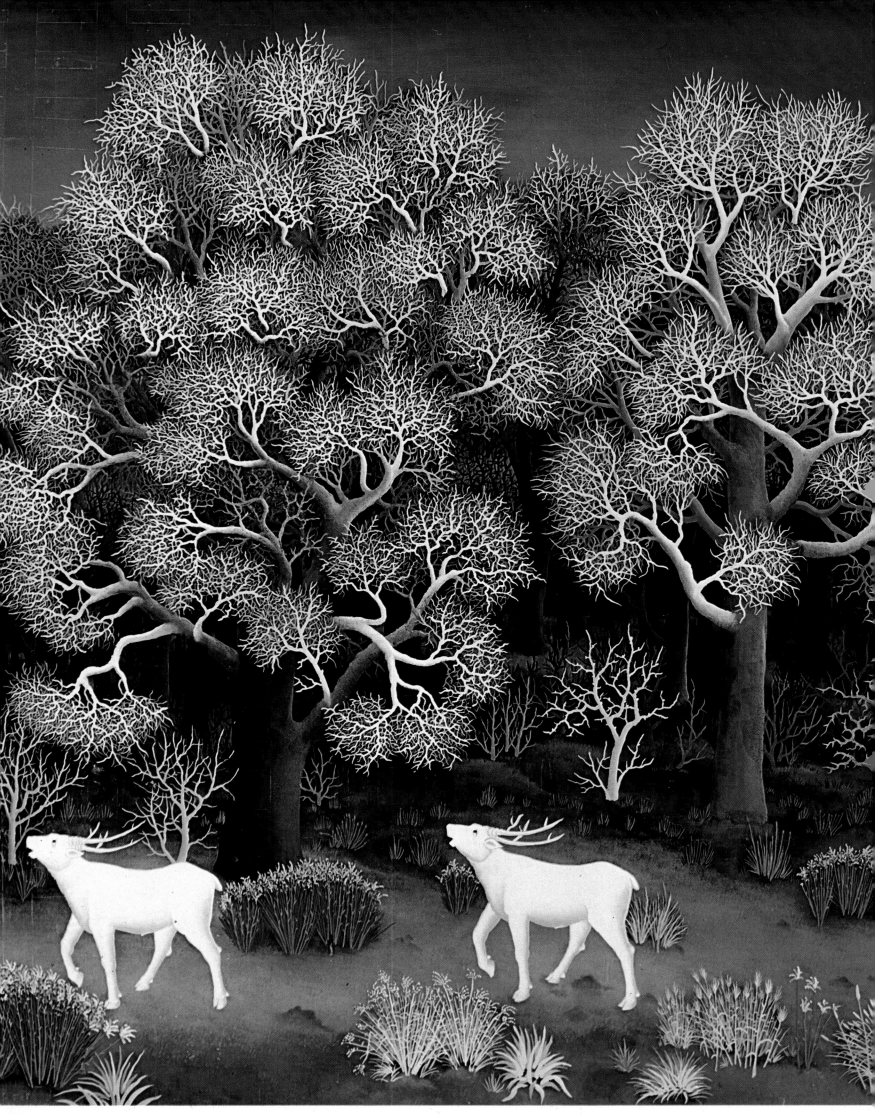

75. *Ivan Generalić*, Deer Courting, *1959*

76. *Ivan Večenaj,* The Flight
Into Egypt, *1967*

77. *Mijo Kovačić,* Winter Scene
With Vast Sky, *1969*

78. *Mirko Virius,* Harvest, *1938*

79. *Ivan Generalić,* The Death of My Friend Virius, *1959*

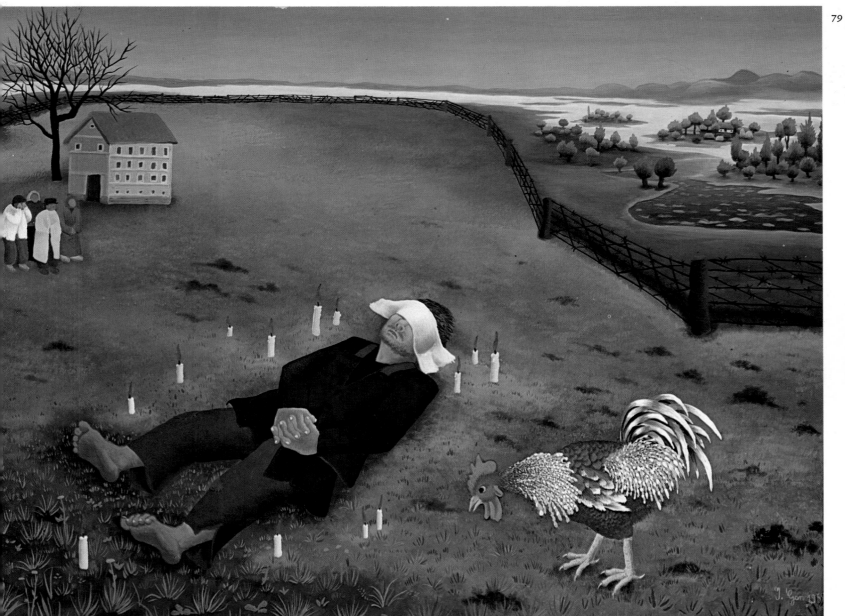

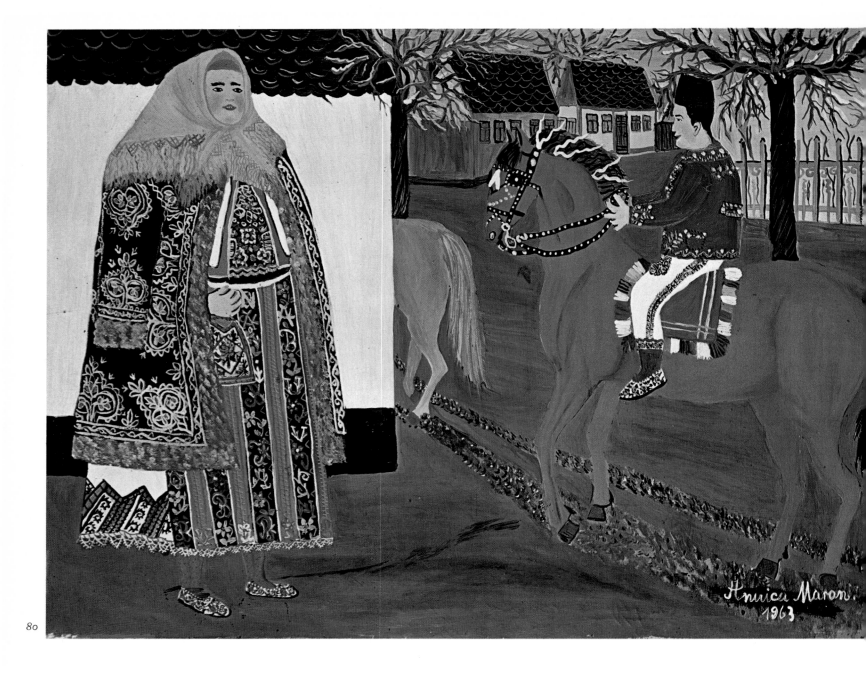

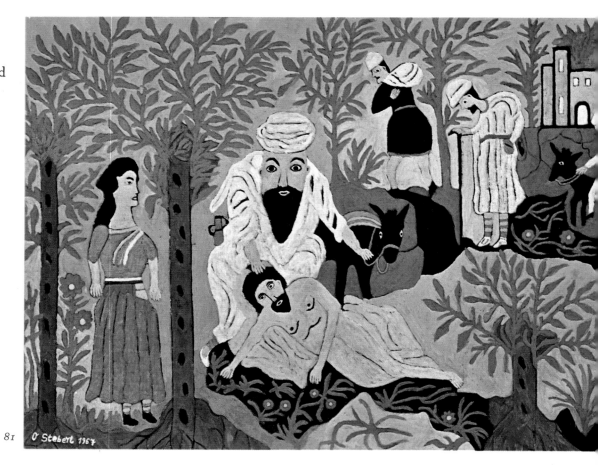

80. *Anuica Maran,* Village
Courtship, *1963*

81. *Ondrej Steberl,* The Good
Samaritan, *1967*

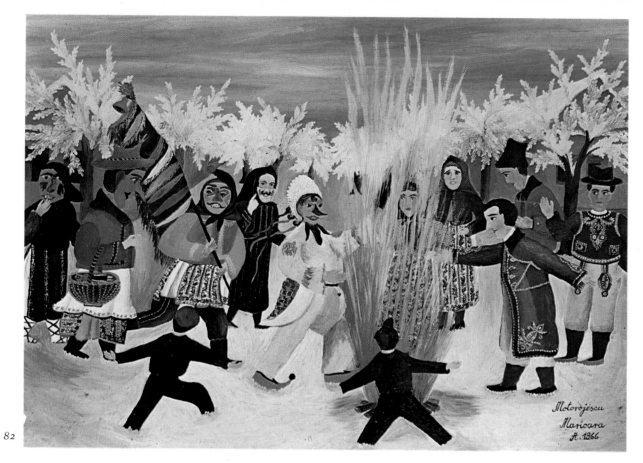

82. *Marioara Motorojescu,* New Year Mummers, *1966*

83. *Jano Knjazović,* Children's Dance, *1954*

Between the dying folk art of inherited forms in anonymous village society and the individual creations of naive artists in our industrial age there is a simple and popular art of peasant naives which still has a strong folklorist element. In the stunned air of motionless representationalism, these peasant artists record their costumes and customs in scenes of daily life and work, of dancing, courtship, mourning, and worship. They produce decorative compositions in festive colors, often with considerable narrative talent and an infectious love of life.

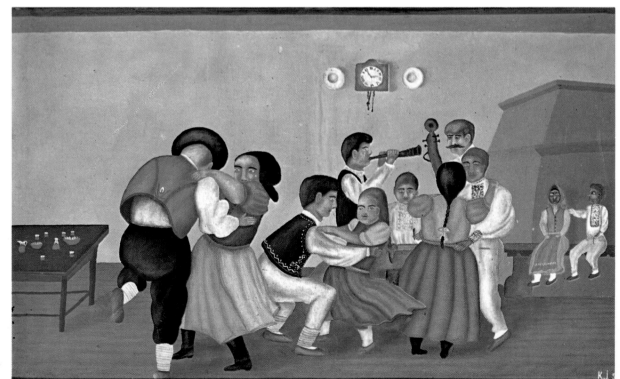

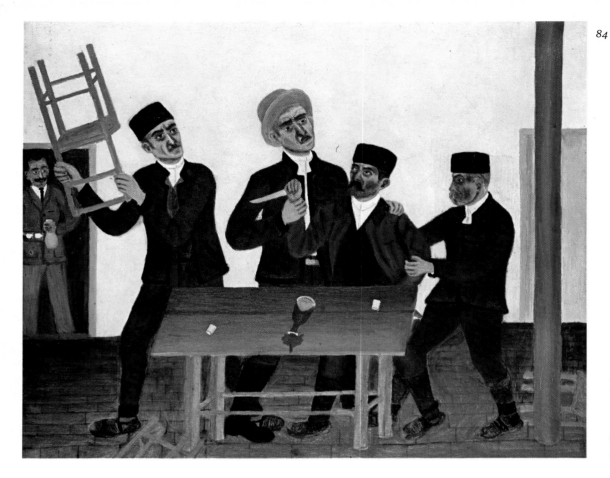

84. *Janko Brašić,* Quarrel in the Tavern, *1935*

85. *Desanka Petrov,* Memory and Custom, *1964*

86. *Michael Kasialos,* Returning From the Fields, *1968*

87. *Taieb Kaouaji,* Inspiration of the Dance, *1967*

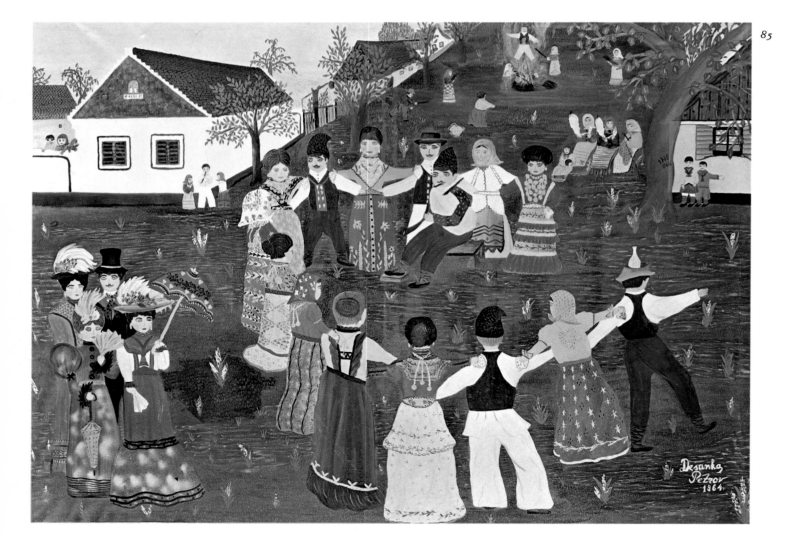

86

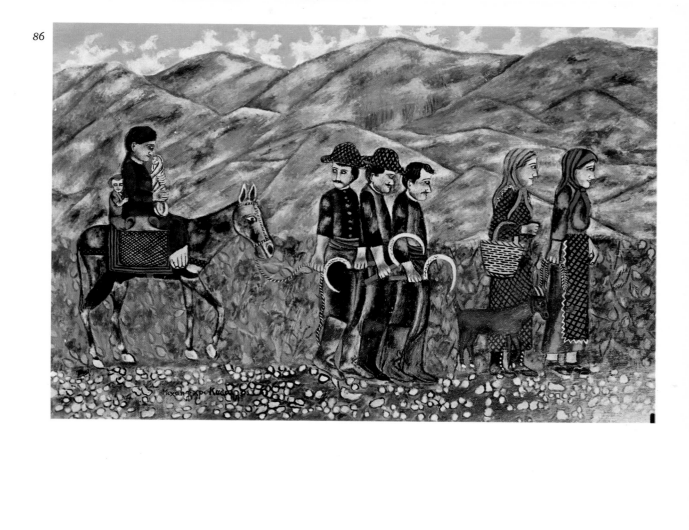

87

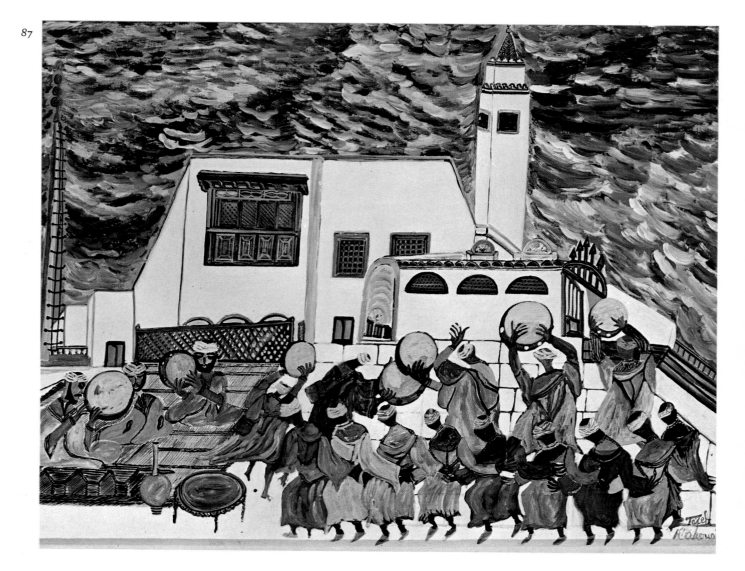

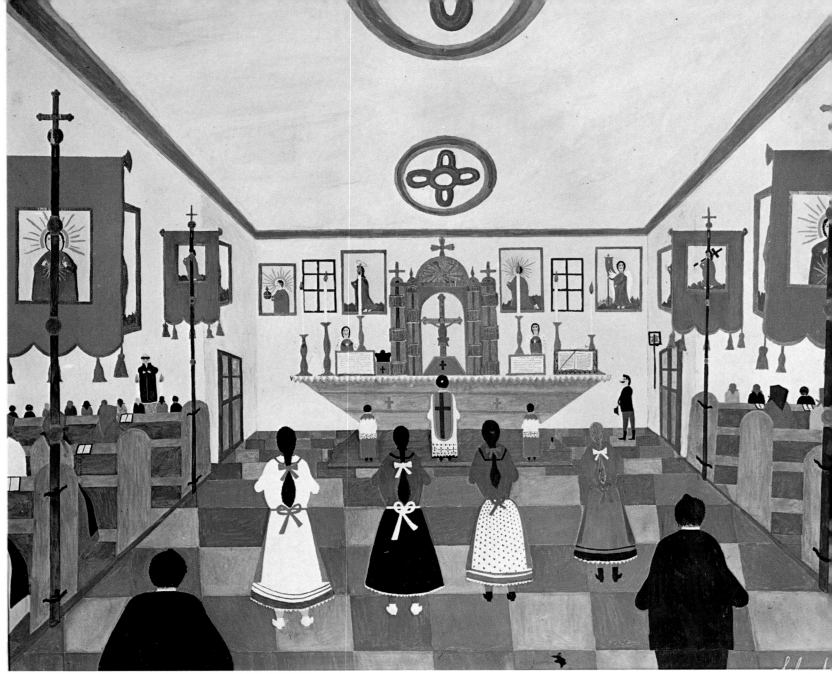

88

Three different peasant artists have depicted their village church. András Süli has rendered his with considerable feeling for linear and architectonic rhythm. The worshipers stand rigidly facing the altar, their backs to us, on the red, yellow, and violet checkerboard of the stone floor. Church banners and pictures of the saints effect a balance between the interior space and the ornamental human figures. The contours of the altar, with the priest and his choirboys in their colorful robes, form the ritual center of composition of well-planned surfaces.

The picture by the German peasant painter Max Raffler also presents the interior of a church. But in contrast to the controlled orna-ment of Süli's painting, the baroque interior of this Bavarian village church is full of the whimsical movement and gaiety of multi-colored and gilt decoration. The bridal pair before the altar and the crowd of witnesses are represented with obvious humor.

The peasant Milan Rašić has depicted the small cloister church of his native Serbian village in the midst of a lush garden of flowers. The men and women of the village are dressed in their local costumes and have arranged themselves in a row as for a kolo dance in front of the austere façade of the Byzantine church. It seems that all of nature's plants and creatures have been awakened by the dynamic force of spring.

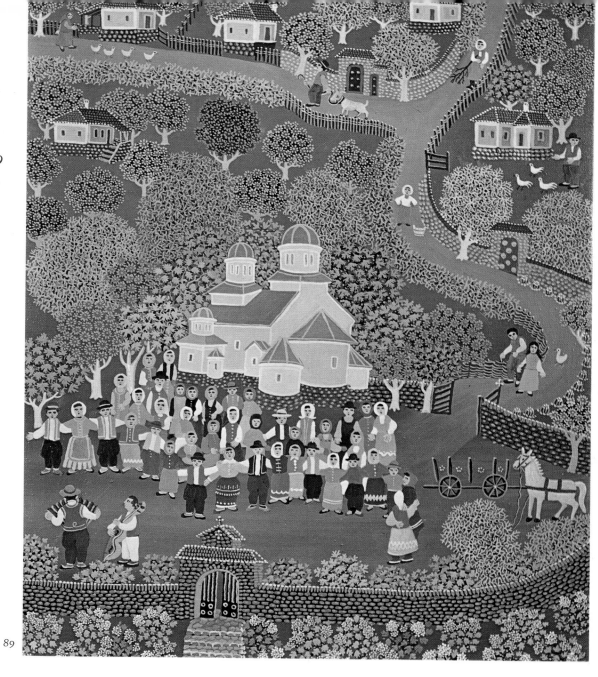

89

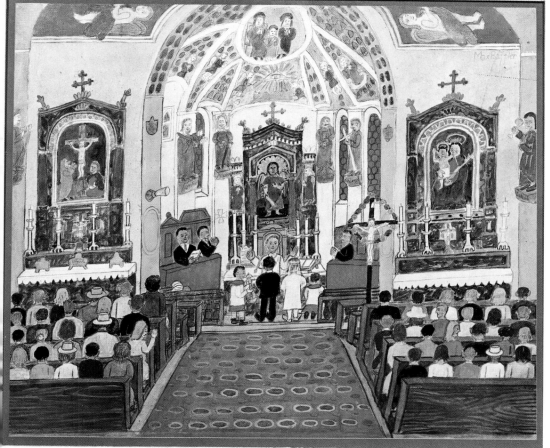

90

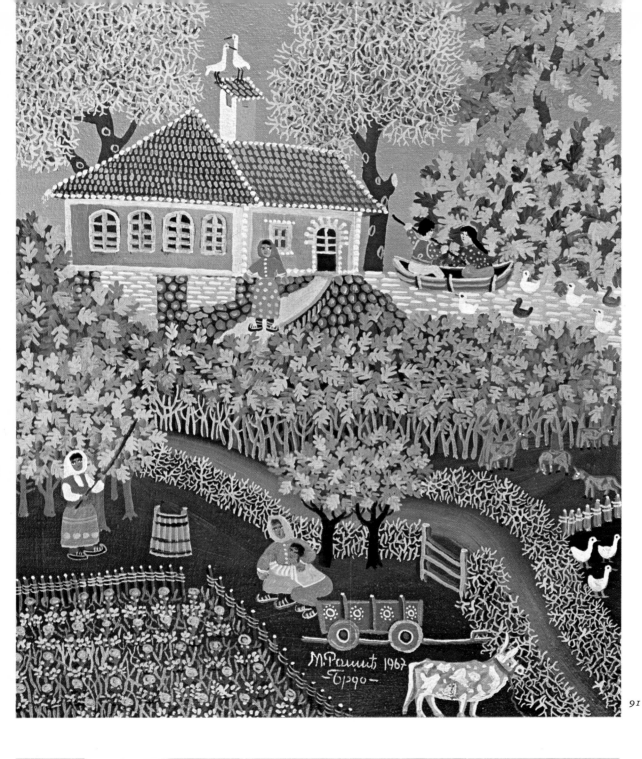

91

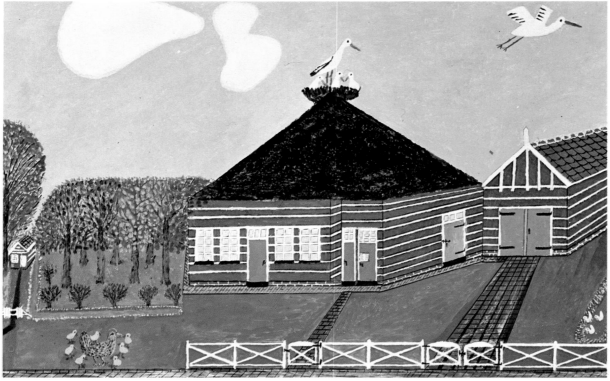

92

91. Milan Rašić, My Village, *1967*

92. Pieter Hagoort, Stork Farm

93. James Lloyd, Child with Young Donkey

94. Sibylle Neff, Bridge Road, *1967*

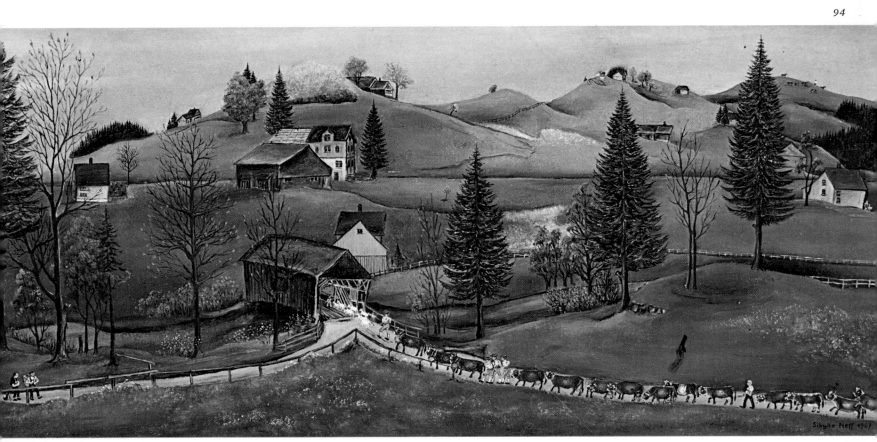

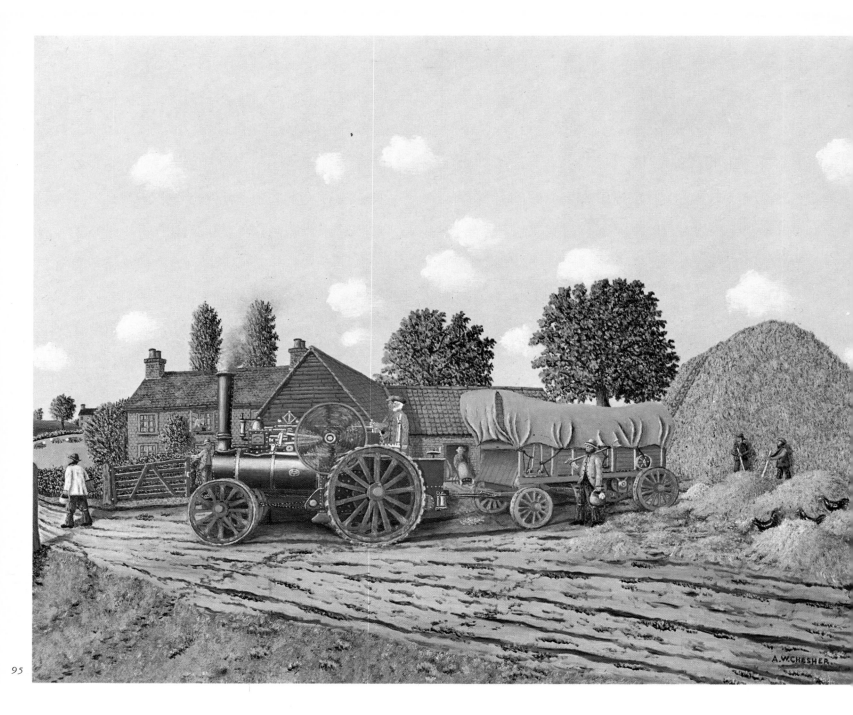

95

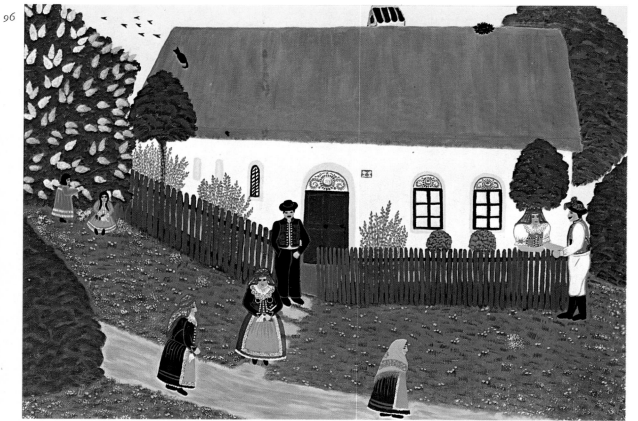

96

95. *A. W. Chesher*, Fowler's
1887 Steam Engine

96. *Ludmila Prochazkowa*,
On the Way to Church, *1969*

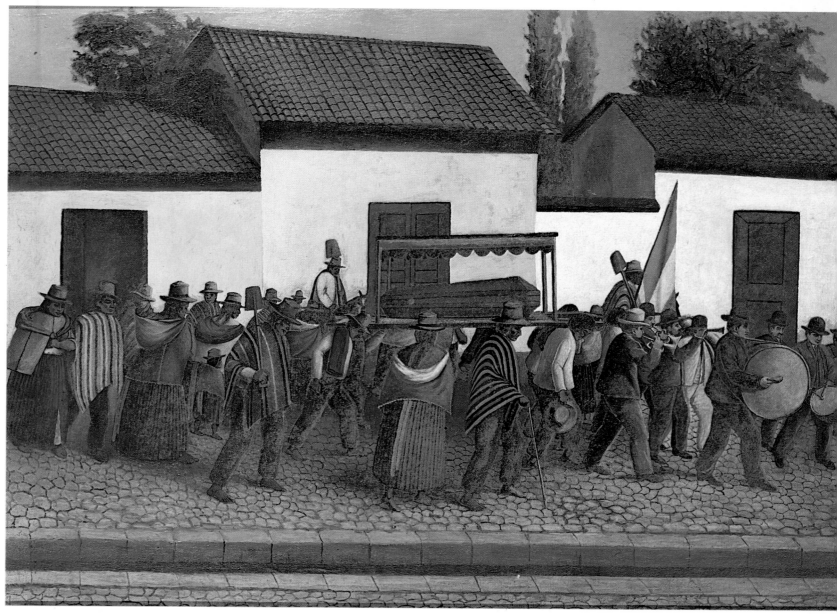

97

97. Mario Urteaga, The Burial of an Illustrious Man, *1936*

With the destruction and dissolution of the Aztec and Inca empires, the demons and gods of pre-Columbian cultures lost their magic powers. Caught in a Europe-centered system of values which acknowledged the absolute supremacy of Greek culture and the Italian Renaissance, artists in America felt themselves to be isolated and without traditions. But stirred by more recent worldwide artistic movements, they began to appreciate the great and complex world of forms to be found in their own jungles and buried in the soil beneath their feet.

Crosses were painted on the sails of Christopher Colum-bus's ships, and the banners of the conquistadors bore likenesses of Jesus and Mary. The reviving gods of the South American continent and its offshore islands were to come face to face with the gods and demons of Africa and the saints of Christendom.

Old forms and motifs come to light again in popular art and in the pictures of the naives. The technological and frigid, rational climate of the industrial age has given us a new appreciation for archaic myth, however it may be transformed today into naive and realistic representation.

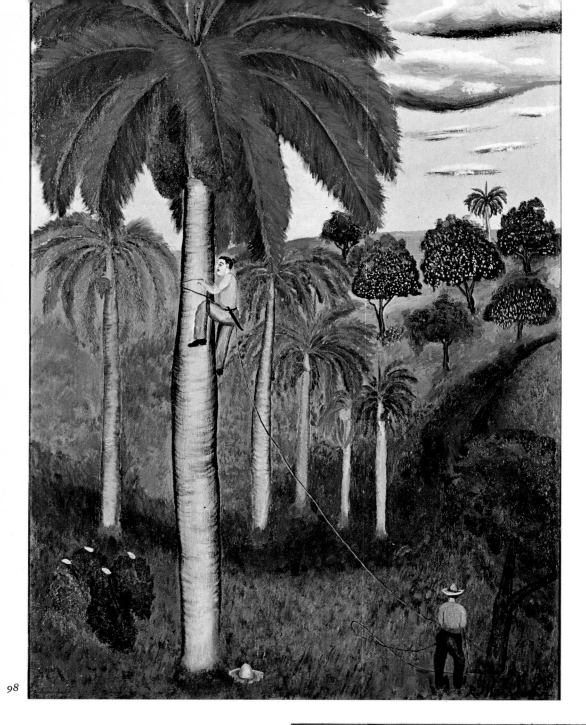

98

98. *Roberto Jay Matamoros,*
Working in the Trees

99. *Rafael Moreno,* Garden in
Havana With Palms, *1943*

100. *Felicindo Iglesias y
Acevedo,* Christopher Columbus
Discovers Cuba, *1944*

101. *Antonio José Velazquez,*
Morazan Square in
Tegucigalpa, *1969*

99

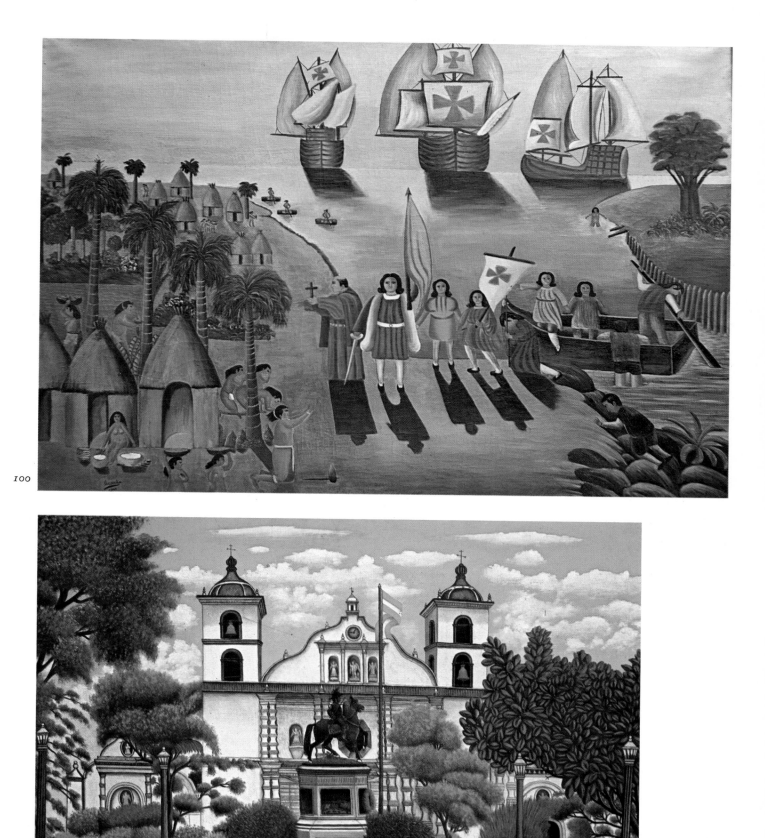

100

101

102. Adela de Ycaza, Rubén Dario's Poem "I", *1968*

The picture reproduced here is inspired by and dedicated to the poetry of Felix Rubén Dario. The mysterious and dark verbal music of the Spanish tradition and of French symbolism has enchanted the painter: "Yesterday I saw a vase of flowers through the window, lilacs and pale roses. . . . I stepped close to them and saw that the lilies and roses were made of wax, the apples and pears of tinted marble, and the grapes of crystal. . . ."

Adela de Ycaza has painted the biblical legend of the first couple in a filmlike sequence. First Adam and Eve as created by God and blessed by Him, then both of them under the tree, picking the forbidden fruit of knowledge, and finally their expulsion from the Garden of Eden by an angel. Even God's epiphany is envisioned as a film, among twinkling stars and glowing birds and flowers.

Christian saints are occasionally fused with figures from the myths of Africa and the Indians by the naive artists of Latin America. Adela de Ycaza blends religious themes with those of great literature. For her, as for many other naive artists, the archetypal legend of the tasting of forbidden fruit has a great symbolic power. When naives eat of this fruit they forsake the innocence of their vision. Mythical truths become mere scenic arrangements, and when we step closer we discover them to be made of wax and marble, having lost their dewy freshness and the scent of timelessness.

The religious and legendary world of images of Adela de Ycaza does not resemble the pious visions of medieval mystics. Her childlike narratives are rather inspired by the baroque literature of Latin America. A genuine gift gives to her artificial scenery a festive radiance and glittering irreality.

The onetime flower seller began to paint at the age of 57 under the urgings of her son. The poems of Felix Rubén Dario, the friend of Mallarmé and Verlaine, stirred her fantasy, and she came to translate these humanistic dreams into naive visual images.

New forms of joyous life are crystallized from the twilight of misty spaces in a lost paradise. Silver stars shine like windows of hope. Men, gods, animals, and plants are submerged in an aquamarine and violet landscape of the soul.

103

103. *Antonio José Velazquez,* Distant View
of San Antonio de Oriente, *1957*

104. *Asilia Guillén,* The Burning of Granada
by American Troops, *1957*

104

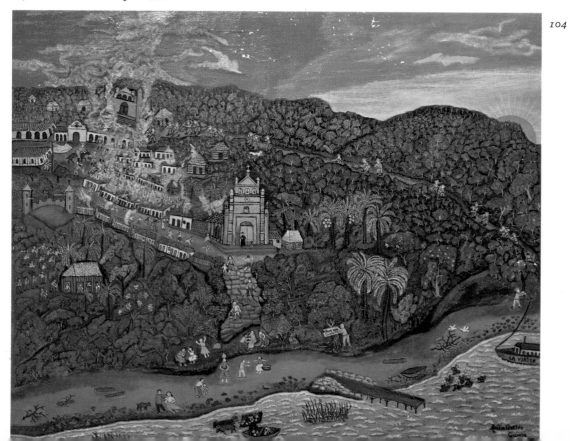

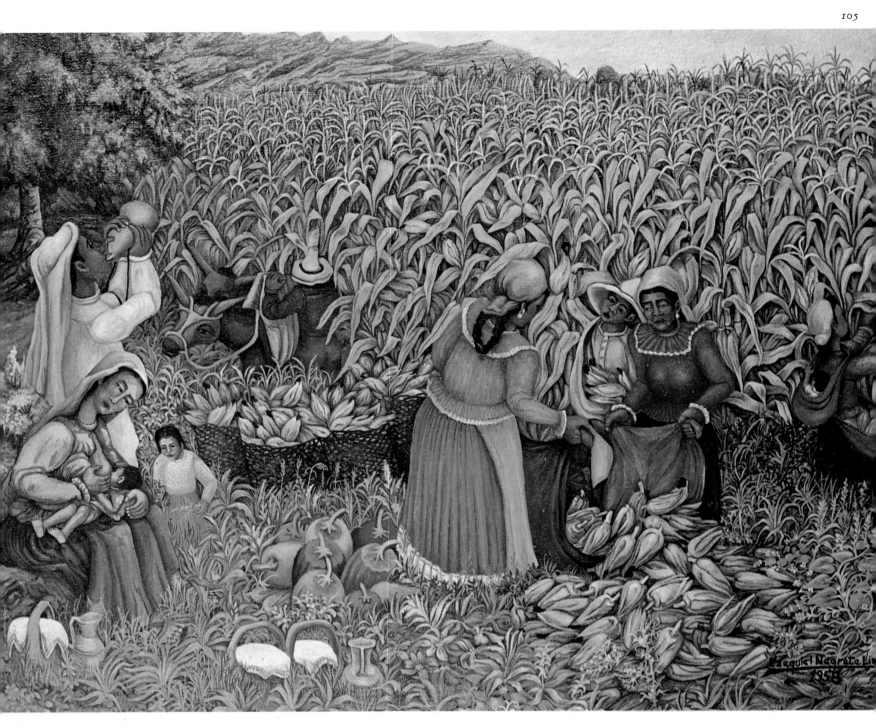

105. *Ezequiel Negrete,* Corn Harvest, *1958*

Even though old forms and models are being suppressed by the rational view of our time, the myths of Old Mexico still have a considerable effect on art. Even in the art of the naives one can discover the melancholy, pious, and pessimistic idea of a world repeatedly destroyed by the gods because of its corruption. Ezequiel Negrete's genre picture celebrates heavy work in gentle forms. The sepia-colored mother nursing her child could be a madonna or even the Aztec corn mother who first gave man the ear full of seeds: "This is my heart. It will be your nourishment, and its juices will sustain you like the milk of my breasts."

The Resurrection of Archaic Gods

Chapter IX

Copper disk with two faces, northern Argentina, before 1500. The double mask of the Aztec and Inca cultures was known in ancient Mexico, Peru, and northwest Argentina. Also the African cultures of the Baule tribe from the Ivory Coast and the Ekoi in Nigeria and Cameroon used the Janus head as a ritual dance mask. The elementary forms of the face reveal and conceal at the same time. I set this double mask appropriately at the beginning of a chapter which deals with the meeting of America and Africa.

The Other America

Stretched between the past and future of the American continent is a history of conquest, exploitation, slavery, and imminent revolution.

The name Hispano-America preserves the heritage of the conquistadors, and Indo-America that of pre-Columbian cultures. Poets of Latin America have looked forward to a Renaissance in the Latin spirit. But in the veins of America flows not only Iberian and pre-Columbian blood; one must also take into account the blacks imported unwillingly from Africa. The heritage of this latter race is to be read on banners in its struggle for emancipation in America.

The time lag between stages of development among different peoples and on different continents determines the essence and forms of naive art. Eighteenth and nineteenth-century limners in the United States created a manner of expression which combined the life style of farmers and handworkers with the memory of a European culture. They were, so to speak, "prenaives." The art of the onetime Haitian slaves imported from Africa combines elements of folklore and ritual with a naive pictorial imagery.

The popular naive art of Nigeria, which developed as a result of the confrontation of a lingering tradition of tribal art with technological and industrial civilization, incorporates motifs from movie posters, comic strips, and pop art (illus. 106–109).

While national characteristics have almost completely disappeared in high art in our time, having been replaced by international styles, the works of the naives often bear a folklorist, regional stamp. This is particularly true in the realm of peasant naive art. Peasants, farmers, and cattle breeders not only share the same themes, but they also see and interpret the world in a way totally foreign to the craftsman and city-dweller.

Country people are close to nature, and they generally include strongly realistic features in their representations of it. Nature is only something longed for by the city-dweller; it is the farmer's medium in his everyday existence. This tendency toward true-to-life realism among peasant naives is all the more obvious in Latin America, where even pre-Columbian art had utilized only slightly distorted natural forms as potent symbols of life.

In most highly developed industrial countries we can see how a waking national consciousness is reaching back toward the traditional forms of folk art. Spanish and Portuguese culture had obscured the remnants of pre-Columbian ritual art in America, and it took a considerable time before its buried sources were rediscovered and could be opened up once again.

The great stream of Africans imported as slaves carried its own traditions onto the American continent. Saints and demons of Christianity were to come face to face here with black and red gods, and to join in a fantastic ethnic symbiosis with them. The Indians of Metepec, Mexico, carry festive paintings full of European and Christian elements in their fertility processions. In today's votive painting, too, in the *santos* or pictures of saints produced both for the church and as tourist items, one can recognize the hybrid forms of the "colonial style."

Antonio J. Velazquez comes from Honduras, the Central American focus of the ancient and widespread Mayan culture. This

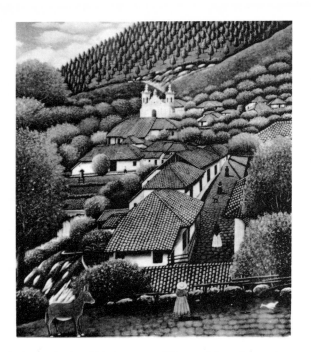

Antonio José Velazquez, View of San Antonio de Oriente, *1957. Detail.*

former telegraph worker, barber, and village mayor portrays the men and surroundings of his homeland with minute precision. The monastery church, its white towers heavy with the ornament of the Spanish Baroque, is the central feature of his world. It sits nestled between green trees, with cobbled streets leading up to it, on which there are often peons leading their heavy-laden gray burros. Sometimes too he will paint the respondent color of a church festival moving along these streets, the rhythm of the bustling crowds and bands with flutes and trumpets. Childlike ministrants carry artifacts from the church while priests and their followers march in the solemnity of their faith—especially women in black, violet, and yellow dresses—while above it all, remote and unmoving, hang painted saints with their paler skins. With stiff simplicity, Velazquez presents this small world of his to us, one in which a bridge of poetic innocence stretches back beyond the merely visible, and into the very depths of time (illus. 101, 104).

Asilia Guillén, who does embroidery by profession, lives in Managua, Nicaragua. At some point in the past, her village of Granada was set on fire by North American troops, an event which has smoldered in the memory of the village and her people. In one of her pictures, one can see khaki-brown soldiers moving along a broad road through the woods, carrying guns and torches while houses and churches burn. Near the river is a sign proclaiming "Here stood Granada!" People are running down the slope away from the houses and toward the river; men, women, and children. A warship is tied to the shore. The incident is related from several points of view at once; figures furthest from us at the top of the mountain are

painted the same size as those standing by the river. The finely brushed colors glow like the threads in an embroidery pattern. An atmosphere of terror derives more from the theme itself than from its representation. All the figures are like little dolls, and the orange flames illuminating this scene of flight and confusion are as though done in silk. Behind the visual scenario there is nonetheless a crudely childlike apprehension of reality and a talent for the expressive representation of psychic turmoil (illus. 103).

The pictures by another painter, Adela de Ycaza, strike me as an odd and noteworthy combination of naive imagery and the obscure *poésie pure* of her Nicaraguan compatriot, the lyricist Felix Rubén Dario. This friend of Mallarmé and Verlaine, a Spanish and Indian half-breed, wrote symbolist poetry of deep humanistic significance, *Cantos de vida y esperanza.*

Adela de Ycaza transposes and harmonizes these poems into otherworldly, mystical allegories of naive vision. New forms of life are crystallized out of a reverence for the world and an inner purity from the misty twilight of a lost paradise. Silvery constellations glitter like windows of hope. With idealizing objectivity, she combines men, gods, animals, and plants in a landscape of the soul shimmering with aquarium blue and violet (illus. 102).

The colors and forms of the naive painter Mario Urteaga from Cajamarca, Peru, are reminiscent of the priceless fabrics and costumes of the Incas, whose fading splendor can still be seen today on mummies. The Museum of Modern Art in New York has acquired his picture *The Burial of an Illustrious Man* (illus. 97) done in 1936. This social occasion is presented in the tragic accent and muted tones of a simple folksong.

The mourners are marching against a background of gray-blue, wine-red, and ivory-yellow houses. In the middle, a brown casket is being carried on a litter by men who appear to be the notables of the village, and on their shoulders lies the dead man of importance. At the head of the procession are drummers and buglers, then comes the flag drooped in mourning over the sunless stone pavement. Hand-woven or hand-tied shawls introduce a tentative note of red into the composition; otherwise everything is brown —the casket, the canopy, shoes, hats, and suits. Gravediggers on horseback carry spades across their shoulders. All the men have solemn faces, sad Indian masks appropriate to convention as well as feeling. The musicians in their city hats and with round faces may well belong either to a different class or a different race.

Urteaga's drawing is firm and clear; the plasticity of his figures and the shadings of

his palette resemble forms of gods and warriors in clay on the jars from the Mochica culture of the north coast of Peru.

Felicindo Iglesias y Acevedo comes from Spain, but lives as a wine and spice merchant in Cuba. In his free time he sings and plays in one of Havana's churches. Since 1939 he has been painting glass-hard compositions resembling medieval altarpieces in their simple faith. One of his works, *Christopher Columbus Discovers Cuba* (illus. 100), is composed with the ghostly rigidity of a vision. It moves us with its intensity and experiential power in spite of the painter's lack of artistic skill. It is as though Acevedo had perceived the sublimity and at the same time the deadly gamble of that landing in his heart, and reproduced these in his work.

The art of the Incas in Peru was an influence in Ecuador, Colombia, and Argentina. Not far from the ancient pilgrim shrines, next to the old, geometric forms of the sunburst doors of megalithic temples, Argentine artists in this second half of the twentieth century have developed a constructivist, geometric art based on light and movement. It is a profound coincidence that a number of important artists—Julio Le Parc, Horacio Garcia Rossi, Francisco Sobrino, Marta Boto, Vardanega, Hugo Demarco—have had to bring these electrifying, kinetic suns of experienced light, like a late after-glow of the pre-Columbian sun cult, to Paris and the world.

In Mexico, the culture of the Aztecs has lived on underground in colors and forms. With the revolt against feudalism and academic art which began shortly after 1900, and which gave rise to a school of monumental fresco painting, there developed as well a renewed admiration for folk art. The naive art of Mexico, with its delight in epic narration and its glowing colors, evolved in the works of Diego Rivera, José Clemente Orozco, Rufino Tamayo, Alfaro Siqueiros, and others. It was borne on the crest of a democratic movement which is clearly depicted in the deliberately simplified and monumental idiom of modern Mexican frescoes. Reserves of past cultures blend with influences from modern civilization and contemporary thought.

The pictures of Ezequiel Negrete display a realistic, peasant, and natural strength. His brush strokes serve a naively poetic, simple narrative style, and produce colors of radiance. I have included his painting, *Corn Harvest* (illus. 105). Against the ocher-colored stalks of ripened maize the workers are shown at work and at rest. The heavy ears are broken off and packed into baskets and sacks; burros wait in the shadows. One woman has raised a gourd to her mouth. It is not yet midday, though the light presses down on the landscape with great intensity. Lunch baskets covered with white cloths have been brought into the field, and jars of wine and water. The people's faces are a sepia tone, for they are Indians. They are dressed in wine-red and pale blue linen. The heavy work is both difficult and joyous. Perhaps the nursing mother in the foreground is meant to imply the presence of the madonna of the workers.

The jurist and hotelkeeper Jaime Saldivar and the architect Luis Jaso are self-conscious naives, intellectuals who use pictures as a sign language for their people. Their works are symbolic, and lack the realism of Negrete's.

I would like to mention one last important naive artist of this region, the Mexican José Guadalupe Posada. Born in Aquascalientes in 1851, he belonged to an older generation, and can be considered as a contemporary of Joseph Pickett. The importance of this graphic artist, who as a primitive master draws from the wellsprings of the folk conscience and speaks to the broad masses, lies in his contribution to the awakening of modern art—especially graphic art—in Mexico.

Ezequiel Negrete, Lunch in the Fields, *1958. Detail.*

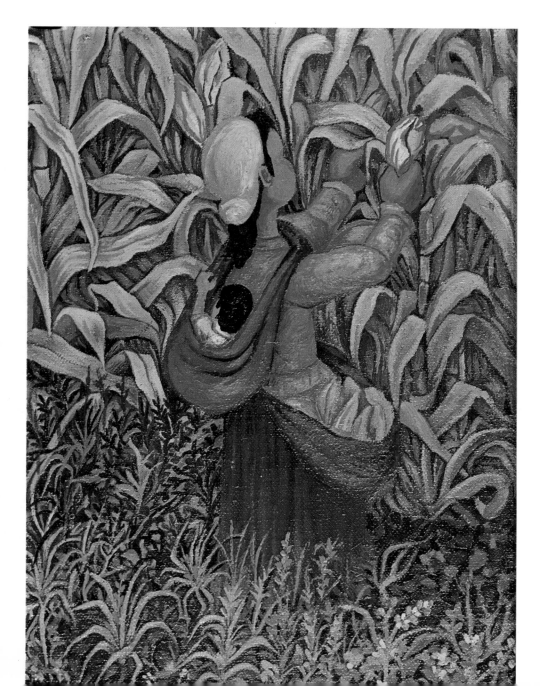

José Guadalupe Posada. Calavera Zapatista.

By 1887 Posada had grown tired of school-teaching and had moved from León to Mexico City. There he began to produce his *corridos, ejemplos,* and *calaveras,* a lasting and devastating chronicle of and witty testimony to the life and suffering of the Mexican people. He created some fifteen thousand prints, either zinc etchings or engravings in steel or lead. They were touching or inflammatory comments on current events, tragedies of love, scandals, and political caricatures addressed to an illiterate populace in clearly understandable black and white, Foolish bravado and brutality, romanticism and aggressive realism, popular humor and melancholy—these characteristics of the soul of the Mexican people pervade his work. The funereal ornamental quality of pre-Columbian sculpture and the allegories of the dance of death in the colonial style of the Spanish Baroque are here united with the gripping narrative talent of the streets.

When Posada died in 1913 his work was completely unknown. But twenty years later his plates were discovered by the Mexican painter Jean Charlot, who published prints from them and exhibited them. Long before the monumental frescoes of modern Mexico had been conceived, Posada had anticipated just such lapidary fullness of Spanish-Indian epic in the folk idiom. In so doing he exercised considerable influence on the development of art in his country, just as the customs official Henri Rousseau did in France.

Naive art in Haiti will be covered in detail in one of the following chapters. Still, it ought to be referred to here, as it too is a force that has helped to shape the spirit of the "other" America.

Africa: Between Archaism, Popular Art, and Naiveté

Wherever archaic cultures come into contact with technical civilization, an artistic crisis is bound to result, one composed of the tension between revolution and tradition, solidarity and dissolution. It is also a truism that with the overthrow of an old form of society its cultural heritage must be forsaken as well, and with a victory over the gods, their art.

The larger distinctions between traditional art and a popular art appealing to the taste of the masses are beginning to disappear.

Throughout the world a kind of art has come to be produced which appeals to the broadest masses of consumers with undeveloped tastes, populations having emerged only recently from the constricting darkness of poverty and ignorance, and having attained but a glimmer of the modern consciousness.

The massive swing toward civilization in our epoch only leads—as has been the case in earlier revolutionary social change—to a leveling of the general cultural achievement. The gap between what is inherited and what derives from the modern spirit is in direct proportion to the degree of disruptiveness and unexpectedness with which social changes are carried out. Great movements toward the emancipation of peoples and races have brought millions of previously unacknowledged people into the sphere of modern civilization: 400 million Hindus, 500 million Chinese, all of Southeast Asia, and Islamic black Africa are striving to participate

Ritual mask of the Songe tribe, Congo

Shop sign for the "New African Barber," signed Willy Arts, Oshogbo, Nigeria.

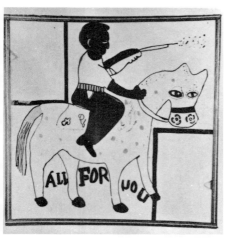

All for You, *Ikorodu, Nigeria.*

in our contemporary, technological culture. This crescendo of development, like an avalanche, is a part of the realignment of peasant and proletarian masses in the social, economic, and political revolutions of our time.

The trend is not proceeding smoothly and uneventfully. Parallel to this movement toward emancipation of peoples and the advance of industrial civilization, reactionary modes of consciousness have developed which are more appropriate to a primitive world in the twilight that precedes the stage of a reflective self-consciousness.

Messianic movements in Africa and America are increasing; Black Muslims, Hindu revivals, sects and confessions formed on the basis of both racist and nationalist ideals. Such quasi-religious movements are not infrequently accompanied by cultist and primitive artistic phenomena.

The Children's Crusade of the Chinese cultural revolution combines the heady mystique of old China with the theses of socialist realism. Hybrids result, blends of an archaic, humanist interpretation of the world from Taoism and Buddhism with the functional technology of a neoprimitivism.

India, on the other hand, still preserves its totem clans, however modified into castes. Yet a spirit like Gandhi could be effective even there, in that he foresaw the threat of further technology to the spiritual life of the people. His was a unique view in the Afro-Asian sphere. In undeveloped countries there is more often a naive faith in the salvation to come from machines. For technology—no matter how well or how poorly it works—is the only possible bridge to the level of existence of advanced civilization. Even in today's world, irrationalism—whether of faith or superstition—lives side by side with knowledge and reason, however it may be threatened by an intellectual outlook. The enlightenment of consciousness can never be reversed, to be sure, but survivals of earlier thought patterns live on in the subconscious.

The political conquest of African territories was achieved at a time when ethnography and art history were still completely oriented toward Europe, and were thus in no position to appreciate the importance of primitive tribal art. Government and missionary schools only tended to reinforce the African's sense of inferiority. His only chance for a good life and development seemed to lie along the route of adaptation to the civilization brought from Europe, and through escape from his own past.

While European artists surfeited with intellect and technology were refreshing their imaginations in contemplation of Africa's carved idols and masks, the Africans themselves were beginning to stir from their sleep of centuries and to wrest free of the idols of

their magicians and the power of the white empires.

Africa's tradition-bound tribal art is quickly evaporating, thanks to contact with industrial civilization. Technology disarms both the gods and their artists. Simple wood carvers and brass founders cannot adapt to the dissolution of tribal society and the development of new and larger political entities. Artistry dies out, and artisans turn to

Shop sign for a portraitist, stamp maker, and bookbinder in Nigeria.

other professions. When it happens that they do hold fast to their techniques, as have the artists of Benin, they tend to produce mere reproductions of past masterworks, and to give them an "antique" patina which will appeal to tourists.

These heirs to a religious and anonymous tribal art are not the ones to explore new ways. The African scholar and collector Uli Baier has described this process well: "Popular art in Africa is characterized by its deliberate divergence from tribal tradition. It flourishes in the cities as the product of a new class, namely that social stratum which has had enough schooling to prohibit its further participation in the old culture, but also too little to admit its full participation in the new possibilities of western civilization" (*Tendenzen,* Special Issue, 1967: "New Art in Africa").

This local art which Baier calls "popular" is produced by petty officials, drivers, mechanics, barbers, and the unemployed—in other words by the lower middle class and the proletariat. Their very bold and evocative

pictures—shop signs, night-club frescoes, commissioned portraits, fair posters, political and historical scenes, and spontaneous landscapes and compositions with figures—have much in common with those of the naives in Europe and America. They are unreflective and reveal an expressive power in their concern for a reality compounded both of what is seen and what is imagined (illus. 106–109). The technical experience of these painters, their artistic understanding, is based on all-too-short apprenticeships or correspondence courses. Motifs from movie posters, illustrated newspapers, and comics produce certain resemblances to the newer configurations of modern painting. A disappearing tribal heritage is thus blended in with the proletarian, pop-art style of a generation which puts the machine and the mechanics of production in the place of the old gods.

A unique branch of this art is the tradition of painting behind glass practiced in Nigeria, one which probably grew out of the practice of adding flowered decorations to picture frames. The technique later asserted its independence, and has become, thanks to its radiant colors and naively emblematic forms, a truly popular local art.

In the Yoruba city of Oshogbo in western Nigeria, a group of artists has developed under the encouragement of the Austrian artist and teacher Susanne Wenger. Her influence has been much like that of the Dutchman De Witt Peters in Haiti, who founded an art center in Port-au-Prince in 1945, and thus gave Haiti's naive painters a chance to earn their living through art.

Compared to the above-mentioned proletarian shop signs with their naive robustness, the work of Asiru Olatunde derives, I feel, directly from a purely African sphere. The metalworker and blacksmith Asiru, who taught himself to read and write the Yoruba language, was at first reluctant to portray the lordly forms of men. Susanne Wenger en-

couraged Asiru to use the ritual drum, which he had learned to play as a boy, as a magical aid to creation. The cult rhythm of the drum in invocation of the African gods enabled him to break through the taboos, and to begin his monumental sculptured sagas and myths of the gods. He hammered his scenes from the heritage of tribal stories and from the Bible on sheets of aluminum. These multifigured compositions, in a pictorial idiom of imaginative simplicity, are of a richness reminiscent of the art of Benin. Benin, the Athens of black Africa, was already remote from him chronologically, if geographically close. These reliefs of men, animals, and plants arranged side by side and in vertical rows show in addition to their naively poetic symbolism and geometric simplification the unconscious memory of a high art once flourishing in this region (illus. 110).

Asiru Olatunde, Scenes From the Life of the Yoruba. *Detail.*

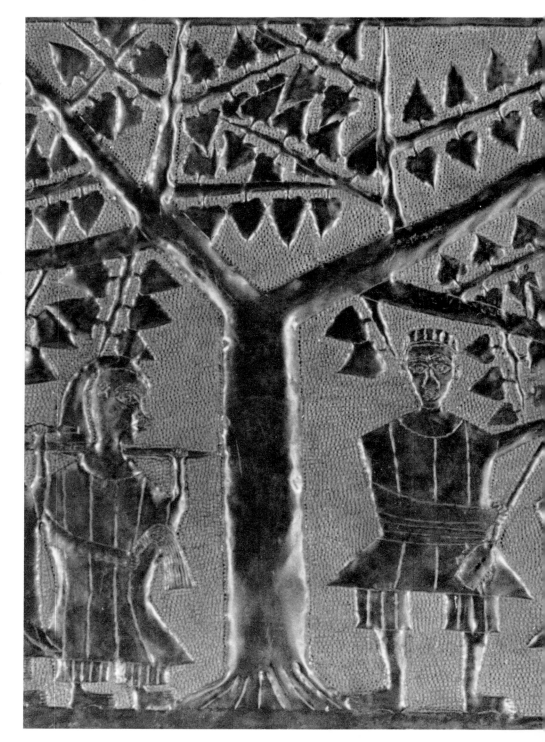

Haiti:
Between Gods,
Poets, and Dealers

Columbus discovered the small island of Haiti in the Caribbean and called it España-ola. Its rich gold deposits later attracted Spanish exploration inland. In the beginning, the native Indians were used to work the mines, then Caribs from the Bahama Islands, and finally Negro slaves brought from Africa. Spanish, French, and English cultural and political forces were to mix with archaic and primitive ones; Catholic ritual became diluted with the secret cults of voodoo, the Negro's belief in fetishes, and the dying myth forms of Indian rites.

Slaves mostly came from Dahomey, from the Yoruba country, and from the Congo. The regions they were taken from had rich artistic traditions, and these were to slumber in the souls of the blacks in Haiti even though it would be a long time until they were reawakened. The Negroes brought with them another tradition too, namely the snake cult from Vida and Allada in Dahomey. This was crossed with Christian, Catholic elements preserving certain magical atavisms of their own, and thus developed the secret religion of voodoo. Its entreaties to dead ancestors and gods, its ecstatic dances, and its initiation rites created a secret order which rose up first against the Spanish plantation owners and later against the French. During a voodoo celebration on the night of August 14, 1791, the exploited Haitians were inspired to take up the fight for their independence which was to rage for twelve years. A blood pact between those from Dahomey and the incendiary ideas of equality and freedom propagated by the French Revolution gave these poorly armed fighters the strength with which to give the Consul, Napoleon Bonaparte, his first taste of defeat. In 1793, the Convention in Paris declared the abolition of slavery in Haiti, and the island's independence.

Under the leadership of the black general Toussaint L'Ouverture, the Spanish part of the island was liberated. Jean-Jacques Dessalines routed the French, crowned himself emperor, and gave back the original Indian name of Haiti to the island of Saint Domingue.

About a century later, the economic and political influence of the United States of America began to be felt in the Caribbean islands.

Without knowing it, these people emancipating themselves from imperialism simply exchanged one yoke for another, for even out of the native population there arose power groups representing their own interests and not the interest of society at large. There persists an upper class in Haiti which once identified with the French colonialists and now feels bound to the United States. Even in the most recent past, the dictatorship of Duvalier has led to revolutionary uprisings which had to be squelched with the help of American warships.

In his foreword to Franz Fanon's book *The Wretched of the Earth,* Jean-Paul Sartre writes: "What was once only a religious phenomenon, a certain way of communication between the faithful and their saints, is becoming an antidote to despair and humiliation. The Czars, the Loas, the holy ones of the tribe, descend to their devotees, take over their wills, and ravish them in a state of trance until they are utterly exhausted. At the same time, the faithful are shielded by these high personages, that is, these colonized peoples defend themselves against colonial disorientation by intensifying the disorientation of their religion. . . ."

Voodoo's anachronistic belief in spirits arose as an unconscious withdrawal from antagonistic, foreign surroundings, and solidified the community of the blacks. Thanks to the blacks' potent natural gift for the pictorial language of color and form, a unique art would arise in this same community. Haiti was rediscovered—this time as an island of artistic sensitivity and colorful narrative power.

The members of the ruling class, however, usually part Spanish or French, consider voodoo and naive art to be remnants of a primitive African past which should be scorned and eliminated. Thus wealthy property owners in the capital, with spiritual ties to France, abandoned the cathedral of the Holy Trinity when its farsighted Bishop Voegeli decided to have the church walls decorated with frescoes of Christian legends by seven naive painters. A monument of naive art was the result—the Sistine Chapel of the blacks.

The Dutchman De Witt Peters went to Haiti in 1943 to supervise instruction in the English language in behalf of the American Department of Education. After six months he resigned his position as a language teacher, for he had come to recognize the originality and power of the naive Haitian painters, and chose to dedicate himself to their artistic encouragement. In 1945 he set up an art center in Port-au-Prince where he gathered together the more talented painters, and where the first exhibits of naive art in Haiti were held.

Peters came to know the voodoo priest Hector Hyppolite, a painter of secret rites

and incantations. In his youth, Hyppolite had traveled through America and Africa. His painting has something of the spirit with which Christian Negroes approach the Bible. It was his suggestive imagery which inspired the surrealist Cuban painter Wilfredo Lam and the poet André Breton to write about this Haitian art.

The Loas told the painter-priest Hyppolite (illus. 111, 197) what to paint, and though a painter of voodoo he frequently included a Christian cross in his ritual compositions. In his *General Bauron Brings an Offering to the God Bobo* (1946) two men are bending over a sacrificial stone. One wears a crown and holds a knife in his left hand and a rooster in his right. The second one is ringing a bell. In addition one can see a green palm tree growing in a vase, a bowl full of glowing raw red meat into which a stiletto has been stabbed, and some gourdlike jars ornamented with pearls and such. There is also a leafless tree and an erect, rigid cross. This is a dramatic scene against a radiant background.

La Dame de Bau Voir (1947) is the snake goddess, a powerfully coiled serpentine body with a woman's head and breasts and wings suggestive of her divinity. The face is brooding and almost threatening. The room in which the serpent lies is like a stage, with curtains that might well close again after her appearance. Below her are standing flower pots in radiant blue, red, gray, and bright orange.

Sheldon Williams writes that the priests, or hougans, first commanded the Haitian painters to put their art in the service of the Loas, the gods. In so doing they began to create furniture, pots, flags, pictures, and wall paintings.

Next to Hyppolite it is chiefly Philomé Obin who inspires the younger talents of Haiti. Both were already painting when De Witt Peters arrived in Port-au-Prince, and soon thereafter a great number of other artists had gathered around them. Obin was originally a clerk, then a barber, a coffee merchant, and an interior painter. With naively realistic objectivity he depicts scenes from the lives of his contemporaries and from Haiti's history. The *Funeral of Charlemagne Péralte* (1946) shows the gloomy grandeur of a resistance fighter's death. Péralte was killed during the American occupation (1918–1922) and is worshiped as a martyr who has since been elevated into the ranks of the Loas. Obin has celebrated this folk hero and now mythical figure in his picture. The painter has united external ceremonial events and the inward experience of mourning with narrative precision and a rigid sense of order. A painterly sensitivity compensates for a certain simplicity in his drawing.

Obin has painted quite recently (1968) the meeting between Jean-Jacques Dessalines, the black Haitian dictator, and the French ambassador, Alexandre Pétion. They are toasting each other while a black woman smiles courteously in the background. A door leads out of the room into a bright landscape.

One theme which has appeared in numerous variations in the painting of Haiti, and which continues to occupy the imagination of naive painters, is the story of Toussaint. Though born the child of a slave, this hero managed to get an education while serving as a carriage driver for a plantation owner by reading through his master's library at night. He became a leader of the Haitian independence movement, and as such he stands as the central figure in Obin's composition *Toussaint L'Ouverture Receives a Messenger from the First Consul*. The messenger from France, in his gray civilian clothes and with a three-cornered hat under his arm, is holding a rolled reddish-brown document in his hands. He stands before Toussaint who in his splendid uniform symbolizes a liberated Haiti, a black Napoleon with a dictator's love of protocol. The dark-eyed woman beside him holding a shy and delicate child is doubtless the hero's wife. Above the scene,

André Pierre, Linglinsou, Bassin Sang.

amid tropical palms, red jungle birds are fluttering in the new air of hope. The composition is perfectly controlled, harmonious, and painterly in its luminous shades of gray, wine red, blue, and velvet green.

Three painters bear the surname Obin: Philomé, whom we have just discussed, is the teacher of Senèque and Antoine. Senèque has done a painting of a freemason's funeral showing a train of mourners accompanying a narrow coffin lying on a cart. Flags lead the procession, then come relatives and friends, and finally the most distant acquaintances and the curious. The symbol of the lodge can be seen on the gable of a house: a compass and square. The painter has managed to communicate the slow movement of a line of mourners with great skill.

Antoine Obin portrays political situations. One of his pictures he calls *Unity in Strength*. Dessalines, the black dictator, is shaking the hand of Pétion. Two black bodyguards stand in ceremonial uniform, one on either side. The two heroes are drawn in profile; mirror images of the same one face. But the white man, M. Pétion, is in a blue uniform, while the black ruler's is red. Rich contrasts enliven the scene.

The works of Enguerrand Gourgue show a certain similarity to Hyppolite. Characteristic of his work is its blend of elements from pre-Christian cults, folklore, and modern objectivity.

Wilson Bigaud (illus. 112) was another one of the group formed about Hyppolite. This painter has recorded the poisonous darkness and dangerous splendor of tropical vegetation, and its secretive violence. One painting shows wild men wielding clubs and attacking a group of peaceful men and women harvesting tropical fruit. His are scenes of death and violence in the brilliant colors of a bird of paradise, infused with the hoarse, dissonant screams of parrots.

Castera Bazile (illus. 113), a messenger and porter in the art center of Port-au-Prince, became one of the best and most harmonious painters of the Haitian school. The men he paints are not idlers, but rather respectable men of affairs.

In his *Ceremony Around a Holy Tree* (1962) Bazile combines a fruit harvest with a festival of voodoo cultists. A man is sitting in a tall palmlike tree, stabbing his knife into its bark and lifting down a piece of fruit. A pearl necklace adorns the trunk of the tree. Seven figures are standing below him. Everything is given in strong, familiar colors: reddish purple, yellow-orange, shell pink, blue-green, and turquoise.

Of all the Haitian artists, Gerard Valçin (illus. 205) seems to me to have preserved most of the primeval rhythm of black Africa. His pictures of workers and of ritual, with their multifigured composition, their rhythmically ordered parallel lines, and their ornamented action, recall the anonymous pictorial symbolism of African wood carving. Between 1963 and 1965 he produced numerous variations of his picture *Collective Field-Work*. In front of dark green, glowing mountains framed by trees with birchlike leaves and bare, cut tops, he shows a field full of laborers. Low green plants—tobacco, sugar, or maize—grow in the wavy furrows. The men's shirts draped on branches of the trees provide welcome bright accents. Horses graze in the middle distance while the blue men are working together to break up the soil. Their tools form patterns of parallel lines echoed by an ornamental wooden fence. Each movement is somehow repeated; the attitude of the men, their hats, and the position of their feet which is one of work and dance at the same time. The harmonious forms are actually complemented by music, as the sound of flutelike instruments reinforces the sense of collective activity. Valçin is a highly skilled painter who combines a very ancient and a modern sensibility.

André Pierre, a voodoo priest, carries on the work of Hyppolite. Most of his pictures are concerned with the explication of voodoo mythology. In a naive and mannerist fashion, as though his hand were guided by an outside force, he paints a weird masquerade of godly forms. He claims that his pictures are indeed painted in accord with the dictates of the Loas. The gods appear in stately arrangements and with fairy-tale pomp, as, for example, his mistress of the waters who blows her trumpet with ecstatic vigor and thus lays all her animals under a spell. Emerging from a sacred spring, and clothed only by its waters, she is clearly the ruler of the three domains, the water and its fishes, the earth with its serpents, and the air full of birds. All life attends to the will of this Haitian Venus, whom the painter calls simply "Sirèna."

André Pierre has painted several versions of a sacrificial feast offered annually to the gods. In lush colors and bedecked with rich jewels, the deities rise up out of the sea—epiphany, sacrifice, and adulation. People come with musical instruments and offerings from far away, for the divinities bring long life and happiness to those who believe (illus. 115).

I have been able to name only a few of the great number of Haitian painters. Let me add just one more. His name was La Forest, also written Forêt, and his dates are unclear; we only know that he died in the late fifties or early sixties. His portraits and paintings of groups are simpler in form and more subdued in color than are those of the other painters of Haiti. The piercing eyes and in-

tense expressions of his faces are sometimes reminiscent of mummy portraits from Fayum.

La Forest has portrayed himself in a garden in front of a temple, of which he may well have been the priest. Dressed in gray, brown, and blue, he is sitting in a swing in quiet meditation. Plants border the picture.

The painting of Haiti is represented in many of the larger exhibits of naive art today. In 1961, in the art gallery in Baden-Baden, I saw an extensive collection brought over by Dietrich Mahlow. More recently Kurt Bachmann has displayed his excellent collection in various European art centers. Sent to Haiti as the employee of an American welfare organization, Bachmann was immediately taken by the beauty and intensity of this art, and it soon became his chief interest.

Bachmann wrote for the catalogue of one of his exhibits: "This untrained and to a great extent unlettered people has found old images and visions which have never been painted before. Many came from the remote countries of Africa, but when I look at their work I feel strongly—and somewhat mysteriously—that they are an integral part of my own world. . . ."

There may be as many as five hundred naive artists working in Haiti today. Most of them are painters, but there are also sculptors among them. From all parts of the country they converge on the capital of Port-au-Prince where their art center and the many galleries encourage them. Nowhere has naive art found such a broad base as it has in Haiti. Why this sudden blossoming? And what is art in Haiti really like?

In a study on Haiti and voodoo, Sheldon Williams has written that a lively market, and not only the spiritual inspiration of voodoo tradition, has spurred such mass creativity. In this tropical Caribbean world, one in which few would choose to work without immediate reward, naive painters are also motivated by the chance for a certain security in their lives. Today there are firm contractual ties between artists and dealers, and even though Haitian painters may also find personal satisfaction through creative activity, it is also true that they work directly for the market, or more specifically these dealers. During periods of lesser demand, they tend to turn to other occupations until the market is again receptive.

Painting in Haiti is threatening to become a kind of naive pictorial home industry. Its mass production is like that of fetishes for tourists by contemporary African wood carvers.

Henri Rousseau, the great master of the modern primitives, bore within himself an unquenchable longing for a legendary jungle landscape of archetypal vegetation. Oddly enough, the fictitious painted world of Rousseau seems more factual in its intensity than that recorded by many Haitian painters from their immediate surroundings. At times their secretive scenes of voodoo ceremony appear to be but banal, contrived passion plays set up for tourists.

The painters of Haiti stand midway between the old gods and the new promoters. Only the most gifted among them can resist commercial temptation, and these are Haiti's true naive masters.

This art is not alone in being susceptible to commercialism; temptations exist in professional as well as naive art. But the significance of naive painting in Haiti is special; wherever its integrity is preserved it seems like the last great lightning flash of a religious art combining naive imagery with a primeval African identity.

In Haiti, the art of the blacks is uniformly compelling, but voodoo gods also exist in Cuba, Brazil, and El Salvador. A second Africa has been founded in America, an art which—though not as aggressive as the Black Power movement—is an articulate voice in the struggle between blacks and whites on the American continent.

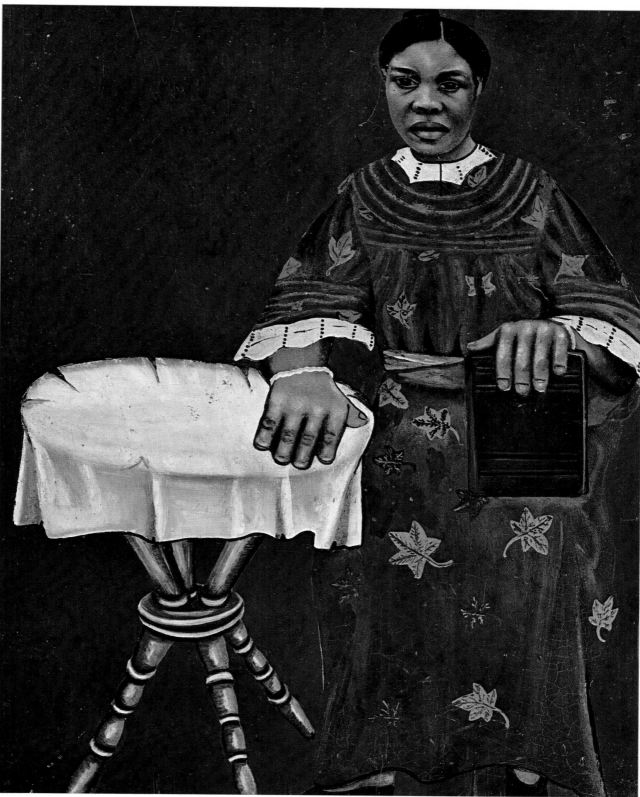

106

106. Portrait of a Seated Woman, *unknown Nigerian artist*

With their emancipation from the dominion of the whites, the young people of Nigeria also struggle to be free of the magicians and and idols of their past. Tradition-bound tribal arts are disappearing in their confrontation with technological civilization.

Artist-craftsmen, graphic artists, sign painters—all are fascinated by the abundance of images carried by the mass media,

melodramatic film posters, insistent advertisements, and brightly colored and dynamic comics and cartoons. The change from a world dominated by ancestors, spirits, and myths to one controlled by rationalism and the machine has been direct and swift. Elemental narrative gifts and a highly instinctive attachment to life insure the authentic force of this dilettantish painting. The human portraits of this new African painting are signs of a naive and plebeian pop art.

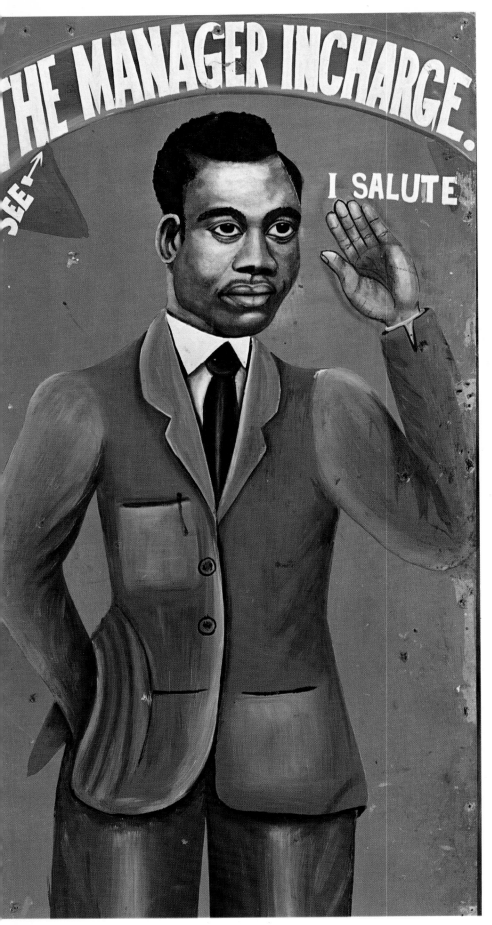

107. The Manager in Charge, *shop sign by the Nigerian painter "Middle Art"*

108. The Woman in Blue, *unknown Nigerian painter*

109. The Family, *unknown Nigerian painter*

The popular figurative painting of young Nigerian artists has little in common with the tribal arts of the bronze casters from Ife and Benin or the wood carvers of Yoruba. These gifted painters from among the people, usually from the lower middle class or the rising proletariat, adopt the external form of a realism in which anatomy and perspective are applied quite naively and in the spirit of photography. This unconscious depiction of reality gives their work a certain similarity to the quite conscious realism of the pop artists who tend to put objects themselves into their pictures instead of copies of them. Robert Rauschenberg, for example, has said: "I don't want a picture to look like something it isn't. I want it to look like what it is. I feel that a picture is more real when it is made of pieces of the real world."

Colette Omagbai, a black artist from Benin, has written with a certain irony and criticism of the "false" reality required by African artists: "Give us pictures full of salad. Full of ice-cream colors. I love the pale pink of ice cream, as soft as little children's frilly dresses, the sweet heavenly blue of a summer day, and the bright yellow of lemons. Don't give me even a suggestion of black. . . . If you can paint, my friend—in such a paternal tone the public addresses its artists— paste real hair, real fingernails, and real teeth on the figures on your canvas. I love to touch them as though I were touching them in real life. . . ."

These remarks could also be applied to pop art. They touch critically on the reality of the supermarket, of the amusement machines of industrialized countries, and the mannequin smiles of sex queens in both hemispheres.

The black "manager" is a reincarnation of the tribal chief. And there is something of the Hollywood hero about him with his cool, commanding glance and his hand slightly raised in greeting. The figure is in blue-violet against a sepia background. Possibly this is the painter himself, advertising his skill as a portraitist.

The Woman in Blue *with her gleaming teeth and expressive eyes has turned her face toward us. The black gentleman in a tuxedo is keeping his hand on her shoulder, possibly to reassure us that she is his.*

The family trio stands before us in motionless and conventional factuality. The three faces are turned to the side, each done according to the same formula, with wide eyes under jet-black hair and a Sunday smile playing about the mouth. The son is a dwarfed adult; the mother is wearing

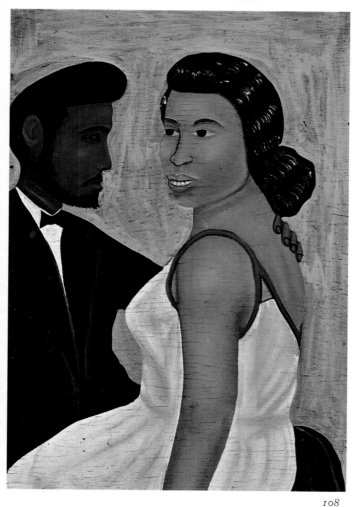

a lemon-yellow scarf and blouse, a pastel blue belt, and a gay red skirt. These are the ice-cream colors of urbanization, and of the dream of well-being, success, and elegance.

The empty smile and false dignity of convention are met everywhere in the pop paintings of young African artists. Perhaps a memory of the old fetishes is lurking in them, those little figures dressed with feathers, teeth, shells, and masks, or decorated with nails as health charms. Whatever these Nigerian pop artists paint is produced with elemental gifts and an instinctive vitality that is touching and impressive.

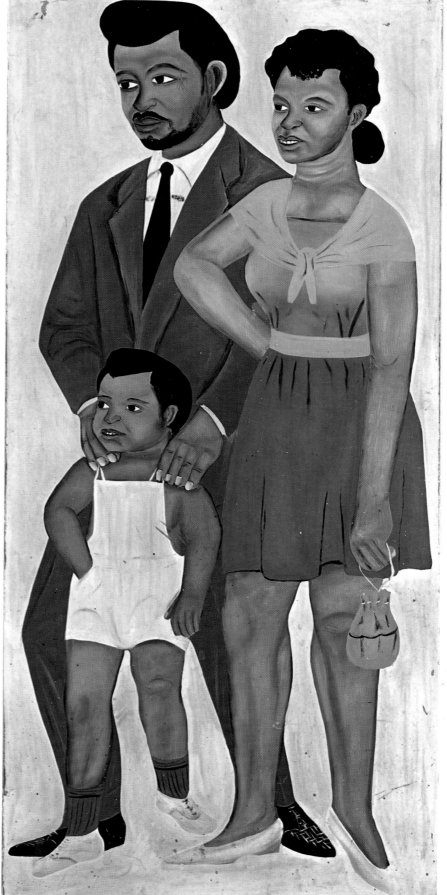

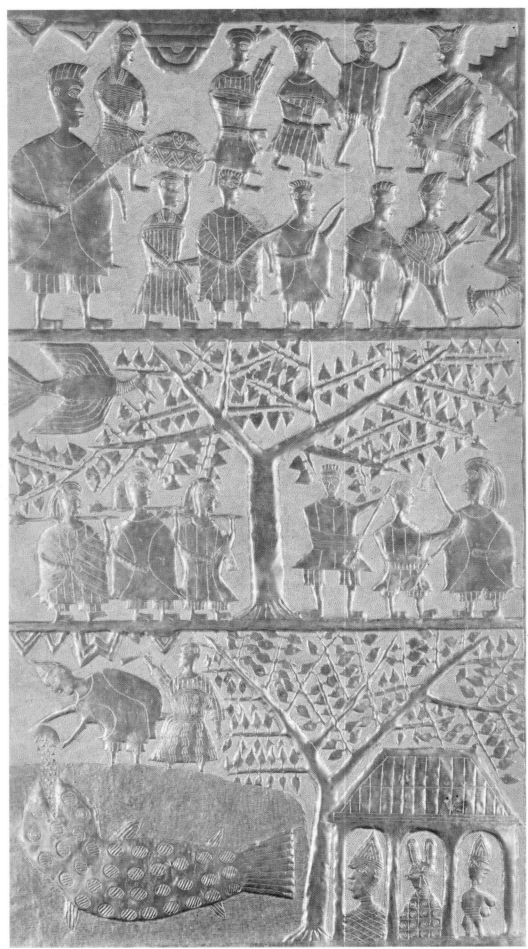

110

110. Asiru Olatunde, Daniel in the Lion's
Den and Other Biblical Scenes

111

112

111. Hector Hyppolite, Woman in Flowers, *1947*

A spirit-infused nature and divine magic can be found in Hector Hyppolite's ethereal portraits and poetic pictures of flowers and women, and not only in his religious compositions. This picture shows a black beauty surrounded by lush tropical growth and idyllic birds. The girl's agate-brown body stands out clearly against the light background. Flamingolike birds, ocher-colored fruits, soft pastel blossoms, and the rhythmic repetition of faded rose and Bordeaux red give the total composition the muted splendor of a precious Gobelin.

112. Wilson Bigaud, Girl With Peacocks

I deliberately place Wilson Bigaud's Girl with Peacocks *next to Hyppolite's charming nude. Here is quite a different range of colors, but still it could almost be the same painter. Bigaud's girl has raised her left hand, in which is perched a tiny bird. Her head is slightly tilted, her eyes veiled with a certain melancholy. Her naked bronze body is flanked by two large birds which are resting in the ice-blue branches forming the frame. Pale rose blossoms dot the tropical scene. The precious violet peacocks with their golden trains have raised their delicate heads as though in conversation with this girl, who may be a love goddess.*

113. *Castera Bazile,* Farm Scene, 1952

Bazile's Farm Scene *reveals a strong and sure feeling for space
and color, and a frescolike composition. Three slender figures,
a man and two women, are hard at work making hemp rope.
On the left side of the picture is a cloud-blue farmhouse with
an orange door, on the right a reddish-brown tree with blue-
green leaves and glowing red round fruit. Below the tree's
branches stand the two women, one in light blue and the other
in an ivy-green dress. Their brown faces are framed by ocher-
colored and orange scarves. The man in a white hat, white shirt,
and blue work pants is sitting on the pole around which the rope
is wound. He calmly smokes a pipe while he works. A child in
a scarlet dress stands in the background watching the work and
eating a piece of fruit. A logical sense of order gives the dynamic
work a calm dignity.*

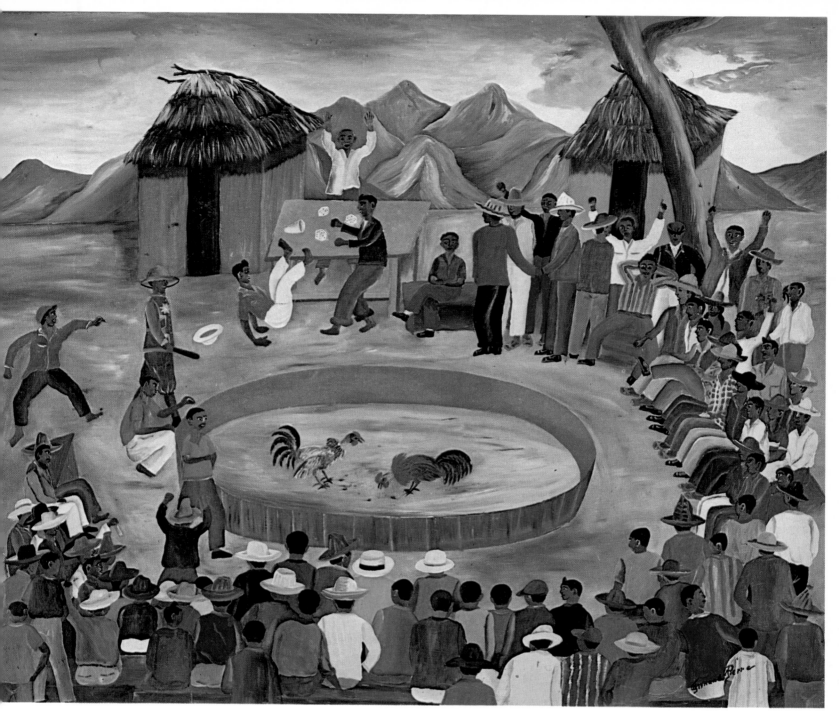

114. *Fernand Pierre*, Cockfight

*Here is presented a Haitian festival against a ritual back-
ground. In the center is the arena with its fiercely fighting
cocks. The participants gesticulate wildly. The painter
has described the main event and the secondary details
in a grotesque manner. A table bearing sacrifices to the
gods stands between the earth-colored hut and the yellow
thatched one. A thief who has attempted to steal a piece
of the offering for himself during the distraction of the
fight is being beaten by a watchful guard. All the partici-
pants, the spectators, the sponsors, and the poor birds
themselves are actors in a common celebration which
has been painted with droll humor and strong colors. In
the background a heavy blue sky hangs over ultramarine-
blue mountains.*

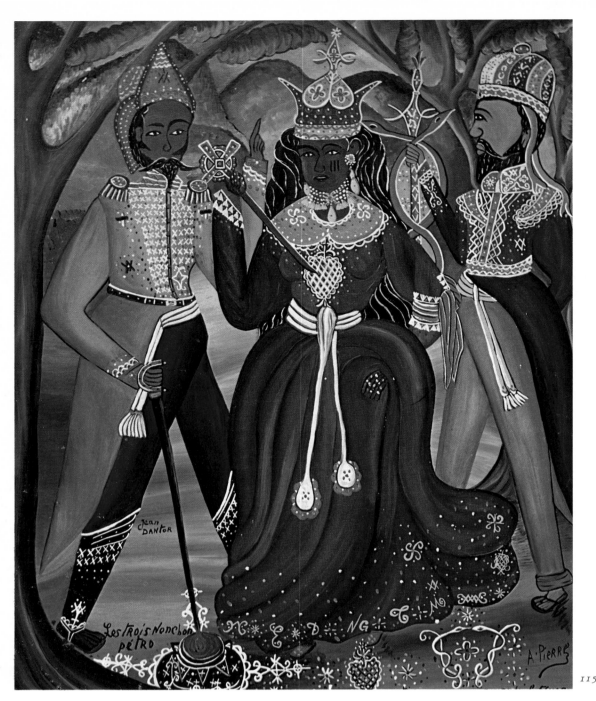

115. *André Pierre,* The Voodoo Divinities Dambala
al'Flambeau and Jean Dantor and the Goddess Erzulie Dantor,
circa 1965

*The iconological significance in religion and art of the complex
of deities in Haiti is difficult and seldom stable, as this pantheon
is in a state of reincarnation and metamorphosis. To be sure,
it is possible and necessary to recognize primal African imagery·
here as well, those ancestral deities from the catacombs of time
have been transfigured in the culture of the Caribbean and of
Latin America, and have been confused with the heroes of the
emancipation. They appear in naive costumes which are often
enriched with the allegories of Christendom. The forms the
naive Haitian painters give to their Loas and demons are both
primitive and fantastic.*

*André Pierre's depictions of the gods are probably not "ortho-
dox." The enchanting goddess Erzulie Dantor appears in a
regal blue long dress with a crown and scepter, accompanied
by the two male deities in sepia-brown tails. The group is framed
by the exotic vegetation of the island. Dambala's light parch-
ment face is shown in rigid profile, while those of the two blacks
are turned directly toward us with their gleaming eyes.*

Excursus
on Naive Sculpture

Chapter X

Mijo Smok, Head of a Girl, *1959.*

Early, Modern, and Timeless Naiveté

In our time, when classical concepts of sculpture have become illusory and traditional forms and techniques are being supplanted in exhibits and art galleries—by body casting, sculptural collages, environments, constructions of plexiglass and fluorescent and neon light, "package art," floating sculpture, color-space objects, minimal forms, alienating and "found" sculpture—it seems wise to stop for a moment to trace the current boundaries between sculpture, nonsculpture, and naive sculpture.

Sculptural expression in the twentieth century runs from traditional realism to abstraction and the total dissolution of form, from strict logic to scarcely ordered chance, and from the use of the classical materials of bronze and stone to that of artificial products of industry and the most worthless of objects either found or fabricated.

But whatever happens across this broad span of artistic endeavor is still a conscious or instinctual, historically determined style of art or antiart reflecting the spirit of the times.

The sculpture of naives, on the contrary—inasmuch as it can be called sculpture at all —lies outside any such distinctions or stylistic trends. Naive artists construct neither visually organic nor abstract copies of nature. Like children and primitive peoples, they do not form what they actually see, but rather what they think and believe. In absolute defiance of visual logic, they accentuate what seems to them most important in their themes, and neglect everything of lesser significance in the context of their representation.

In those rare cases when naive sculpture is completely spontaneous, it is of course unaffected by tradition and by changes in aesthetic fashion.

We tend to consider lay painting and the work of modern primitive artists as a last manifestation of peasant art. But we seldom speak of the continuance of an instinctual plastic art among the mass of the people, though sculpture is the most ancient as well as the most modern of artistic media. .

While the originality, poetic immediacy, and childish delight of naive painting exercise an ever-increasing power over us, naive sculpture has remained practically unnoticed by students and lovers of art. Obviously the color and line of painting can satisfy one's desire for expression more immediately than can the more challenging materials of sculpture. Since Henri Rousseau it seems that naive painting is particularly suited as a means of recalling the lost paradise of a wholeness of vision and communication.

This is all the more apparent when one recalls that the artistic imagination of our century, after having succumbed to a surfeit of intellect and technology, achieved a rebirth and a vital new breath through the study of archaic and primitive sculpture. The art forms of advanced civilization, dissipated through illusionism and empty virtuosity, were to be revitalized after contact with the sculpture of Africa and its strong and mysterious magnetism. Between the sculpture of antiquity and that of folk art there is a certain affinity; the practical forms used by herders and farmers are sufficient testimony to this, whether they be shepherds' crooks or furniture carved in wood, or grave markers naively carved in stone.

Yugoslavia has excellent examples of medieval folk art in its funeral steles of Bosnia

and Herzegovina (illus. 6, 128, 129). These can still be found alongside country roads, in forests and fields, and on mountaintops where they have stood since at least the twelfth century. Anonymous stonecutters belonged to the Bogomil heresy, a movement in revolt both against the pope and against the Orthodox hierarchy. The monumental hunting scenes and circles of dancers which they carved onto these grave markers are a part of the formal idiom of Slavic shepherd and farming culture.

Their archaic inventiveness and the directness of their gnostic faith allowed these Bogomil sculptors to achieve the seemingly impossible and create over 30,000 steles. The Bogomil stones are an artistic manifestation of total conviction and faith.

Another variety of rustic sculpture was developed in the sixteenth century and lives on into the present, the art of gravestones made for village cemeteries in Serbia (illus. 133, 135–137).

The other-worldly figures on these stones have a delightfully naive rigidity; with the

"Raised Hand," detail from a Bogomil stone from Radimlja, Herzagovina.

simple lines of children's art they try to interpret the revelation of the inexpressible. They incorporate all manner of zoological forms, creatures with sun disks instead of heads, angular and geometrical figures arranged with severe sobriety, quite everyday people, and images of death. Once these tombstones were painted in the bright colors of folklore, but today they have weathered until only in the deepest cuts is there a trace

of them adhering to the stone.

When art criticism finally turned to look at naive sculpture, it did so with a mien of condescension which was felt to be appropriate to those scurrilous and very strange forms created by loners outside the bustle of the city, by convicts, lighthouse keepers, seamen and fishermen, or by country folk trapped by long winters on isolated farms, and worked in wood, cork, shells, wax, clay, or stone. Some naives, like the Abbé Fouré, have devoted years out of their lives to the carving of human shapes into the natural rock of rugged cliffs (illus. 141). Or there is the postman Fernand Cheval who took decades to build his fairy castle, the *Palais Ideal,* in the village of Dauphiné out of stones and shells he collected himself (illus. 143–145).

Anatole Jakowsky tells of the Abbé Fouré in his book, *Demons and Miracles,* and how this solitary, possessed worker populated a segment of the steep coastline near Saint-Malo with his now famous monumental figures.

Following suggested and intuited natural shapes formed of the folds, veins, twistings, and clefts in the stone, he constructed faces, bodies, and whole pictures on the face of the cliffs. He gave life to his material through the fascinating imaginativeness of his naive vision. The Abbé's figures have preserved the heavy factuality of these outcroppings; they seem to have inhabited the shoreline forever. This untrained sculptor began to chisel out these forms in a fanatical urge to breathe life into a dead material.

Just as the postal inspector Louis Vivin was to capture with the painstaking strokes of his pointed brush the squares and bridges he had crossed in the endless walking of his profession, the country letter carrier Fernand Cheval diligently created an enchanted castle over a period of thirty-four years from the stones picked up and carried home along his daily circuit.

The plan of his architecture was given him in dreams—or at least so he writes in his journal. "I am a farmer's son, and a farmer myself. My life should prove that even among people of my kind there are men of genius and accomplishment. . . . I built my palace and grotto in a dream. . . ."

Fernand Cheval constructed the whimsical architecture of his fancy from a mixture of lime, cement, iron girders, and masonry. On the west façade, which resembles a mosque, stands the main entrance to the "palace." Beneath this is an Indian temple, and beside it are a Swiss cottage, the White House, the Algerian House of Dice, and a medieval castle. Inside are a labyrinth, a catacomb, and a terrace leading up from the steps to the little enthroned spirit that illuminates the world. A grotto with three giants in it has

Anthropomorphic shepherd's staff.

Fernand Cheval, west gate of the Palais Idéal *in Hauterives, Drôme, France.*

quite an Egyptian look about it. Also, a burial vault was provided in which the simple postman wanted to be laid to rest in the manner of the pharaohs.

This irrational, illogical blend of anachronistic and transplanted styles and forms comprises an eclectic ensemble of an absurd and mysterious fascination. A commonplace imagination accentuated by his personal mannerism is reflected in these variations on historical styles. The technical freedom of this self-taught builder, who in his freedom from architectural rules invented everything anew, gives the dreamlike structure a touch of the surreal.

This habitable sculpture became a monumental self-analysis of the poor and limited life of a letter carrier. Cheval conquered his actual poverty and limitations through this wish projection of an ideal palace. Its stylistic splendor, with interiors lined with fabulous beasts, served as a clear compensation. His feelings of inferiority in an anonymous career were eased by his infantile but creative talent for form.

Naive sculpture is often found on the borderline of folk art. It takes its last, whimsical inspiration from a dying tradition of peasant creativity. Two men in Poland have created stunning figures of saints which in their singularity and sincerity show a deep religious feeling and seem to transcend tradition. These are the miner, stonecutter, logger, and junk dealer Jedrzej Wawro (illus. 153), and the day laborer, postman, and shopkeeper Leon Kudla (illus. 151, 152, 154). A vital strength in naive imagery characterizes the towering clay assemblages of flowers, birds, and animals made by the potter Stanislav Zagajevski, and the figured chests of the one-time handyman and blacksmith, Zygmund Skretowicz, which are decorated with the tragic, ghostly figures of Auschwitz and Bergen-Belsen.

In Rumania it is Neculai Popa (illus. 148), a farmer in the workers' collective of Tirpesti-Neamt, who carries forward the anonymous folklore heritage into the vicinity of naive art with a personal, imaginative touch.

The Slovak shepherd and farmer Jozef Kemko has also invented figures of men and animals which still belong to the conceptual world of folk tradition. But in spite of his indebtedness to tradition, Kemko manages to produce the unexpected and to create out of himself collective archetypes. His portrait of Janošik, the legendary rebel and peasant challenger of feudal authority, stands carved in unpainted wood, the patterns of his folk costume in deep relief, and his black hat lying flat on his round head.

The architectonic gravity of Kemko's figures is quite a contrast to the light, plantlike wire figures of Jozef Kerak. This artist was a wiremaker and tinsmith who went from town to town mending pots and pans. His figure *Ježibaba*—doubtless a witch from the mists of Slavic fable—is an enchantress carrying an owl on her stooped shoulder. Kerak has twisted his forms of men, women, and animals out of wire, cleverly holding them together, where necessary, with leather strips. His naive constructions, with their curves and sculptural modulations, seem to transcend the physical, reminding one of the traditional straw figures of Argentine folk art—or even the glass figures of Oskar Schlemmer's *Triadic Ballet*. Thus with simple wire figures, a primitive village artist has unsuspectingly come close to the spatial compositions of modern art which manage to catch a kind of movement which is transparent and otherwise ineffable.

Bogosav Živković:
An Enchanted
Garden in Leskovac

One often says of a farmer that he is "as though carved in wood," stiff, awkward, strong, and resistant. Živković's sculptures are not only carved in wood, they are born of it, and still bear the essential character of the material. The men and fabulous creatures he creates are strange, surprising, and at the same time familiar, as though one had come across them while reading an old fairy tale. Animal heads on human bodies, centaurs, miraculous beasts resembling the decorated initials of old Serbian manuscripts, and men and women not far removed from those on tombstones in country cemeteries and along the local roads. Flower stalks and tall columns composed of human figures, houses, exotic animals, and rank vegetation reveal both the skill and imagination of this naive artist and his sense of total composition.

Just as the human and animal heads on Indian totem poles from the northwest coast of America represent dead ancestors and have a supraindividual significance, Živković's heads are also the most expressive parts of his sculpture. It sometimes even happens that he will construct a straight vertical shaft composed of heads without bodies, complete in themselves, but also the monumental columns made up of half-human and miraculous creatures are dominated by faces (illus. 121, 126).

According to some archaic perception, the relative sizes of his components are not kept within the limits of reason and perspective, but rather determined by a childlike and naive sensibility, so that faces representing the soul are given the most intense and most evocative detail. Men, animals, and plants are all one in this unsophisticated world; good and bad are but two sides of the same thing. The creatures and things of the everyday world are enlivened by a current of uncommon intensity, and transposed into the atypically miraculous. The medium itself, the grain of the wood and the knots and branchings of the tree, plays its part in giving the figures their rhythm and compactness.

The more closely we examine Živković's work, the more we recognize how various and at the same time unindividuated the faces of his figures are. Men have bearded muzzles and grotesquely vinelike ears; the faces of women are framed by the suggestion of a hair style and a headdress. Young girls wear long braids, and their arms appear to have fused together under their flowing gowns. Nuns have faces shrunken with resignation and self-denial, while the rest of their bodies is completely denied under medieval habits of rigorous simplicity.

The creatures sprout intertwining limbs which metamorphose from man to animal and animal to plant; each figure braces itself on one below, or supports the next one in its climb toward the top of the column. In his nocturnal visions, threatening animals are carrying birds of death on their backs, while heads supporting houses portend still darker realms. Sometimes the faces display a faint attempted smile, but more often they are utterly passive in meditation of their wooden existence.

Pain and oppression can also be found in these faces, staring as they do with owl-like eyes. But Živković does not carve episodes from war or other troubled times; he is not anecdotal, and one cannot translate his work. Živković himself cannot put into words the mystery of his work, neither what the monks and nuns might mean to him, nor why they seem so much a part of the community of farmers, animals, and plants which populate his erect columns.

Bogosav Živković is constantly concerned with an archetypal image, the sense of which is scarcely accessible to reason. His is pure, evolving form, feeding upon and reproducing itself, an indestructible chain of life in which things and creatures develop and decay, give birth to and prey upon one another. The artist is inspired by all metamorphosis; the world is a single whole, and all dead and living things are but ciphers of the manifold unity. Of course for Živković this is no conscious philosophy, nor even a consequential rule of his life. His conscious existence is without intensity, but the somnambulant instinct with which he creates his world is of a rare and infallible quality.

The chief materials used in the realization of these dreams are simple tree trunks, and these determine the vertical orientation of his sculpture. Never—or almost never—does he reduce a log to a single, ordinary block. When he works with smaller chunks of wood the results seem somehow exceptional, as though temporarily excluded from the abundance of the community.

An essential quality of this sculptor's work is its absolute integrity with regard to its medium. The naive artist perceives the figures he carves as somehow contained within the wood, residing in the medium provided him by nature. His task, his unquestioned calling, is to realize the suggestions of the wood, to release, and to preserve.

When we look at the large columns which must be considered as his most important creations, we recognize that the figures are never completely set free of the material.

Bogosav Živković, Axle.
Detail of a small wooden column.

The mysteriously expressive heads are modeled with considerable attention, and also the upper part of the body is worked with care. Everything else is only suggested, either still trapped in the wood or serving as a link in the chain of metamorphosis in which, for example, the lower part of a body can become the wall of a cloister, arms turn into columns, or a donkey's ears into a peasant's shoulders. The transformation of man into animal or animal into plant is by no means a deliberate metaphysical demotion, nor is there behind it a surrealistic point of some kind. Živković works as though in a dream, encircling the archetypal model of his perception of the world. Attempting to analyze for a moment, we might assume that the female centaur is but woman "ridden" and held in bondage by man. From the man's shoulders a child emerges, and thus the cycle of life is complete. The trunk and lower body are still deeply encased in wood, just as in another carving of a woman riding on a rooster which in turn whispers something to a man—the intriguing secrets of village life.

What could be the inspiration behind such a work? What moves the simple peasant artist Bogosav to dedicate the energies of his outwardly modest existence to the formulation of these singular creatures? He has a mild, round face, and he smiles with pleasure when one bends to examine his work carefully. He explains it all in an unexpectedly factual and direct way, as though himself unaware of its mysterious poetry.

One could scarcely trace the inexhaustible variety of his figures back to experiences of his childhood. From these early years may well come his peasant's love of wood, the organic material provided by nature, and which can be easily worked and molded. And from them may come his rootedness in nature, thanks to which he can intuit human or animal figures lurking in the knots and branches and roots of tree trunks—any shepherd boy displays such intuition when he looks at the dancing movements of the willow tree and selects the best twig for his flute or his crook—but something more is required to stimulate such profound creativity.

Listening to Bogosav Živković's non-sequential narrative, one can penetrate to the threshold of some shattering experience. He conjures up a chamber of horrors when he relates the war years, a time when he was hunted, arrested, and mistreated. He lived through it, to be sure, but a seriously injured spine still causes him pain and insomnia.

"I have bad dreams," Bogosav confesses. "One night a snake followed me out onto my little meadow, and wherever it wound, it left the moist trace of its body. And then I dreamed that the snake was coiling itself

Bogosav Živković, Head of an Old Man, *1969–70.*

around a man, and so I got up and, still half asleep, began to work with my hatchet and a chunk of wood until I had that man and that snake free of it. That was my first creation. . . ."

His past acquaintance with the power of physical terror still haunts him today, and transforms his nights into a prison. Dreams bring no relief, only the recollection of aggressions and visions of ghostly spirits and bodies. Only by expressing them all in wood can he break free of the nightmare.

The original title page for Goya's *Caprichos* was called *The Sleep of Reason Gives Birth to Monsters.* The artist Goya is seen lying across his working table in a fever, while bats, vampires, and ghostly birds flutter around his head. An owl hands him a stylus with which to portray his nightmares.

Bogosav Živković likewise carves his ghostly columns in order to free himself of the horrifying visions of his dreams. A serpent hands him his tools, not an owl; not the bird of reason, but the primeval animal of the nether world.

Živković is not aware of the boundary between dream and reality; fantasy and factuality are all one. With the childlike smile of a naive, he points to a wooden snake he has made, and which lives under a peasant chest in his room. "As long as this one lives here I won't worry," he explains with utter seriousness. "I have tried to make it feel at home."

Memories of childhood have mitigated and partially reconciled his vision of horror.

Without them his world would be one of evil. But as it is, goodness exists side by side with darkness, and even the perilous snake can be entreated and befriended. Old men and women from the deepest levels of his memory may become witchlike or devilish figures, or wise peasants, holy monks, and kindly nuns. Specifically, the figure of his grandmother surfaces with striking clarity from time to time as a personification of the "Great Mother," matriarchal and creative, seated regally under a pear tree with a wand in her hand as the teller of the sagas and tales which now stream forth through the sculptor.

His carved legends go beyond the spheres of his own experience, his family tradition, and his inheritance from folk culture. The formal metamorphoses which he traces as an artist lead him to images lying in the remotest past. The symbolic forms of exotic and archaic cultures which come to light in the carving of this Serbian peasant can scarcely be explained except as products of the collective unconscious slumbering in his soul. Bogosav has never seen pictures of African or Oceanic sculpture in his limited, village-oriented life; he, knows nothing of the artistic styles of Sepik or of the totem poles of North America. Still many of his figures resemble the products of those distant arts (illus. 116).

Solely dependent on instinct, Bogosav has been in possession of a unique archetypal canon of form since the first day of his artistic career. And it is thus clear that his work belongs undeniably to the realm of the primitive and naive. He has been what he is from the beginning; there has been no development, only a broadening and enrichment in his work. Psychic material is given him as directly as is the wood with which he works.

On a gray, autumn afternoon recently I drove out to the village of Leskovac, the birthplace of Bogosav Živković and the setting for his work. Like the letter carrier Cheval, Bogosav has built a *palais idéal* (illus. 138–140). It is hardly monumental, however, consisting of a farmyard with a few buildings and sheds in a large overgrown garden. In it grow a few small palms, vines, and oleander bushes, with tree stumps, old cooking pots, and vases standing about. In among the faded autumn vegetation one could see stone tables, tiled fireplaces constructed out of concrete forms, millstones,

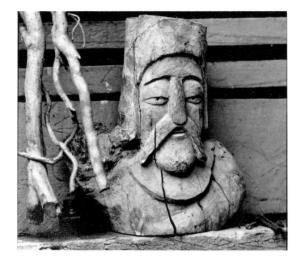

and rotating pedestals for his sculpture.

Bogosav's chiseled figures lurk all about. The faces of men with long, exotic mustaches and of women with sharp, pursed lips look out between violet-colored bushes. A wooden serpent coils among the bare branches of a tree, the ever-present totem animal of this peasant sculptor.

The largest building is his studio-museum, containing a few pieces of peasant furniture and some of his large columns which have come back from an exhibit somewhere and still have shipping tags pasted on them. Carved wooden bas-reliefs are suspended on chains, cut out as though with a huge coping saw and resembling cookie forms.

Again like the postman Cheval, whose life and work are of course totally unknown to him, Bogosav has collected his materials from everywhere, both for use in the fabric and ornamentation of his buildings and as inspiration for his work as a sculptor.

The loveliest thing about this garden is its look of whimsical chance and accident. It seems as though the whole hodgepodge might have grown here naturally. Water jars with long snouts and metal watering cans sit under pale blue flowers, possibly forget-me-nots. On the walls of the building can be seen crudely painted figures of the pope and his assistant celebrating a mass, as well as the names of film stars seemingly wishing to perpetuate themselves and the solidity of the house as well.

The countless hybrid creatures in this Serbian Arcadia of a peasant's fantasy peer between the leaves, and stony ghosts tell their own fantastic tales. Farmers from the vicinity and art lovers from the city make frequent visits to this haven of strangeness, kindness, and naive art.

The Meaning and Power of Naive Wood Sculpture

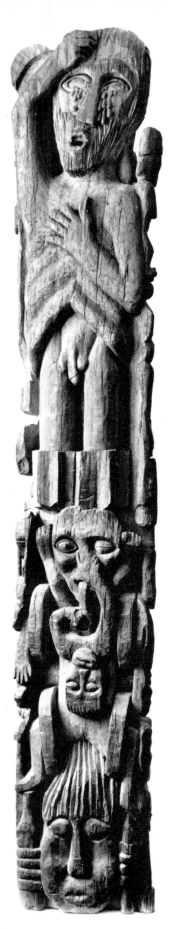

Milan Stanisavljević, Wedding Dirge, *1967.*

Just as the visual poetry of Ivan Generalić has had a considerable influence on naive painters in the Croatian Podravina, so has the work of the peasant Bogosav Živković served as the point of departure for the sculptural efforts of naive woodcarvers in Serbia. Let me mention only two from among his large following, the Stanisavljevićs, father and son.

In one of the wooden reliefs by the father, Dragiša Stanisavljević, a lunar rocket can be seen (illus. 156). In six successive frames, the various stages of the flight are represented. At the bottom are figures of ordinary men, above them astronauts that have the look of remote ancestors or gods about them, still higher is the flying rocket, and at the very top the moon which is its goal. This naive narration strikes me as being quite symbolic; the peasant woodcarver has described, with an emblematic simplicity and primitive use of form like that found on wooden storehouse doors from the Ivory Coast, a flight from our familiar planet and escape from its gravitational pull. A prelogical and mythical view of the world has taken up a contemporary motif, treating the spacemen as angels and demons. The preestablished harmony of the repeated figures, recognizable only by certain repeated attributes, gives the relief a cultist, ritual effect.

The plastic forms are rhythmical, compact, and childlike. A genuine sense of awe at the accomplished miracle has found its expression in sculpture.

Milan Stanisavljević, the son, has none of the quiet serenity of his father. His visions are more dynamic, and they force him to explore more complex possibilities. Obviously influenced by Živković, his figures also resemble totem poles (illus. 122, 125). But unlike those of Bogosav, his tall, upright tree trunks are not so readily apprehended. One work, called *Wedding Dirge* (illus. 157, 158), shows the miraculous indissolubility of human community. Rhythmic groups composed of the actors in this fantastic wedding come together and move apart. Someone is holding the reins of two leaping horses—a coachman, obviously, and behind him the bridal pair seems to be lying back into the carriage. So much for the upper part of the column; the lower section turns these same figures around. Here there are men with demijohns or flasks, farming tools, animals,

musicians with a harmonica, a fiddle, and a bass viol, and one man singing while lovers dance above him. Below them all is a fishlike human figure which ends in a tail. We can discern still other details: a man holding a sheep by the tail, a female nude hovering low over a gravestone—for there is where it all ends—and a saint or a corpse with his arms crossed. At the very bottom, like caryatids, are the parents.

On the other side of the column is an even more obscure and mysterious scene. A towering man stands in sorrow with one hand over his heart and the other raised to his forehead. Tears like those of Spanish madonnas course down across his face. Below this mourner, whose ribs and sex are accentuated with particular ornamental clarity, there are two figures facing in opposite directions. The one with his head lowered is grasping the head of his counterpart, pulling his tongue with one finger poked in his nose. A peasant proverb?

A smaller column which he calls *A Family* represents something like a genealogical tree. On a horse's skull which forms the base sits the ultimate female ancestor with her small breasts and narrow shoulders. Out of her head rise other figures in increasing numbers, with round faces staring from under the round rims of their hats. The mother of the line has shadowy eyes that gaze into emptiness, and a wide-open mouth. All the heads are rigid and erect, the faces earnest, and together they comprise a multifaceted, rhythmic unity.

Stanisavljević seems less concerned with the natural shape of the log. The strength of his expression lies rather in his well-planned composition. The mystery, or rather the demonic strangeness of his work, is balanced by a clear striving for form, mitigated of course by a naive yet deliberate style.

The Dalmatian peasant and self-taught cartwright, barber, and woodcarver Petar Smajić (illus. 119, 120, 159) carved his first shepherd's gusla in 1932. Its scroll depicting a horse and rider came to the attention of people of taste, and their encouragement led him to do further work of this kind.

Smajić's severe but emotional stylization is in many ways akin to Negro sculpture from the Ivory Coast. *Adam and Eve* (illus. 120) is his name for one naked couple, two identical bodies done in controlled lines, distinguishable only by their breasts and sexual parts. The bodies rest on the four identical cylinders of their legs which seem never to have taken a long striding step. The faces of the man and woman are nearly the same, an archaic smile glowing through the stiffness of their masks. The small paws of their hands are placed on each other's hips and shoulders with an apparent shyness. Simply

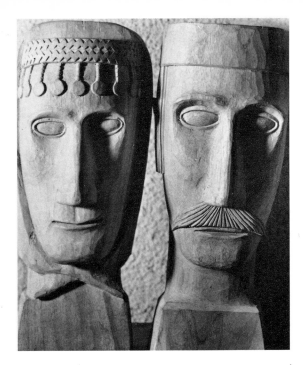

Petar Smajić. Mary and Peter, *1963.*

and sincerely, this piece of wood brought to life has a singular power as a symbol of mutual human longing.

Smajić's heads have the beauty of fragments of archaic statues. Their long, oval faces with slender noses and almost sightless eyes under the clearly arching brow—here are two leaning against each other, called *Mother and Daughter*. The melancholy, narrow curves of these two female heads are related to Modigliani's portraits. Spare and full of portent is the head which he calls *The Citizen,* whose bitter, twisted mouth reveals the inner being of this person. Another mother and child, her face framed by the severe folds of her scarf, the small, idol-like creature pressed to her breast—this is no

mother of god, but rather the one who gives life to the tragic human spirit. All of these workers, diggers, riders, and animals are formed in the naive spirit of ancient cult images.

The carved wooden figures of the Croatian sculptor Djordje Kreča are evocations of childhood, death, and the destruction of the war years. He combines his experience of agony at seeing his father put to death before his eyes, the loneliness of long empty years in an orphanage, and his discovery of hope in woods and nature while attending a school for forest management. He was to form a close acquaintanceship with trees, out of whose substance he learned to give form to his past and future life. His sculptures have the heaviness of idols, and this massiveness reveals a genuine sculptural sensibility. He has done an Icarus with a bird, a troubadour, a tangled Laocoön column, widowed sirens with obviously vital natural drives, and a Joan of Arc—an heroic girl with a defiant nose, round eyes filled with wonder, and a lower lip set with determination. There is also the legendary medieval nun Jefimija (illus. 118), naked under her cloak and with a headdress of an eagle's head recalling the helmet of Athena. On the reverse side is a king's daughter pressing close to her flowing cloak, and the crowned king, bearded and in armor, standing among his vassals. Kreča's fabulating fantasy gives movement to his wooden forms, and the awkward strength of experienced instinct.

The symbolic compositions with many figures on his reliefs tend to become pure rhythm and allegorical ornament, with curves and vaultings and monumental rosettes carried out almost with a draftsman's precision.

Petar Smajić,
Night of the Shepherd, *1963.*

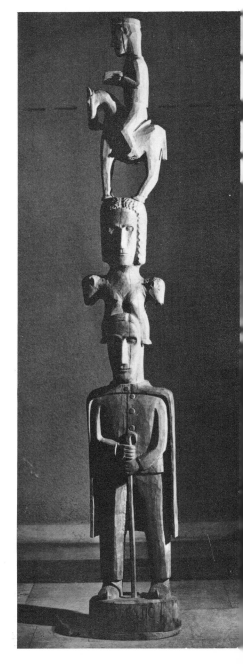

Fantasy and Reality in Iron and Cement

Like the painting of Haiti, the sculpture of that close community of blacks is also a synthesis of African and Latin American elements. The more immediately rewarding medium of painting is clearly preferred, however, for in spite of the African tradition of sculptural talent there are but very few sculptors among vast numbers of painters.

In the late forties and early fifties, the blacksmith and sculptor George Liautaud, from the Haitian village of Croix de Bouquets, cut strange figures from sheet iron which prefigured in their grotesque two-

dimensionality the *Objects* created by Ceroli in 1970. The human shapes and shadows summoned forth by Ceroli are made from boards from wooden crates, but they strongly resemble Liautaud's iron and copper animals, men, sirens, devils, and Christs. His mouths and eyes are punched out, noses and breasts hammered from the back or welded on, and jewelry and chains are added last. Only Liautaud's crucifixes are truly plastic, perhaps in deliberate imitation of traditional Christian models. His forged iron cemetery crosses are fanciful, and, like many of his figures, they bespeak the synthesis of Christianity and voodoo. The fetish quality of Liautaud's shapes is appropriate to the level of consciousness of the Haitian people, and it gives them a magical glow.

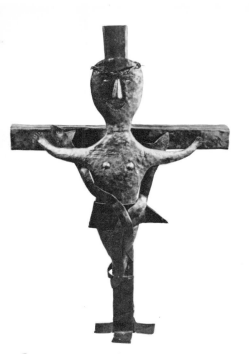

Georges Liautaud, Crucifix, *1959.*

One might well contrast George Liautaud with the Nigerian metalworker, blacksmith, and naive sculptor Asiru Olatunde. Asiru's pictorial compositions in aluminum have already been discussed in a chapter on the native art of Nigeria. Thanks to his sense of tradition and his gentle imagination, his work forms an integral whole which is in sharp contrast to the crudely naive, popular art of neoprimitive painting in Nigeria.

The cement sculptures of the Yoruba and Ibibio peoples are splendidly expressive and direct. Historically they are remnants of so-called "Brazilian" structural forms, brought back by returning slaves and now used by newly rich farmers to adorn their imposing buildings. While the Yorubas decorate their houses with heraldic lions or occasionally elephants, the Ibibios concentrate on grave markers on which they portray the dead or angels, and which they call *itiatudos*. These painted concrete figures have a close affinity to Serbian peasant tombstones, the *krajputaši*.

Aside from this expressive, though somewhat crude folk art, there exist individual artists still working within the tradition of the brass founders but who have developed an individual style.

The naive artists and blacksmiths of Nigeria and Haiti no longer belong to the sphere of peasant life, but rather to the working class. Yet their stolid industry is just as determined as that of the traditional peasant sculptor.

Quite another story, and arising out of an entirely different motivation, are the sculptures of the German industrial worker Erich Boedeker, whose richly figured compositions bring this chapter to a close.

Boedeker worked as a miner for thirty-five years, and at the same time as a farmer and butcher. His work in art only began after he had stopped going down in the mines. A little lawn elf that someone gave him for his birthday was his first inspiration. Boedeker did not like it at all, and he set about making something better. He first modeled a deer, and only later a dwarf of his own. The possibilities of expressing himself in sculpture satisfied him so completely that he continued, and since 1959 he has created upwards of a thousand figures.

His themes generally come from fairy tales, from the Bible, or from everyday life; his figures come in all sizes. During the winter he mostly works with wood, but in summer he finds concrete his best medium. His creatures are like crude little posts with round heads and arms and hands that tend to be mere globs. He will do portraits on commission, from photographs, from memory, or from life. His wife serves as a judge of the likeness. The finished sculptures are painted in strong colors. Often he will use a ready-made object like a flowerpot for a hat, or the base of a miner's stove as a seat. With an eye for anything usable, Boedeker has constructed a free composition of life-size figures

Erich Boedeker, two figures from the composition Modern Society Considering the Fruits of the Quarrel Between Adam and Eve, *1970.*

which he calls *Modern Society Considering the Fruits of the Quarrel Between Adam and Eve* (illus. 117). There are twenty-one figures on the "stage." Adam and Eve stand in the center performing the apple scene. Grouped around them are people of today, blacks and whites: a crowned queen wearing garish decorations, a housewife carrying a real shopping bag, a sheriff with his metal star pinned to a sky-blue jacket (illus. 149), a farmer with a pipe between his teeth, boys, workers, a family, the Apollo space pilots, and a pink pig flanked by two grotesque poodles. A cook has his arms raised as though inviting his fellow citizens to step closer and see it all for themselves. These heavy cement figures are brutally direct and convincing—concrete memories in the medium of our time. His is a sculpture of simple, unambiguous factuality. This artist knows neither George Segal's plaster casts of people nor Edward Kienholz's environments of hopelessness. Boedeker looks at the world with his own eyes, as though it were standing on a podium and posing for him. The result

is strange, unique, and not a little grotesque.

With the development of modern art, the clear boundary between sculpture and painting has broken down. Customary definitions of the plastic arts have become inadequate. During the first half of the century, art was dominated by a desire for two-dimensionality, and interest in sculpture was at an ebb. But sculpture has again come into its own in the past decade. The main artistic thrust at the moment seems determined to burst the frame, the whole concept, of the flat picture, to transcend the illusionist world of two dimensions, and to create actual spaces composed of real elements—and to deal no longer in copies.

Artists are turning to the precision of cybernetics, and to the magic of pretechnical creation. Will they also cast a glance at these obscure, awkward, and humble naive sculptors? Scarcely touched by our high civilization and the intellectual programs of recognized art, naive sculptors continue with their unique and gripping sculptural commentary on existence with quiet intensity.

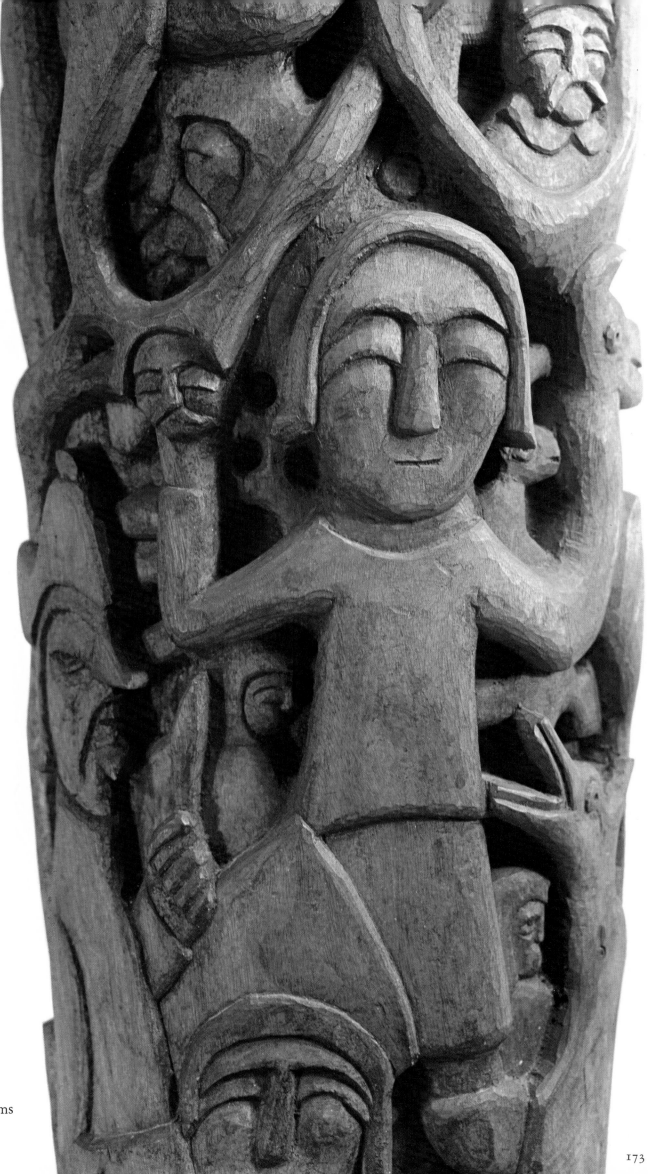

116. Bogosav Živković, Dreams and Thoughts, *1965*

117. Erich Boedeker, Modern Society
Considering the Fruits of the Quarrel
Between Adam and Eve, *1970*

*I have described and analyzed this group
sculpture of the naive artist Boedeker else-
where in my main text. Here I would like to
speak of the reinstatement of the human
form in recent sculpture after decades of
abstraction. Boedeker's group quite uncon-
sciously achieves an avant-garde effect. The
twenty-one quite separate figures of painted
wood and cement arranged together have a
certain affinity to the sculpture of pop art
and of the New Figuration. The tendency of
pop artists to employ actual objects instead
of artificial replicas is one that goes back to
Dada. Enrico Bay's science fiction heroes are
monstrous sculptures of primitiveness and
power. H. P. Alvermann forms plastic works
of social criticism in his ready-mades, col-*

*lages, and sculpture-painting. Frank Gallo
makes cultist love objects out of artificial
materials, whose effect depends on their
realism, the smoothness of skin, the heavy
eyelashes, and the sensuously opened mouths.
A new illusionism of almost photographic
authenticity is evident in the groupings of
Robert Graham, in one of which a sun-tanned
man is climbing out of a pool carrying on
his shoulders a girl dressed in a bikini and
hose.*

*George Segal fabricates life snapshots of a
magical reality out of plaster casts of human
bodies and everyday objects. Edward Kien-
holz's environments are accurately furnished
interiors with an atmosphere of exhibitionism
and decay. His figures dressed in underwear,
shoes, and street clothes are like fetishes.
His* Barney's Beanery *depicts a deperson-
alized, lost, and lonely society in the modern*

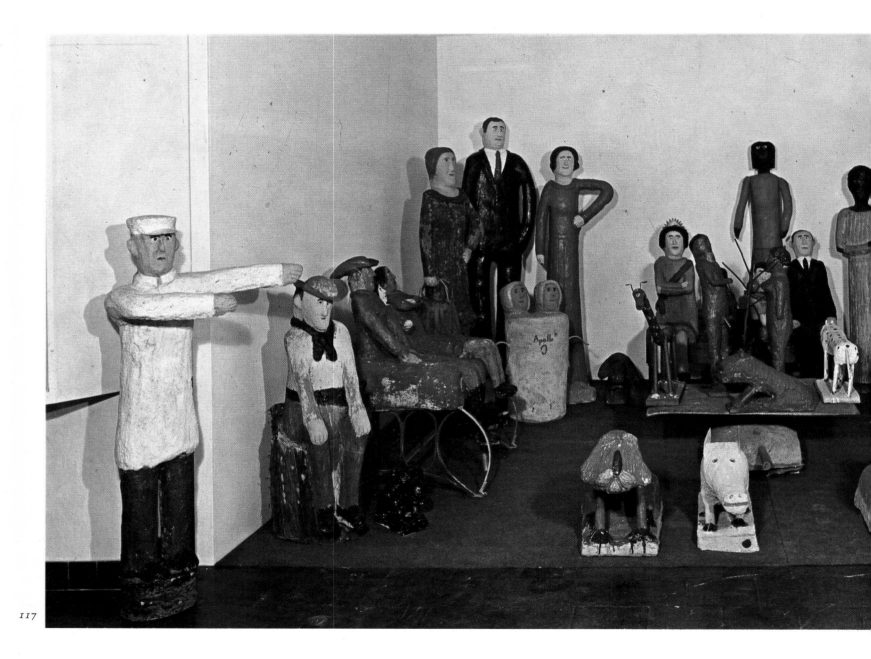

117

metropolis. Men in a bar are surrounded by posters, loudspeakers, and television sets while they frantically consume food and drink along their journey out of nothingness into nothingness.

In this connection, the naive sculptures of the naive miner Erich Boedeker take on a new significance. Without any intent to parody other artists, and led only by the instinct of his lively humor, Boedeker has unconsciously created solidified scenes of a naive living theater, an environment full of sensual frankness and instinctive accuracy. Though it may be that traditional forms of figurative sculpture no longer play a central role in the cybernetic age, naive sculpture will survive as a continuous expression of the soul's creative need to give form to its invented images.

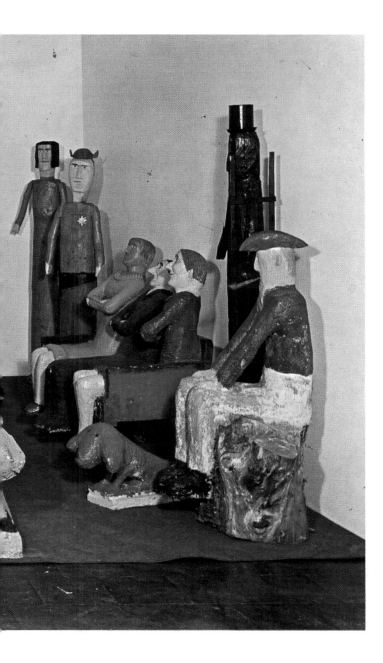

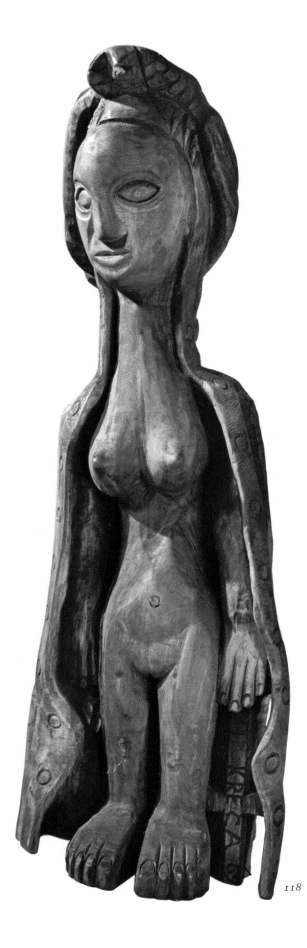

118. Djordje Kreča, Jefimija, 1969

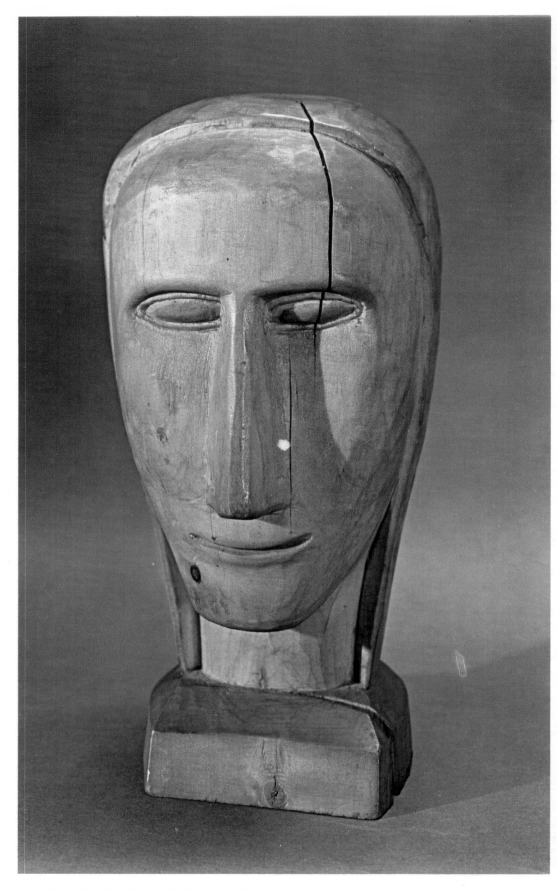

119. Petar Smajić, Head of a Peasant Woman

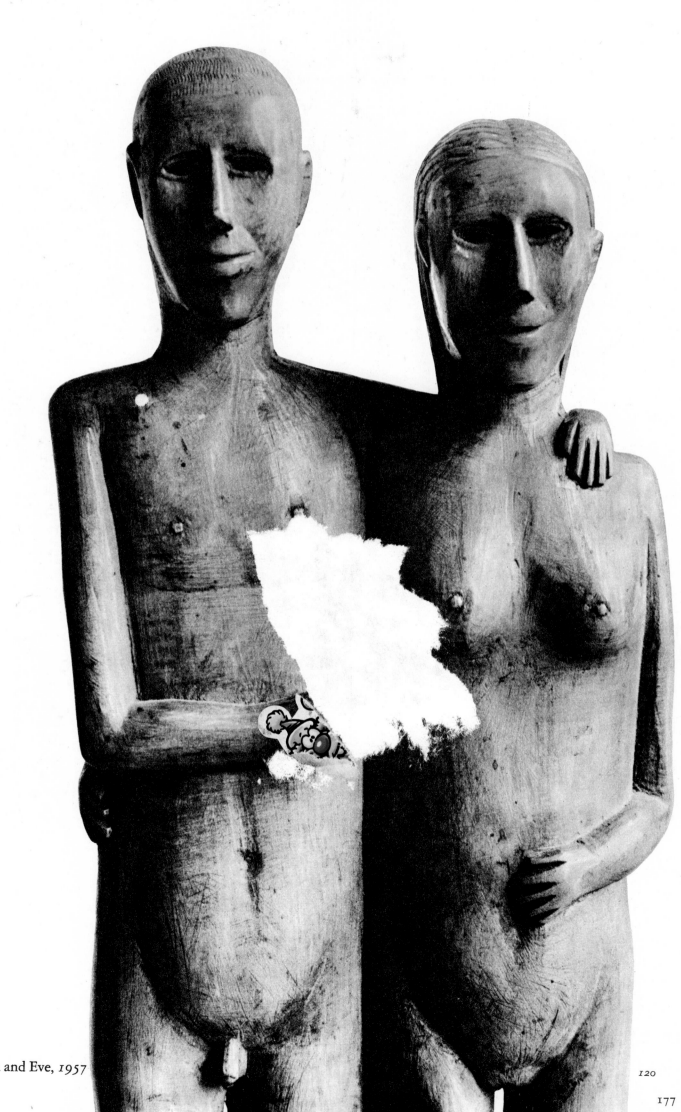

120. Petar Smajić, Adam and Eve, *1957*

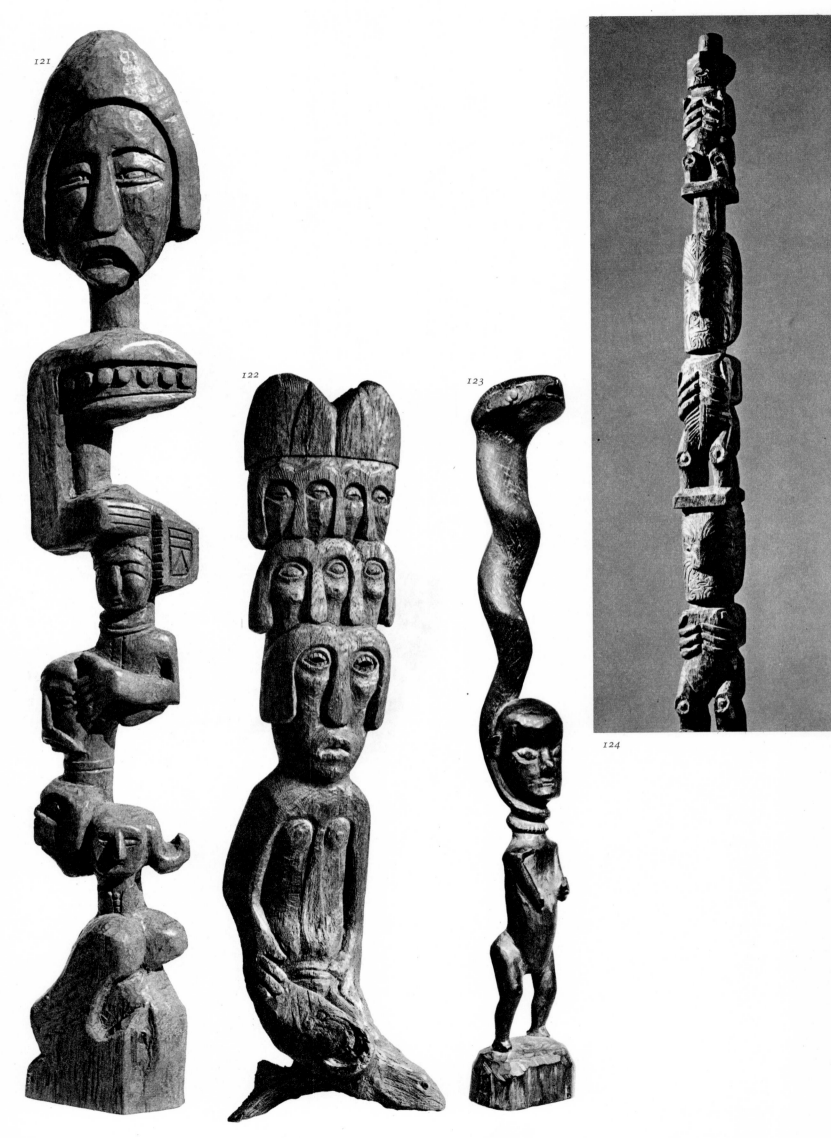

121

122

123

124

126

121. *Bogosav Živković*, Axle, *1962*

122. *Milan Stanisavljević, A Family, 1969. Detail*

123. Woman With Snake, *wood sculpture from Toba-Batak, Sumatra*

124. Totem pole from New Zealand

125. *Milan Stanisavljević, Wedding Dirge, 1967. Detail*

126. *Bogosav Živković*, Novice, *1963*

Many and various are the faces and figures that come to the peasant and sculptor Bogosav in his dreams, like the young nun in a Serbian cloister which he represents with sleepy features and an introspective expression. Through the simplicity of his instinct he has succeeded in freeing this head from the living material, transforming the mere wood into something new and rare.

125

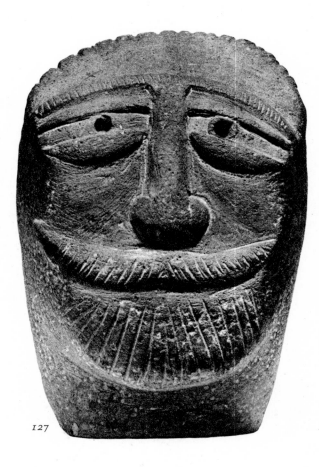

127

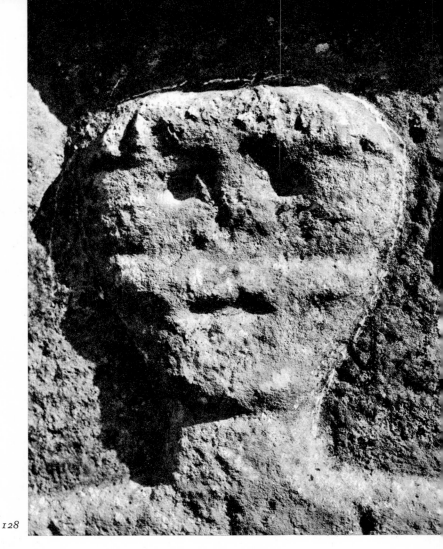

128

129

127. *Lavoslav Torti*, Self-Portrait

128. *Head from a Bogomil tombstone from the necropolis at Radimlja, Herzegovina. 13th–14th century*

129. The Deceased With His Children. *Bogomil tombstone from Radimlja, Herzegovina. 13th–14th century*

130. *Face of a weeping woman, woven straw from Cafayate, Argentina*

131. *Ladislav Jurovaty*, Madonna, 1969 (*wire sculpture*)

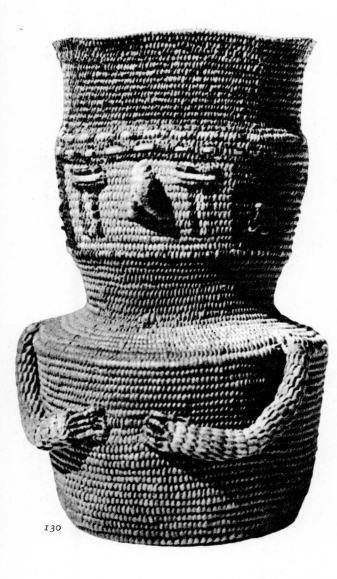

130

131

132

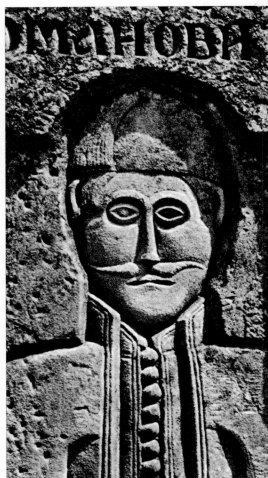

133

134

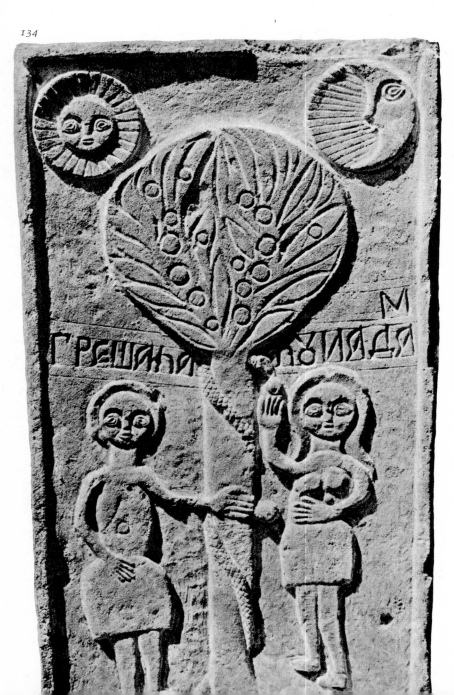

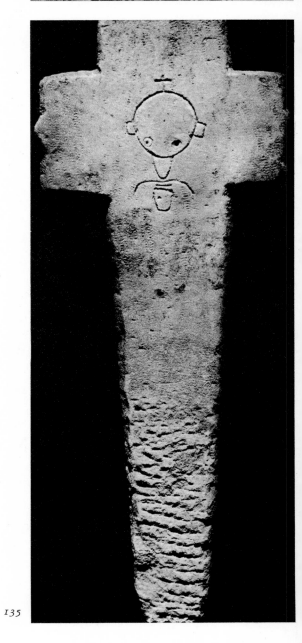

135

132. *Sculptures in wood at the entrance to a Rumanian farmyard*

133. *Bust of Rade Domanović, early nineteenth century (detail from a village cemetery in Serbia)*

134. *Adam and Eve on a tombstone in Rumania*

135. *A circle and cross combined to form a portrait of Tanasko, Serbian tombstone from Studenica, 1863*

136. *Bust of Lastomir Petrović (detail from a Serbian peasant tombstone)*

137. *A group of Serbian peasant tombstones from the nineteenth century*

138

139

140

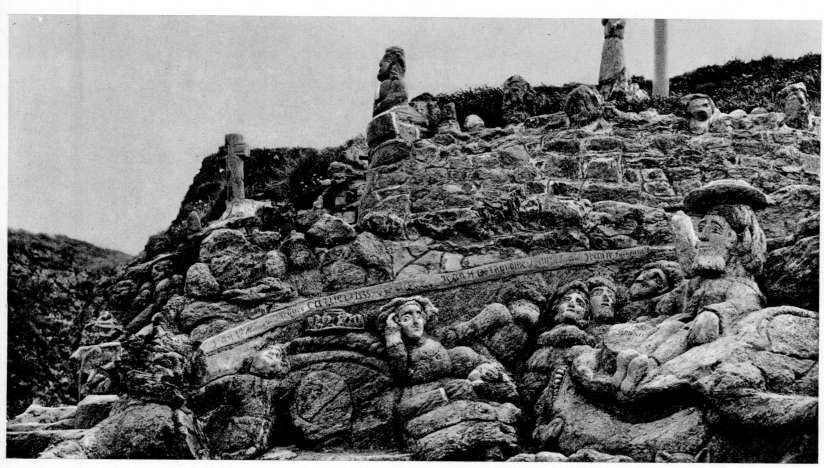

141

142

138. *Figures in iron and stone by Bogosav Zivković in the artist's garden in Leskovac*

139–140. *Bogosav Zivković, sculptures in the garden in Leskovac*

141. *Abbé Fouré, cliff sculptures at Rothéneuf near Saint-Malo, second half of the nineteenth century*

142. *Ivan Jurjević-Knez, portrait bust in the artist's garden on the island of Korčula*

143

143. *Fernand Cheval, head of a figure from the west front of the* Palais Idéal (*detail with Arabic characters*)

144. *Fernand Cheval, the* Palais Idéal *in Hauterives, Drôme, France*

145. *Fernand Cheval, large grotto with three gigantic figures in the* Palais Idéal

144

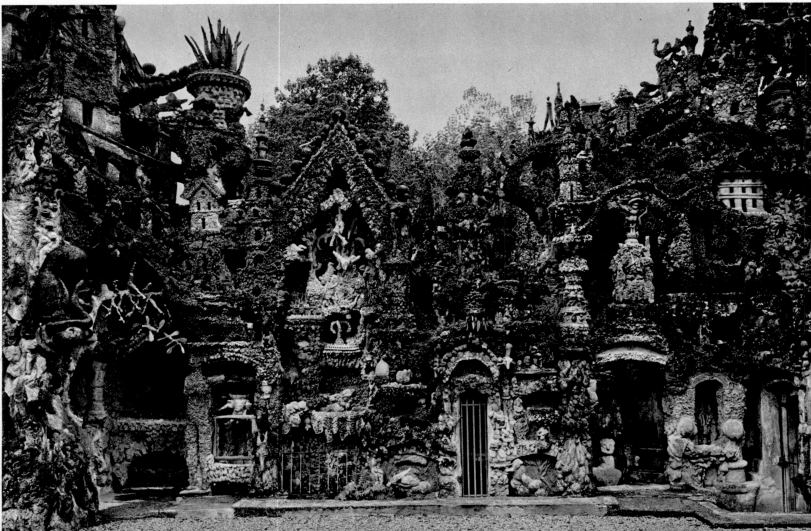

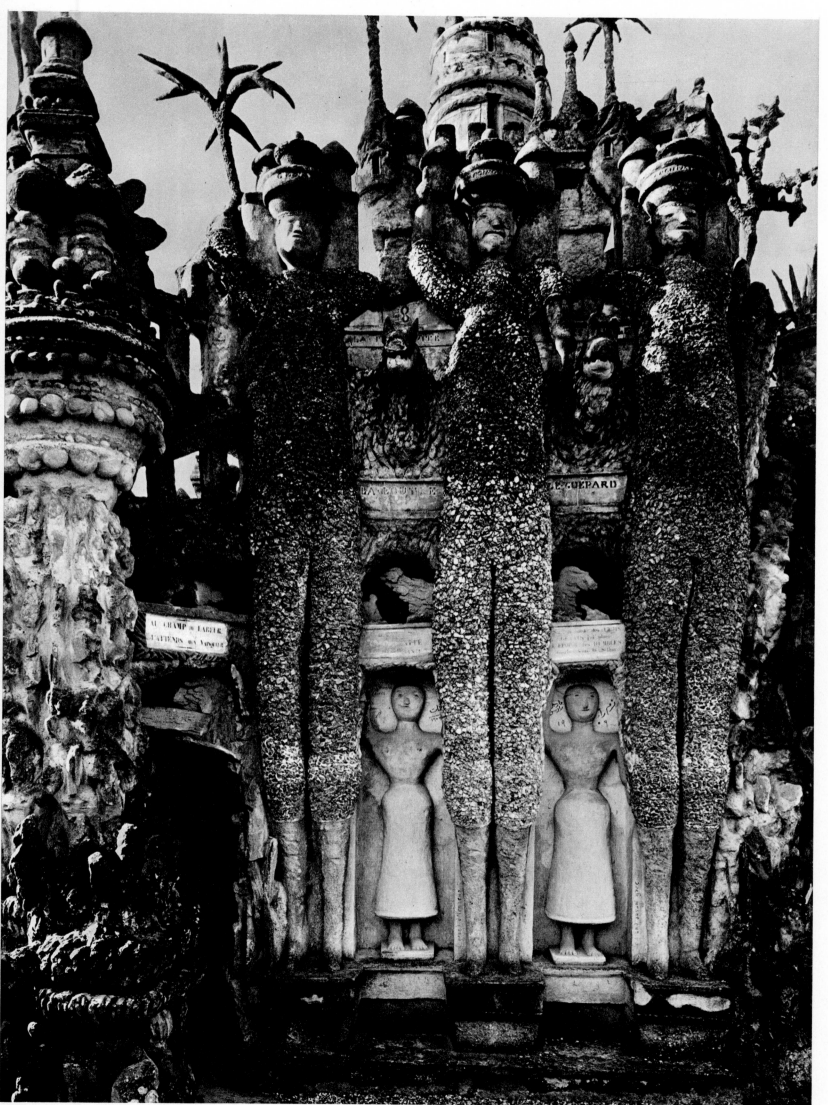

146

147

146. European, *painted wood from Ghana, early twentieth century*

147. European with Pad and Pencil, *painted wood by a Yoruba artist in Nigeria*

148. *Neculai Popa,* Lute Player

149. *Erich Boedeker, "The Sheriff" from the group sculpture* Modern Society Considering the Fruits of the Quarrel Between Adam and Eve, *1970*

150. *Adam Zegado,* St. Cecelia, *wood*

151. *Leon Kudla,* Councilman, *painted wood*

152. *Leon Kudla,* Pietà, *painted wood*

153. *Jedrzej Wawro,* The Troubled Christ, *wood*

154. *Leon Kudla,* Leon Kudla's Wedding, *painted wood*

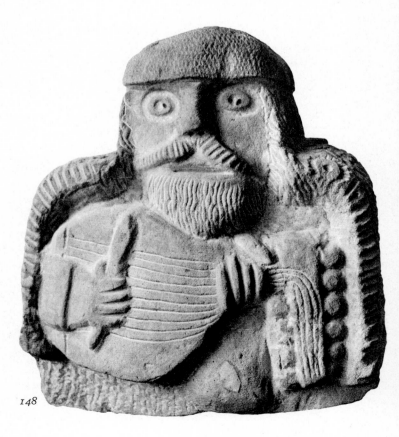

148

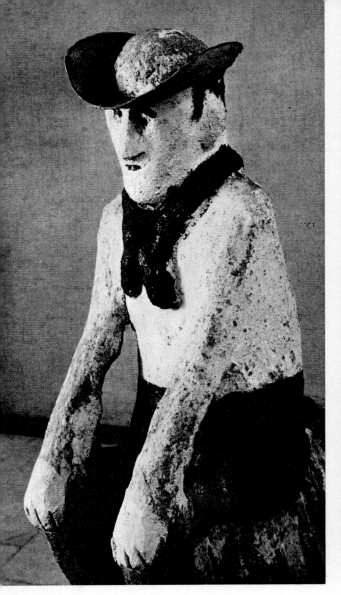
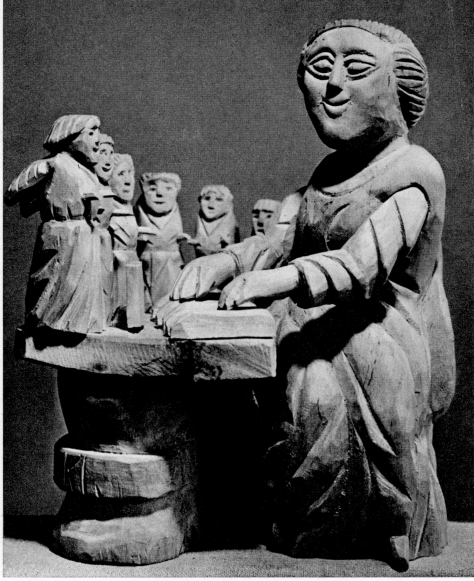

150

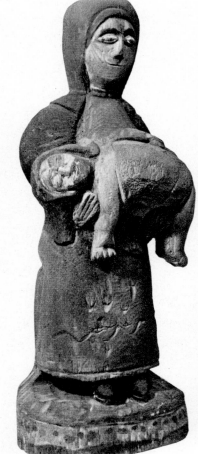
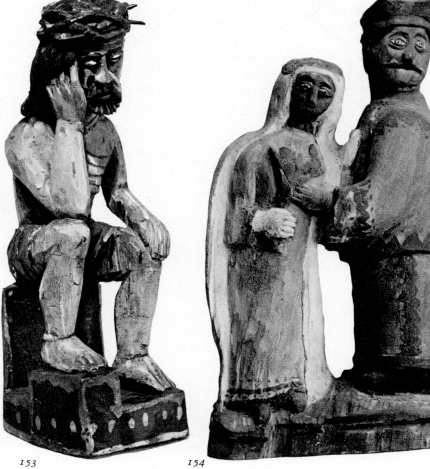

152　　　　　　　　153　　　　　　　154

155. *Mato Generalić*, The Bride, *1970*

156. *Dragiša Stanisavljević*, Cosmonauts, *1967*

157. *Milan Stanisavljević*, Wedding Dirge, *1967*

158. *Milan Stanisavljević*, Wedding Dirge, *1967* (*detail*)

155

156

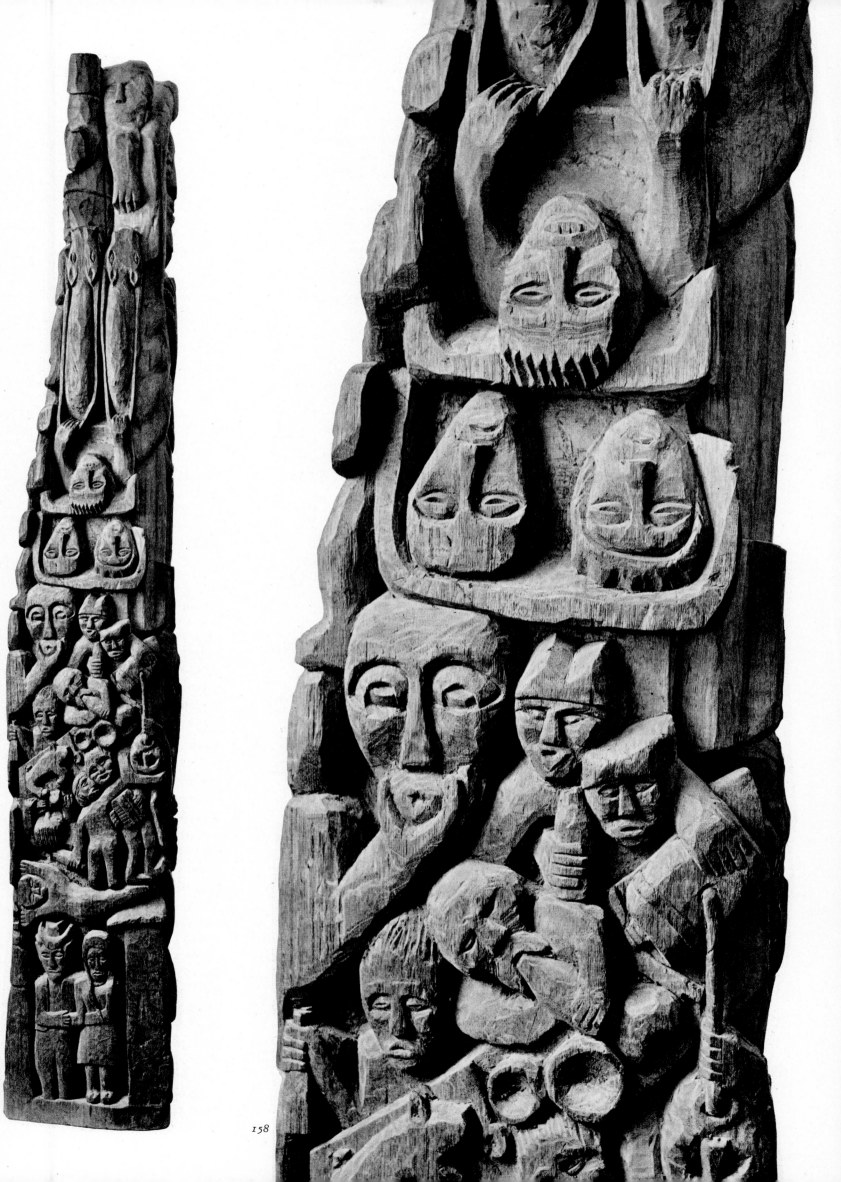

157

158

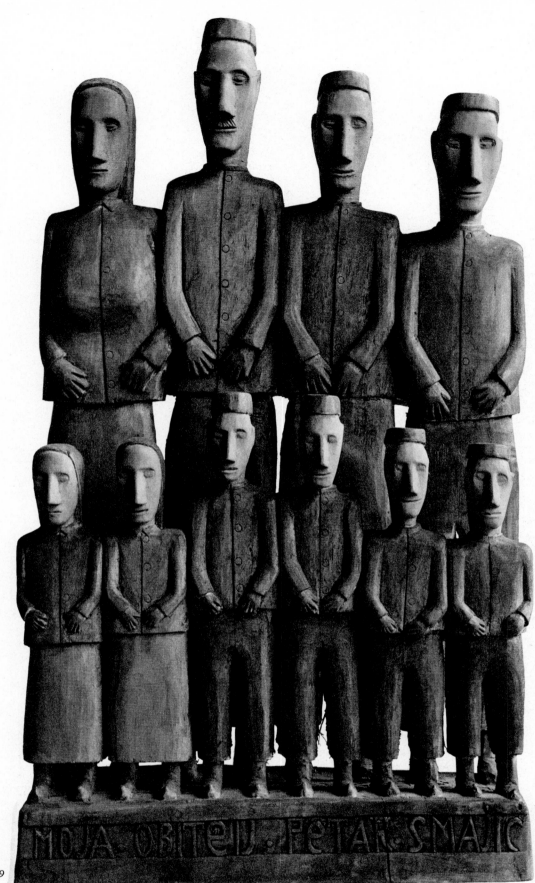

159

159. *Petar Smajić,* My Family, 1960

Two generations are represented here in orderly rows; a family tree is growing upward if one can assume that the lower row contains the oldest members of the family. In the thought of primitives children always have the form of miniature adults, in any case.

The stiff postures of these figures reveal no movement, no freedom, and no closer relationships between separate members. They all stand as though stuck to each other, each one resembling all the others with his tiny, childlike hands and short arms. The men wear the traditional flat Dalmatian cap; the women wear scarves which frame their faces severely. Their clothes are identical, all with the same buttons down the front. Their feet are resting flat on the wooden base, the earth on which they live and work. They have the seriousness, the simplicity, and the motionlessness that characterize the material, the sculptor himself, the family relationships, and the monotony of their existence.

Part Three

Landscape and Regionalism

Chapter XI

The Discovery of Landscape

Landscape is one of the last things to enter the consciousness of the artist. Primitive painters, like children, tend to store up only clearly outlined "things" in their visual memory. Through artistic tradition for thousands of years there was scarcely any approach to the representation of landscape, and nothing held to be as worthy of reproduction as the forms of animals and men, or of their expansion into demons and gods. The child can only deal with single elements of the landscape, and will outline at most a tree and a few flowers. Only when one grows older does one come to appreciate mountains, valleys, and rivers as a whole, and can one translate them from the infinite context of nature into the limited space of a picture.

The anthropocentric view of the world was satisfied to let man stand as the center of the universe, with the sun and stars merely providing light for him, animals his food, and flowers his momentary pleasure. The Christian view considered the world a vale of sorrow unworthy of pictorial representation.

Henri Rousseau, The Flamingos, *1907.*

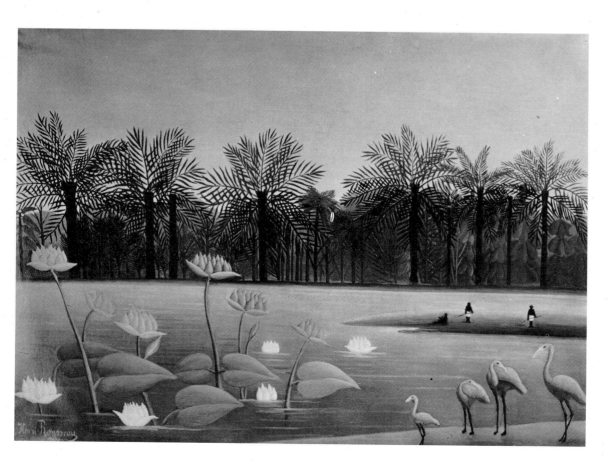

In medieval contemplative pictures, landscapes were accordingly limited to at best little fragments in the background.

The art of the naives is in many ways analogous to the painting of primitives and the drawings of children. In the painting of landscape, however, there can be but a few points in common. The practical, naive peasant painters and the wandering limners, as well as *le Douanier* Rousseau and his followers, have created landscapes brimming with the fullness of nature. Surrounded by the masterworks of the French artistic tradition, Rousseau could hardly paint his invented landscapes in the manner of the primitives. He loved landscape above all as the bond between man and nature. He placed himself, his portraits of his friends, his acquaintances, and his wives deep into the landscape of a park or in the woods. At times he portrayed landscapes with rank, exotic growth, and many of his paintings give this impression of exoticism even though they do not specifically depict a tropical region.

Following his own obscure principles of form, he abstracts nature by supplanting the perceptions of the eye with those of the heart. His intimate relationship with the whole of existence simply could not help but generously endow his painted flowers and trees, rivers and bridges, streets and squares with a new formal expressiveness.

One of his first pictures of man in nature is the *Promenade in the Woods* (illus. 47), which portrays the slender figure of a woman in a long, reddish-brown dress, holding a parasol and standing alone among the large bushes and tall trees of a pleasant forest.

In his urge to explore distant lands, perhaps also in an unconscious desire to transcend the narrowness of his ordinary city life, Rousseau conjured up an exotic world of fantasy. He put his ear to the secret heartbeat of the jungle, displaying the exotic abundance of animals and archetypal vegetation, and the drama of the life struggle between man and beast in his lovely but terrifying paradise.

Nature as Seen by the Naive City-Dweller

Having considered Rousseau, I would next like to examine the landscape painting of Bauchant, Bombois, and Peyronnet. In a remarkable essay on naive painters as landscape artists, Manuel Gasser has written: "Considering only the poetic quality of his landscapes, André Bauchant stands closest to *le Douanier*. But in their respective imagery and specific styles there is absolutely no similarity between them. Far more astonishing are the parallels between Bauchant's use of color and that of Piero della Francesca. . . ."

Vivid color in the clarity of space served the Renaissance master Piero della Francesca as a background for his studies of the plastic dignity of man. Bauchant also used landscape occasionally as a backdrop for the heroes of his own imagination. Whether as background or for its own sake, he painted nature with the loving understanding of the gardener who instinctively knows its colors, its smells, and the delicate design of even its smallest plants (illus. 50). He experienced and painted everything as part of a cycle of blossoming, growth, and decay.

Camille Bombois's autumn scene in the Bois de Vincennes (illus. 49) shows a gentleness one would not have expected from

this otherwise droll clown of the naives; a golden light falls on brown, ocher-yellow, and wine-red leaves, and all is blended into the rusty brown of dying vegetation. The deep green carpet of grass and the shiny mirror of the water are strewn, almost covered, with the falling fire of the leaves. This is a beautiful indulgence in feeling for the lateness of the season and its decay.

I also include an autumn picture by Dominique-Paul Peyronnet, called *Forest Clearing* (illus. 54). The harmony of Peyronnet's palette is clearly different from that of Bombois, a simple chord composed of a flat green and penetrating violet-brown. Between the bare verticals of the tree trunks, the copper-colored leaves of the branches form an ornamental design. A curving path leads back to the gray-green silhouette of the forest's edge—a melancholy tonality of color, the presentiment of the inexorable dying of the year.

Jean Eve's *Hills of Sours-en-Vexin* (illus. 169) have been planned with delicate taste. Should this painter be included among the naives? Eve leads the viewer's eye up out of the valley toward the softly swelling hills. Fields and meadows are marked off by hedgerows; a bridge twice crosses the stream, then disappears into the green. Houses are lightly strew about, and perhaps it is a factory with smokestacks that stands in the valley. Nothing is detailed with the pedantry so common among naives. There are sparse clouds in the sky, and the horizon of the line of hills leans up in curves against them.

Maler Paps, Evening in Holland, *1958.*

Charles-Lucien Pinçon has painted a cheery white winter landscape with small figures in the foreground, called *Snow in Limay* (Illus. 168). In it he shows us hills and villages with white roofs and church spires. In the bluish brightness of the snow rests a hilly landscape with orchards and shrubbery—possibly junipers—of a delicate green, everything seemingly touched by sleep.

Adolf Dietrich's work has already been discussed, but it must be mentioned again in the context of landscape. No naive painter has stood so comfortably and humbly in nature. Dietrich painted, from his own sphere of experience, the actual landscape between Berlingen and Ermatingen on Lake Constance. With sure and simple craftsmanship and at the same time with a creative transfiguration of what he saw, he painted the vineyards and fields and the melodic lines of the curved horizon, the western shores of the lake, the clean hoarfrost, and the garden plots of his locality in summer and winter. With a poetic candor and unproblematic clarity he painted, with naiveté and to perfection, the changing moods of nature.

Among the German naive painters I know of none who could have painted the hushed stillness of a park in the evening as sincerely and honestly as the painter Paps. One could ask whether his *English Garden* (illus. 166) is a landscape at all, whether it is nature or merely an urban imitation of it. Ultimately it is both at once.

Paps has taken the friendly evening mood of the Munich park home with him into his workroom. The trees are now bare, but the Delft-blue stream with ducks swimming on it flows gleaming through the ordered landscape while people stroll beside it on footpaths. In the foreground, the strollers have paused to pose for their portraits. The blinding white of the baby carriage heightens the effect of the general twilight glow. In the background, on the dark green lawns, there are small figures in soft shades of blue, seemingly vanishing slowly from the stage of the picture. The dark trunks of the trees strive upwards in pleasing vertical rhythms.

The last time I walked with him along the forest paths of Frauenried, the painter Paps showed me the pale green shoots collecting in the depressions of a newly planted area after a hailstorm. His voice was touched with emotion as he spoke of the dying plants. He loved the ornamental richness of the grass and the contours of trees against the transparent afternoon sky, the moss and twisted bark of their trunks that look like archaic sculpture with a patina of algae.

Naiveté and primitiveness can be combined; we have seen them paired in the naive popular artists of the new Africa. There are also many peasant painters who combine backward ignorance with a genuine feeling for form. But Paps was not an ignorant man. He was a cultivated spirit who had managed to preserve his original simplicity and the directness of his childhood. No habitual routines of his craft could seduce him into superficiality and convention.

The landscapes of Joseph Pickett (illus. 163) and John Kane (illus. 164) display a charming lack of technical sophistication. Pickett's work is a concerned questioning of reality. A puffing locomotive pulls its train of

cars across the picture diagonally as in a child's painting. Decades ago he made use of the bold technique of applying bits of plaster or other materials to his canvas in order to heighten its illusion of reality, just as pop artists often do today. John Kane was capable of comprehending the landscape as a whole, and of reproducing its harmony in the fullness of its forms and colors.

The Dutch innkeeper and farmer Jentje van der Sloot loved to paint the sparse Frisian landscape with its dark green grazing land and its cows (illus. 171). In the lower section of this picture are the curves of a steel-blue ship canal, and above them hang black and threatening clouds. The raw face of his nature, in spite of the clumsiness of his drawing, has deep and symbolic significance.

The imposing ivy-covered villa in *Oud Amelisweerd,* built of red bricks and surrounded by a well-kept parklike landscape, was painted by the housekeeper and naive

painter Anna Zomer. She knew how to appreciate and to recapture the seclusion—and possibly also the monotony—of this gentle and peaceful artifice of nature in its formal order and muted tonalities.

Pieter Hagoort,
Horse-drawn Trolley Depot.

Ivan Rabuzin: Nature as Eden

The picture introducing this chapter on landscape was painted by Ivan Rabuzin (illus. 160). He has given our epoch of alienation between man and things an art of rare identification between the self and the world. The Eden he portrays in his paintings is not off somewhere in the misty distance, but is rather his homeland, the Croatian Zagorje, and only incidentally that other spot toward which the sails of his simple heart are set. It is a paradise composed of the here-and-now only transformed and laid under a spell by the purity of his visionary experience.

Going back to Rabuzin's beginnings, I can still remember the day when the key to the ciphers of his view of the world was given him. It was in 1959 that he first perceived the hills and valleys, flowers and trees, and apples and clouds as simple round forms, and began to paint them as such. The circle was to become his primal form, the dot his basic point of departure (illus. 161). He came to develop a whole cosmos of these; they could serve simultaneously as his flowers, his sun, and his stars. He puts the elements of his happy landscape into separate layers. Huge spherical blossoms rise up out of the hills, and his village with its little church and rows of houses is contained within a flowerpot. It could be that the whole world is like a garden which Rabuzin explores in his childlike

faith, hoping one day to find the door that might open into heaven. Yet it could hardly be lovelier there than it is in his own world.

Rabuzin's symbolism seems to have developed out of a modern and at the same time naive, sun myth. For his sun is *the* life circle and our source of strength, a glowing sphere whose rays take on the appearance of branches and veins of fantastic growths. In all directions, this sun shoots forth its shimmering, coral-like branches—the *mandorla* enclosing all of life (illus. 234).

Rabuzin combines in his painting a craftsmanly precision and a sense of organic natural form. His compositions are not mere collections of many carefully wrought individual parts; they form a rhythmic and poetical unity born of the integrity of his inner vision, where everything seen and experienced blends into a cosmic order as though following a mystic code.

Once his expressive idiom had been found, he never altered it; he has only refined and perfected his technique. The result is a set of variations on a theme, a series of separate versions of the same thing, each one seen in a new light or from a new vantage point.

Though there may not be obvious stylistic development in the work of Rabuzin—as is always the case with genuine naives—there are nonetheless oscillations reflecting his inner commitment and the strength and fecundity of the specific inspiration. There occur periods of concentration in which the total picture seems to have been thrown down at one cast. The furrows like strings of pearls, the ropes of spherical clouds, the

Pal Homonai,
Children and Horses, *1970.*

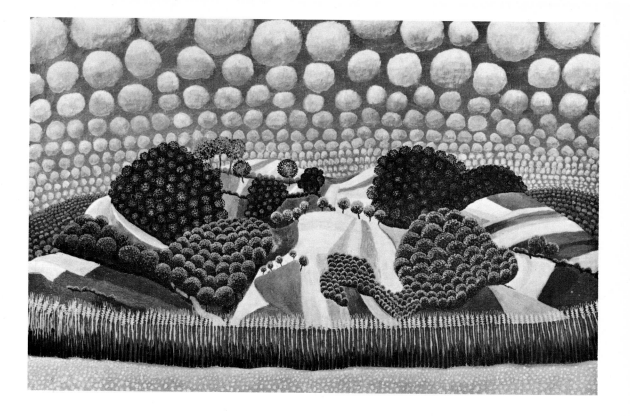

bright curves of paths and roads, and the
dawn blues and astral-green carpeted hill-
sides all belong to a painted pastorale, a
poetic restatement of natural experience. I
am hard put to think of anyone like Rabuzin.
Possibly one could perceive a remote similar-
ity to the gardener and painter of genius,
Bauchant, who not only transformed the
landscape into flowery forms, however, but
his people as well.

Rabuzin's painted nature may be utterly
harmonious, but the state of its inhabitants is
questionable. It almost seems that he is paint-
ing Eden just after its first masters have been
driven out. It is true, of course, that the gods
always create the world first and only later
make animals and men. Perhaps Rabuzin has
chosen to follow their example. His human
figures look like the gingerbread men sold at
fairs. And when they do appear, they look
somehow foreign and grotesque in the lyrical
space of his landscape.

Rabuzin's flowers are like gray-green, wine-
red, and amber towers, clear symbols of
growth and fertility. His bouquets of fields,
hills, and woods, which look for all the
world like clusters of colored pins, are in fact
but fairy tales blooming in a childlike heart
(illus. 161). A strong, glowing form, either
the sun or an island hovering in the depths
of space, gives his picture of a village an
unexpected quality of self-sufficient per-
fection.

Ivan Rabuzin and Pal Homonai are both
cabinetmakers, and therefore belong among
the naives of the workshops and not those·of
the land. Homonai creates his pictures with a
dedicated sense of order and symmetry. His
long years as a painter of intarsia had a
definite influence on his pictorial sense.

Neither Rabuzin nor Homonai paints the
landscape as it is perceived, but as a world
transfigured, abstracted, and translated into
another private idiom.

The landscapes and street-scenes of Pal
Homonai are compositions of gentle, bal-
anced colors (illus. 162). Abutting planes of
color are joined by simple outlines, and are
thus incorporated into the larger, decorative
surface. Created from memory or from his
imagination, his pictures are never natural-
istic. I find his sure sense of wholeness de-
riving from his close bond with nature par-
ticularly moving.

The tall and narrow format of his pictures
has proven itself suitable for a number of
basic themes, each with innumerable varia-
tions: flat green fields with decoratively lay-
ered haystacks, rose and velvet-green willows
whose flowery crows gleam like church can-
dles, trees like open umbrellas rising up in a
musical rhythm of pastels.

One of Homonai's series of pictures is
distinguished by certain hill-shaped arches
rising above the fields and pastures, *man-
dorla*-like domes of a weak brightness. In
these vaulted spaces, or below them, are lyri-
cally stylized clusters of animals or men in
ornamental groupings. His cows, goats, and
horses seem to be even more a part of the
unity of nature than are his people.

Like other primitives, Homonai paints his
figures either straight on or in absolute pro-
file. His drawing has preserved the directness
of childhood and his color seems to come
from his heart. He tends to paint animals
climbing up between velvety green hills,
trees that shimmer like crystal glasses and
are vaulted at the top, and shepherds stand-
ing in conversation with animals and trees.

The Peasant View of Nature in Landscape Painting

So far we have considered naive landscape painting from the perspective of the city, a genre that wears the poetic gloss of an unrealized desire, opposing as it does the living and organic to the civilizing process of estrangement from nature.

The peasant naives do not regard nature as a lost and longed-for Eden, but as an established fact of their own existence and the means of their support. They paint what to them is a possession, and the setting of their productive days; a place of bitter harvests and of country customs. They paint with the vital tension and in the knowing idiom of those who do not merely rhapsodize over nature, but who must wrest from it their daily bread.

The peasant painter Ivan Generalić combines a sharply defined observation of the real and visible with an obscure and subconscious knowledge of the miracle of growth from seeding time to harvest.

In his earliest landscapes we cannot help but recall the harvest pictures and illustrations of country proverbs of Pieter Brueghel. Generalić's boldly rendered and droll yet sensitively experienced landscapes obviously invite such comparison with their positive colors and vital forms. In his later years one can notice a change, reflecting his long artistic experience and a more critical approach. The soft yellow tracery of his coral-like bare trees, the melting dark green of his meadows, and the pale shimmer of the transparent background give his rhythmic, logically ordered portraits of nature a dreamlike and mysterious intensity.

The *Deer Courting* (illus. 75) included here belongs among Generalić's later works. The row of stylized and proud white deer appears against the intricate tracery of his coral trees. The magical repetition of the fabulous animal is the result of an unconscious synthesis of the trend in modern art toward multiple images and a statement of the archaic ritual of the eternal return.

Below the winter landscape by the postman and painter Ivan Lacković (illus. 167), which we have spread across two pages of this book, there was enough space remaining in which to include a discussion of that picture and refer briefly to his work in general. But here it is important that we note his ties to Generalić, and also his independence. Like Generalić he comes from a village in Croatia, and he was inspired by the precise drawing and spare expressiveness of the school of Hlebine. While Generalić remained close to the soil of his home, Lacković left his village to wander as a letter carrier through the barren maze of city streets. He took an image of the village with him and transformed it unconsciously into an idealized landscape of childhood. The concreteness and perfection of his drawing, the miniaturist detail and efficiency of his composition, and the ambiguous light of his sympathetic palette insure for his pictures the somewhat melancholy air of a remote world which nonetheless remains a part of him.

Mijo Kovačić, Gold-digging on the Drava, *1960. Detail.*

Masters in the Naive Rendering of Architecture

In children's work and in the painting of naives, houses, streets, bridges, and squares play an important role. Rousseau's views of clusters of houses and of viaducts, of bridges and boulevards, were expressive of his moods and his inner bearing through the elementary simplicity of their forms and the inspired vitality of his palette. Charming as these pictures may be, however, they do not truly belong to the genre of naive architecture-painting.

The characteristic naive painters of cityscapes are, rather, Louis Vivin (illus. 52) and Emerik Feješ (illus. 178). The life story of Louis Vivin and a sampling of his work were given in an earlier chapter, called "Painters of the Sacred Heart."

Living in an entirely different setting, and with no knowledge of Vivin, the maker of buttons and combs Feješ created his singular contributions to this genre. When I last visited him shortly before his death, he asked me with obvious concern: "Have you seen any pictures by this fellow Vivin? The way he builds up his buildings and streets out of pale little stones . . . ? Don't you think he might be copying me?" In his friendly and somewhat clouded eyes there flashed a shimmer of triumph. He was an innocent, completely remote from his time and from history.

The most imposing and most naive city portraits are those of Louis Vivin. He erected the rhythmic construction of his predictable yet fantastic buildings with the precision of a cartographer and a network of lines one might expect from an adolescent.

The street scenes of Emerik Feješ are but flights of his imagination. He was a world traveler who had scarcely set foot outside his own house, and who experienced remote places only through the touched up pictures of them on post cards. Feješ had counted all the bricks in the world, collecting them from the poor prints of cheap magazines, and his workroom was lined with them. He looked over his glasses at his visitor with surprise and concern. "Most of my pictures I painted with matchsticks," he confessed. His little splinters of wood were dipped into the glowing colors of his imagination, for a long time doing the work of brushes. With them he built up his zebra-striped churches, the brickwork of endless rows of buildings, and his idealized palaces from London, Paris, Basel, Venice, Worms, and Novi Sad (illus. 178). The narrow Gothic gables of Amsterdam are wine red, emerald green, and aquamarine, towering above the canals like pointed cupolas. The towers of the Palazzo Vecchio in Florence stand out against a dark sky. The Doge's Palace in Venice is like a jewel box in bright enamel. In Novi Sad, the city in which he lived, little horse-drawn carriages stand in front of the Baroque façades of the houses, waiting as they might have a century ago.

For Vivin as well, human figures were but props required as a suggestion of life within the grandiose architectural spaces. Feješ often leaves out human actors completely. The architecture of his cities becomes a creature in its own right, a breathing organism. The façades of London streets seem to hover with the rhythm of the Thames, full of gentle grace and movement. Buildings look more like paper lanterns and dragons, or those little Japanese flowers that open in a glass of water. It would be impossible to enter any of his buildings, and it appears that no one lives behind their glistening façades. His pictures glow like stained-glass windows.

Though human figures are almost completely hidden in the urban scenes of René Rimbert as well (illus. 56), half obscured in the shadows of doors and passageways, they nonetheless have a greater significance there. Rimbert's streets and squares and house fronts are painted in a transitory light, one that reveals and obscures at the same time. The people are there but seldom visible. They have just passed by—pedestrians with only one foot in this street and this world. One half of the familiar face of the great naive Rousseau looks out from a window. He is holding his palette in his hand as he does in the self-portrait now in Prague, and gazing out of this picture with a look of astonished discovery. Rimbert calls this charming little painting *The Window of le Douanier Rousseau*. Rimbert captures, through the intensity of his vision, the preposterousness and vitality of things in the infinite stillness of the material world. For years I have been fond of this master from the whispering, haunted streets and corners

Emerik Feješ, Bastion in Subotica, *1950.*

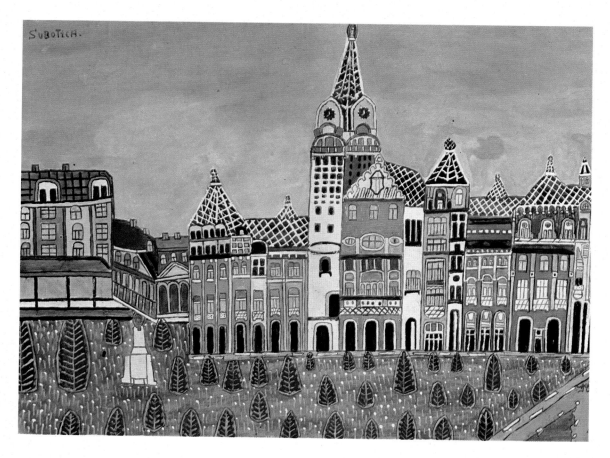

of St. Germain des Près, where the walls have absorbed the echo of life and now carry on a dialogue with the past. In my book *The Naive Picture of the World,* I have called Rimbert the Vermeer of the *peintres populaires.* He builds his houses, like the Dutch master, out of the intense and translucent substance light. To be sure, Rimbert has not attained the intimate glow and spiritual order of the Delft master, and yet there is something of the music of that enclosed clarity in his paintings.

Cities as Utopias

I would like to bring this survey of naive urban scenes to a close with some reproductions of the work of the American painter Erasmus Salisbury Field.

One might well ask whether Field's pictures belong in this chapter, or whether he belongs to the family of the naives at all. Is he an artist of architectonic compositions or a painter of the religious and fantastic? As a gifted amateur, Erasmus S. Field combined both genres, and was one of the precursors of the naive city painters of our time. Field was born in 1805 in Leverett, Massachusetts. For a few months he studied in the studio of the painter F. T. Morse. He painted portraits and fantastic compositions based on biblical and mythological themes, and died around the turn of the century.

He has now been rediscovered as a result of the growing interest in the primitive and fantastic. I am more impressed by his magically engineered visionary architecture than by his carefully modeled portraits in their glassy, enamel colors.

Field's philosophical, pedantic visions taken from schoolbooks on history, his architectonic backdrops for a dilettantish theater, are enlivened by nightmarish events. He painted his naively metaphysical spaces with technical skill and an intellectual primitiveness. Like the gardener André Bauchant, Erasmus Field created folios of historical illustration with a tragic undertone. In his *Ulysses Departing,* the hero is standing in an incredibly grotesque warship, surveying the entire Greek fleet which lies at anchor in a harbor lined with temples and palaces. Field's biblical scene *He Turned Their Waters Into Blood* (illus. 175) took shape between 1870 and 1880. An ancient city is full of people gesturing in astonishment and incomprehension as the sea turns blood red. Even the water pouring out of jars has turned red, and a white ship entering the harbor is reflected in the crimson waves. The populace is dressed in fantastic costumes—white, red, olive green, and ultramarine blue —half oriental and half medieval, as all spread the news of the ghastly event.

More important than this moralizing episode is the picture begun in 1876 and completed only much later, called *The Historical Monument of the American Republic* (illus. 177). It is probably the last picture he painted. There are in it nine main towers rising from arcades, and a park dominated by an imposing fountain. The skyscraper towers are joined by bridges traversed by trains bringing sightseers to the galleries. This is a grandiose leap into a utopian urbanism, with its schematic juxtaposition of Babylonian towers, an intuitive play of metaphysical fantasy with familiar architectonic elements, a combination of proportion and excess, displaying both nineteenth-century mannerism and a surrealist prophecy of the coming American metropolis.

Erasmus S. Field's phantasmagoria of temples, towers, and castles-in-air is nonetheless born of a simple taste; it is a populist vision enhanced by accurate prophecy.

Field's pictures belong in the genealogy of that fantastic architecture which began with the weirdly hypnotic city-scapes and prospects of Desiderio Monsu, which was further developed in the city planner's utopias of Giovanni Battista Piranesi, and which in our century has been represented by the flatiron skyscrapers of El. Lissitzky, the projections of gigantic ideal cities by Frank Lloyd Wright and Le Corbusier, and the dynamic spaces of Nicola Schoeffer.

An architecture of Babylonian towers has meanwhile actually begun to rise—no longer a mere dream, but rather the product of new techniques and materials. Modern city planning incorporates the naive utopian structures of Erasmus S. Field.

Emerik Feješ, The Tower of Babel.

Nikifor, Landscape with Architectur

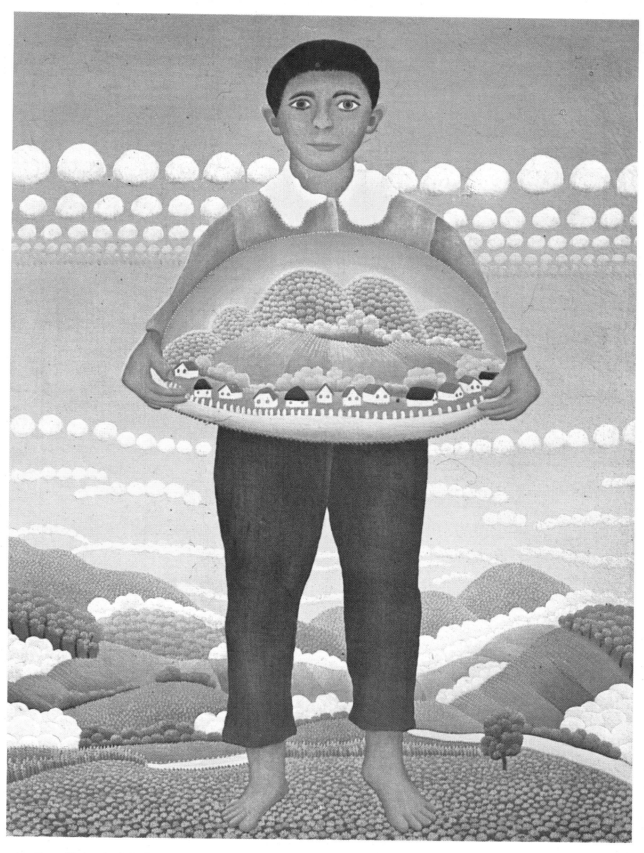

160. Ivan Rabuzin, My Son, 1966

A boy holding his village—the world of his childhood—in his arms. He stands with his strong naked feet planted firmly on a green meadow full of small blossoms. His head reaches into the sky. His face is radiant, and the wide eyes look out of the picture as do the eyes on ancient Egyptian frescoes. The boy carries the whole village landscape on his platter, complete with a wreath of houses around the edge. Summer clouds behind him are suspended above the hills surrounding his village, the pale stretch of sky along the horizon, the springtime green of the fields and the flatter green of the woods and hills—cathedrals to the joyous unity of earth and sky.

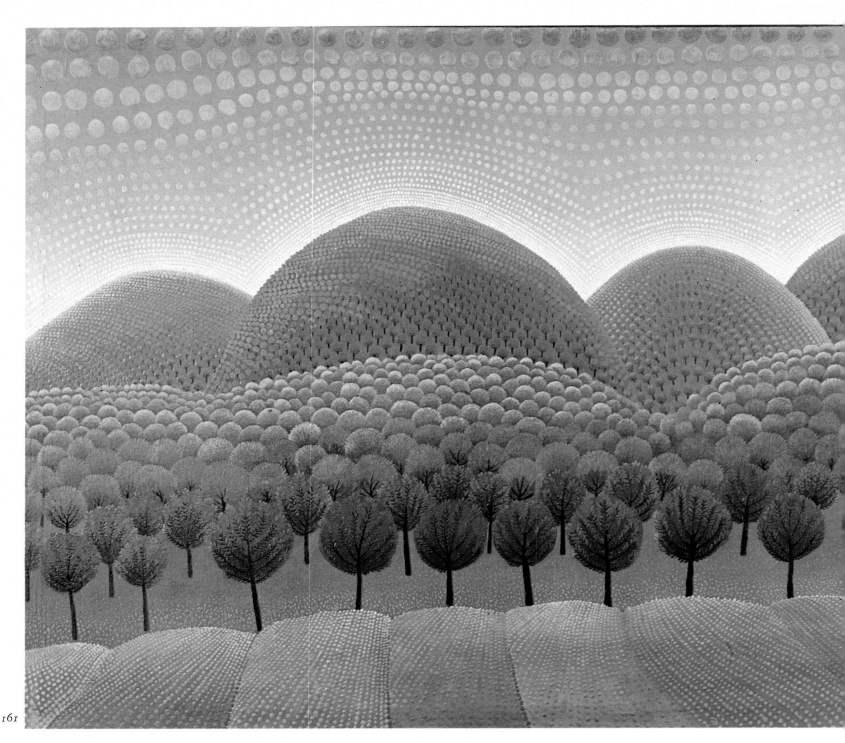

161

161. *Ivan Rabuzin,* The Great Forest, 1960

Of all the naive painters who push their pictorial images into the sphere of ornamentation—not just incidentally, but as a basic means of artistic expression—Rabuzin alone has achieved a contemplative spirituality touching on the borders of abstraction, but which never wholly deserts living nature.

Rabuzin came to his ornamental paradise through a structural reduction to the circle as the elementary building block of nature. His landscape composed of arcs and spheres is a naively and poetically transfigured reality, as consequential in its formulation as are Buckminster Fuller's buildings based on geodesic domes; it is a world transformed into a garden, planned with humanity and persistent care.

In the center of the painting is the happy, sunlit, burgeoning forest casting cool turquoise shadows. Its soft green is surmounted by the powerful arches of the wooded mountains which are equally radiant in blue shading into violet, filled with the harmony of growth.

In this light-filled and clearly ordered space there is no sign of man as an active gardener. Below the frieze of the forest, painted with incredible care, are fields with ordered rows of gray-green shading into orange. Above the blue summits of the mountains is the breathing radiance of the sky, full of pearly little clouds, first white, then pink and violet, rising in waves until they fade into infinity.

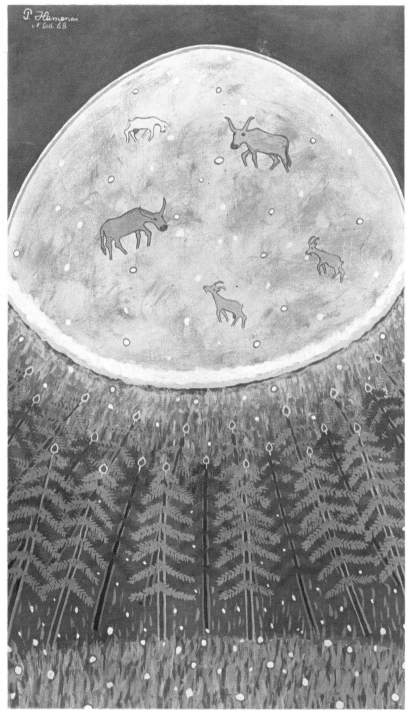

162. *Pal Homonai*, On the Meadow, *1968*

Homonai's landscapes in a vertical format are composed with a harmonic affinity for nature. In many of his pictures the fir forest ends at the edge of a pale yellow, glowing, circular mountain meadow. The round plane resembles the disc of the moon, and its magically filtered light transforms cows and goats into symbolic animals of a dream landscape.

Decades of work as an inlay painter gave the cabinetmaker a feeling for the rhythmically ordered detail of a drawing and a spare and musical sense of color. Such a harmony of the self and the cosmos is only to be found in the world of children and of the naives.

163

163. *Joseph Pickett*, Manchester Valley, *1914–18*

Joseph Pickett's well-known painting Manchester Valley *was bought by his widow at the estate auction for a dollar, and given to the school that can be seen flying the flag in the picture. The colorful little train that crosses the landscape like a child's toy is supposed to represent the first train to pass through New Hope, Pennsylvania, the painter's birthplace. But the local school later sold Pickett's painting at a very high price in order to begin the construction of a new building.*

164. John Kane, Through Coleman Hollow up the Allegheny Valley

The realistic painter Gustave Courbet rehabilitated nature and freed it from myth. Unconsciously—and a half-century later—the strong and vital hand of the industrial worker Kane shaped a landscape quite similar to Courbet's. Kane painted the confrontation of nature with civilization: the strip of smoke from a locomotive pulling a rust-brown string of cars through the fresh green valleys, a dredging barge floating on a yellow-green river—the childlike signs of a concept of imagery corresponding to the social consciousness of Courbet, or better to its factuality.

Kane painted his first picture in 1900. This was the year in which Paul Gauguin's Noa-Noa *appeared, that travel diary of an attempted return to the sources of nature and art. Kane knew neither Courbet nor Gauguin. He knew nothing of classical, baroque, romantic, or any other traditions of landscape interpretation. He was unaware of the works that the Fauvists and the expressionist painters of "Die Brücke" were creating in those years. Three years before his death, when his name was beginning to be known, some members of the Junior League that visited him were quite upset to find that Kane often used photographs as inspiration for his late paintings, even to the point of simply painting over them. His childlike and naive spirit was uncomprehending and shaken by their accusations. The very practice for which they criticized him is today one of the standard techniques of collage painters and pop artists.*

Naively and without preconceptions, Kane painted this picture of the view through a canyon into the valley of the Allegheny. With only a few main colors within a muted range of ocher and green, he composed a landscape of broad rolling hills, woods, and an overcast sky. The shades of green alone suggest darkness and light, the gloomy ivy green of the woods, the olive green and yellow-green of the fields, the patina green of the river, and the shimmering stormy green of the cloudy sky.

165. Grandma Moses, The Dead Tree

Three Naive Artists Comment on Their Work

"Sometimes I have no idea which shade of green I ought to use, for there are hundreds of trees and each one is made up of three or four kinds of green. I look at a tree and its branches and see that the green behind them is quite dark, so that from then on I have to use a lighter one, and so forth. On the outside, it is either a yellowish or whitish green, for that's the way trees look. And then there's the snow. People tell me I should shade it more or use more blue, but I've looked at snow time and time again, and I can't see any blue. Sometimes there is a little shadow, like the shadow of a tree, but as I see it, it is more gray than blue. . . ." (Grandma Moses)

"We can occasionally reproduce a little corner of perfection when it has been registered in the clean mirror of our spirit. And those are our happiest moments. But from childhood on there are almost no instructions about how we should keep that mirror clear and calm. The slightest breeze throws uneasy ripples across it, not to mention the great storms that can cost us years out of our lives. Pain and sorrow force us to persist until we have found a style of life in which we can keep that mirror clear, inasmuch as that is possible here on this plane of

the necessarily imperfect. Only now, in my advanced age, have I learned how to do it through painting. Theoretically I have known that activity can give pleasure and recreation, but I had never experienced it before. What an old man can't discover!

"My paintings are my journeys now, and I can just as well land in the Red Sea or in Venice." (Maler Paps)

"My deepest soul was impoverished and fallow. And I would have forgotten about it entirely if I had not had memories of my childhood, and if I had not carried countless unpainted pictures inside me that demanded their own place in life, their light, and their freedom . . .

"For years I carried the burden of these pictures inside of me, and every day it became heavier. My eyes saw more and more, and my feelings became deeper and stronger. But my ignorance of the method of painting a picture was even greater.

"On my walks I would take along an empty picture frame without a canvas, holding it up in front of me so that I could view the landscape through a frame. Or I would fasten the frame to a post and then back away and gaze through it. Later I began to see the changing picture of a landscape in the mirror of a bus or in the window of a train car across from me. Land-

scapes would glide across before my eyes like films, but in
absolutely natural colors. I occasionally took a large mirror
with me outside so that I could capture in it a select and
finished picture. But it was only a mirror! At last I understood.
One only had to paint on a picture until it had become that
one in the mirror . . ." (*Ivan Rabuzin*)

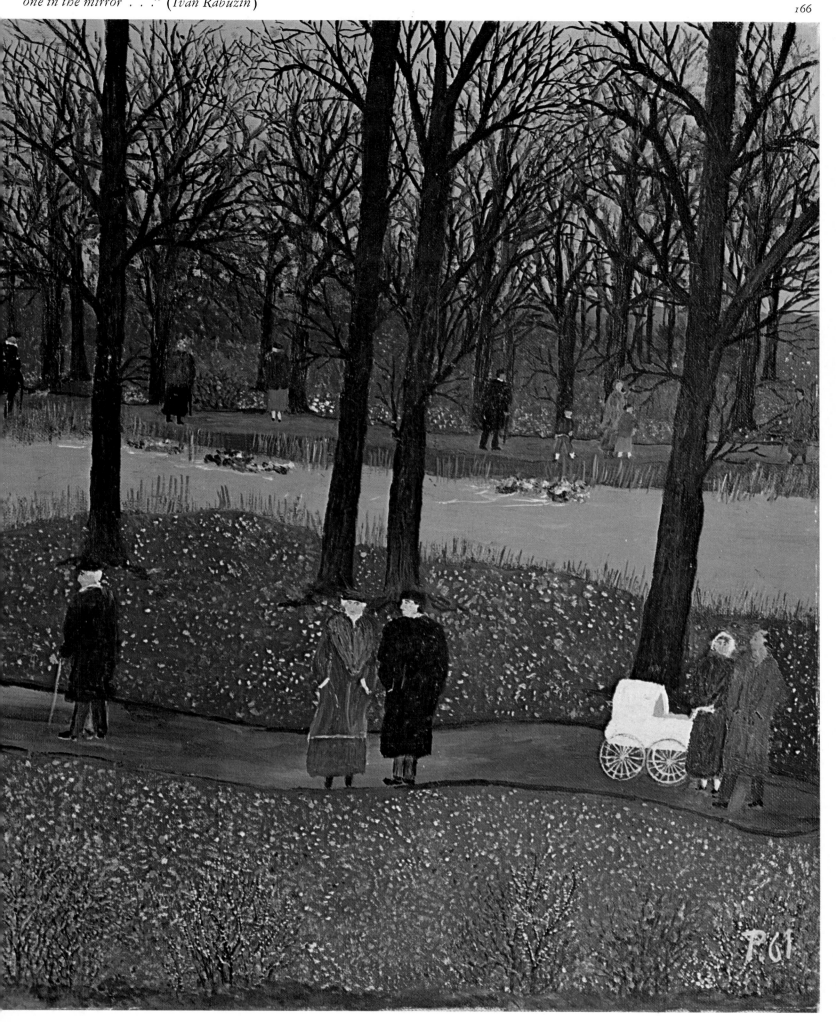

167

167. Ivan Lacković, Long Winter, 1966

A long narrow village, a line of snow-covered roofs suffused in evening light coming out of the depths of the distant horizon. This is more than a mood in space and time: it is a portrait of the village of his childhood, the one Lacković left in order to become a day laborer and later a letter carrier, and the one to which he now returns as a painter by means of his art: "My pictures are like a debt that must be repaid to my true home. . . ." The expansive breadth of this snowy landscape can only astonish the viewer. Where could Lacković, who only finished grammar school, have learned to capture the transparent shimmer of this landscape, this sense of space and of the damp air of the atmosphere?

With quiet intensity and true perfection the artist has formed both the work of nature and that of man as a single rhythmic ordering of the world. His spirit perceives the delicate branching of the trees and the birds that nest in them in a very graphic and visual way.

Lacković is a precise draftsman, a master of the details on which he concentrates in order to transcend the documentary and local sphere, and to attain one of universal validity. His handling of space, his sense of aerial perspective, and the delicacy of his range of colors attest to a secure feeling for balance and harmony. It may be that only Japanese masters of the woodcut or of silk painting have managed to portray such sunsets without becoming all too sweet and cloying. Lacković is also indebted to the "academy" of naive painting which has developed through the decades as the school of Hlebine. His drawings and paintings show that a vital renewal is possible within the influence of Hlebine, when a real gift for observation is preserved:

168. *Charles-Lucien Pinçon,* Snow in Limay

169. *Jean Eve,* Hills of Sours-en-Vexin, *1946*

170. *Anna Zomer,* Oud
Amelisweerd

171. *Jentje van der Sloot,* Frisia

172. *Miguel García Vivancos,* Notre Dame of Marais, *1964*

Born in Murcia, the Spaniard Vivancos was successively a chauffeur, a dock worker, a mason and ditchdigger, a warrior for Spain and hero of Puigcerdá. He had five years in a concentration camp in which to ponder over the darkness of his imagined sky. He then began to paint a world that he could not improve otherwise. At first he did paintings on silk for ladies' fashions, but the clichéed patterns bored him and he soon began to develop his own. He painted the stories of simple people, people at shooting galleries and carousels, still lifes in dramatic and radiant color. An ultramarine-blue silk curtain, theatrically draped, will frame our view out into the rhetorical landscape of his ornamental and colorful dreams.

A Gothic church, the focus and chief monument of the little town, stands under a pastel blue sky. To the left is a café with a red-and-blue-striped awning; behind and to the right are the building-block houses of the town. It may well be noon, for the light is falling vertically upon the innkeeper standing in front of his door. A few people seem to be heading for the church. Are they strangers?

Vivancos depicts the paving and the stones from which one builds cathedrals with the patience of a miniaturist. The sum of his details and the calm control of his colors evoke a vision of a better life. His muted harmony is challenged by the gleaming triad of phosphorescent blue, wine red, and emerald green. This is a banal and simpli-fied representation, but his poetic and naive interpretation of reality somehow raises it above the level of mere picture-postcard narrative.

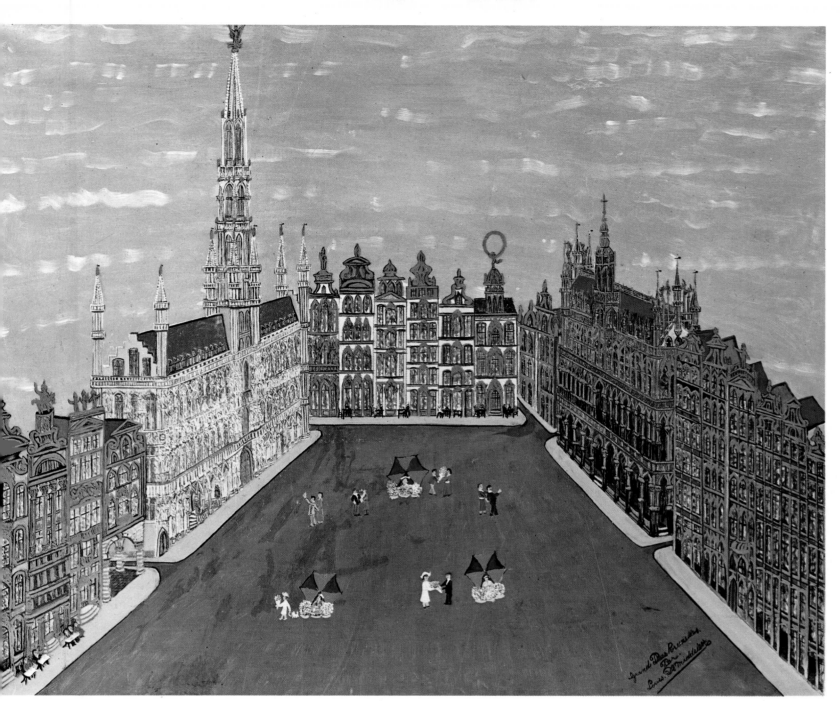

173. *Louis de Middeleer,* The Great Square in Brussels

While serving on the jury for the exhibit "Fifty Years of Modern Art" in Brussels in 1958, I often visited this golden square. I only came to know Middeleer's naive picture of it at the "Second Triennial of Naive Art" in Bratislava in 1969. Standing in front of this picture that had been sent to the exhibit by Emile Langui, the friend and promoter of naive art in Belgium, I came to appreciate anew the longing for utopia in the art of the naives. Middeleer has painted a joyous and harmonious picture. The city hall with its Gothic tower, the guild and merchants' houses with their ornamental gables arranged in a neat rectangle comprise the jeweled pride of the wealthy city. The façades gleam with the opaque gold of icons. The sky above glows with the transparent azure of the sea. On the square itself one can see the red and green umbrellas of flower stalls, and little figures are presenting each other with charming bouquets. A legendary calm and solemnity reigns in a square which is filled today with hundreds of automobiles parked right up against the façades. The childlike imagination of this painter has preferred the look of the square as it was in olden times; the golden buildings are but an echo of a long-lost golden age.

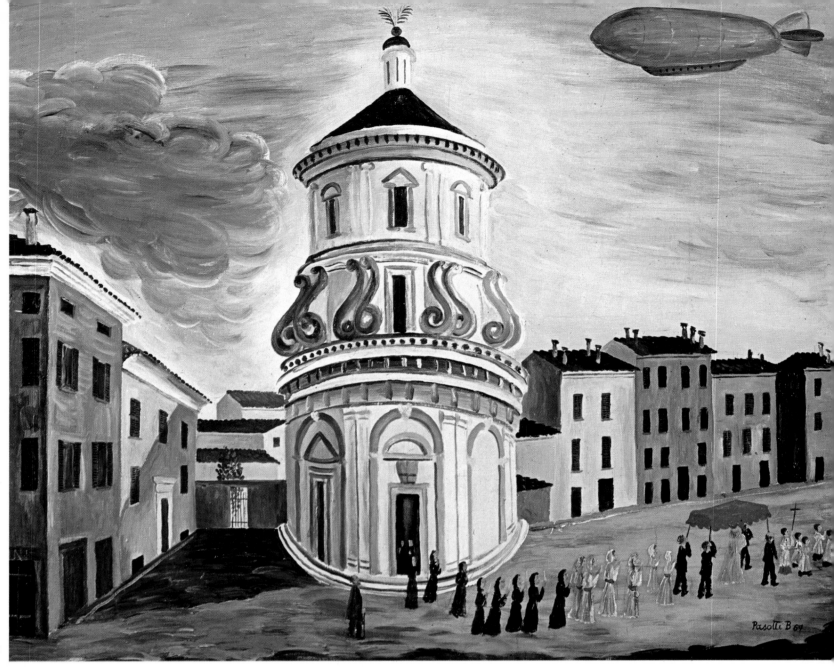

174

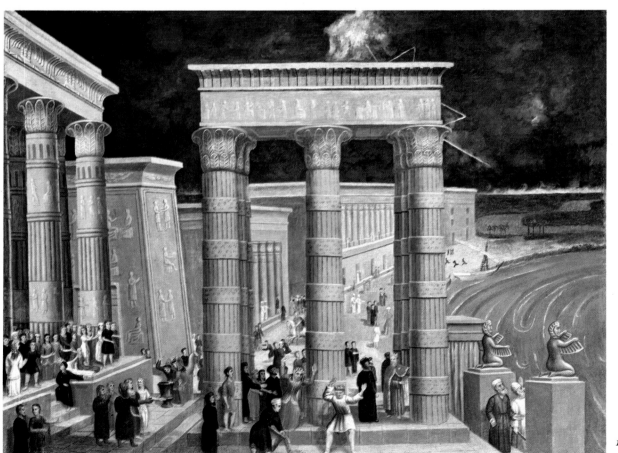

174. *Bernardo Pasotti,* Street
Scene With Dirigible

175. *Erasmus Salisbury Field,*
He Turned Their Waters into
Blood, *1870–80*

176. *Orneore Metelli,* After the
Performance, *1938*

177. *Erasmus Salisbury Field,*
The Historical Monument of
the American Republic,
1870–80

175

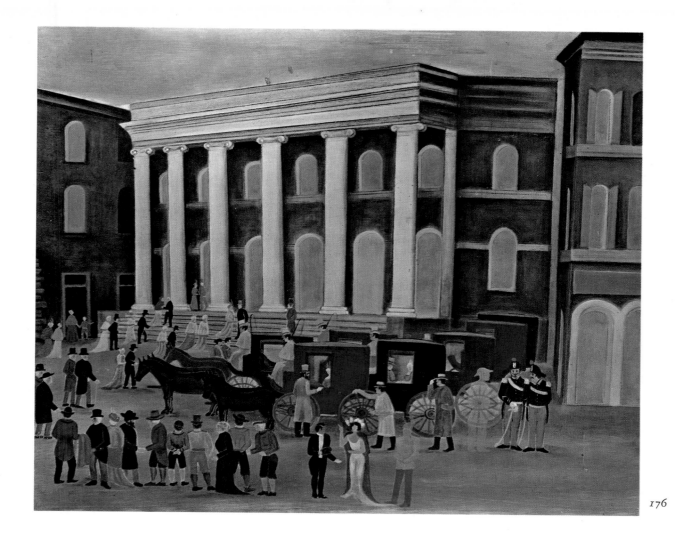

176

178. Emerik Feješ, Worms, 1963

*The paintings of the button and comb maker
Emerik Feješ have nothing about them of true
gravity and realism. He was a man of the
city, and his soul loved to dream of faraway
places.*

*With the help of post cards he journeyed into
the imaginary world of distant architecture,
which he then built anew in the dissonant
colors of his naive mosaics. In so doing he
surmounted mere reality and entered into an
indefinite and dreamy disoriented realm.*

Portraiture and Self-Portraits of the Naives

Chapter XII

D.B. 1969.

Above:
Dragiša Bunjevački, The Ascension
of the Naive Painter Emerik Feješ,
1969.
*From the text: "The first men have
landed on the moon. The whole
world is rejoicing. But many lament,
for at the same time the naive painter
Emerik Feješ has left forever our
world and the strange cities he
painted.*
*"May the dark soil lie gently on him,
our friend and colleague, the naive
artist who suffered so much in life,
and who took leave of his wife
Josephine and his friends in July,
1969."*

Right:
Dragiša Bunjevački, Feješ and His
Wife With a Cat, *1964.*

The Rationale of the Portrait

Neither the preperspectivist disregard for space and time of primitive art, which shows all its figures from the front or in profile, nor the scientific formulation of central perspective as it has been formulated and applied since the Renaissance corresponds to the essence of naive art. Naiveté is perfectly content to combine the typical and the individual, the visible and the imaginable.

Primitive art does not recognize particular individuals as the bearers of unique psychic qualities. The art of earliest times as well as that of all primitive cultures is oriented toward type and genre. Individualization comes into art only through preoccupation with the portrait and self-portrait.

Portraiture has been dedicated above all to the presentation and acknowledgement of power. Likenesses of priests from Uruk in Mesopotamia, bronze masks of the kings of Nineveh, the columnar reliefs of the lawmaker Hammurabi and the Gudean sculptures of tyrants, the chiseled and painted portraits of pharaohs and statues of Roman generals and emperors—all served to incorporate and make visible the wielders of earthly and other-worldly power.

The Christian Middle Ages negated the

individual for philosophical reasons. A man was above all a member of his order. The individual was not distinguished from others on the basis of his facial features, but solely by the signs and emblems of his stature.

The early bourgeois, humanistic consciousness broke free of the ritual and courtly conventions of the middle ages. Jan van Eyck's portraits of burghers, Hans Holbein's likenesses of English nobility, and the autobiographical spiritual confessions of Rembrandt were to develop as physical and psychic mirrors of personality.

Since the middle of the nineteenth century, the painted portrait has been supplanted by the daguerreotype and the photograph. The well-adjusted and stereotyped city-dweller of today no longer satisfies his craving for prestige with portraits in oils and marble busts. With our rapidly changing view of reality, figure paintings and portraits have gone the way of landscape and still life. The face and form have lost their significance; man has become but a simile of form itself. Not that we are any the less interested in likenesses. A temporary epiphany of portraiture can be got with the help of the still camera and the clever configurations of the motion picture. The sound and movement of television and films and the snapshop likenesses caught by millions of portraitists with their cameras have demolished the barriers between art and nonart. An unlimited number of portraits from life, with true rendering and anatomical exactness, can be produced by anyone at all.

Henri Rousseau,
The Painter and His Model,
after 1905. Detail.

The Naives' Rediscovery of the Human Form

The profound caesura effected by the picture machine of the photographic camera and possibly also by the early manifestations of computer art does not entirely preclude the continuation of artistic development, but it clearly has changed its direction.

The eyes of artists and students of art, glazed with the exhaustion of civilization and the sight of mass-produced objects, find relief in the art of primitives and naives. After having witnessed the dissection and destruction of the human form, one can rediscover in the portraits and self-portraits of naive artists a lost integrity of the living body. Free from convention and the formal styles of modern iconoclasts, the naives are still capable of disclosing the unfamiliar face of man.

Rousseau's portraits of others and of himself have influenced the art of our culture in the same way that the primitive sculptures of Africa and Polynesia have. The message transmitted by the likenesses of *le Douanier* could not be deciphered immediately, because they came at a time when the break with a tradition of virtuosity that had become empty was just beginning. Rousseau's unconscious forms provided an answer to artists embarked on a new quest.

In spite of their often astonishing resemblance to his models, Rousseau's portraits are much more personifications of his imaginings than they are actual persons. He does not express the visual alone, but the conceptual as well. At first one is likely put off by the paucity of facial expression: the all too simple trapeze of the nose, the childish line of the mouth, and the frozen, stylized shape of the face. They participate in a nonindividualized anonymity. When we examine Rousseau's faces more closely and more frequently, we come to recognize his intuitive ability to penetrate other personalities, which lends his stiff, lamed, unmoving features a magical separate life.

In place of gesture, Rousseau depicts the repose of timelessness. Motionless, as though turned to stone but still not without soul, his lips have attempted smiles. Did the artist fail to take the step of release from archaic rigidity, or did he deliberately step backwards into it? Did he not know how to curve the lips of his languorous dreamers and to capture the gleam of a smile? In the face of the sleeping gypsy (illus. 2) we can recognize an attempt to shape the smile of a dreamer, for with tremendous intensity Rousseau penetrated to the essence of this sleeping woman. The ebony face, framed by the faded rose color of the pleated kerchief, is shown straight on in spite of her sleeping position.

Though it is relatively easy for the unschooled eye to achieve a likeness by noting down the simple lines of the profile, the view of the full face confronts him with a certain difficulty. But still the primitive and the naive artist will often choose this aspect, because it alone is considered to be a valid portrait, while the profile strikes him as somehow insufficient. Rousseau occasionally took advantage of both possibilities, choosing a slightly sidewise turn of the face which allowed him

Henri Rousseau,
The Painter and His Model. *Detail.*

to show the strong outline of the nose, cheek, and forehead, and at the same time to use both eyes to reinforce the expression. His most important portraits, however, are done strictly *en face.* The pictures of Joseph Brummer, of Apollinaire and his muse, and of the eight people in the group portrait of *Wedding in the Country* (illus. 44) stare out from the canvas just as directly as do the so-called "football players." Also his portraits of women (illus. 45) and the likeness of Pierre Loti and the cat are laid out according to the same simple scheme.

Rousseau did not paint many portraits of children, perhaps because he too, like most naives, saw children as only miniature adults. The *Boy on the Cliff* is wearing a blue-black smock, and his round head is set onto his body without a neck and without any transition whatsoever, like the face on a clock. He is looking toward us while standing or hovering above some grayish-blue rocks, with the sea and the sky behind him. The exciting pattern of the white and black striped legs and the chubby doll hands that seem incapable of holding anything make this monumental little creature somehow startling and mysterious, like Fernand Betero's pictures of children.

The self-portrait is a late development in the history of art. The simplest representation of the self can only succeed after one has mastered the painting of others, and still the need to express oneself through the depiction of one's own personality, to step out of a picture with one's eye upon the viewer, is something felt by every artist in his growth toward individuality.

Almost without exception, the earliest self-portraits are disguised as secondary figures placed in the margins of larger compositions. Even Rousseau's work contains examples of this practice. We can discover him in the *Wedding in the Country,* in the fantasy *Liberty's Invitation to the Artists . . .* (illus. 48), where he is seen shaking hands with Odilon Redon, in the *Cart of Père Juniet* (illus. 236), and four times at once among the *Ball-Players in the Woods.* We can guess too that he is included among the little men with large hats that stroll through the parks and boulevards of his landscapes.

We also have a double portrait of Rousseau in the picture that shows him with his second wife. This painting, *Present and Past,* was done in 1890 and then reworked in 1899 when the artist married for the second time. He felt that his pictures ought to change with him. Still, he left himself and his first wife looking down out of the clouds.

In the years 1902–03 he did two portraits, one of himself and one of his second wife, Joséphine. The painter is no longer wearing sideburns, but a mustache with turned-up ends instead, as was the rage just then. His wife's opaque face has grown older and is marked with illness. A splendid brooch holds her blouse closed below her collar. The strange importance of these paintings derives from the transitoriness and at the same time the permanence they exemplify.

Both paintings are found in the collection of Picasso, who was charmed by their sobriety and directness.

Two Self-Portraits with Palette

In March of 1890 Rousseau exhibited the grand self-portrait which he called *I Myself: Portrait-Landscape* (illus. 182) in the Salon des Indépendants. The critics reacted to it with irony. In the *Journal des Arts* one could read: "It was difficult for me to warm up to Rousseau, whom I dare to call the one blemish of the salon. Rousseau stands among the advance guard of painters. He has invented the portrait-landscape, and I would advise him to have his title patented, for there are after all unscrupulous persons about who are perfectly capable of appropriating it for themselves. . . ." Such sarcasm did not trouble Rousseau. He was firm in his faith that a portrait and a natural landscape could be blended into an integral unity, and he continued to construct his immortal pictures on this union of man and nature.

As though hovering, not standing—like a medieval angel at the annunciation—flanked by dirigibles, he painted himself with a black beret on his head and in a black suit and white cuffs. Behind him are one of the bridges of the Seine and a ship flying pennants of all colors. Small people are strolling along the bank admiring the ship which has probably just come in under the soft blue-green sky from some exotic port. In the background stand a row of buildings and behind them the angular architecture of the Eiffel

Tower. Rousseau is holding his palette like an emblem of himself, and on it is written the magical formula of his constancy and his love: "Clémence and Joséphine."

Wherein lies the magic of this picture? Is it the earnest look of the eyes in a masklike face framed by a dark beard? Is it the pure black of his body and the whitish gleam of the clouds slightly muted by the sand-colored *sfumato* of the patina of time? In solemn dignity, touchingly and at the same time sublimely, he stands before us, Rousseau as he saw himself and as we carry him in our memories. A lonely little man climbing out of the misery of his poverty and neglect to create with diligence and determination the work which would usher in the adventuresome puzzle of our century's art.

I have reproduced this self-portrait, which since 1923 has hung in the National Gallery in Prague, together with one by the peasant painter from Hlebine, Ivan Generalić (illus. 183). In the imaginary gallery of the centuries there are pictures which are so unique as to have no parallel. If I place the self-portrait of Generalić next to Rousseau's *I Myself* nonetheless, it is for the purpose of exposing contrasts as much as similarities. Produced out of a different way of life and a different culture, Generalić's painting is in its own way perfection. This painter too has often placed his subjects into the midst of landscape, washerwomen at a village pond, men and women harvesting grapes, a gypsy wedding, or even the body of his dead friend Virius (illus. 79). Generalić only rarely ven-

tured to do a portrait of himself. It could be that he has discovered a narcissistic streak in himself which he has chosen to suppress rather than to let it get out of hand, or he may simply not enjoy self-analysis. The career of this farmer whose name became known around the world in such a short time must still seem strange and almost inexplicable to him. For his likeness of himself he chose the setting of his everyday life, and called it *My Studio.*

The painter stands in the center of his country place, surrounded by barns, a well, and behind them the toy roofs and church towers of Hlebine. He places himself in front of a small, cinnabar-colored easel in his light working clothes patched at the knees and a white cap. He does not appear to be too self-conscious in the landscape comprising the space of his picture. His left hand is holding a palette bluer than the sky that arches above him. At the lower edge the same blue is repeated in the surface of a pond.

A feeling for life causes the artist to pause for a moment in his work. While he searches for the expressive symbols of his composition, the barnyard animals crowd around, a pink cow, a graphite-gray pig, white baby ducks, and the bright-colored, companionable rooster. They are curious to see what he is doing and to judge his work. For in the lyric idiom of his painting can be heard the voice even of lifeless things, not only the thoughts of dumb animals and miraculous grass-covered fields.

Adolf Dietrich, Self-Portrait With Concertina, *1906.*

The Self and Others in Portraits by Metelli and Dietrich

Self-portraits of naive painters are especially rewarding in that their simple and childlike candor reveal much that can help us to form an impression of the artist and to see more deeply into his soul. A comparison of Metelli's and Dietrich's portraits of themselves can point up the differences between their respective techniques and personalities.

Metelli, the shoemaker of Terni, chose to put on the fancy uniform he wore as a member of the town's theater orchestra when he began his self-portrait in 1932. It was black with gold trim; a lyre, the symbol of sublime music, was embroidered on the sleeve.

Metelli is leaning comfortably against a chair covered in the same green as that of the feathers on his hat. He looks out from the picture with a steady gaze; his nose is an expressive one, and a small and very red mouth lurks beneath his jaunty mustache. The whole attitude is one of seriousness and solemnity. The naive painter is quite conscious of his dignity, for musicians counted among the worthies of the town (illus. 185).

With self-conscious pride and in an imposing conventional posture, he does not take lightly this business of showing himself to the world. It is a Sunday brimming with light and vitality, and the cares of the world have been suppressed or forgotten. He has reached the shores of an imaginery land; those who knew him as a mere master shoemaker could not know that behind this life of constant manual labor another man was at work who knew how to contemplate on the meaning of life: Metelli, artist and creative

genius. All of this can be read quite clearly in this self-portrait.

Quite different indeed is the portrait (illus. 186) Adolf Dietrich made of himself in the same year, 1932. The fifty-five-year-old artist painted himself in a blue striped shirt against a dark background. The grayish-brown vest stands open in front, and one can admire its fine stitching as well as each detail of its buttons and buttonholes. His long face shows the traces of his habit of contemplation; his blue eyes seem penetrating and observant. His hair is brown, lying close to his head, and his nose is quite narrow. A small mustache adorns his upper lip, and a half-open mouth suggests that he is taciturn by nature and much alone. Striking is his high, furrowed forehead which shows signs of very serious questioning. The hands in this portrait have not been finished, although it was they who produced the work conceived behind that brow. The picture was done with a sensitive and muted palette; the deep seriousness apparent in his features suggests the artist's inner struggle during the work of creation. Here there is no trace of vanity or inflated self-consciousness. He was possessed of a spiritual stillness and childlike intuition.

The two portraits that I would juxtapose to these self-portraits of Metelli and Dietrich tend to confirm the respective character of these two painters.

Metelli's *The Venus of Terni* (illus. 184) shows us a lovely Italian woman with round shoulders, rich dark hair that hugs her head, and large, expressive eyes. She has lifted her right arm and put her hand to her ear, as though listening to music approaching. Her bosom is contained in a waistcoast fitted as perfectly as Metelli was accustomed to fit his best shoes and boots, with the sweeping line he knew meant perfection. A double chain with a medallion set with a gem adorns the woman's throat. Balance demands that her left arm should hang down; the hand is not visible, though it is doubtless lying in the lap which discretion has not shown. A buckle holds the wide band that marks her waist and brings the picture to a close. The expression on her face is thoughtful, a bit reserved, and enticing all the same.

The Girl With Striped Apron (illus. 187) is full of the sincere simplicity with which Adolf Dietrich portrayed all living things. Done with a sensitive and quiet brush, each bit of edging, each ribbon and strand of hair is recorded with careful precision. The thoughtful face, the round and intelligent forehead, the soft blue eyes that look inward, and the lavender blue and white striped apron show the painter's gift of observation and his penetration into the essence of this half-grown but perceptive creature. Fritz Billeter has written: "He can paint a girl who looks as pure as an angel, but not forget the slightly oily shine of the hair that one can often enough see on peasant children. . . ."

Even though this charming girl's hair is properly combed, the few loose strands reveal the liveliness of the young thing, who possibly only held still for so long because she especially liked the painter.

Martin Mehkek, Man with Cat, *1962.*

Peasant and Proletarian Portraitists

Any strictly sociological analysis of artists would produce quite predictable results. Adolf Dietrich combines a patriarchal peasant heritage with proletarian, working-class practicality. Ivan Generalić cannot isolate himself totally from the influence of the outer world in an age of mass media. The forms of dense communal existence affect the work of even the most remote peasant artists, however altered they may be after passing through the channels of social processes. But in addition to the influences of a class or a community there always remains the strength of the individual personality.

Each of the five peasant portraits I have included here enjoys a unique character within the social order. Perhaps the least individual is the portrait painted by Anuica Maran (illus. 189) from the village of Uzdin. The pretty girl—probably a bride—painted before her mirror stands as a type, rigidly maintaining her pose directly in front of the bright reflecting glass. She is surrounded by real flowers and embroidered ones, and she herself has become only a stationary ornament in two-dimensional color. The painter has appliqued some brocade and some silver threads in order to give the picture a holiday spirit.

The painter Janko Brašić has broken free of ornamental folklore elements. The portrait of his mother (illus. 190) shows a synthesis of experiences of his childhood and of his art. He paints with a documentary exact-

ness and realistic intensity. The woman in her muted brown colors is pictured against the colorful background of a country garden. In her simple and self-contained old face we can discover the symbolic traces of motherhood *an sich.*

Mirko Virius has done the portrait of a beggar, or possibly a landless peasant (illus. 193). With its long nose, mustache, and deep furrows, it is the face of a man who knows the brutality of life and still the self-conscious dignity of poverty. Strong arms and hands contribute to this personification of work and rebellion. His bright eyes are critical. The forms and colors in this portrait are realistic, powerful, and controlled.

Mihael Bireš does portraits of great simplicity (illus. 191). His pictures of old people are especially successful. This woman against a radiant blue background and framed by a gray-black shawl is clearly caught by fate and humbled by the knowledge of her imminent departure. The deeply sunken eyes look out from a great distance through her pale, masklike face. Below her large nose, her mouth smiles with sorrow, like a Nō mask from ancient Japan.

The portraits by the farmer Dragan Gaži have the effect of metaphor. An old earth-colored woman (illus. 192), whose wrinkles done with shaky sepia brush lines resemble plowed furrows, holds her eyes closed as though lost in prayer. Here is a concentrated stillness, and somehow the dying face is already being transformed into a death mask.

Jože Tisnikar is a lay painter of peasant origins. He works as an unskilled laborer in a Slovenian hospital. After his eight-hour working day and on holidays, he paints pictures having to do with the physical and spiritual realms of sickness and decay. Death and fate have cast their shadows over this expressive artist. In 1951 he began to paint from an inner urge to get down the things that preyed on his sensitive nerves. The professional painter Karel Pećko helped him learn the techniques of tempera and oils, and convinced him to preserve the naive and elementary features of his pictorial concepts. In his imposing pictures there is a clarity of vision which penetrates into obscure areas of existence. A *Self-Portrait* (illus. 188) shows the artist's mummylike face cloaked in doubt and exhaustion. Tisnikar is standing with his back toward his easel, on which can be seen a picture of a greenish-blue corpse, and above it another of the bright face of a woman.

Here men and objects have a tragic and symbolic significance in their definite outlines and luminous colors. Influences from various art styles reveal that this artist is only a borderline naive. The dictates of his subconscious belong to the experiential level of the naives, however, and are only slightly colored by the narrative element of surrealistic literature.

It is not an easy matter to compose a human face, to infuse a painted visage with thought and feeling. John Kane managed to avoid the stereotyped preconceptions about how a man ought to look. In order to penetrate into a living person one must surrender himself to the unknown. Kane did just this. His self-portrait (illus. 179) is a union of the external and internal; it arises out of direct experience, and it is bold, honest, and true.

Joseph Wittlich's portrait figures (illus. 194) are experiences from the world as gathered through the mass media of our time. He has not seen the people he paints face to face. Illustrated magazines, mail-order catalogues, and film posters provide him with the material from which he creates his forms. Wittlich unconsciously fuses contradictory phenomena and incompatible styles in a manner that could only be achieved by the masters of collage with great deliberation. Surrounded by enticing pictures, Wittlich reproduces the visual experiences that beleaguer him as they are received by his childlike soul.

I introduced this chapter with the self-portrait of John Kane, and I end it with the double portrait by Joseph Wittlich. Both painters were industrial workers.

The group of naive painters considered in this context could be infinitely enlarged. Many who have not been mentioned are implicitly included in this attempt to disclose the unity that is to be found in naive portraiture.

Millennia had to pass before artists mastered the image of the individual. The portrait belongs among the later developments in art, and not to archaic tradition. In our age with its limitless capacity for the production of portraits with the help of the still or motion picture camera, the professional artist has begun to defend himself against such pictures from machines. Forsaking his own virtuosity, he is beginning to try to look at the human face in a new way—through the eyes of the naives.

Martin Paluška, Portrait of His Wife, *1950.*

Joseph Wittlich, Girl in Yellow, *1968.*

179

179. John Kane, Self-Portrait, 1929

In unstinting self-analysis the artist portrays his aging body and the stern dignity of his own consciousness. With perfect and static symmetry he shows us his face and torso—precise and clear, realistic and at the same time symbolic—a man compounded of hardness but also of sensibility, possibly an anticipation of his picture of a boxer after a fight. His is the individuality of a tree, or a cliff; what we see is both superficial and profound. His gaze meets us directly; this is the self that looks back at him in the mirror.

Thanks to a certain stylization, this realistic personality becomes an objectified object, the portrait of an industrial worker. His own perception of himself is blended in with what he sees. The bows and ellipses create a kind of aura around the man's earnest face. This is an icon of the self, one man's inquiry into the sense of existence, pursued with penetration though ultimately undiscoverable.

180

180. *John Bradley*, Little Girl in Lavender, *circa 1840*

John Bradley, who was known in New York as a portraitist and painter of miniatures, was active between 1837 and 1845. This girl is standing on a spring-green carpet, dressed according to the fashion of the time in lace pantaloons that are visible under her lavender silk dress. An apron with a flower on it, a necklace, and ruffle sleeves that leave her shoulders bare as a ball dress would complete her costume. The dark eyes beneath her carefully parted hair are looking out into the distance. One hand is holding a basket of flowers, the other is touching a branch of a potted plant with fiery red blooms. A cat is playing with a fallen rose at her feet. It is all very charming, in its essence reminiscent of children's portraits in the Empire style, with a breath of sadness which causes us to ask whether this portrait was painted during the girl's life or only as a memorial after her death.

181. *Arsenije Petrović,* Portrait of the Children Jovan and Jelisaveta Popović, *1856.*

In the art of the early industrial society of the nineteenth century there developed alongside the "high" art of late Classicism a petit bourgeois style sustained by craftsmen and amateurs which might be called a "retarded" Biedermeier. Usually created on commission, these portraits from the Serbian Vojvodina, which then belonged to the Austro-Hungarian monarchy, have certain naive features. This cultural province which looked toward Vienna for its models developed an art of portraiture which bears an affinity to the paintings of families and of children by the North American limners and folk painters.

The cheerful double portrait of the Popović children, painted by Arsenije Petrović (1803–1867), displays a bit

of Sunday posing, but it is not at all too stiff, and it suggests something of the personality of the children and certainly a family likeness. The little girl was placed on the table in order to keep her chubby figure from seeming less important than that of the older brother, who holds a little whip in his right hand while proffering his left politely to his sister.

The colors in the picture are restricted to a modest white, red, brown, black, and blue. The children's heads are a bit too large, but their hair is freshly parted and combed. They are standing stock-still as though for a photograph. The fabrics, jewelry, and lace that were so fashionable at that time—including the pantaloon legs protruding from the girl's skirt—are painted with great care. It is a picture of grace and craftsmanlike exactness, corresponding to the wishes of the patron.

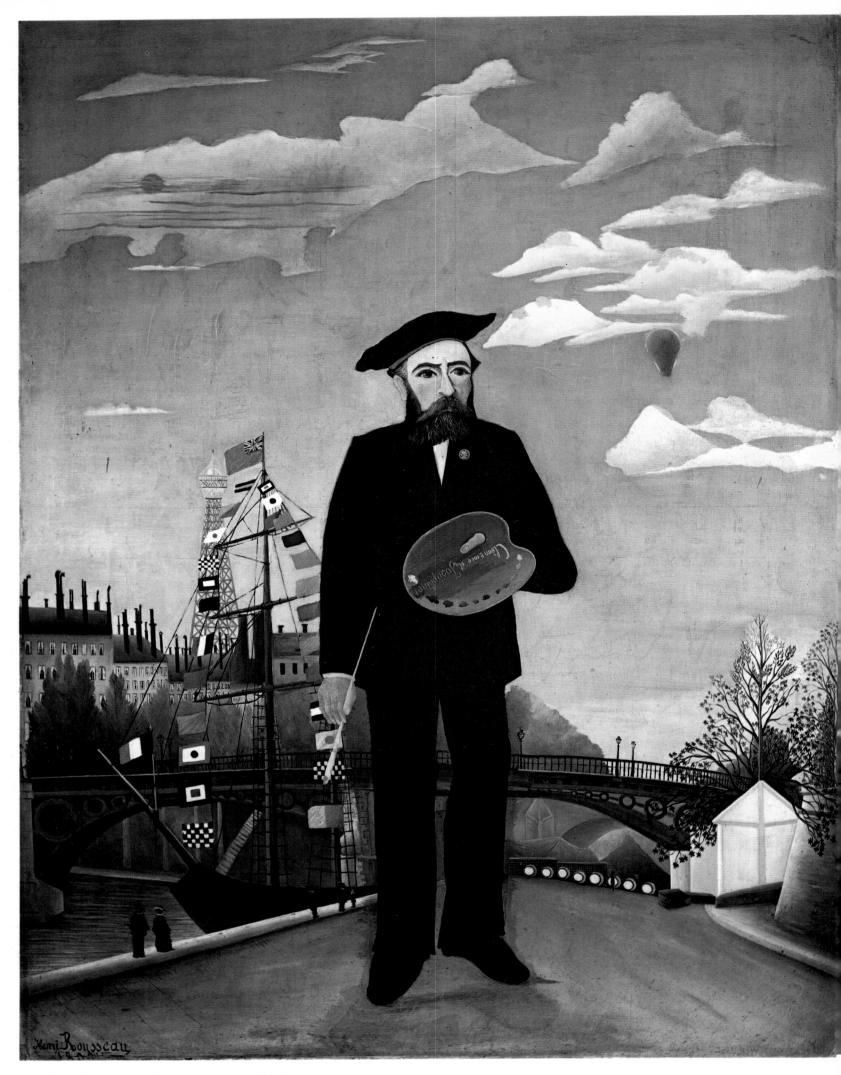

182. Henri Rousseau, I Myself: Portrait-Landscape, *1890*

183. *Ivan Generalić*, My Studio, 1959

184. Orneore Metelli, The Venus of Terni, *1935*

185. Orneore Metelli, Self-Portrait As a Musician, *1932*

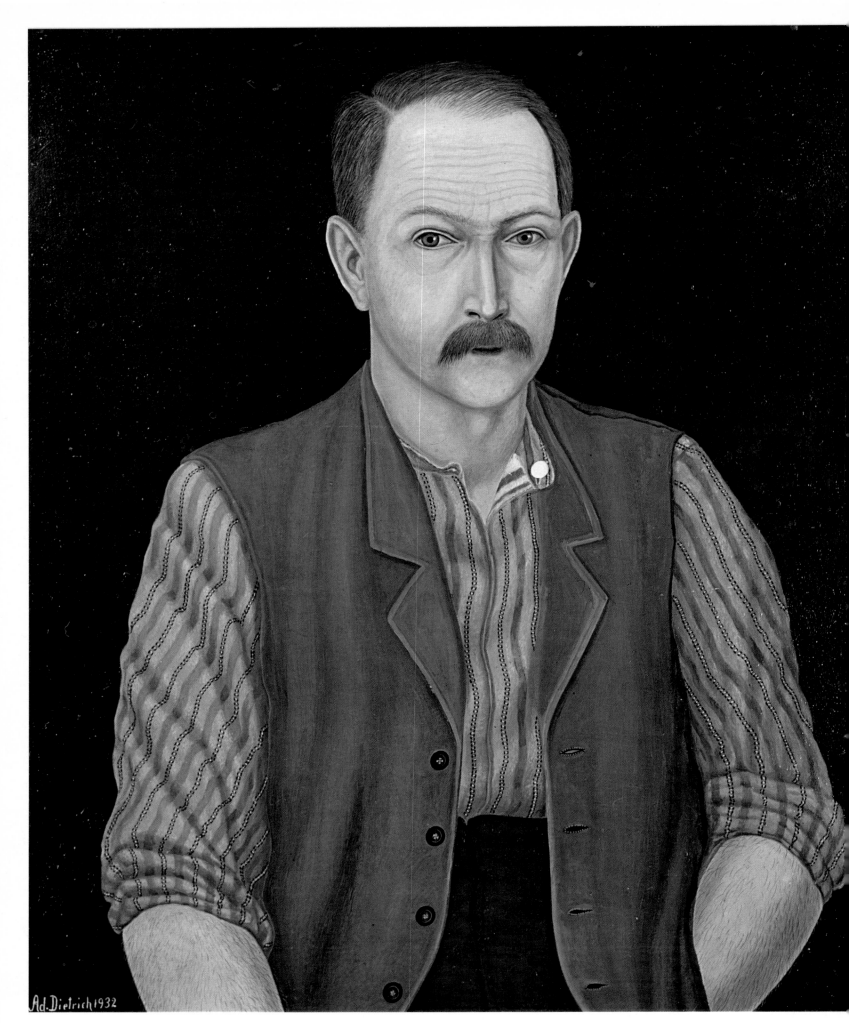

186. *Adolf Dietrich,* Self-Portrait, *1932*

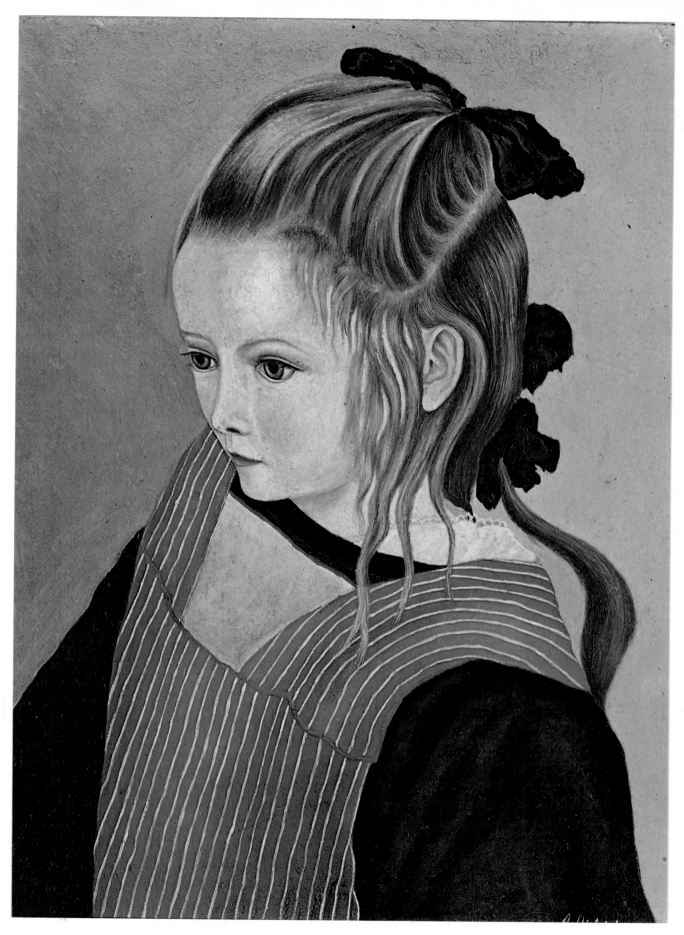

187. *Adolph Dietrich,* Girl With Striped Apron, *1923*

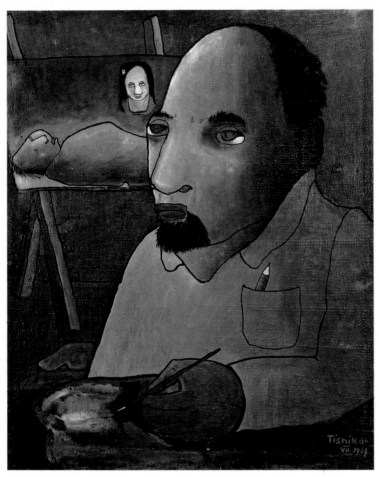

188

188. *Jože Tisnikar,* Self-Portrait, *1969*

189. *Anuica Maran,* The Bride, *1964*

190. *Janko Brašić,* Portrait of My Mother, *1935*

191. *Mihael Bireš,* Portrait of an Old Woman, *1967*

192. *Dragan Gaži,* Portrait of an Old Woman (Grandmother Dijak), *1956*

193. *Mirko Virius,* The Beggar, *1938*

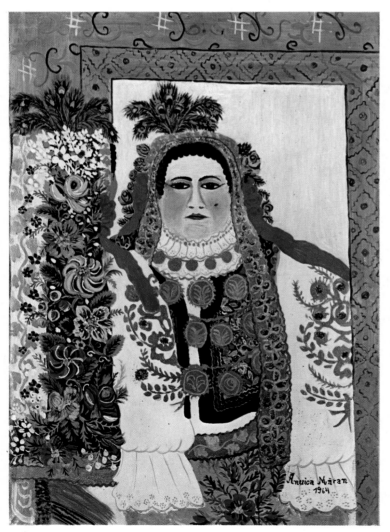

189

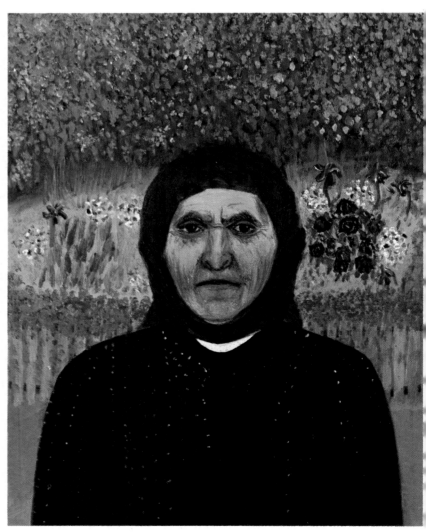

190

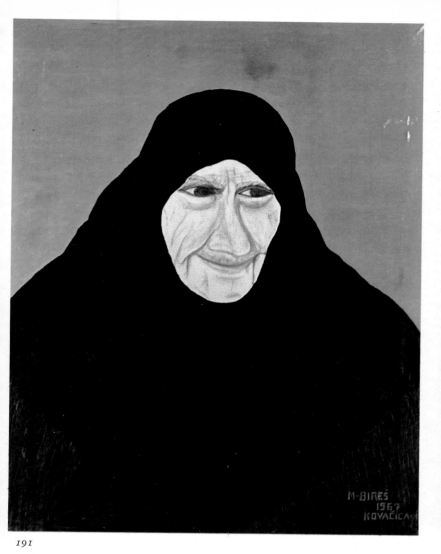

191

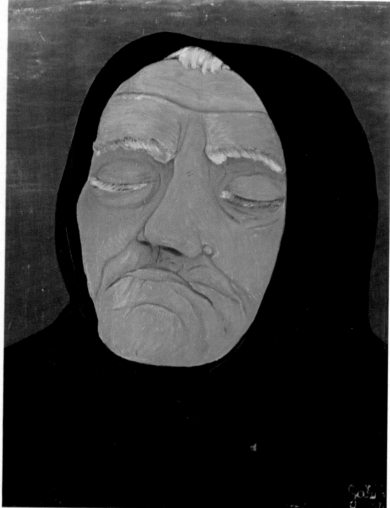

192

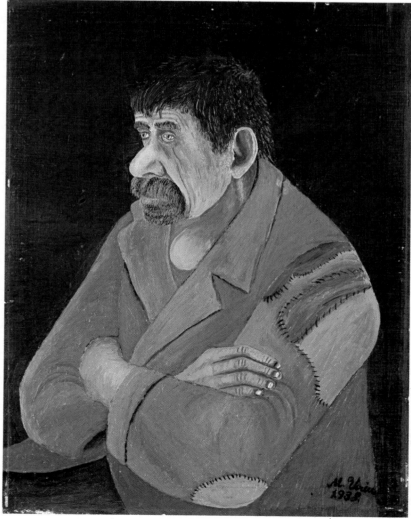

193

194. *Joseph Wittlich*, Women, *1968*

The imaginary portraits and likenesses from the hand of the miner Joseph Wittlich are unconscious and independent reflections of our contemporary civilization. The naive artist too is surrounded by a flood of colorful magazines, daily papers, film advertisements and still pictures, comic strips, and the magical images of the television set. Naive pop art arises as the expression of a primitive longing for things out of the ordinary, an identification with the heroes of the modern mass myths.

With sharp and definite lines, Wittlich shapes his figures and portraits from contemporary history in glaring colors and frozen motion. Ultramarine blue, chromium yellow, and cinnabar red form the triad of his dissonant statement. His women are prototypes of the consumer society. They are smiling for they have to smile. That is part of life and of survival. These are glamorous smiles meant to be enticing, but they are forced and tortured. The teeth participate in the smile, though a bit too aggressively, and the eyes seem glassy and empty. Does his manner contain a touch of social criticism? Hardly. Wittlich's engagement is without protest. Like his painted personalities, he too believes in film stars, sport heroes, and the comings and goings of the jet set.

The Religious
and the Fantastic

Chapter XIII

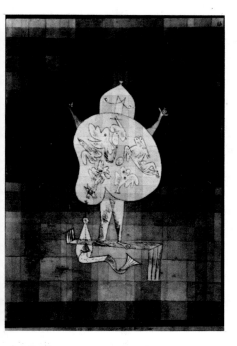

Paul Klee, Ventriloquist, *1923.*

The Unknown

In the depths of time, and scarcely illuminated by consciousness, lurks the unknown. It is obscured in the past as it is in the present and future. Man is thus surrounded by mystery beyond the narrow horizon of his known history.

As long as man believes in gods, they are quite real to him. But the factual is not fantastic, nor the fantastic factual. Even science fiction's visions of the future are fantastic only so long as they adhere to the realm of the impossible. A journey to the stars still seems fantastic to us, but the trip to the moon is scarcely more than an extension of space routes now quite familiar.

What we now call the fantastic in art was originally an element of religion. Once profaned, it has become fantastic. When faith dies out, the deposed gods and demons become but bizarre historical objects, and when we rediscover them we place them not in shrines, but in museums.

But in the soul of the naive artist, even in an age of atomic power and space flights, magic and the miraculous can still persist. His lack of historical perspective and the directness of his experience preclude any firm boundaries between deception and reality.

Naive artists are by no means *maîtres populaires de la réalité.* If I interpret Kandinsky's expression "the Great Reality" correctly, it suggests the mythical union of naive art with things, its infantile identification with the creatures it represents. Children do not paint pictures; they invent a world, establishing signs for it as they go by which they can trace their way in the future. The reality of naive artists is not at all the reality of mere visual verisimilitude.

In the realm of the religious and fantastic, it is not the theme which is so conclusive as it is the artist's perception and his point of view. The rediscovered paradise of eternal peace of Edward Hicks (illus. 36) is naive, to be sure, but in spite of its legendary, utopian air it is painted realistically, not fantastically.

The confused course of modern art has led through Dada, Surrealism, Tachism, pop art, *arte povera,* and conceptual art to the "new figuration" and the fantastic realists. All of these, even though we cannot always decipher them, have reflected the crisis of this our world.

The choreography of the artificially fantastic is scarcely convincing, however, in comparison to the realities of our time. Things as such are not fantastic, but their forms and essences may be, when viewed from the vantage point of a foreign system of thought. Considered in the light of reason, totems and fetishes, ancient Chinese talismans, and Egyptian and Tibetan texts of the dead are but the magical formulas of shamans and the creations of fantasts. To the peoples and cultures which gave rise to them they were reality, symbols and potencies in the struggle with the forces of the unknown.

Under the sacred golden sky of the European Middle Ages, the descendants of deposed gods, fallen angels, and conquered spirits lived together with the martyrs and saints of high religion. Suppressed and excluded from our more rational, scientific world, they live on in our day in the underground of the collective soul, and in the innocent pictures of the naives.

Arsen Pohribny writes: "In Hajkova, Ociepka, Gourgue, Liautaud, and Živković,

an ancient totemism filters through; their visions resemble the secret conversations of a shaman with the spirits of his ancestors and the masks of death. . . ."

The naive and the childlike are fantastic as long as they are undisturbed, and they are capable of discovering the world instead of merely making copies of it.

Metamorphosis

Favorable conditions are necessary before the demons and gods of past levels of consciousness can be conjured up in this scientific age. They have made possible the naive art of Haiti. While other religious sources have gone dry, and no longer offer inspiration to artists, religious concepts on this Caribbean island have given rise to a new imagery. Geographic and psychic isolation have favored such development. The black people have been attentive to the traces of the past in their search for identity in the world of the present.

In the iconography of the Haitian painter Hector Hyppolite there was originally no presumption of the exclusive dominion of African gods. Christian saints and symbols were mixed in with voodoo ritual—"The siren and St. John watch over me," Hyppolite would say. The siren aided him in the reality of life, while John the Baptist gave him the ideas he was to use in his painting.

The painting by Hyppolite which I include in this chapter, *Queen Congua* (illus. 197), shows just such a marriage between African and Christian faith. The black madonna in her dark brown robe, with the Christ child in her hands and surrounded by angels, is at the same time a primeval goddess, the Great Mother of the past. Under a clouded sky there are three faces, their eyes gleaming white in the darkness, and they suggest the sacral, full-face expressions of archaic masks. The symbolic value of its ecstatic forms and the expressive vitality of his drawing, all experienced with naive human feeling, show this ritual picture to be the highly individual vision of this artist and priest, Hyppolite.

Jean Metellus, another follower and interpreter of the cult of voodoo, explains that the priest and artist becomes infused with the god and is possessed by him in a mystical trance; that the success of the naive artists of Haiti lies in the authenticity of their contact with the gods. This experience is supposed to give them the transfer of artistic current which is converted into the form of pictures. Voodoo is black Haiti's liberation and source of harmony in the turmoil of the world.

Considered from the point of view of modern European rationalism, such union with the divinity may well seem to be a phenomenon of hysteria or paranoia, although the Christian religion and numerous others admit to possessions, disorientation, and ecstatic trances among the faithful. The original voodoo ceremonies of communication with demons and gods are not only of cultist and artistic import for Haitian painters; they also strike a note of political rebellion, however nonaggressive, and of identification with the fate of black men everywhere.

Metellus is of the opinion that the similarity between the art of Haiti and that of the naive tradition in France is only superficial. He holds that one only needs to look closely at a few pictures in order to recognize the strongly mystical current in Haitian painting, an unmistakable influence of the gods, which is nowhere in evidence in French naive art. The presence of the Loas in Valçin's voodoo scenes and in the whole of his work, Metellus claims, makes any comparison with the naive school in France impossible. Gerard Valçin has preserved, or at least rediscovered, the primeval rhythm of black Africa. In his lovely and harmonious voodoo pictures (illus. 205) one can sense an ornamental integrity—and the music of the jungle drum.

Joan Miró, Figure with Star.

Cliff painting from Tassili, Africa, between 6000 and 4000 B.C.

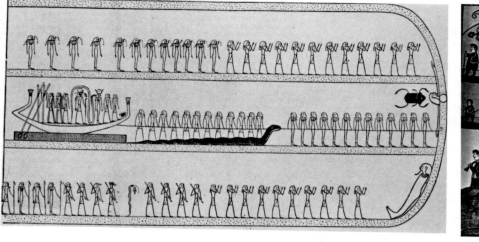

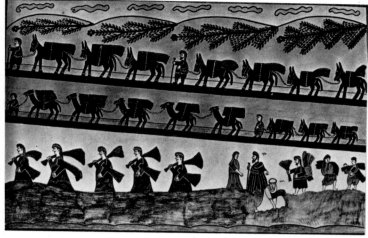

Shalom of Safed: A Naive Narrates the Bible

The ritual painting of voodoo art may be indeed distinct from the art of the naives in France, but there is nonetheless naive religious art in other places besides Haiti.

The watchmaker and silversmith Shalom of Safed was well past sixty when he began to paint. The town of Safed, built up in the hills of Galilee, was once a colony of Jewish refugees from Spain. Later a cabbalistic school was located there, and today Safed is a place frequented by artists and tourists.

Shalom lives a quiet life devoted to his religion. He loves children, and used to delight in making brightly colored toys for them. A professional artist saw some of these one day and encouraged Shalom to paint. The illustrations that have resulted document the history of the Jewish people. In his pictures, each with an accompanying text, there is no distinction between past and present. He arranges his people and animals and plants in rhythmic patterns on parallel strips, as in painting from Chaldea, Assyria, and ancient Egypt (illus. 204, 206).

The precision and the monotonous epic repetition of Shalom's hieroglyphic human figures resemble inscriptions in the forbidden chamber in the burial rooms of Amenophis II in the Valley of the Kings at Luxor. Taking up an ancient oriental tradition, Shalom obviously defies Hebrew prohibitions against making images of God and his creatures. But in his seeming disregard for the law, he actually manifests it on a higher plane, by giving form to a tradition of nonindividual,

collective vision. Shalom feels that his work is justifiable because all his images are before his eyes and created in him before he puts them down in lines and colors. "I am a serious person," says Shalom, "and I do not develop anything out of my imagination beyond what occurs to me directly." But the fantasy of this naive painter expresses itself in an uncommon vitality of color and joy in representation, in the freshness and warmth of his pictures.

Medieval painting achieved the development of a theme through a sequence of situations, through compositions of separate, successive scenes. This was a primitive use of the rectangular picture which was to be perfected in the twentieth century in the medium of light and film. In a childlike way, Shalom has filmed the stories of the Old Testament. His picture of *Paradise* begins at the top with the Garden of Eden. An angel occupies the frame below, threatening with a raised finger. Then follows the Fall with the serpent, and Adam and Eve already wearing their fig leaves. The angel then banishes them from paradise with his sword, and in the lowest frame there are decorative little ducks swimming in blue water.

Abraham Receives the Angel is a two-part picture consisting of the arrival of the guest and of Abraham's hospitality. An illustration of *The Ten Plagues* is neatly divided into ten rectangular sections.

A desire to make life somehow lovelier and more festive leads many naive painters into some kind of decorative ornamentation. Those who remain within the sphere of folklore use local ornaments, varying them for their own purposes. Shalom's picture sequences with their naive fragmentation have rediscovered the original significance of decoration. His linear narrations slide past our eyes like a film strip; birds with bright feathers, red-throated flowers, trees trimmed

into perfect spheres with brown trunks and evergreen leaves, and fields and gardens accompany the well-known figures of Old Testament legend: the wedding of Isaac and Rebecca, the caravan of Joseph and his brothers, and the cabbalists of Safed setting out to pray for rain.

Daniel Doron, who brought Shalom of Safed's work to the attention of the world, writes that the naive painter sets his goals and fulfills them with quiet devotion. Bent over his kitchen table, he will hum some familiar melody to himself and paint with great speed and ease. First he puts a frame down, and only then does he begin to sketch lines and figures within this established space and proceed to fill it with color. His creativity includes both a love of painting and a whimsical sense of humor. Shalom is not obliged to struggle for the forms of his artistic expression; they come to him automatically.

Trillhaase: Jacob's Ladder

Juliane Roh's biography of Adalbert Trillhaase suggests something of a schizoid trait in this painter, accompanied by a certain tendency toward withdrawal. His unique combination of an inner sensitivity and an outward insecurity, and his distrust, his persecution complex, and his jealousy lead one to suspect a severe psychic disjunction which was only brought under control relatively late—that is, when he began to paint.

The concepts of what is normal, infantile, or deranged are not too sharply distinguished in modern art criticism. Deviation or even total separation from the norm can no longer be determined on purely aesthetic grounds, since the deformations of Expressionism and the scourging observation of Surrealism. The alternative pair of concepts "healthy" and "sick" is long since outdated. In their stead, any kind of artistic expression is recognized without prejudice.

I have spoken of Trillhaase's life and work at length above in the chapter called "European Resonances." Here I would like to focus on two of his paintings, *The Resurrection of Christ* (illus. 202) and *Jacob's Ladder* (illus. 203). Both pictures take their imagery from the Bible, whose fantastic and mysterious legends had obviously made a deep impression on Trillhaase's consciousness as a child, and continued to concern him throughout his life.

The miracle of the resurrection takes place in a gloomy green landscape. Wrapped in what appear to be shawls, Christ takes flight with a mighty bound out of the cavelike tomb. The hilly landscape is wrapped in the darkness of night. With arms raised in a pathetic gesture, Christ renounces this place of death in order to embark on his cosmic journey. A yellow butterfly is the witness to the truth of his return to life. Female angels with red wings are sitting about, as little party to the miracle as are the oblivious sleeping soldiers. The relative sizes of the figures are determined by their ultimate importance. The five watchmen in armor in the foreground are by far the smallest, while the rising Christ, who dominates the picture, is infinitely enlarged. The faces portrayed in profile or squarely head on are like masks, without any individualized expression. Lively gestures accompany and elucidate the portentous event. The stereotyped spiritual exaltation of his figures derives from a psychic disturbance, but it makes for a composition of scenic integrity.

The inner harmony of the colors and the strength of the overwhelming image produce an archaic pictorial experience. The acuteness of his observation and the suggestiveness of his palette combine to create magical effects. The dissonances of the copper green, agate brown, ash gray, amethyst violet, and midnight blue dissolve into a single, harmonious impression.

I would like to juxtapose Trillhaase's vision of *Jacob's Ladder* and the picture on the same theme by Shalom of Safed. Trillhaase's painting shows a mountainous landscape, and in the foreground the young Jacob stretched out asleep in a white fur cloak. His arms are curved around his head, which rests against a large stone that he will later erect at this spot as a reminder of his vision.

The wanderer's staff and water jar lie beside him, and round about are the deer and palm trees and blossoms of the promised land. The ladder descends out of the sky, and upon it there are cupidlike, winged messengers of God dancing up and down. The faces of other angels watch from the clouds. Jacob has been favored by God, and commanded to recognize Him alone as his Lord.

In Shalom of Safed's version of the same legend, Jacob has interrupted his journey to his relatives to rest beside a well. He is seen lying on the wall, his sandals off, his bearded face tilted back, and his arms stretched out. A figure bends over the dreamer, addressing

Adalbert Trillhaase, The Picture: Self-Portrait with Model.

him with a raised hand. The ladder of the vision descends from heaven like a wide two-lane highway, angels on every step. On one side they are moving downward, and on the other they climb back toward heaven with their backs to us. The canvas is broken up into separate decorative sections. A settlement quite close to the sky looks very like a present-day village. On the left side of the picture stands the pilgrim's staff, and a slender tree of life fills a free space just to the right of the heavenly ladder. A heavy-laden tree with large leaves reveals that the place where the wanderer has chosen to rest is an oasis.

A condition of physical abandonment and visionary insight pervades both pictures. In Trillhaase it is revealed as a monologue of insecurity, ecstatically uncontrolled in the double sense of its being spiritually ambiguous and technically imperfect. Still the lightning vision is full of promise and the breath of life; it is a naive exploration into realms beyond.

Shalom stands under the spell of the sacred texts he so dutifully explicates. Just as the cantor in his church retells holy events in a pleasant singsong, Shalom paints them in spaces and with figures that are only suggestive and linear, not solidly sculptured. The sleeper and the angels here are frozen as though according to a formula that will insure an effect of timelessness. The figures are constructed with a strict geometry corresponding to the architecture visible on the mountains and below the ornamental clouds. Shalom's picture is simple, striking, and religious—but without ecstasy.

Ilija and the Ark

On one of my visits to Ilija in the small village of Šid, I found him lying sick in his bed under blue-and-white-checked covers. His eyes were bright, but his glance a bit confused. His hair was gray, his ears incredibly large, and his mouth stubborn. He had removed his false teeth, and his tongue stumbled about in his mouth.

I wonder if I could imagine the uniqueness and incomparable richness of the pictorial fantasies of this tired old peasant if I did not have them before my eyes. What was it that led to this sudden burst of pictures in the last years of his life? Femininity is represented in this household only by Ilija's abrupt wife, and she was against his painting from the start. "Children paint, not grownups. Not farmers. Farmers belong out in the fields." Moreover she didn't care for the finished products of his brush. But Ilija would not be deterred. In his patient stubbornness he simply turned his back on everything in order to paint.

Throughout his long working life, Ilija Bosilj-Bašićević had a deep dislike for art. For years he avoided talking with his son Dimitrije, the art historian, about his profession. But as a sixty-year-old he began to paint as though possessed, ornamenting bedspreads, towels, boards, bedframes, and the walls of his rambling house. He filled these spaces with gods and demons of unknown origin, with hybrid, fabulous creatures, and with the saints, kings, angels, and animals of this world and his world of fantasy. He paints in glowing, brilliant colors, sometimes on a background of gold, and sometimes on the deep blue of space.

The peasant Ilija only attended school for three years. His mother often reminded him that he had come into the world unexpected and unwanted, and he carried this sense of being superfluous through his quiet, puritanical, and hard-working life.

The first picture he tried to paint was supposed to portray his guardian saints, Cosmos and Damian. But the two figures flowed together in spite of him, and one figure with two faces was the result. When he stepped back from his finished work, the farmer was shocked by what he had done. It seemed to cast a spell over him, for he felt that with this two-faced figure he had represented the double aspect of life in general—day and night, good and evil. Since that time, these Janus-headed, two-faced figures of men and demons have constantly recurred among his themes.

While most peasant painters remain tied to visible reality and the practical things of life, in Ilija's pictures we discover icons from a religion of his own making. In his iconography it is possible to recognize certain expected Byzantine elements, but also there are some ghostly figures which can only be found elsewhere on cliffs in Tassili or in traditional representations of coronations and burials from Rusape in Southern Rhodesia.

I have asked Ilija what books he knows. There are only three in the house: the Bible, Dostoevski's *Notes from Underground,* and selections from the Indian epic, *The Mahabharata.* He is certainly influenced by the ubiquitous Slavic oral folk legends which he

too knows by heart, tales of love and war, of heroism, betrayal, and death. And he keeps up with the news of the day and the hour through newspapers, whose stories sometimes strike him as being more fantastic than any of the sacred legends. Can there really be people who undertake to walk in space and circle the moon? For Ilija the ascension of Christ has taken the form of an adventuresome cosmonaut (illus. 196). His portrait of the heavenly voyager hovers above a crowd of earth-bound men looking upward and pointing toward the miracle. They are done in orange, turquoise, blue-violet, and crimson. The cosmos glows with pink. The space-flyer and the Christ-bird have the twin faces of his earlier pictures.

Ilija's fancy is stirred by the figures of the Apocalypse as well (illus. 198). In his ecstasy, John hears a voice like a trumpet commanding him to write down the vision he has been given. Ilija shows us what he saw: "He had seven stars in his right hand, and out of his mouth there came a two-edged sword, and his face shone as the sun." Is it a kind of religious transport that gives rise to Ilija's apocalyptic pictures, or merely an unbridled fantasy? Saints with rainbow-colored halos ride on two-headed birds; butterfly-angels have lavender-blue wings covered with winking peacock eyes; men wear horses' skulls. Animals appear as described in the Revelation of St. John: "Four beasts full of eyes before and behind . . . the third beast had a face as a man . . . And the four beasts had each of them six wings about him; and they were full of eyes within." But the lamb with seven horns and seven eyes holds the secret concealed within himself.

Christ stands in a two-faced paste-white mask across from the huge book with seven seals. He is stretching out his green hand toward it, as though interpreting its veiled secrets to the stars. Below him is a mighty angel dressed in violet, with garish green wings and an orange heart-shaped face. And still further down, the lowest in this sacred hierarchy, is a poor, small creature, a penguin-like little man, St. John. The archangel is showing him what transpires in the exalted world above.

The sword in his mouth manages to transform itself into a ribbon of speech, a sermon in many colors. Such are the pictures and figures of Ilija. At times his people step across the frame, and some of his animals leap out of the picture entirely. There are riders of fabulous red galloping horses, men with their arms stretched high above them, and golden crowns and cupolas in the background. Byzantine Orthodox music seems to pervade his work.

His son Dimitrije explains that Ilija is searching after a clarity art cannot attain, and that he can only hope to suggest something of the essence of man.

Once more I would like to compare two pictures, this time two versions of Noah's ark, one by Ilija and one by Shalom of Safed.

All around the world, the horrors of diluvian tides have left their mark in myths passed down originally by word of mouth, then set down in writing and expanded into whole epics on the fate of man. Countless variations of the great flood are found in cultures utterly remote from each other in space and time. The gods determined to destroy mankind in its sinfulness, but in nearly every case a Promethean friend of man is present in the council of the gods. In the Babylonian *Gilgamesh,* for example, the bright-eyed god Ea calls out to the mortal Utnapishtim:

Tear down your house, build a ship,
Forget your wealth, think of life.
Scorn worldly goods, salvage your skin,
Lead all kinds of creatures into a ship.

Utnapishtim builds the ark, takes his family, his possessions, and all kinds of creatures on board. Then he closes the doors, and the torrential rains begin to fall.

The god of Israel also came to regret that he had created man: "I will destroy man

Below left:
Ilija Bosilj-Bašičević,
Noah's Ark, *1963.*

Below right:
Shalom of Safed, Noah's Ark.

Robert Guttmann, Carpatho-Ukrainian Jews in the Synagogue, *1941.*

whom I have created from the face of the earth; both man, and beast, and the creeping thing, and the fowls of the air. . . ."

The flood in the Bible is a late version of the Babylonian legend. Noah-Utnapishtim rescues himself, his family, and his zoo.

Shalom's picture of *Noah Releasing the Dove After the Waters of the Flood Have Subsided* is simultaneously a bird's-eye view and a head-on shot. The painter arranges the visible world in strips and sections. The ornamental spaces saved between figures and the contours between sections heighten the impact of the narration; each segment stands apart with its own details of the event. The middle section surrounding the blue and white striped ark is made up of the sepia-brown earth after the waters have subsided, perhaps a shoulder of Mount Ararat. The pale blue region below is occupied by ornamental flesh-colored rows of drowned bodies. The horror of this mass execution is softened by the regularity and rhythm of the design. It is still clear that the painter is in essential agreement with the will of God.

Groups of leafless brown trees stand in the light gray fields—or possibly they are sand dunes. Above the ark are an ocher-colored strip of land and a bright sky with decorative clouds which look reassuringly empty.

Noah is bending out of an open window of the ark, wearing a black Assyrian beard and retrieving the white dove with a green branch in its beak. It has returned with the symbol of salvation.

Ilija's *Noah's Ark,* by contrast, is a raft on which the animals are assembled under the direct threat of the coming flood; snakes, crocodiles, pigs, snails, and some indistinct but clearly marvelous animals with heads on either end. Noah stands silhouetted in his boat, a bird perched on his shoulder, his hands clasped together like a bright flower. A rabbit peeps up over the railing. Rain is already streaming down out of the sky.

Noah's weightless silhouette and the insubstantial animals resemble scissor pictures as they stand in conversation; they seem more appropriate to a ship of fools than to a life-boat in the midst of a great catastrophe. It is as though the Bible legend had been used only as an excuse for some comments on the strange and burlesque adventures of a crew of men and animals. The characters in this invented world of fable are painted in brilliant colors, with a child's fascination with demons.

Shalom, however, interprets the old legend word for word. Through long centuries, even millennia, the work of art was not a creation of individual soul, but rather a communal expression of cult and custom. Shalom has reverted to this state of affairs. Obediently he retires behind his symbols of the ineffable.

The American primitive Edward Hicks also did a version of Noah's ark (illus. 37). With skillful and naive precision he portrayed a believable landscape and an accurate and charming crew of animals. His realistic view transforms the Biblical words into a humanistic genre picture, one perfectly comprehensible to any farm hand.

This legend of the catastrophe of the raging waters and of the rescue of one just man with a boatload of innocent beasts has its place in all religions. Again and again the miraculous story has been illustrated by artists *ex voto.* It has been given new life in the hands of Raphael and through the more direct imagery of the naives.

Dream and Mask

Surrealism incorporated dreams and delirium, neurosis and the visions of madness, and the unconscious and absurd. It would be too much to say that modern man has forgotten how to shudder. Visions of hell from the Middle Ages have lost their impact, to be sure, for they are pale and childish compared to the hell of our times. But how are fear and emptiness represented in the pictures of the naives?

Robert Guttmann was a lay painter with a childlike soul, a wanderer, a vagabond in life, a man of no profession, and a man of the world. He was a poet who had once known Kafka, but he was also a ne'er-do-

well in a slouch hat, wide tie, and violet velvet coat. Professional painters made light of him, and their scorn brings to mind the reception of *le Douanier.* Perhaps certain things in Guttmann's painting reflect Rousseau as well. The figures which he painted with such simple affection and the vitality of his flower market in Prague with the artist in the foreground recall Rousseau's self-portrait in front of a backdrop of Paris.

But once he had witnessed the segregation of the Jews in an occupied Prague, his contrasts of light and darkness became hectic and abysmal, shattering in their evocation of isolation and danger. Guttmann has painted both the Prague of his childhood and a beleaguered Prague of covert synagogues and a hidden soul.

The colors in one picture of a synagogue gleam like stained-glass windows. Jews in

black caftans and in black and white striped prayer shawls appeal in full-face and in profile to a remote and supernatural power. The infinite blue of the transparent walls, the honey-yellow of the round chandeliers, and the black and white designs on the prayer shawls stress the solemnity and ominousness of these days of destruction. The heavy, pasty brush strokes and the lapidary freshness and sensual splendor of his colors are an echo of Expressionism. Guttmann inhabits a border region between lay art and naiveté.

Are Guttmann's pictorial transfigurations of experience naive? Fantastic? The unknown and enigmatic is frequently joined to the history of religious feeling, but not always. Materialized dreams and fantasies can become pictures just as well without the presence of the divine.

The gardener André Bauchant set out on a journey into the Arcadia of pseudoclassical mythology. Simple people costumed as gods, heroes, and nymphs of antiquity are the incarnation of his dream of a golden age. With them he set out upon the wide ocean, and with them he experienced the miracles and the great risks of life in paradise (illus. 207).

If one goes to the Adriatic island of Šolta and looks at the home and the paintings of Eugen Buktenica—houses, churches, cypresses, fields, and behind them the flat planes of the sea and sky—one's eyes and heart are opened, and the difference between Buktenica and the naive painters of the interior becomes obvious.

The fisherman and painter Buktenica has a native sense of form which may derive in part from the depth and breadth of his horizon. His picture of fishing boats against gray and rugged mountains across a blue sea resembles the votive pictures of men at sea. I include here his fantastic picture *Carnival*, with a king carrying in his hand a scepter adorned with bull horns (illus. 208). A man with a trident and a horn-blowing herald accompany him—figures from a naive fable whose significance is long since forgotten, but whose magic persists in this carnival parade of fishermen.

In every use of masks there is something crude and primeval, a mimicry of popular fantasy, terror, and play. The small picture by Viktor Magyar that I reproduce here (illus. 199) touches on the traditional mummery of Slovenia. We see a geometric landscape, towering mountains, and white lines of snow beneath forklike trees. Two human figures in rooster heads are having a snow-

ball fight under a green sky; cubistically simplified figures from a children's book, or scarecrows enjoying the earnestly playful business of masks. Is Magyar to be considered a naive, or, are not the things he shapes from subsurface levels of the unconscious rather a part of the new vogue of the fantastic?

For a long time the Polish miner Teofil Ociepka suffered the black existence of a worker underground. His pictures are night-born utopias of light, fantastic primeval landscapes of a wild nature and symbolic of the human condition. Actual and invented animals hunt and destroy one another; terrifying scenes are presented in soft fuzzy colors like those on gaudy peasant coverlets. *The Saturnian Monster* (illus. 200) has an ultramarine-blue mane and a red spotted horn, large and sad human eyes, and a mask-like face almost concealed behind a gigantic beak. He is throttling a tiny mouse with his trunk. The creature from Saturn, with its elephantine body boasting a sort of rainbow on its back, is trampling small plants into the ground. This odd scene is ponderous and deformed, but has a demonic effect nonetheless.

Ociepka painted his creature as an emblematic sign of bestiality. Joseph Georges has composed a collection of animals on a village square in his *Cattle-Market of Sion* as a rhythmic mass, with a style of movement akin to that of South African cliff paintings in Basutoland. Memories of childhood have engaged the fantasy of this naive painter, and have led him back into the childhood of man, to the hunting and propitiary scenes of archaic times.

Many painters have not been mentioned at all or have been discussed in another context. Certainly the grotesque pictures of Aloys Sauter, the absurd feverish dreams of Morris Hirshfield, the omnipresent melancholy of Bernardo Pasotti, the simple illustrations for a primer of poverty by Ondrej Steberl, the dreamy astral gardens of Adela de Ycaza, the ecstatic and sensual flowers of Séraphine, and the hallucinatory visions of the analphabet and poet Nikifor have a place in any survey of the fantastic in naive painting.

Rumblings from cosmic and social explosions are shaking our earth and sky, both at home and in the remotest places. These fragmentary, dissonant, and fantastic events are but gleams and reflections on the dusky background of space and time. The art of naives, as part of its quest through the sense and meaninglessness of life, is also turning quite naturally to the fantastic.

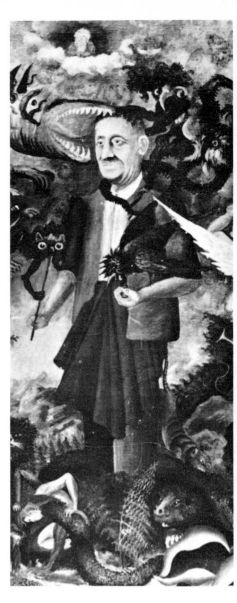

Teofil Ociepka, Self-Portrait in Terrifying Landscape, *1960.*

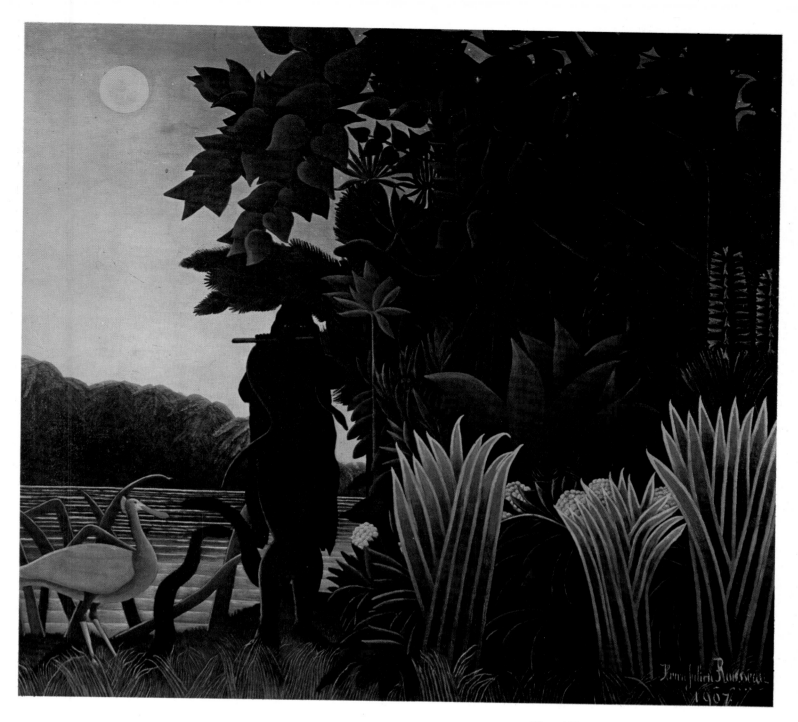

195. Henri Rousseau, The Snake Charmer, *1907*

The black form of the naked snake charmer is backlighted; she is facing away from the green glow of the sky and the shimmering river. The twisting snakes emerge from the jungle vegetation in order to dance, and one coils like a slippery chain around the shoulders and breasts of this lovely Eve. What is the picture supposed to tell us? The woman's eyes glow mysteriously in the dark face. Heart-shaped fabulous leaves, white and yellow veined lancelike stalks, and prehistoric feathery branches appear to have been made of molten glass or carved from some hard material. The plants, the water, the moon, and the rosy pink flamingo are entranced by the song of this charmer of serpents.

196

197

196. *Ilija Bosilj-Bašičević,* Legend of the Flying Man, *1962*

197. *Hector Hyppolite,* Queen Congua

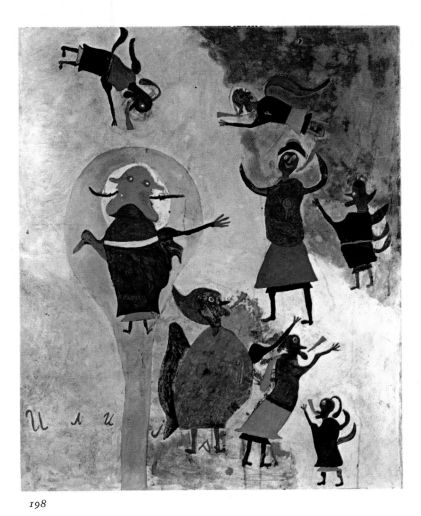

198. *Ilija Bosilj-Bašićević,* Apocalypse, *1966*

199. *Viktor Magyar,* Winter Landscape With Rooster-Men, *1970*

200. *Teofil Ociepka,* The Saturnian Monster, *1955*

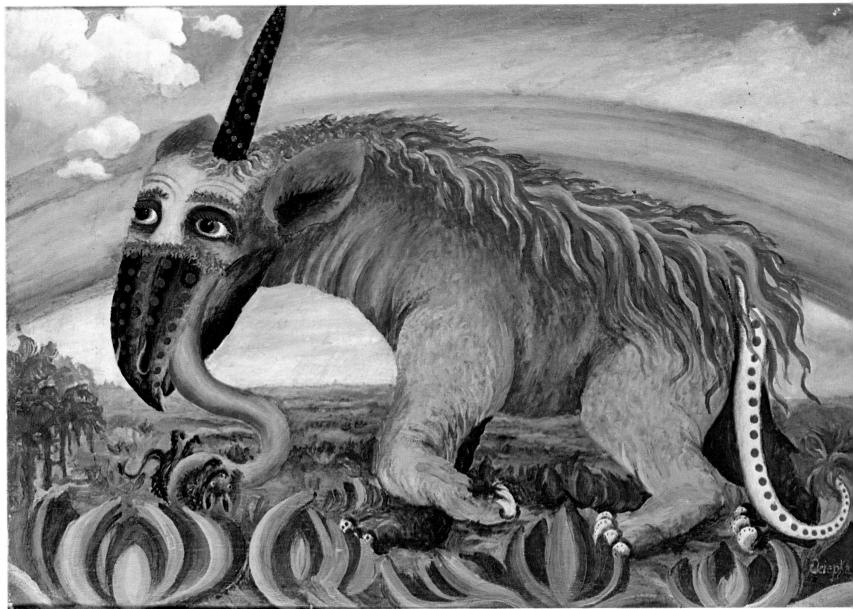

201. *Matija Skurjeni*, Gypsy Lovers, *1959*

202. *Adalbert Trillhaase,* Resurrection

203. *Adalbert Trillhaase,* Jacob's Ladder

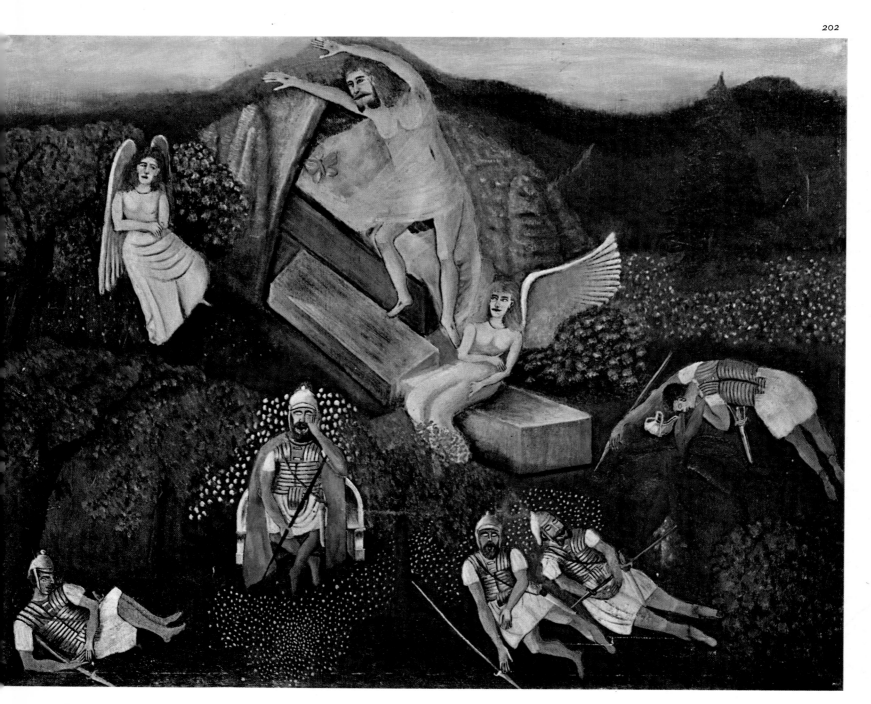

204. *Shalom of Safed,* Moses and the Tables of the Law

205. *Gerard Valçin,* Voodoo Ceremony Around a Holy Tree, *1963*

Dark men dressed in white are kneeling in a circle around the sacred tree. It is the chief festival of the year. Candles have been inserted between the roots of the tree.

A brightly dressed priest is performing the sacrifice. The participants directly in front of him bow deeply, while those opposite, still on their knees, are more erect. To the right of the ritual scene, and standing beneath another tree, is a group of men in red shirts and blue trousers playing banjo music.

The sacred performance has been placed in a spot permeated by the blue-gray atmosphere of a mountainous landscape. Outside the circle of worshipers one can see rhythmic curved lines of gleaming green plants, the ordered symbols of rebirth and return. They recall the sacred symbolism of Nigerian forms.

בצאת ישראל ממצרים בעצם היום הזה יצאו כל צבאות ה' מארץ מצרים וה' הלך לפניהם יומם בעמוד ענן לנחתם הדרך (שי״)

206. *Shalom of Safed,* Exodus

I have juxtaposed Gerard Valçin's symbolism of community and bondage to the voodoo deities and the Old Testament composition of Shalom of Safed. Both artists treat the supraindividual as a hieratic order and a metaphor of holiness.

Shalom of Safed reveals a unique blend of fantasy and systematic order. He concentrates on the miraculous in the old legends—the receipt of the commandments on Mount Sinai and the evacuation of the children of Israel from Egypt—as though on broad frescoes of filmlike simultaneity, without beginning and inexorable. His pictures resemble the remnants of ancient Egyptian tomb painting, or the creative stylization of Mesopo-

tamian sculpture. They have the limping rhythm of repetition, the monotony of the desert and of psalmody.

In an oriental manner, the narration proceeds upward from the bottom. In the two lower sections are mules and laden camels, pedestrians and riders against a desert-yellow horizon. Agate-brown animals and wine-red, emerald-green, and lavender-blue robed figures are advancing, separated by a sepia-colored strip of road. The third section is composed of an ornamental pattern in shell pink, ivy green, and copper, which may represent a mountain range or possibly a mirage of the flowery meadows of the promised land. The last and highest section presents the glassy green, gleaming sky with hovering pools of blue cloud.

207. *André Bauchant*, Odysseus and
the Sirens, *1921*

208. *Eugen Buktenica*, Carnival, *1956*

*To the landscape of the fantastic belong
the hallucinatory tensions and the
insoluble labyrinths of the naive soul,
figures arising out of terror and dreams,
delirium distilled into form, fleeting
silhouettes of origin and destruction.
Saints and angels are well met in the
abandon of carnival, disguised as
Don Quixotes and space-men.
Phosphorescent will-o-the-wisps from
the supernatural realm of naiveté.*

208

Eros in Naive Painting

Chapter XIV

Paradise Lost

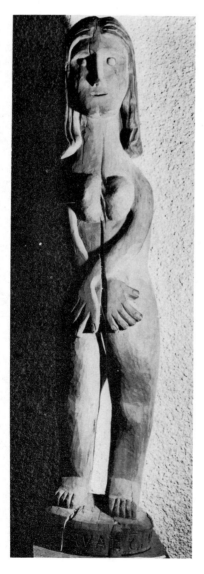

Josip Horvat, Eve, *1963.*

In many areas of creativity there are points of contact between naive art, the art of primitives, and that of children. With respect to eroticism, they have but little in common. The naives possess neither the instinctual directness of the primitive nor the innocence of the child.

Coming mostly from laboring classes or tied to a petit bourgeois heritage, naive painters are subjected to the commandments and taboos of puritanical Christian or other religious codes of behavior handed down from their fathers. In such traditions, sex is naturally scorned on the surface, and only condoned in the twilight behind drawn shades. Artists of all times have understood the relationship of art and Eros. In China India, Persia, and ancient Greece, Eros and the art of love were represented with unstinting naturalism; to a degree this had its religious justification, as a reflection of the natural act of creation. Roughly a half a century ago Edward Fuchs exposed the absurdity of denying the erotic effect of art: "Even the greatest art is always sensual. Every Greek nude has definitely erotic features. The *Venus de Milo* and the *Venus Kallipygos* are two very gallant ladies; the women of Botticelli, Correggio, Rubens, Goya, Courbet, and Renoir are not only suggestive, they veritably explode with eroticism. In sum, it is not a question of the presence or absence of Eros, but rather one of degree. . . ." These bold observations which by now have found universal acceptance were the beginning of the emancipation of erotic art.

When naive artists turn to erotic themes they generally disguise them in Biblical legends. By the same token, medieval artists delighted in the representation of Adam and Eve, because this was their only chance to display nudity.

A picture of paradise from around 1830 by an unknown painter, probably from Pennsylvania, stands at the beginning of this chapter (illus. 209). Adam and Eve have been painted in a lovely green parklike landscape. Eve is feeding and embracing a deer that has approached without shyness. Adam is sitting nearby, gazing meditatively into the distance. A lamb and a panther have nestled at his feet. It is clearly before the Fall. An inner and untroubled peace reigns over everything. In the middle distance are a soft blue lake and strong trees bearing grapelike fruit. Bushes with red and white blossoms flourish in this garden of paradise.

The human pair is represented more as being undressed than in a state of natural nudity. Through their positioning and draping the artist has rendered their bold exposure quite harmless; Eve's tresses and Adam's gesturing hand discretely obscure the forbidden sexual zones. The pale-tinted, delineated bodies correspond to the ubiquitous and eclectic models of furtive eroticism.

Does this watercolor of modest nudity have a place in a chapter on Eros? Considered historically, and from the point of view of the moral intolerance of its time, such a lyrical expression of the wish for the liberation of the human body can indeed be taken as a gentle introduction to my theme.

The onetime house painter Matija Skurjeni has also produced, a full century later, a version of the paradisical garden—this time after the Fall. Adam and Eve are standing outside the garden, exiled and homeless, while snakes, a pelican, a lion, and other

Vivian Ellis, Paradise, *1967. The first couple lives in apricot-colored nakedness in an Eden that gleams like a stained-glass window. Why this black nurse and naive painter has portrayed the biblical figures as whites we cannot know. Her fine sense of form has treated the luxurious vegetation as a decorative ornament, and even the animals repose in a rhythmic order. The creativity and vitality of her Afro-American origins blend in the consciousness of the self-taught artist with her university experience and training. It is an ironic touch that the naive artist herself has obviously tasted of the forbidden fruit.*

animals continue to be at home in paradise.

But Skurjeni has also painted a gypsy pair (illus. 201), accompanied by a winged horse, wandering through the world under a waxing moon. A cloud hovering over them is mirrored in a pond. The couple and the symbolic animal are feeling their way through the night along a narrow path, the lovers hand in hand and each with a pipe in his mouth. They may well have lost a paradise, but they have found a new one in each other.

Yadwigha and the Magic of Eros

In the sphere of industrialized society, the gap between instinct and intellect continues to widen. Myth has migrated from the misty regions of common memory into the more rarefied atmosphere of literature and art; Aphrodite rising up out of the waves, the hot-blooded Leda, and Helen's catastrophic beauty. As motifs for the stage, for poetry, opera, and painting, the unity of form and the presence of the gods which was present in archaic texts and in ritual art has lost much of the tension and directness of its appeal. Baudelaire's *Flowers of Evil* introduced the split in consciousness of the poetry of decadence. In the 1880s, Odilon Redon enveloped feminine nudity with the nimbus of holiness. An inner excitement, veiled in the restraint of classicism, sought symbolic expression.

In 1891 Paul Gauguin painted a picture called *The Portal of Virginity, or the Awakening of Spring,* a languorous nude stretched out on the beach. With absent-minded gentleness she is playing with a fox. The desire for emancipation from "Greece," a longing for the primeval, and a new mystical strength caused Gauguin to abandon Europe and to seek the sources of a more natural existence on the islands of the Marquesas, "the dream stretching before us in the infinity of space."

A craving for the unknown and primeval was not necessarily tied to geographical distances. In the Plaisance quarter of Paris it was possible to rediscover the mystery of Eros amid a tropical landscape. Henri Rousseau dreamed up the archetypal symbolic figures of femininity out of his unconscious sensibility.

One cannot completely understand Rousseau without recognizing the true source of his visions: true and imagined love. In him delusion and reality, simplicity and sublimity, and a delicacy and intensity of eroticism resided side by side. His wedded goddesses Clémence and Joséphine shared his imagination with the women of his daydreams, the sleeping gypsy (illus. 2) in the solitude of the desert, the snake charmer in the jungle (illus. 195), and Yadwigha lying on a red plush sofa in the forest primeval. Love comes as an echo of his sensitivity and loneliness, his tormented but yearning heart. This love gave him the strength with which to overcome the prudery of his petit bourgeois surroundings and of his upbringing, and to realize in his last masterpiece, in anticipation of Surrealism, the improbable and impossible in sublime pictorial harmony.

Yadwigha (illus. 212) lies naked on the red sofa from the rue Perrel—on which she doubtless never sat—ensconced in a dark thicket of gigantic lilies, lianas, ferns, and luxurious trees of a fantasy jungle. She is listening to the sound of a magic flute. A dark figure is playing a haunting melody while tigers, elephants, and birds stare from the depths of the thicket. The magic of this picture causes us to accept the furnishing of the jungle with a red sofa as thoroughly plausible and necessary. Rousseau dreams in the symbols of waking reality; he believes in his vision as though he had had a look at this fabulous world through an actual telescope; and thus the strange time and incomparable space become a clearly localized place of factual reality. The lapidary, petit bourgeois, idealized vision is transformed by the strength of his belief, one which renders everything possible in a world of disarmingly simple and delicate poetry.

Ambroise Vollard, who bought *The Dream of Yadwigha,* has recorded a reflective conversation with Rousseau in his *Memoirs of an Art Dealer.* He asked the painter how he managed to make everything in this painting appear so real. Whereupon Rousseau answered simply: "It is because I am a student of nature."

For primitives and children everything is real. But this reality is transformed and spellbound by the poetry of their innocence.

Karl Kazmierczak, Paradise, 1961.

Morris Hirshfield: Embarrassed Exposure

In these years of open and nearly fetishist use of sex in art, of drastically realistic forms of expression which do not bother with any pretense of anthropological objectivity or concern for the history of morals, the erotic art of the naives strikes us as a veritably pious use of erotic, infantile symbolism.

In contrast to the artists of primitive cultures, and also to the treatment of these motifs from Picasso to Debuffet, the naives generally approach eroticism in a veiled and roundabout way. The conventions of morality and good taste, which have only limited force in today's society, are abandoned by these painters only with the greatest caution.

The erotic appeal in Morris Hirshfield's pictures seems to me to be particularly intense. Yet even his presentation of nudity is guarded, as though occurring under the clandestine sign of something forbidden. Coming from a small town in Russian Poland, he brought with him to New York the Mosaic prohibition against representations of God and of his image in man. It still clung to him when as an eighteen-year-old he began his career in ladies' fashions, and when as the wealthy owner of a bedroom-slipper concern he began to paint at age sixty-five.

The short squat man with reddish hair painted from nine o'clock in the morning until seven at night, bent over the commode in his bedroom which he used as an easel. He painted as though driven to do so in the lonely fulfillment of a life-long desire, turning away from God and from the family which thought his figures foolish. His only support came from the friend of the naives, Sidney Janis, and from a curator of the Brooklyn Museum to whom he showed each picture as it was finished. These two encouraged him, for they clearly had faith in his gifts.

Though Hirshfield has been discussed earlier in this book, it is worth examining here his relationship to erotic art.

Everything that Hirshfield painted—plants, animals, and people—is impregnated with the magical fluid of eroticism, but I confine myself here to his female nudes.

The *Girl Before the Mirror* (illus. 216), his first nude, shows a suppressed modesty and simplicity in utter defiance of the laws of optics. The girl and her image are both seen from the back. These two harmless nudes, one behind the other, resemble two parts of a sewing pattern with the help of which in his

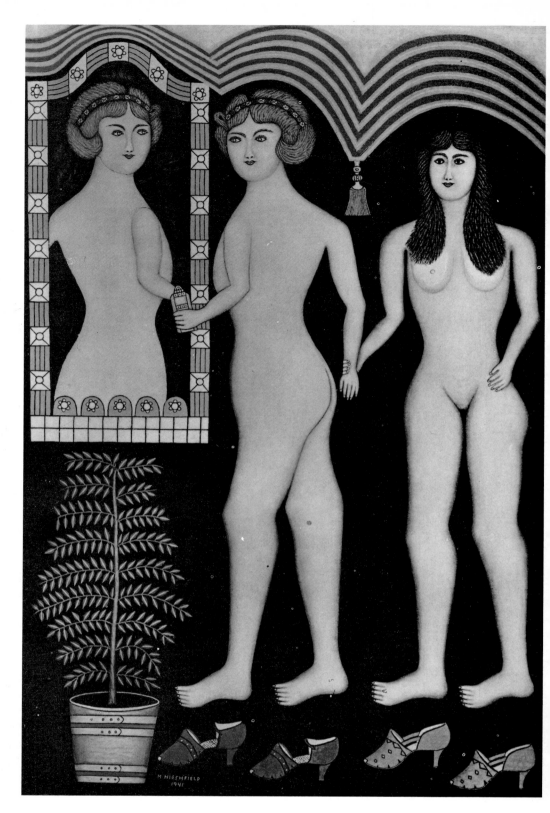

profession one would cut a number of identical pieces—a sensual activity in itself.

The *Inseparable Friends* consists of two girls with the mirrored reflection of one of them. The relationship of the naked girls is indicated by their interlocked hands. Possibly the high-heeled slippers left standing at the bottom of the picture struck the painter as particularly seductive. The two real girls and the one reflection stand beneath a drape which is caught up into swooping curves and can be let down. A theater curtain, or a canopied bed?

Hirshfield painted the figures in his pictures *en face* or in profile. The arms are always too short and underdeveloped, and the faces inexpressive. They are neither sensual nor

Morris Hirshfield, Inseparable Friends, 1941.

suggestive with their pristine bodies of untouched nakedness.

Another woman boasts a lush lion's mane—the symbol of femininity—and is seen sitting in an armchair and holding a mirror in her right hand. The nude is conscious of her perfection, proudly displaying her ample breasts, her buttocks, and the legs which so appealed to the painter that he made them extra long. Perhaps this one is his image of absolute erotic enticement.

His *Nude with Gods of Love* shows a woman stepping in out of the night, parting the blue striped curtain with her hand. Her young girl's body is outlined in red, and her golden yellow hair is splendidly full. She clearly fulfills the wishes of the painter, surrounded as she is by suns and stars. The cupids embroidered on the curtain are not toying with bows and arrows, but playing flutes instead.

Does the nude mother belong in this series of erotic presentations? Framed by a festive wreath of flowers (illus. 215), the naked woman is sitting stiffly on a chair; her child is naked too and has a firm round belly. Both have fresh permanent waves in their hair, and idealized faces. Their bodies are edged with a dark line. The pinkish-red armchair stands in front of a blue-patterned tapestry, and the white flowers of the frame repeat themselves, arranged into a semicircular green decoration. This woman is at least sitting properly in her chair, her back bent against its resisting upholstery, while in another picture a fully dressed girl with a dove is supposed to be lying on a sofa, but is actually painted in a rigid standing posture. All of which seems quite primitive, but nevertheless possesses an undeniably straightforward and singular charm.

Are Hirshfield's naked girls really any more erotic than his clothed ones? A *Beach Girl* in one of his earliest pictures is wearing a brief skirt and a blouse, coquettishly holding a red sun hat and a basket in her hand, and has loose cascading hair and slightly bent knees. Another temptress is his *Tailor-Made Girl,* who is wearing a stylish made-to-order suit with a lace collar, has wavy hair, and holds a bunch of flowers in a vase in front of her décolleté.

Perhaps Hirshfield's *The Artist and His Model* can give one special insight into the ambivalent nature of this painter. Hirshfield stands ready to work in a splendid housecoat and striped pants. A nude girl posing for him is holding a piece of embroidered cloth, possibly a curtain, in front of her. She is round and ample; her breasts, like the curves of her stomach and genitals, reveal the painter's concept of beauty in forms tending toward the abstract. In his right hand he is holding a palette, comparing his colors to those of nature. In his other hand are three large and imposing brushes. On the wall hangs one of his own pictures, with a tiger, a butterfly, and a tree; a decorative rug lies at the model's feet.

This, then, is the painter Hirshfield, here portrayed as a recognized artist. No wonder that he has chosen this artist and model motif. But it remained a vain wish, one only fulfilled in his own picture. Hirshfield never used a model: "I couldn't possibly bring a naked woman into the house and paint her," he confessed, "It wouldn't look right."

It is not entirely clear just what it is that we find so touching in these pictures in an age of general sexual liberation and the rapid inflation of erotic art. Perhaps it is precisely their sensual restraint and childish caution in their furtive exhibition of forbidden sights.

Hirshfield's early years in a near-ghetto cemented the taboos under which he worked. And yet Hebrew literature makes full use of the intensely poetic theme of eroticism; the *Song of Songs* that has found its way into the Bible is a dialogue between impassioned lovers, and full of erotic surrender. In the puritanical, petit bourgeois world of the New York garment industry a new and repressive code of sexual morality was in force. Designers and makers of women's coats and later of the endless shelves of bedroom slippers could nonetheless come to see these as fetishes of femininity, and accumulate erotic situations in the camera of the soul which could later be developed into enticing paintings.

This style is reminiscent of the ornamental manner of Persian miniatures and the undulating forms and patterns of Islamic stylization. The embroidered slippers belonged to the reality of Hirshfield's life, to be sure, but they also have a telling similarity to elements in the *Scented Garden* of Sheikh Nifzăwi. The boudoir pumps that Hirshfield painted are both naive and sinful; they betray something of the Lolita-complex of the aging artist.

Camille Bombois:
Eros in the
Popular Vein

Among primitive peoples, stirrings of physical drives can easily inspire the forms of ritual art. In the puritanical Christian atmosphere of the condemnation of desire, suppressed feelings can only find veiled expression. At the moment, the undertows of instinct are searching for a vocabulary of imagery among the erotic and the repulsive and the deliberately blasphemous. They surface in a flood of pornography in the obscene scrawls on public buildings and on rest-room partitions. These are the results of compulsive, primitive acts, not far from the habitual scribbling of children or the pictorial signs of primitive peoples.

For the painters of Haiti the erotic is a ritual element which finds its way into their work legitimately enough as a symbol of life and fertility. André Pierre's *Sirène* (illus. 211) shows the queen of the waters rising naked from a sacred spring, holding in her left hand a fish—the symbol of conception—and in her right the trumpet with which she can charm forth all the creatures of water, earth, and sky.

Hector Hyppolite has painted a picture of the elemental feminine, *La Dame de Beau Voir*. Out of a powerfully coiled serpent's body there blooms a winged goddess with breasts of obvious abundance. Hyppolite has also done a Haitian Venus covered with flowers, in a conception similar to the *Girl With Peacocks* (illus. 112) by Wilson Bigaud. These are attractive figures, incorporated into the fecund abundance of the nature over which they reign.

Stirred by the mood of the times, Nina Barka has painted pseudomythological pictures: *The Birth of Venus, Helen of Troy,* and *The Well of the Sirens*. As in André Pierre, the latter picture again shows a divine creature rising out of a spring. But while the Haitian figure is rooted in the painter's faith, Nina Barka's is only a phenomenon of costume-ball mythology and affected naiveté. She gives shape to her images with a smile of knowing pretense; her sweet nymphs emerge from Botticelli-like shells blinking big kitschy eyes, while garlands of coral and starfish form a triumphal arch over the latest incarnation of femininity.

Helen of Troy is sitting on a Récamier couch, adorned with roses, and fanned by an Egyptian Negro slave girl. Warriors are just at the point of climbing into the Trojan Horse which stands in a setting of palm trees, a blue sea, and an Arab castle. Her little monkey is holding one mirror and Helen another, so we are lucky enough to glimpse her lovely face twice. Her hair is yellow and topped by a golden diadem. She is wearing a confection of gold chains instead of a dress. Nina Barka has clearly studied well how one makes up a face and puts on lipstick. Her pictures lack all individuality and genuine simplicity of feeling; they might make nice decorations for a beauty salon.

Josip Generalić, the gifted son of the founder of the school of Hlebine, has also contributed a Venus risen from the sea. His is a fisherwoman standing on the shore of some unknown Arcadia (illus. 220). The pretty sportswoman with an empty mask of a face conceals her femininity by holding directly in front of her the huge fish she has just caught. Delicate and distant islands are floating on a silken blue sea, each paired with a fleecy cloud in the sun-filled sky.

The fisherwoman is standing on a shimmering carpet of blossoms, one of which stands taller than she and has unfolded a gigantic Delft-blue rosette. This is a still life composed of flowers, a figure, and distance, a bit wooden and conventional, and with a lightly erotic intent. The earthly paradise with its radiant huge flowers and undraped girl can hardly be called naive any longer, nor for that matter can the man who painted it. But for all that it is not without skill and grace.

As one more medium for the mood of our times, everything erotic has become the desired motif of visual consumption, and everywhere on the postered walls of our cities one can see a phantasmagoria of lurid scenic promise, the filmed expression of the dumb and hidden wishes of naives.

One naive painter of importance who has made his own contribution to the theme of the erotic is Dominique-Paul Peyronnet, who has been mentioned before. Against a background of real wallpaper and parquet flooring samples, Peyronnet has painted a reclining woman on a dark red sofa, wearing a pink shift and gray silk stockings (illus. 210). The cramped discomfort of her attitude and the disproportionately long legs displaying a ring of yellowish stretched skin between the tops of her stockings and her slip make this teasing scene with its carefully painted setting a nightmare. The wavy hairdo and the frozen, rigid face mirror a certain erotic suspense. In front of the sofa on a little rug are a pet dog and a pair of discarded slippers, which as in Morris Hirshfield are symbolic of enticing femininity.

The painter intended his reclining figure to be the quintessence of beauty and tempta-

Nina Barca, The Birth of Venus.

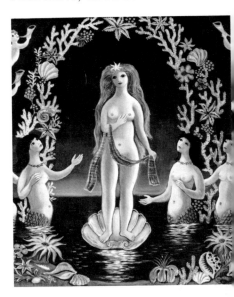

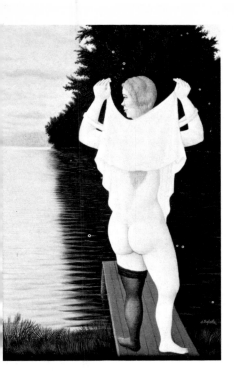

György Stefula, Bather, *1965.*

tion. But she is neither pretty nor especially provocative. The semidaring seminudity of the situation is doubtless a wish projection of suppressed eroticism in this unconscious contribution to the contemporary aesthetic of the beautifully ugly.

Of all the naive painters I know, Camille Bombois has expressed most clearly the abandon, the vitality, and the universal delight of the erotic.

I have already discussed Bombois's well-known picture of *The Carnival Athlete* (illus. 53). Less well-known, but no less successful, is his tightrope walker, who balances at a dangerous height while waving with her little handkerchief and places one little ballet-slippered foot after the other along the wire. Almost all the onlookers are gazing with pale astonishment at the dancer, their faces frozen in fascination. There are mothers with their children, young men and old, and also some very elegantly dressed patrons who form the margin of the crowd. One can recognize the attractions of the carnival in the cages of tigers and snakes and in the peaked pavilion of the carousel. But the weightless movement of the tightrope walker is what is unforgettable, and what alone captures the imagination of the crowd.

Bombois has formed the factual, visible solidity of the human body with uncommon eloquence, treating his female nude (illus. 214) as a set of planes of simple and vital color. Although he is in search of truth, he does not copy the merely visible, but rather

his virile masculine imagination corrects what his eyes take in. His nude becomes an idol. Her torso is all-important; the ample rounding of her belly and her breasts shows her elemental, feminine character as a symbol of life and desire.

Bombois has formed with simplified, bold generalization and vivid expressiveness this well-proportioned and enticing Venus of the naives. One marvels at her firm breasts, the elastic swing of her buttocks, and the powerful, resilient thighs that press together halfway toward the knee. The painter has paid less attention to the arms crossed behind her head and to the head itself, which though slightly bent is still cut off by the upper margin of the picture. The red-rouged face beneath her conventional page-boy hair is incidental. Unhampered by a secure knowlege of anatomy, Bombois still shows a great feeling for the architecture of the body, enhanced by his love of woman, the lines of her full, bending frame, and the rhythm of its furrows and folds. Against a backdrop of Bordeaux-red velvet drapery, borrowed perhaps from the furnishings of the bordello that Bombois had painted earlier, the radiant, tantalizing vitality of this unknown beauty is dramatically portrayed. Bombois, who painted with a strong, vigorous hand, sought to capture the elemental and factual, the sweep and the grottoes and hills of this grand body. At the same time he succeeded in giving form to the great fullness of the feminine nude as the incarnation of sex.

Schröder-Sonnenstern: Eros and Madness

The medieval imagination enjoyed considering odd groups of people standing outside society, collecting them in isolated settings as in Sebastian Brant's *Ship of Fools.* Hieronymus Bosch painted just such a collection in his own *Ship of Fools* which hangs in the Louvre, a moralizing genre painting of deep irony in which a carnival gathering is carried along in a ship without a rudder. Many a painter of Surrealism and of the new trend toward the fantastic has found inspiration in Bosch. I have no idea whether Friedrich Schröder-Sonnenstern had ever seen this picture by Hieronymus Bosch, or whether he had it in mind when in 1956 he painted his *Magic Ship of State* (illus. 218). I doubt it very much, in spite of inner similarities be-

tween the works. It is a characteristic of Schröder-Sonnenstern that he seems completely untouched by any historical or contemporary styles. His egocentric and imaginative pictures, lying somewhere between the isolation of the psychotic and that of the naive, have their own symbolic idiom which will probably never be completely decoded.

Schröder-Sonnenstern's *Magic Ship* is a symbolic picture of political and moral significance. The representatives of power are obviously quite comfortable on board, bemedaled bigwigs from politics, the military, and the church, who are at the same time circus acrobats and clowns. Perched on the top hat of the obvious head of state and pilot sits a little bird, quite likely in allusion to the popular saying *"Er hat einen Vogel,"* meaning "He's crazy as a loon." Some people are putting out a fire while others catch fish. In the place of a charming female masthead stands an archetypal emblem of femininity composed of forms of buttocks and breasts.

Under the bird-mask beak of the jaunty bow there is a skull as a coat of arms. A small plaque on the side gives the vessel's name, "Ship's Circus."

Friedrich Schröder-Sonnenstern's works are both damned and admired. They are certainly valuable for their artistic expression in which psychopathic features are an essential quantity. Clearly their pathological aspects should remind us that a work may well be studied by the psychiatrist as well as by the art critic.

Schröder-Sonnenstern is an artist whose creative forces are nurtured in psychosis, and break through the everyday barriers of existence. Once they have taken on an artistic form, they serve, in turn, as a spiritual catalyst.

In his study on Sonnenstern, Peter Gorsen speaks of the fecundity of symbolism in this artist which appears to be an aspect of egocentric compensation: "The symbol fetishism of a picture points back to the sensual hunger of the man who painted it. Even the fantasy names the painter gave himself could tell us as much. Long before he began to draw, when he was frequenting the North Sea spas of Grömitz and Travemünde as a magnetist and soothsayer in the early twenties, he would refer to himself as 'His Excellency Count Sonnenstern' or 'Eliot von Sonnenstern.' There can be no doubt about the symbolic significance of these fantasy titles, aside from the further confirmation we find in the jottings, verses, and graphic work of the later artist. . . ."

Gorsen speaks of the ambivalence, the oscillation between the constructive and destructive in the symbolic store of this artist. And precisely because of this ambiguity he can be of particular interest for the study of art in our time, for herein he converges with the situation of many a professional painter. Another age would have ignored Schröder-Sonnenstern's work or condemned it as being the expression of a madman. Today such art which has not yet reached the threshold of official aesthetic recognition—like that of the mentally disturbed, of children, and of the naives—cannot be less interesting to the viewer than a cybernetic art that has already left the classical, human sphere behind.

It becomes more and more difficult to set up binding aesthetic values. All sorts of things, from the private image-making of pathological states to obscene schizophrenic scrawls, have become acceptable to official art. What the psychiatrist of just a few decades ago would have recognized as the symptoms of schizophrenia is today part and parcel of *nouveau réalisme,* of pop art, and of the neofantastic school.

In Schröder-Sonnenstern's private mythology, anything resembling the moon corresponds to the night sky and the underworld, while the archetypal image of the positive and the world of light is the sun or "Sonnenstern." But such a polarity covers only a portion of the secret vocabulary of the artist's compositions. Also, the form montages which nearly always have to do with male and female sexual signs, the pathophile metaphors of his pornograms, can never be fully elucidated by psychoanalysis.

The symbols of Schröder-Sonnenstern's work are variations on round and closed

Friedrich Schröder-Sonnenstern, Fork and Moon-Dial.

Friedrich Schröder-Sonnenstern,
Lunar Firebird, *1956.*

forms, cosmic spheres of the sun, the stars, and the moon, and earthly forms of elemental femininity like the vessel symbolism of the womb and the breast.

The picture *Diplomatic Courtship* (illus. 217) shows a monstrous bride with a pig's head standing quite naked except for her stockings. The bridal veil which hangs down from her crown of myrtle still allows us to see the powerful spheres of her buttocks and the spiral of her tail. Her reddish-blond hair falls loosely down her back. The Hottentot exaggeration of her fleshiness is further heightened by an overlay or ornamental circular lines.

Below her gross, udderlike breasts, the bride is holding a little cup coquettishly in her hand. A tiny, mascotlike figure of a man is standing below her like a wanderer among mountain peaks. He is holding a daisy on a long stem close to her snout, as though she were about to speak into a microphone to an invisible audience.

This ultimately inexplicable, obscene presentation of an anti-idol of femininity is by no means dedicated to her worship. It is not the mother-woman's fertility which is stressed, but rather her terrifying aspect; she is horrifying and ugly, risen from a well of fear. This bride is the constricting, the orgiastic mistress of the flesh, symbolic of hell, the grave, and extinction, one of those monumental and monstrous visions of depravity to whom everything masculine appears dwarfed and weak, exposed and threatened.

This is not the mythology of a primeval and matriarchal world, but its suppression in favor of an opposite, patriarchal side. Sonnenstern's grotesquely vital moon-women are products of the night which he juxtaposes to the light of the sun-star of his ego.

The portrait of a bride as well as many other paintings of Schröder-Sonnenstern clearly come from the dreadful psychoses of a deranged mind. The crude and primitive motifs which a rational mind would tend to veil or wholly conceal found open expression in his work, precisely because illness had weakened all his mental restraints.

Dr. A. Bader, the student and interpreter of the art of schizophrenics, has written me recently that his study of Schröder-Sonnenstern is just now being printed, and that Peter Gorsen has also published a thorough examination of this painter. Readers interested in schizophrenic manifestations of naive art can thus consult these two authors.

Sonnenstern's pictures, which prove shocking to any philistine taste, seem to me not only obscene, but also quite enlightening. They are expressions of madness in an artistic medium, mannered and yet naive, contradictory in themselves and yet unified in their succinct presentation of archaic and demonic concepts. They are up-to-date and singular manifestations of the subconscious.

Eros, Naiveté, and Abstraction

In the early history of man, sex reigned unconcealed. The ritual nudity of antique goddesses has degenerated in our time to the commercial striptease, as the instinctively sexual again presses toward the foreground of our thought. Can it be that we are witnessing the return of an original freedom, that mythic survivals have broken through civilization's shell of a moral structure?

Present-day art and literature have contributed to the abolition of secrecy and prohibition in the realm of sex with direct and challenging honesty.

Picasso, after the period of his blue tightrope walkers and somnambulant drinkers, caused the physical body to become fragmented and to totally disintegrate. But later he would again take up the theme of passionate tension between the sexes, portraying his Eve who either behind or in front of the curtain of morality, with dreamlike gentleness or brutal sensuality, proffers her enticing womb. In the drawings of his old age, Picasso has represented sex with the unprejudiced candor of modern exhibitionism. The artist's drive toward creative expression coincides and becomes one with the instinctive union of lovers. Picasso's eye has perceived the vital beauty of the unresisting female body and the subterranean violence of sex.

The predominance of feminine nudity in this chapter on Eros is appropriate to the common concepts of a male-oriented society. But also the naive painters, more than all others, are subjected to the reigning moral norms.

While the naive painters attempt to incorporate eroticism into accepted conceptions of morality, high art has opened the floodgates and released into the world all that has previously been avoided or forbidden, in violent, glaring, and exaggerated clarity. This has occurred not in the context of a highly

ambiguous and living sensual totality, but rather with provocative exhibitionism, making fetishes of the male and female genitalia: Frank Gallo's perverted cultist nudes, Hans Bellmer's obscene linear cosmos with its center a blooming vulva, Richard Lindner's high-booted and obviously sadistic leopard-woman, Niki de Saint-Phalle's *Nana,* a monumental vessel of lust, Paul Wunderlich's copulations *à trois.*

These modern myths of sex and antisex are by no means the products of naive belief, but deliberately formed caricatures of our vital existence. Wherever genuine naiveté is at work there arises a manner of expression independent of style and reason; such freedom is not available to naives in the province of Eros.

The art of the erotic cannot be limited solely to the thematic representation of sex. Such elementary forms are of course understandable as a reaction against the cultural sublimation of sex, but erotic art is not all representation; it is the expression of sensuality in form. Hemmed in by prohibitions, only a very few naive artists transcend the established standards of morality existing in their region. Their choice of themes tends toward the idyllic and utopian. From a one-sided, purely thematic point of view, one would conclude that there are no systematic explicators of the erotic among naives. But eroticism as an intensity of life residing in art, as an expression of elementary images, is met with repeatedly in their work; not only in Henri Rousseau, Morris Hirshfield, and Camille Bombois, but also in the erotic dreams of the cleaning-lady Séraphine transfigured into lush bouquets (illus. 57, 221). With a truly naive gift and in mystical, erotic transport, Séraphine created these trees of life from her imagination, in which luxuriant leafy ornament, delicately colored feathers, transparent stamens, copper-green mosses, and languorous opening fruits resemble eyes and moist lips and the delicate cleavages of sex. These are painfully sensual canvases; Eros translated into almost wholly disintegrative, yet breathing, abstraction.

Vangel Naumovski is no longer the naive narrator of Macedonian folk myth that we once knew (illus. 219). The one time gardener, mason, cartwright, lemonade seller, and furniture builder—this melancholy figure haunting Slavic-oriental cafés—has turned into an artist who tries to come to terms with the styles and problems of twentieth-century art.

His pictures are the dreamy visions of a decorative paradise, with the rampant vegetation of *Art Nouveau;* surrealist chords of a romantically expressive musicality. Shapes in jade green, flamingo red, saffron yellow, and heliotrope are suspended from an azure sky. They pour downward or float upward, hover, blur, and disintegrate through subtle transfiguration into pure white light. It could be that the shimmering waters of Lake Ohrid are the basis and medium for his world of sensuality.

Vangel Naumovski's calligraphic forms continue to fertilize each other in their peripheral contact. A drama of restless desire dissolves the boundaries between legend and decoration, reality and abstraction, plant and man. Nude girls in shell pink and icy blue have been conceived with minute precision and baroque fantasy. Vessels, welling flowers, hovering spheres, bursting balls, vines that reproduce themselves in chains—all these comprise his *Garden of Desires.* Forms and things copulate in an orgasm of color. Nature, landscape, and Eros are fused into a sensual, artistic simultaneity.

Naumovski's work causes us to ask the question we would put to many another lay painter of our time, namely, what happens to the naive painter when practice, understanding, and success have corrupted or destroyed his instinct and innocence?

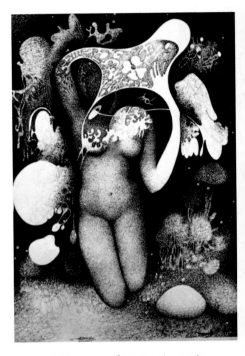

Vangel Naumovski, Youth, *1969.*

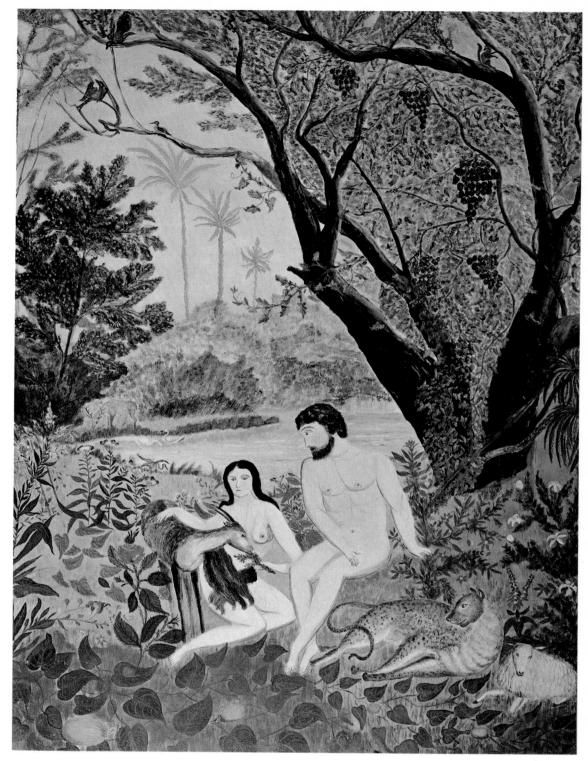

209. Adam and Eve, *by an unknown*
American naive, circa 1830

Eros wears numerous faces and masks among
the naives. It includes the portrayal of taboo
regions from shy and hesitant or idealized
representation in a classicist manner and
antithetic to the essential authenticity of the
naives to gross, fetishist scrawls of obscenity,
the most primitive expressions of potency.

Erotic art is only naive as long as it draws
with unbroken honesty and instinctiveness
from the magical springs of primeval
imagery.

210. *Dominique-Paul Peyronnet,* Reclining Woman, *circa 1925*

211. *André Pierre,* Sirène (*the voodoo Sea-Goddess*), *1962*

212. *Henri Rousseau,* The Dream of Yadwigha, *1910*

213. *Jan Balet,* La Paloma, *1965*

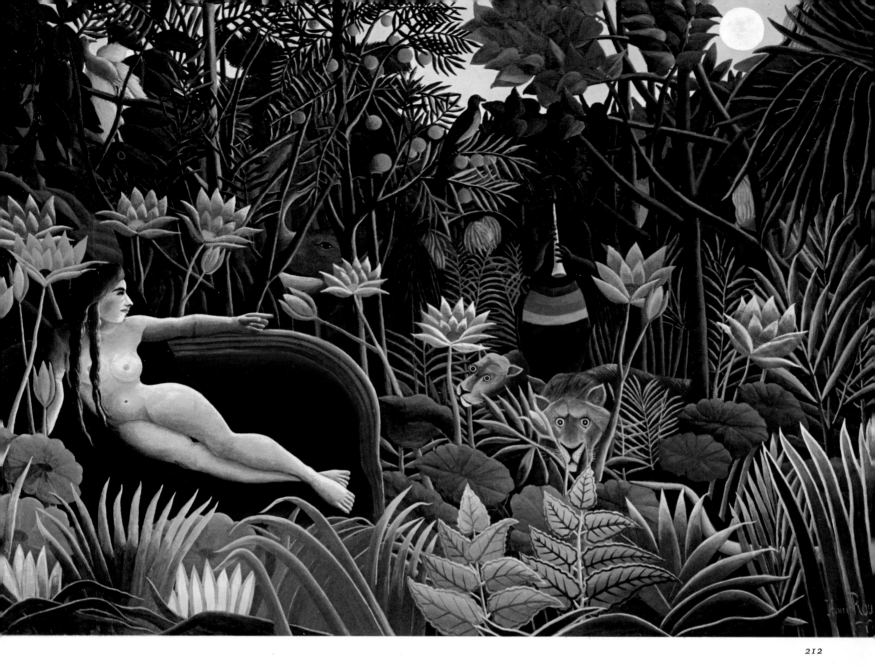

212

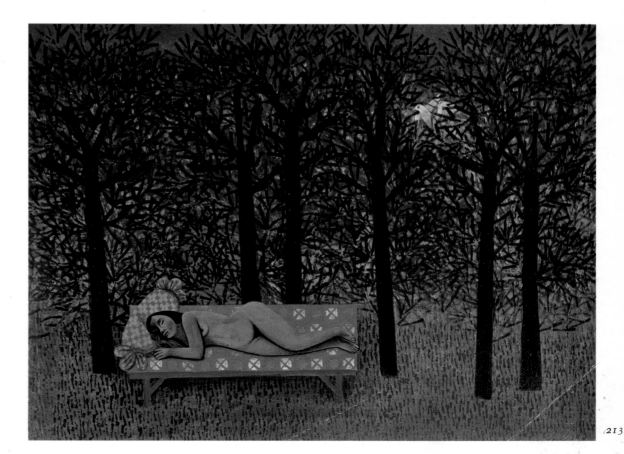

213

214

214. Camille Bombois, Nude With Raised Arms, *1925*

Since the sixties, it seems that not only the boundary between painting and sculpture has been lifted, but also that between image and reality. Just as in pop art real objects are often used in place of painted copies, the real bodies of living people are frequently offered us in place of mere representations of them as the last possibility in the exploitation of a theme.

This craving for authenticity, whetted in the advertisements of the mass media and encouraged by the naturalism of the New Figuration, was felt unconsciously and with naive immediacy by Camille Bombois as early as 1925. His nudes nearly have the density and plasticity of feminine flesh, realized in static monumentality as idols, wish projections of primitive male urgings.

215. *Morris Hirshfield,* Motherhood, *1942*

216. *Morris Hirshfield,* Girl Before the
Mirror, *1940*

*While Bombois's female nudes express the
elemental strength of the "Great Reality," those
of Morris Hirshfield are formed with sensibility
as products of a suppressed Eros and
unconsciously recollected drives. His pictures of
girls are fetishlike cultivated dreams, evocations
of forbidden things. At times they hover between
kitsch and pornography, like the naked women
of Labisse, Delvaux, and Magritte, the "Great
American Nude" of Tom Wesselman, and
the wax sculptures of Frank Gallo. The works
of these well-known painters are produced quite
consciously and with a strong accent of irony
and exhibitionism. By contrast, the naive
Hirshfield created out of his subconscious; the
violation of sacred law meant for him a release
from tension and a liberation of the self.*

216

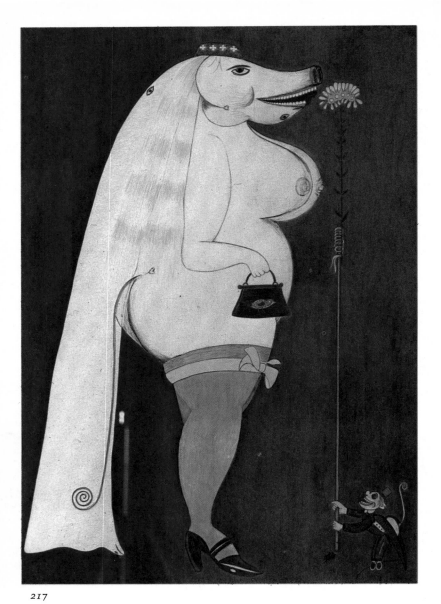

217

217. *Friedrich Schröder-Sonnenstern,* Diplomatic Courtship, *1959*

218. *Friedrich Schröder-Sonnenstern,* The Magic Ship of State, *1956*

219. *Vangel Naumovski,* What Is Adultery?, *1969*

220. *Josip Generalić,* Eve With a Fish, *1969*

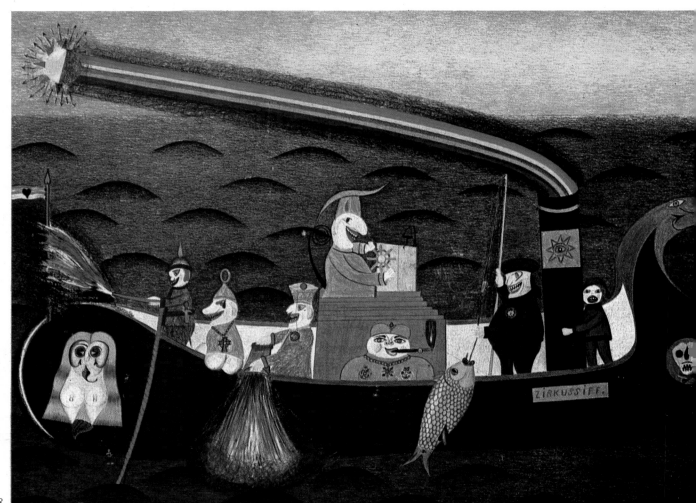

218

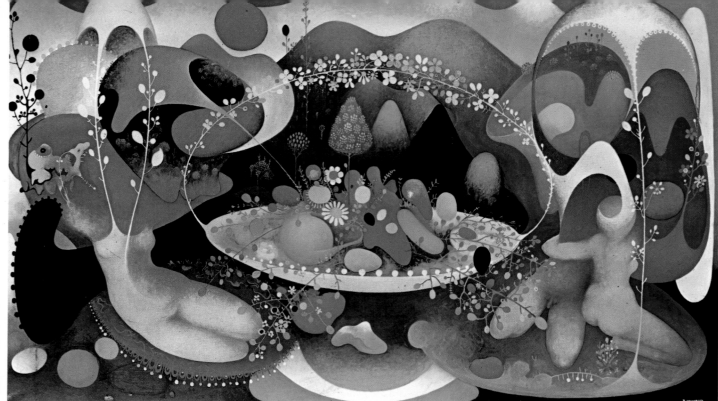

219

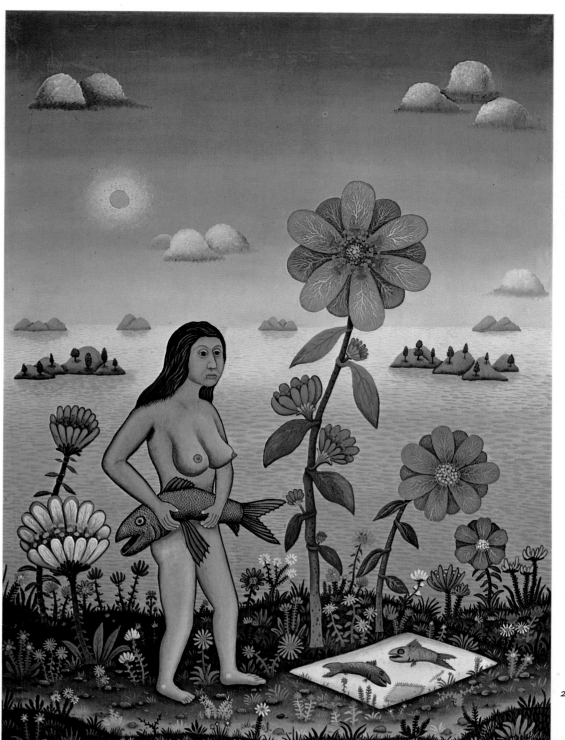

220

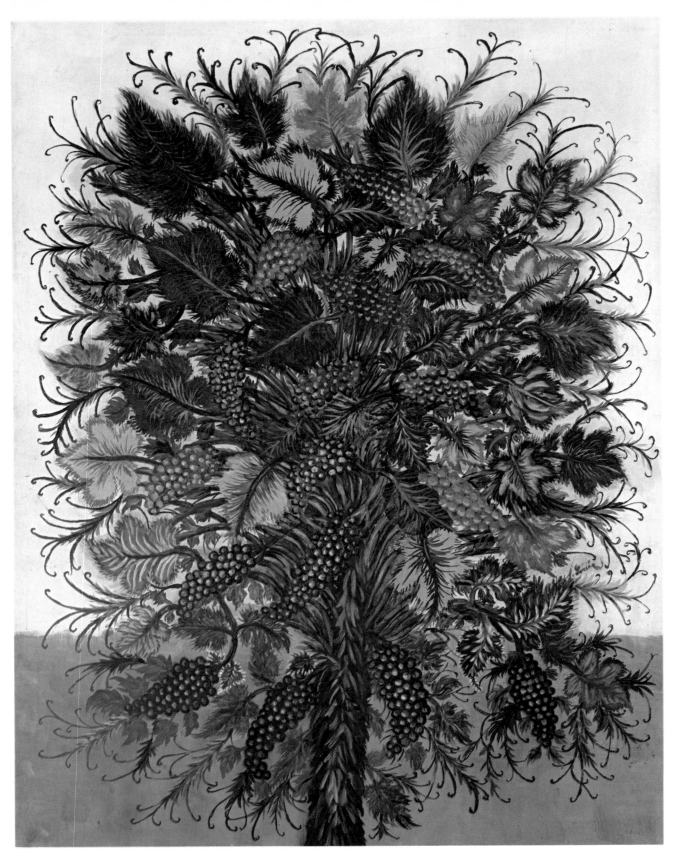

221. *Séraphine Louis*, Grapes

*Art conquered Séraphine like a revelation. Painting was for
her—as it was for Van Gogh—an experience of transport. It
was as though she found salvation in the act of creation. She
moved through the monotonous everyday of her simple life
unseeing though with wide-open eyes. Ignorant outsiders
thought of her only as the simple maid of Senlis. But she felt
herself called upon to look behind the transitory props of
temporality, to study the eternal and communicate what she
saw. She created her ecstatic bouquets of rapture in glowing
colors and with sensuously ornamental fantasy.*

The Last Chapter

Chapter XV

Radiations

Demonic face with raised hands, late Stone Age image from the Monte·Bego region of the Maritime Alps.

Since around the turn of the century, when modern artists had begun to turn to experiences of primitive originality, the simplicity of children's work, and the realism of peasant votive painting as a source of inspiration and renewal, traces of naive perception have been increasingly apparent in professional art.

Henri Rousseau's directness, his magical factuality, and the frugality of his technique had a discernible influence on the art of the avant garde. The jug and mandolin of his sleeping gypsy were an inspiration to Picasso, Braque, and Juan Gris. Rousseau also had an effect on *Pittura Metafisica* and Magical Realism, from Chirico to Beckmann. It may be that his *Ball-Players* directly influenced Picasso; certainly Delaunay, the friend and admirer of *le Douanier,* took them as models for his *Racers.*

Directness in art is not limited to the works of the naives. Every important artist carries something of the stock of memory of his original and exploratory childhood observation into his work. Without these simplest existential signs, his work would lack spontaneity and magical penetration. Paul Klee, Joan Miró, Fernand Léger, Pablo Picasso, and Marc Chagall have managed to preserve an uncommon measure of the wonder of childhood experience. Especially apparent is the unity of naiveté and refined intellection in the paintings of Marc Chagall. This synthesis of factual naiveté, which reminds us of Rousseau, and the spirit of the Parisian school have given his direct and magical world of fable that expressive idiom that so fascinates us. Chagall is to be sure no naive painter, but his narrative vision allies him with the *maîtres populaires de la réalité.*

Marc Chagall's composition *Her World* (illus. 223) was created on a canvas that had been painted years before, then later cut up and newly prepared. The picture combines two epochs in his creative development, that of the Slavic-Hassidic stories of miracles—closest to Rousseau in the symbolic power of its imaginative simplicity—and that of a more mature, more refined sensibility and deliberate symbolism belonging to the creative achievements of the *école de Paris.*

Chagall's picture, finished after the death of his beloved wife Bella, still bears something of the magical innocence which allows unpromising everyday things to seem legendary and miraculous. At the same time it shows the artist's ripened self-analysis and his surrealist métier.

The painter, with his head turned around on his shoulders, and the melancholy figure of his dead wife are united in the circle of moonlit landscape of their mutual past. Above them hover human and animal figures from dreams and memories, the symbols of a lasting love.

Maximilien Gauthier has claimed that Henri Rousseau's *Yadwigha* (illus. 212) was the point of departure for the painting of Surrealism. Also other important works of naives following Rousseau have been influential: the dream palace of irrational and fantastic eclecticism of the letter carrier Cheval (illus. 144), the simply painted tightrope walkers, athletes, and whores of Camille Bombois, as well as the transfigured world of a Nikifor caught in picture signs in lined school notebooks and painted in schoolboy colors. Even the demonic delusions and erotic nightmares of a Friedrich Schröder-Sonnenstern have influenced trends in art either directly or indirectly.

In his *Art Critic's Journal,* Klaus Jürgen-Fischer has outlined certain qualities of naive painting which have been of particular interest to professional artists in our time:

The naive painter surrenders himself wholly to the fundamental human desire for creating order, and he achieves order with his forms and colors to astonishing aesthetic perfection. Their economic disposition of planes and spaces is one area in which the naives often far surpass the professionals. The professionals have learned from them, and in the painting of the younger and newest generations, at least in Germany, I see how these principles are again being accepted and spread, so that there is often a surprising similarity between today's painting and New Realism, which in turn had been influenced by Rousseau—who to be sure was not a true naive—or Bombois. . . .

Such influences occur in pop art and in the New Figuration, both of which have again made room for the simple objects banned from painting since the victory of abstractionism. This migration of banal everyday objects of mass consumption into the realms of art and antiart tends to lessen the gap between naive and professional painting. The practice of designating only slightly distorted natural and popular objects as art—from Marcel Duchamp's bottle brush to Claes Oldenburg's monumental lipstick and popsicle, César's thumb monument, Joseph Beuy's ice-covered grand piano, and Michelangelo Pistoletto's photographic painting on sheets of aluminum—shows an obvious desire to regain an elementary freshness of vision through directness and spontaneity.

A long series of experiments in modern art has resulted from this attempt to be understood and accepted by the masses of the modern metropolis through the discovery of an image appropriate to the visual illiteracy and manipulated taste of industrial society.

In many respects, earth art, food art, minimal art, and *ars ludens* have reduced the distance between the producers of art and its consumers. Often we no longer speak of creativity or skill, but instead of planning, construction, and design. It would be incorrect to prefer the phenomena of naive art over others, but equally incorrect and unjust to overlook the work of the naives or deny it. It is there, and a part of us.

One could scarcely maintain that Chagall's legends told with such warmth and simplicity have affected the art of naives, for stylistic influences are not to be found in any of the truly important naive painters. But they are quite apparent among the borderline, self-conscious naives, who are indeed much indebted to Chagall's depth of feeling and

sense of the miraculous. The work of lay painters and amateurs which might otherwise be merely spirited and humorous, however perverse and self-centered, will occasionally take on nuances of surrealistic, lyrical expression thanks to contact with Chagall's imagery of dreams.

Robert Guttmann has surely seen Chagall's work, or at least reproductions of it. His morosely lyrical pictures possess something of Chagall's sensually expressive and colorful narrative power.

I include here a little picture of a shepherd by Anja Hefti-Stamm (illus. 224) in order to show something from the borderline region between the daydreams of genuine naiveté and those continually influenced by our contemporary surroundings. This realm includes both the widespread distribution of truly creative art as well as that of picture post cards. This woman paints mood pictures of delicate sensitivity, such as this one of a good shepherd with his gentle sheep in a moonlit landscape of alpine solitude, all presented as seen through the rose-colored telescope of the city-dweller. The evocative colors give the somewhat cloying little picture a gloss of innocence.

Maurice Utrillo, the popular painter of the milieu of Parisian suburbs, stands between the *poètes maudits* and the *maîtres populaires de la réalité.* His mother, Suzanne Valadon, was his teacher. She was a onetime bareback rider in a circus, and later modeled for Puvis de Chavannes, Toulouse-Lautrec, Renoir, and Degas. She was also a self-taught painter and engraver of a certain natural talent. In order to rescue her son from drink—for in his early youth Utrillo had become addicted to alcohol—she made him paint. In a short time, and somewhere along the circular route between his bars, jail cells, convalescent homes, and his mother's house, he was producing works of a singular intensity. His was the life of a vagabond, hereditarily shortchanged and unhappy, like that of Nikifor or Kiyoshi Yamashita. Utrillo was nonetheless endowed with a curious power which could utterly transform the world of his gloomy alleys and courtyards in Banlieue. Impressionism was for him less a period style than the natural air of his native milieu. With the occasional clearsightedness of the alcoholic, he broke out of the shell of Impressionism and painted—"with a mad thirst for reality," as he himself put it—the loneliness of those miserable bistros, flophouses, and dull façades in the reticent colors of his awkward brush. In the process he produced masterpieces of a poetically naive reality. In order to come as close as possible to material reality he once used to mix chalk and sand with his brighter early colors, or paste moss and other plants onto

Pablo Picasso, Still Life With Guitar, *1926. Detail.*

Henri Rousseau, "Guitar." Detail from The Sleeping Gypsy, *1897.*

his painted masonry; in this he is like Joseph Pickett in America, and he achieved a concreteness of definition characteristic of the naives. Like the later button maker Emerik Feješ, Utrillo also is known to have painted from picture post cards, and they were just as evocative for him as if he had felt across their walls with his own hands and not merely seen them.

A typical Utrillo street scene (illus. 229) is dominated by the chalky, light, gray-green, graffiti-covered wall of a building. Half a century after these paintings were done, the action painters—Jackson Pollock, Georges Mathieu, Emilio Vedova—sought surfaces on which to display the signs dredged up from their unconscious, and found them in planes quite like those walls of Utrillo's. Unconsciously Utrillo sensed the beauty of that formless and miserably monotonous expanse of material with its changing texture, a beauty only few had seen before him.

Like Utrillo, Andreas Barth is only a lay painter who was encouraged in his work by those around him. Barth is not a vagabond, but rather a compulsive gardener. He does love faraway places, however, and, in his travels, especially in the South, he has ex-

perienced a great deal of art. Traces of other paintings slip into his own. Utrillo was satisfied with dirty, shabby, and melancholy walls, but Barth chooses especially lovely places with exotic architecture. The picture included here, *Grandeza de España* (illus. 228), may well be Valladolid—at least that is what is written on the bullfight poster with the yellow toreador, the red cape, and the swarthy bull.

Dominating the picture are an imposing cathedral, the square in front of it, and streets lined with buildings disappearing into the distance. There are no groups of people, only a farmer on a donkey, a man sitting on a chair by his front door, and a nun climbing the cathedral steps. The statues of saints on the façade of the church look quite like the few people on the streets. The head of a policeman which pops up from the bottom of the picture is painted larger, and is seemingly more important, than the town's population.

It is an hieratically shaped space, done by a hand that knows how to structure things. The foreground is gray-green, the sky a transparent blue that fades into the distance, and connecting them are the brown shades of the church's architecture. All forms are classical, and arranged with clarity and balance. In contrast to the blurred transiency of the life and painting of Utrillo, Barth strives to render his experience of the space with concreteness, as a place of fulfillment. In spite of the naturalism of his pictures, Utrillo is the imaginary architect of a spiritual suburb of pervasive melancholy. Both are technically lay painters, but Barth adapts himself to things he has read and art he has seen, while Utrillo formed a world out of himself with a style that continues to influence others.

The Conscious Naives

The picture that introduces this chapter is the *Home Wedding* (illus. 222) of the schoolmaster and lay painter Oluf Braren. The art historian Franz Roh, who was an ardent champion of naive painting in Germany, has said of Braren: "I see the summit of German painting in this odd and tragic man." Braren lived on the North Sea island of Föhr, and he found the past and its customs to a large

degree preserved there in his own day. So in rising above his surroundings he came to feel both the narrowness and importance of his world. During the long winter months, and in his isolation from the mainland, he had ample leisure time in which to meditate and to achieve a very personal style.

Braren was no more naive than were the North American limners, whose works are contemporary with his, roughly from the close of the eighteenth century. But they were also precursors of naive painting. In Braren's sympathetic and lyrical invocation of objects there are elements of both classical and romantic style.

Parallel to the artistic activity of naive painters among the people, well-schooled intellectuals also strive to achieve direct self-expression, though without artistic training, in the color and line of painting. The borders between lay painting, naiveté, and professional art are often fluid; many variations and trespasses occur.

The poetic simplicity in Edgar Tytgat's love of storytelling is a refined naiveté. His slightly melancholy fairs, the sad grace of his clowns, the shy eroticism of his lovers, and the solemn spectacle of his pious processions seem to be taken from a picture book of folklore and to lie close to the childlike heart of life. But behind the innocent stage and primitively decorated scenes of this charming and colorful puppet theater there is to be discovered the feeling for artistic form of a knowing and demanding director.

While pausing at this frontier station of naive art it might be possible to speak of certain phenomena which lie close at hand. Several highly admired painters in Prague, Muzika, Zrzavy, Čapek, and Hoffmeister, have sounded the refrain of innocence with virtuosity and self-awareness. Doubtless their experience of the work of Henri Rousseau has affected them, for his magnificent self-portrait is housed in Prague's National Gallery.

A conscious naiveté and an intrusion of a deliberately archaic primitiveness can also be observed among contemporary painters in Italy. Turning away from the bravura of the rhetoric of painting in the *Novecento*, these gifted Italians have allowed themselves to be influenced by the innocent realism of the *maîtres populaires*. Ottone Rosai has described the poetry in the melancholy back streets of the poor sections of Florence with ascetic simplification and childlike conviction. Denying himself the beauty of mere color effects and virtuosity in his rendering, he deliberately stationed himself in the vicinity of that tart factualness that so characterizes Rousseau.

Giuseppe Cesetti too, who began as a self-taught painter, belongs among the deliberate naives striving to escape the pull of excessive rationalism and civilization.

Antonio Ligabue's brush has an original and bold manner of expression. His self-portraits reveal the terror in the abyss of his own soul. The passion of his color and the strength of his drawing are combined in pictures of animals with a wildness of spirit and landscape. Painted in the full light of consciousness, these pictures born of elemental feeling and with perhaps just a touch of madness are nevertheless hardly to be labeled naive.

Irene Invrea likes to paint the golden age of a lost animal paradise. Her ultramarine

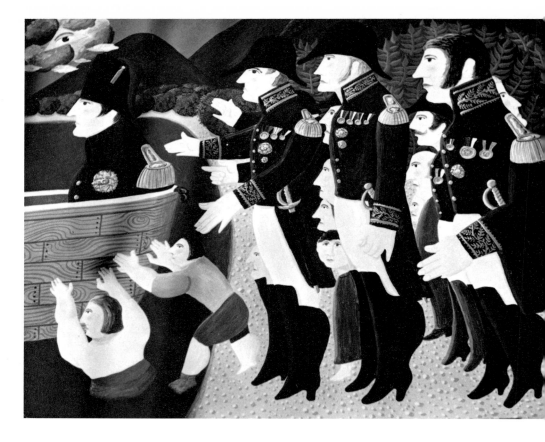

rhinoceroses, sinewy panthers (illus. 230), and herds of zebras live in a primeval world as yet untouched by man. Her lyrical and sometimes rather idealized representations reveal the setting of a life tinged with mystery. In an aquarium of endless water she floats islands painted with a bravura technique, covers them with carpets of embroidered flowers, and populates them with prehistoric animals with halos. Invrea is doubtless too literary to qualify as a naive; these are the daydreams of a painter who has even begun to emerge from the ambience of the layman painter, and to have ties with the world of surrealism.

The New York painter Oscar de Mejo succeeds in inventing situations of miraculous simplicity with his quite sensitive talent. The wooden, severely profiled figures of his *Departure From Elba* or the mysterious static movement of his *Last Supper* have been created with that conscious distance which partakes of the childlike and naive, but which at the same time suggests to the viewer that he should not take anything too literally.

Should we call the religious Jaroslav Fiedler a naive, or a gifted amateur? He lives in a village and makes his days more beautiful by occupying himself with the landscapes of his painted dreams. He restores primeval forms to nature, with female figures lounging under his lianas and a heavy moon suspended above tropical vegetation. Still, he does not enjoy that primitive compactness and strength with which he might communicate the image experienced within in all its sensuality.

Ludmila Pokorna is a gifted Sunday

Oscar de Mejo, Departure from Elba.

painter. The things of her life as a ballet dancer she translates into color and form in her leisure time. Life in her pictures is dressed up in costume as though for the stage, caught in Biedermeier idylls of grace and delicate color: orange roofs, lemon-yellow roses, dresses in the soft violet of butterflies, a transparent green sky, and brown fish that swim out across the proscenium of her picture. A certain irony accompanies her craving for honesty, for she knows and feels the limits to her naiveté. At times she truly achieves the poetic atmosphere of the miniature with its simple imagery. She is an amateur with a warm, engaging talent.

The cubistic bouquets, the green balloons of treetops, and the bright house-flats of the cameramen and assistant director Pavel Horak are painted out of a love of simplicity. They are splendid stage decorations with structures and transparencies, a conscious toying with the childish intellect.

Josef Hlinomac maps the hell of modern life in moralistic and fantastic compositions; the pathology of power, the tyranny of money and sex, and the empty industry of the metropolis. As an actor and self-taught painter, Hlinomac creates highly successful street ballads of our age. This is a ballet of thugs, policemen, whores, pushers, cabbies, and jazz musicians, staged somewhere between Dali, pop art, and naiveté.

The onetime pastry baker, boilerman, porter, and stagehand Karel Chaba has registered the glow of the times with an observant eye. A Gothic and a Baroque Prague shimmer with neon color in his work. His rows of buildings are suggested in strong lines of lemon yellow, grass green, midnight blue, and brick red. Surrealist and Cubist elements are mixed in with his love of simplicity.

Felix Muche, originally named Ramholz, stands between lay painting and naive art. In his studio hang originals by Chagall and Picasso, Franz Marc and Paul Klee. In conversation with his son Georg Muche, the Bauhaus artist, he has closely followed the vicissitudes of modern art. Yet with his inner compulsion to paint he has produced pictures of charming, deliberate simplicity. The humorous fantasy of his anecdotes is confined to a popular idiom, but still it is not naive.

Even more self-conscious than these are the pictures of the poet Joachim Ringelnatz, reflections of his scurrilous, long-suffering, and satirical commentaries on life. The symbolism of his painting has aspects of surrealism, and, in spite of the lay imperfection of his technique, it belongs to the realm of feeling of the sensitive amateur.

The desire to effect a new contact with the world of things and with social realities in an age of alienation led Krsto Hegedušić to combine the techniques and insights of mod-

ernity with the directness of naive and popular visual forms.

The penetrating and fantastic expressiveness of the self-taught Jose Horvat-Jaki, who unexpectedly emerged from peasant surroundings, can no longer qualify as naive. His magic, visionary style touches upon surrealism. His faces and bodies have aspects that are both fantastic and compulsive.

Vojislav Stanić is a deliberate primitive. Though academically schooled, he has preserved the taste of a child, and has created charming human situations in a simplified imagery.

In the tradition of Slovenia, Jose Svetina, Polde Mihelič, Anton Plemelj, Greta Pećnik, Anton Repnik, and Jose and Konrad Peternelj tend to paint landscapes and figured compositions with expressive, surrealist stylistic elements. They are talented amateurs who for years now have been showing their work in exhibits of naive and self-taught painters.

One can see how strong the feeling for naive art has become in our time by the constant borrowing of naive effects to be found in commercial graphics and paintings appealing to the mass taste. Images formed unconsciously and with unskilled hands by self-taught painters from among the people are now quite deliberately produced with disguised virtuosity and a false poetic gloss.

The French graphic artist André François amuses himself and the public by posing as a child, and thus capturing the attention of his viewers. With careful practice, and with considerable talent and industry, he has suppressed his native perfectionism to the point that he can achieve his little masterworks of deliberately simple good humor with genuine and artificial childishness.

His colleague Christine Chagnoux has invented a touching paradise for animals which one might well call a Rousseau jungle book for all ages.

Along with the music of the Beatles and the countdowns of moon-flights, a longing for a simpler way of life is part of the rhythm of our times. Painters and graphic artists look with envy at the childlike sense of discovery of the naives. Uccello is closer to them than Veronese, and *le Douanier* Rousseau moves them more than does Raphael. One such is Patrick Byrne (illus. 231), with his pictures of dreamy young boys with animals from the gardens of fairy-tale mythology, old-fashioned and super-modern at one and the same time, childlike yet appropriate to the studio of the master Uccello. Byrne's boys are only undersized adults, a trait that ties his work with pictures from the *Trecento* and those of *le Douanier*. In their troubled faces and over-large puppet eyes are reminiscences of *Alice in Wonderland* and at

atrick Byrne, "Head of a Lion." etail from Melanie with a Lion.

the same time of Beckett's tale of hopelessness in *Waiting for Godot*. People and animals stare lifelessly and without communication into our world, with touching pathos and the disappointment of a shattered trust.

Dorothea and Gyorgy Stefula (illus. 226) belong among the deliberate naive painters who have been able to salvage so much from their childhood that they can combine technical skill with the fresh astonishment of the child. A catalogue from the Galerie van der Loo (Munich, 1964) said of Gyorgy Stefula: "Technically he is a professional man who once decided he would rather become a painter while whitewashing an airport fence a kilometer long."

Dorothea's quiet dreaminess recalls the virginal and idealized family portraits of sensitive amateurs from the Biedermeier epoch. With studied simplicity, Gyorgy Stefula paints lovely pictures of a sincere reverence for life, quite like the products of genuine naive imagery.

The German painter and graphic artist Jan Balet utilizes his masterful technique in describing tragically moving, grotesquely poetic experiences of everyday life. In my chapter on "Eros in Naive Painting," I placed Balet's nude *La Paloma* (illus. 213) next to Rousseau's *Yadwigha*. His dreamer is lying on a bench in the blue shadow of trees, clearly a painting born out of a reverence for Rousseau. Balet's picture *The Team* (illus. 225) has been juxtaposed to Fernand Léger's group of cyclists (illus. 227). The three team members in sporting costume have prominent numbers on their chests which give them an identity such as their interchangeably dumb and vain faces never could.

Rousseau's *Yadwigha* has become a symbol for us of the sublimely naive; Balet's *Team* is rather a composition of deliberate naiveté affecting a popular simplicity. Fernand Léger's *Family Outing on Bicycles* was conceived with a sense of the magical dignity of the world of objects in a style influenced by Rousseau's concept of reality. Léger's art is one shaped with great deliberation, in which artistry has been abandoned in a deeper sense only to be preserved in popular themes close to life: *The Country Outing, Picnic on the Grass, The Great Constructors,* and *Sunday Cyclists*. The emblematically basic shapes of men and things is rooted in elements of constructivism and cubism as well as in an exciting realism like that of the

sublimely naive. The son of a Norman cattleman, Léger speaks of life in the plastic and pure forms of pop art, expressing solidarity with the world of the simple worker.

Can one discover historical parallels for this preference for the naive and craving after an original simplicity? In the later epochs of advanced urban cultures in which nature could not be experienced directly, art has become its intermediary, the shepherd's pipe, the artificial echo of lost ages. The pastoral idylls of the New Kingdom in Egypt, the rustic novels of Greece, and the bucolic verses of Roman poets were products of an oversaturated urban culture done with artistic taste in a popular vein. Pastoral romances in Spain were the expressions of a cult of chivalry remote from nature. In the effete and courtly late Baroque, bucolic idylls and hermit landscapes were a part of the insubstantial indulgences of social coquetry, and attest to the influence of bourgeois sentimentality and a craving for nature. From antiquity to the time of Jean-Jacques Rousseau, people trapped in luxury and abundance longed for a simpler integrity. The appearance of naive artists out of the shadow of anonymity is also a symptom of the exhaustion of civilization in our own twentieth century.

The burst of an archaic primitiveness into modern art was a decisive event of our time. As a reaction against technical virtuosity, disintegration, and abstraction, an ingredient of spontaneity was sought and found. These skirmishes on the borderlands of direct imagery and conscious naiveté belong among the strangest and most remarkable artistic phenomena of our age.

Dorothea Stefula, The Portraitist. *Detail.*

Limitations

Technology and industry, the forces which shape our epoch, even make themselves felt in the isolated studios and workshops of the naives. Within the limitations of their perception, these artists consciously or unconsciously incorporate the signals reaching their eyes and ears through our manifold channels of communication and information. Can the naives thus remain untouched by the standards of art history and the spread of contemporary art forms? Through long years of practice they develop a craftsmanlike sureness which insures them a freedom of pictorial expression, so that the personal stamp of an individual artist is immediately recognizable. Does even this break down the wall between the naive and the professional? Should one assume that naive artists have transcended the specific boundaries of their art and joined the common train of artistic creation?

When I think of something that happened during the 1970 Hlebine Symposium, Klaus Jürgen-Fischer's warning seems fully justified when he says of the Hlebine School: "It has lost its innocence, and is in danger of developing into an academy of amateurism, an easterly Montmartre. . . ."

On one of those days, Ivan Generalić, the founder of the whole flurry of artistic activity in Hlebine and in the Podravina generally, led me to see the children of the village, and to show me their talent, their industry, and their success in the medium of painting on glass. Samples of their work had been hung on the garden fence around the Hlebine art gallery—a small but colorful exhibit. I was enchanted and touched by the vitality and vivid expressiveness of these children's paintings, and stepped toward a twelve-year-old girl dressed in white to say hello. But the child misunderstood my intention and blurted out with determination: "Four hundred dinars apiece!" I was stunned by the naked commercialism of this use of art, by the absurd synthesis of innocence and calculation.

Standing as it does in a spotlight, Hlebine faces two possibilities: either it could remain a village known for its pleasant naive art, in which the gifted villagers create the stuff of dreams and pictures along with their daily bread, a village visited because of its art by many admirers from afar, or—and though it is painful to say so, it applies not only to Hlebine—it could be transformed into a mecca of cultivated amateurism and the professional manufacture of souvenirs, in which all remnants of creative originality would disappear. Friends and critics of naive art are of the opinion that the growing number of naive artists and the increasing interest in their work—with the simultaneous proliferation of styles in professional art—tend to discredit the view that naive art stands isolated from the course of history.

Could naive art be understood as one of the major styles of the twentieth century? At the beginning of the great adventure of modern art, the work of *le Douanier* Rousseau was a major force. Also Utrillo, and possibly Chagall and Léger, could to an extent be counted as being in the family of the conscious naives. In the past few decades, many a professional painter has turned away from the artificial and esoteric in order to find his way back to an imagery of simple appeal. Should we perhaps expand and rewrite our definition of what we would call naive? Any such conceptual change would only tend to call into question the unique quality of true naiveté. Taken as a whole into the dizzying alternation of styles in art, naive painting would become merely a curious marginal phenomenon in history, a short-lived and innocent "happening." Brevity and transiency, as is the case with all artistic styles, would be the result of its inclusion in the mainstream of the historical process, and its destruction would soon follow. Modern art with its imagination and its symbols has much in common with the earliest expressions of mankind. But from our intellectual experience of life there is after all no chance of a genuine return to innocence and a mythical world view.

Modern myths are not those of naive belief, but are rather deliberate shorthand portrayals of existence formulated in the bright light of day. Wherever genuine naiveté is to be found, there is also a tendency toward self-sufficiency and isolation. Only a childlike insulation from historical and present-day processes and a primary and instinctive habit of perception could insure an art independent of the times. In every other case, the anachronistic and vague surrender of naive art to an eternally peaceful condition of existence, its indifference to the problems and conflicts of society, can only be judged to be a private and petit bourgeois backsliding and regression.

The naive painter can improve his craftsmanship and concentrate his observation. Klaus Jürgen-Fischer writes: "His expressiveness can be increased on occasion, but there is no growth, no vertical progression, no succession of stages. Ripening toward mastery, the opportunity and reward of high art, would constitute the death of naive painting. It has to remain immature, for therein lies its freshness, its charm, and its value."

Fernand Léger, Composition With Three Sisters, *1952.*

A very few naive artists have achieved that lonely frontier in which any attempt at categorization is immaterial and pointless. They have eaten of the tree of knowledge, but they have never ceased to create out of the wellspring of our origins. They have emerged into the immortal and timeless landscape of art.

By contrast there is a route that leads from naive art back into a kind of popular folk art. There are naive painters who have become the dextrous arrangers of rustic genre pictures and touching scenes of industrial folklore. They have forsaken the pleasures of discovery and feeling, developing a technical ability with which they continue to grind out marketable works. Their creative powers are inadequate for the preservation of a spiritual innocence once in touch with the artistic market and the public taste. Their pleasantly banal, pseudonaive creations are now only a part of the common current of popular art.

Naive art which takes notice of the temptations of the market, whether in Paris or Hlebine, New York or Haiti, always runs the risk of forsaking the true climate of its existence.

True Light and False

At a turning point in historical development, Europe's faith in progress had been put into question. Looking back along our wake, the animals and figures on Magdalenian cavern walls unexpectedly appeared to resemble the psychic miniatures of Paul Klee and the magic of things in Joan Miró. Picasso's early Cubist configurations are to a certain extent Europeanized masks from the Ivory Coast. From the mammoth outlines in caves in Combarell to the jungle scenes of *le Douanier* there is evident a depth of vision which suggests a timeless consistency in the pictorial conquest of things and creatures of this world. Paolo Uccello's stiff horsemen (illus. 232) are mysteriously akin to the dwarflike figure of a rider which Rousseau chose to use as the personification of war (illus. 233).

A war-torn landscape of shattered trees, and storming through it a wildly galloping yet oddly immobile steed, carrying a strange and childlike female rider—this is Rousseau's goddess of war, and it has nothing to do with the noble grandeur of the romanticism of death. What might the painter have had in mind when he drew this creature with the masklike face and the waving clouds of hair? Beneath the hooves of the horse, which fills the whole width of the canvas, lie the decaying, light-colored bodies of the dead in plastic solidity. The dark accents of the birds of death, ravens and crows, perch with their pointed, evil beaks probing into eyes and intestines. Behind the tangle of bare trees stretches a citrus-yellow sky blending into a silken blue. Pinkish banks of clouds might seem to suggest the smoke from burning cities.

The same intractable silence of death, the same frozen motionlessness in the dynamics of war, this singular hardness and factuality —all these are present in Uccello's painting of *The Battle of San Romano*.

Uccello, who, as André Malraux has said, "went his own way in the midst of the masterworks of Florence," chose to stylize his scene of war into a tragic and ritual event not unlike a ballet. The plastic representation of volume strikes the painter as the fulfillment of a new artistic reality. Pure colors within stiff outlines, totally without nuance and shading, lead to extreme contrasts within a very geometric picture. As in Rousseau, the actual colors of things have been supplanted by a set of imaginary ones bringing with them their own symbolic values. Thus, some four hundred years before Franz Marc's *Tower of Blue Horses,* Uccello calmly painted his steel-blue cavalry horses and—to Vasari's great dismay—bright red cities. A recent restoration has exposed for the first time the figure of the fallen horse in the foreground in all its blue splendor. Each detail of the skirmish is clearly outlined and fixed. Newly discovered perspective techniques allowed the artist some daring distortions; only the background landscape is flat and childish. Uccello, having been nurtured on a Gothic sense of form, one which stood in contrast to the new concepts of space, seems to combine both styles in an astonishing and mysterious eclecticism. Absurdly enough, both painters seem to have perceived the living and the dead in the turmoil of war with the eyes of still-life painters.

Of course such analogies have only limited value. Uccello painted this composition to

Cliff painting of hands from Tassili, Africa.
The magical symbol of the double hand. Spattered outlines of outstretched fingers. In old Stone Age cliff painting such hands signify the invocation of natural forces and the practice of hunting magic.

celebrate the victory of the city of Florence. Rousseau was creating an antiwar allegory. They share the elemental force and intensity of sublime naiveté. Their hyperrealism and simultaneous otherworldliness comprise the magic of these two paintings.

The ambiance of many naive artists has been loneliness, exclusion, and estrangement. This was the case with the beggar and painter Nikifor and with Kiyoshi Yamashita.

Kiyoshi, the retarded son of an alcoholic, set out on his course through the darkness of violent pride and scorn at the age of twelve. Reformatories, convalescent homes, and taverns were the stations along his route. He stole, and when enraged he was quick to draw his knife. Wherever he settled long enough he strove to perfect his skill at *hari-e* collage-making. Drawing became an articulate means of expression for this illiterate, and the passion with which he surrendered himself to his art helped him to alter the course of his plunge into the abyss of self-abandonment toward the magic of creativity.

Kiyoshi Yamashita completed his collage called *Fireworks in Nagaoka* in 1950. With extreme patience this pasted picture (illus. 235) has been created like a mosaic from countless tiny paper cuttings, developing into a shadowy landscape of hallucinatory splendor. As though gold powder had been sprinkled on a black lacquer background, the large silvery and reddish-yellow circles shimmer and glow against a night sky. Below them the canvas is divided into three sections: in the far distance is the moving line of the mountains, in front of them a lake in which the fiery circles are reflected, and in the foreground a plain, crowded with little figures, and resembling a flower-covered meadow.

This must have been a profound event in the consciousness of the boy, a miracle he carried within himself for years until he found the strength and had achieved the skill with which he could properly present this transfigured nocturnal vision.

Edvard Munch once said: "Death is pitch-black, but colors are composed of light. Being a painter means working with light-rays. . . ." Out of the decorative play of fiery cascades and glistening golden rain—all for the entertainment of the assembled people—Yamashita formed this visionary scene; hovering lights flashing on and being extinguished in the dark night of life.

The timeless darkness, death as a goal and not as a limitation—these had to be, and could be, overcome through the symbolic force of his pictures. These particles of color and shape against the Nagaoka sky are the calligraphic signs of his self-achievement. Night has been turned into day.

I have placed the artificial, firework suns of Yamashita next to the miraculous cosmic blossoms of natural light which are the inventions of Ivan Rabuzin. Against the silken springtime blue of a transparent firmament, the monumental flower of light—itself composed of smaller white blossoms—stretches and twists upward until it fills the green valleys and hills of the human world with a harmony perceived in the heart of the naive.

While the glowing spheres of Yamashita resemble phosphorescent deep-sea medusas or the deadly glowing flares set out by advance squadrons of planes over cities to be destroyed by bombs, Ivan Rabuzin's rosette of light awakens a sense of hope. It is an emblem of life, and its light penetrates the earthly landscape, banishing pain and guilt.

At the 1969 Triennial Exhibit of Naive Art in Bratislava, I saw still another display of fireworks, one painted by the Dutchwoman Josephine Hermans. Many small dark figures are standing on the flat roof of an apartment house, looking up at the pyrotechnical ornaments lighting up the night. Mammoth trees stretch out their golden branches from which fiery blossoms drop back toward the earth. The round disk of a full moon appears hesitantly against the solemn background.

Josephine Hermans' people are individuals, differentiated and clearly distinguishable personalities. The people who fill Yamashita's meadow resemble stemmed flowers in a field. The outlines of individuals disappear here into the structure of an undifferentiated mass.

Rabuzin has included no figures at all under his ornamental sunflower (illus. 234). Endless rows of flowers are reaching toward the light in patient abstraction. It is as though these reflected the brilliance and beauty of the earth. Here are three examples, variations on the theme of light in which each artist has represented a visible event and interpreted it in his own way.

Light and darkness were clearly distinguished in the past. Light meant the brilliance of the day, the cosmic glow of the sun; darkness was the absence of sunlight, and the night. This natural rhythm of light and dark has been transcended by modern civilization, for man has created artificial sources of light which can transform the night into day whenever he wills it. Such days remain nonetheless the offspring of night. Their light is the false, cold light of electricity, lacking the generous warm radiance of the sun. The splash of color and form produced by neon light is admittedly splendid, but its artificial glowing script encourages no living growth. And so it is with the art that is advancing into the magnetic field of science. To the classical three dimensions of art it is adding a fourth in time. Its machines of playing lights

Matija Skurjeni, Hands.
Enchantment and inspiration adhere to this ancient and vital gesture of raised hands, the sign of human frailty, man's need for faith, and his artistic gifts.

are reflections of human fantasy, but belong to the realm of the transhuman.

Grand artificial abstractions stand in total contrast to the sublime naiveté of childish directness; the latter preserves a lost paradise of imagery and the current of life.

Not everything which is shown under the rubric of naive painting has artistic value. Many anonymous people who seek creative diversion from the tiresome monotony of their professions make their own contribution to the fresh perception of the world with the spontaneity of their brushes. With the metaphors of childhood they occasionally break through the ring of their alienation and poverty of contacts. As in all areas of creative endeavor, there is only a limited number of important talents among the naives. Only a very few attain the timeless shores of utter fulfillment.

The reasoning self-consciousness of the professional artist develops in a manner parallel to the rise of science. In the confrontation of knowledge and instinct, of technology and experience, it can happen that the artist begins to doubt the world and the possibility of his comprehension and explication of it.

In order to be able to confront this complicated and questionable world without mistrust, one needs something of the integral soul of childlike naiveté. Only the consciousness of the naives remains unfragmented, and, in spite of the contradictory synthesis of past and present, full of a positive imagery of life. Past and present are terms that suggest a temporal relation of development and decay, two stations along the route from paleolithic times to the brink of the twenty-first century; paths from the primitives of our prehistory up to the primitives of the 1900s, from the fishermen and hunters of our beginnings to the drivers and pilots of space travel. This is the course of the emancipation of man from nature.

The further the world expands into our consciousness, the more strongly do we perceive the self-estrangement of mankind within it. New life processes and new secrets of the makeup of matter hold the attention of the experimenting and searching professional artist. Is it not rather paradoxical that in these days of breakthrough into interstellar space we should champion the return to the purest and most childlike region of human perception—into the art of the naives?

Science and technology will no longer represent a threat to the personality and our spiritual existence in the humanized society we all dream of. Mankind cannot turn his back on the strengths of technical civilization. But the world will not be protected from psychic impoverishment and stagnation by opposing art, but rather in dialectical union with it.

I love naive art, even though I must consider it more critically than I did decades ago when it first saw the light of publicity. I love it because its original and unambiguous expressiveness restores to me a glimmer of the archaic landscape of a lost imagery, and because its existence strengthens my conviction that even in a climate of optical apparatus and cybernetic constructions the quiet growth of its childlike grasses and imaginary blossoms is being preserved for us.

Ivan Rabuzin,
Peasant Women at Work, *1963.*

222. *Oluf Braren*, Home Wedding on the Island of Föhr (*detail*)

This North Frisian teacher and earliest lay painter in Germany has created a picture representing marriage symbolically as a bond and a bridge. The nuptials are a solemn ceremony in which the bridal couple and the pastor form the focus, though in this detail they are not shown. The guests in their old-fashioned and precisely rendered costumes are looking on with astonishment. The plasticity of his drawing and the crystalline glow of his colors intensify the individuality and self-sufficiency of the figures. There is something of the bleak silence of insular life in this definition of reality, which at the same time has an effect that is realistic, naive, and poetic.

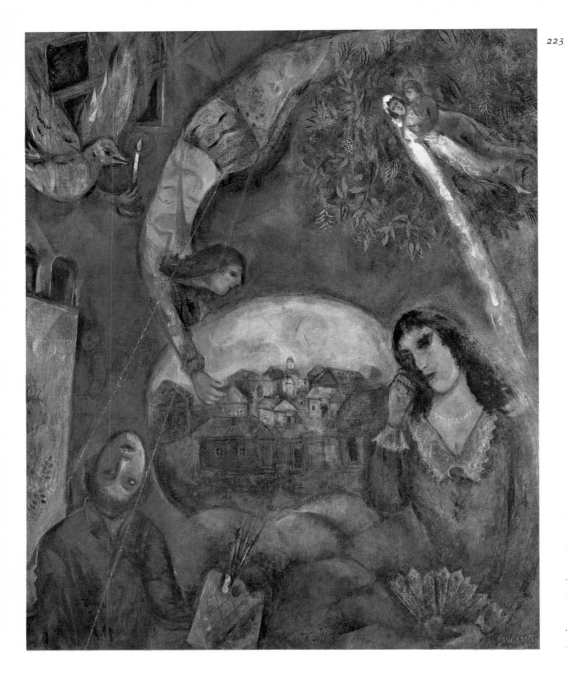

223

223. *Marc Chagall,* Her World, *1945*

224. *Anja Hefti-Stamm,* The Little Shepherd

225. *Jan Balet,* The Team, *1968*

226. *György Stefula,* Construction Workers, *1962*

227. *Fernand Léger,* Sunday Cyclists, *1948–49*

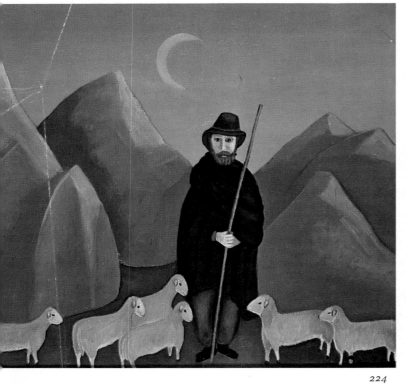

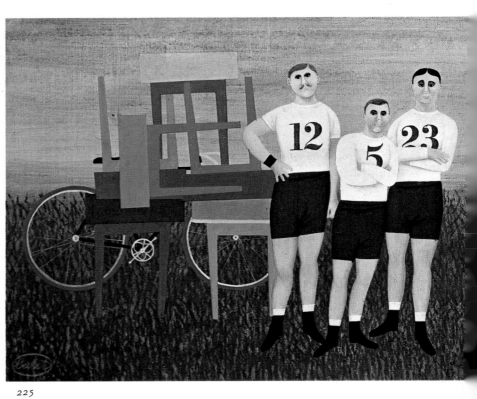

224 225

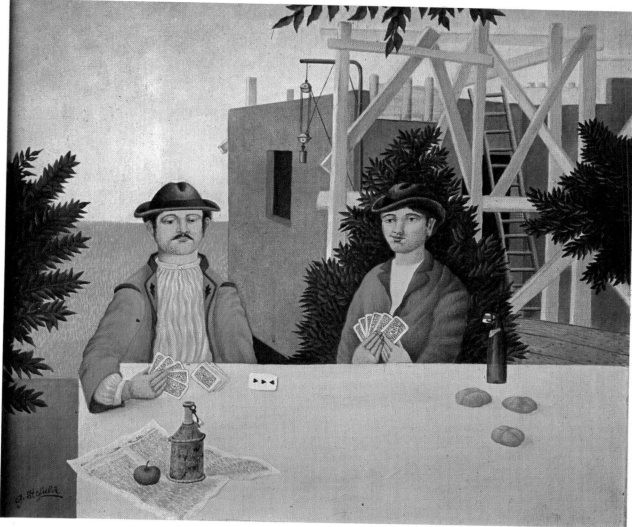

226

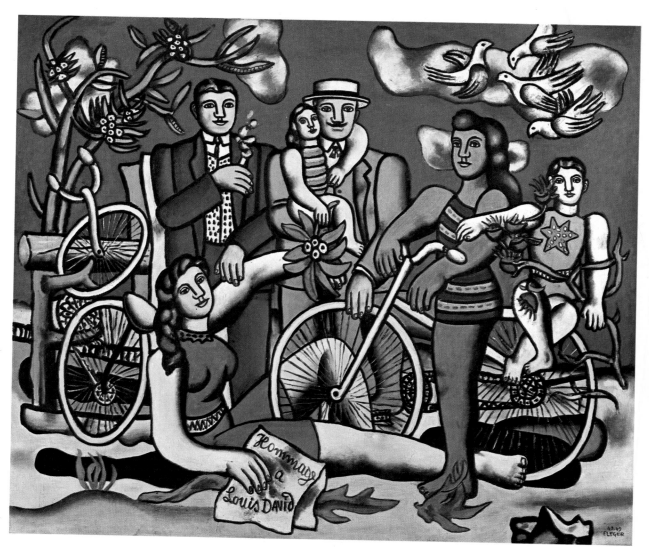

227

228. *Andreas Barth,* Grandeza de España, *1964*

229. *Maurice Utrillo,* The Street in Mont-Cenis, *circa 1910*

230. *Irene Invrea,* Panther in a Field of Daisies, *1968*

231. *Patrick Byrne,* Jasper's Dream

229

230

231

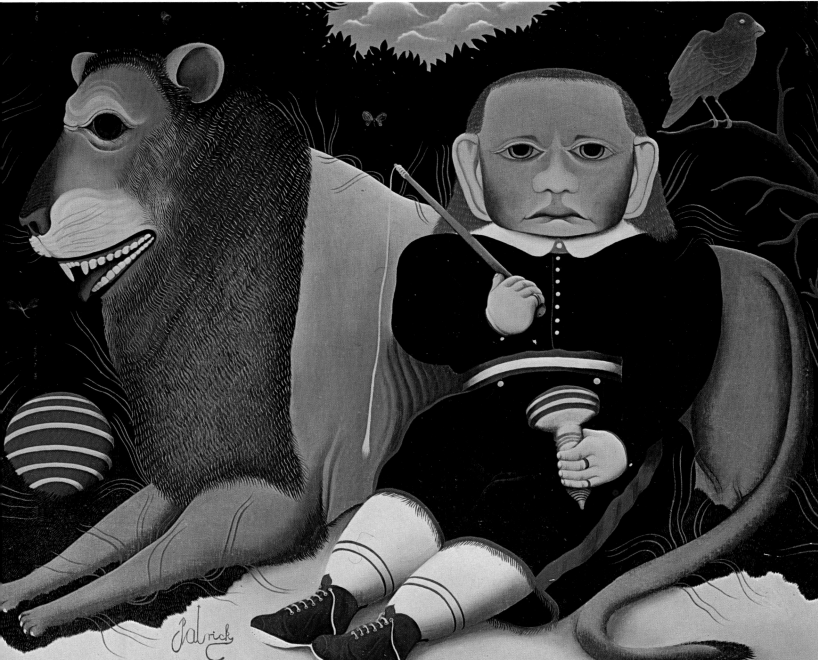

232. *Paolo Uccello,* The Battle of San Romano, *circa 1455*

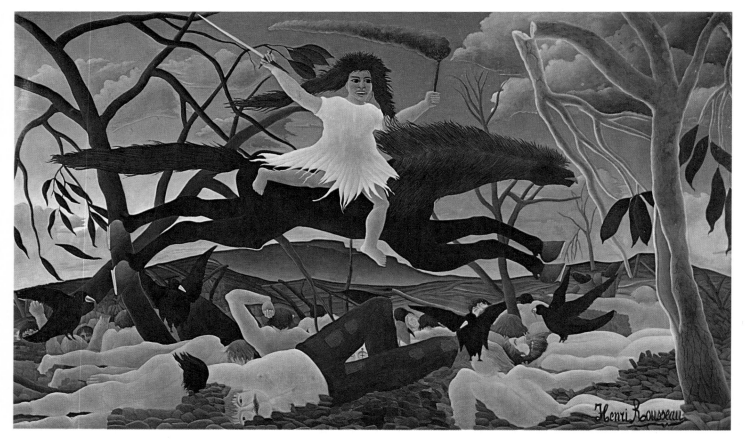

233. *Henri Rousseau,* War, *1897*

234. *Ivan Rabuzin*, Circle of Life, *1968*

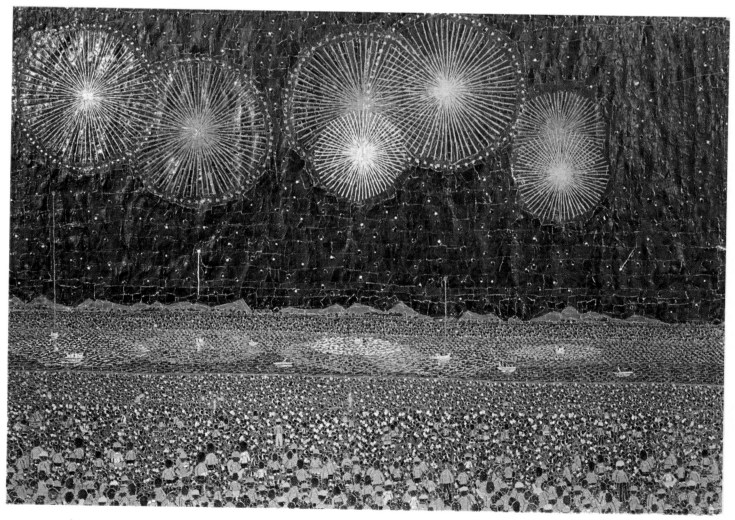

235. *Kiyoshi Yamashita*, Fireworks in Nagaoka, *1950* (*collage*)

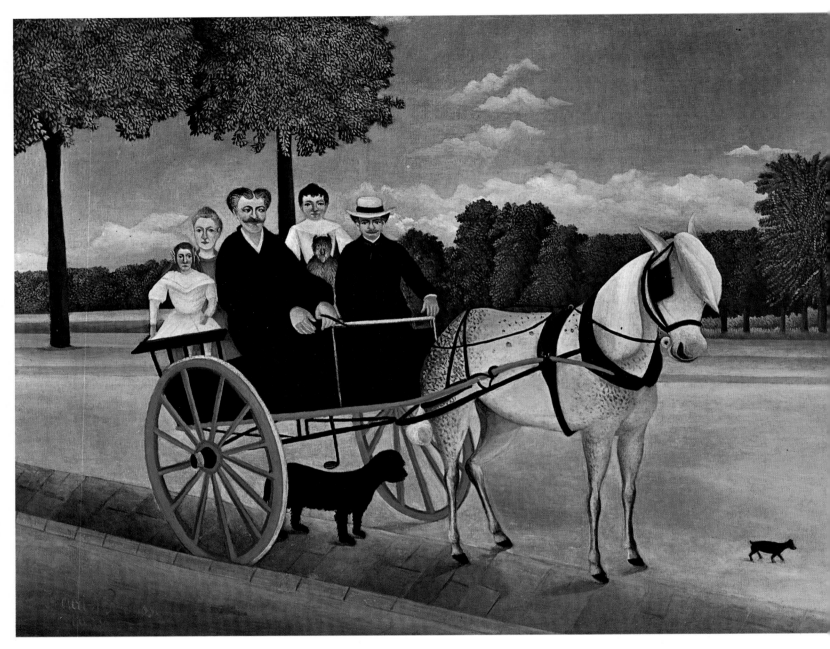

236. Henri Rousseau, The Cart of Père Juniet, *1908*

*One cannot guess whether the party in the two-wheeled
cart which so infectiously radiates the happiness of
a Sunday outing is only out for a drive in the sun, or
whether it is setting off to visit friends in the next
town. The whole family is sitting in the carriage behind
a dapple-gray with a face as childlike as the faces of
donkeys in medieval cloister frescoes. In addition we get
to see the two silly little dogs that had to be stopped in
their tracks in order to be included in the picture.
The men sit in front as is appropriate to their station,
with the women and children in their Sunday best behind.
Rousseau himself is among them. This journey into
the world of the naives began with him, and it quite
rightly ends with the cart of Père Juniet.*

Biographies

For reasons of space, only those artists who are represented with reproductions in this book could be included here. For the same reasons it has been necessary to restrict these sketches to a listing of the most important dates and exhibits of each artist, where available, without any presumption of completeness. Exhibits, except for those in well-known museums or galleries, have also been listed with only the city and date. This applies as well to extensive international exhibits of naive art which could not be mentioned each time by their full titles in the biographies, and are therefore listed only here:

"Les Maîtres Populaires de la Réalité," Paris–Zurich, 1937; under the title "Masters of Popular Painting," New York–London, 1939.

"Moderne Primitieven," Stedelijk Museum, Amsterdam, 1941.

"Moderne primitive Maler," Kunsthalle, Bern, 1949.

"La Peinture naive du douanier Rousseau à nos jours," Knokke-Le Zoute, Belgium, 1958.

"Das naive Bild der Welt," Baden-Baden–Frankfurt–Hannover, 1961.

"Laienmaler," Kunstgewerbemuseum, Basel, 1961.

"Die Welt der naiven Malerei," Salzburg, 1964.

"I Pittori Naïfs," Rome, 1964.

"De Lusthof der Naieven," Rotterdam, 1964; under the title "Le Monde des Naïfs," Paris, 1964.

"Le Panorama International de la Peinture Naïve," Rabat, 1964.

"First Triennial of Naive Art," Bratislava, 1966.

"Second Triennial of Naive Art," Bratislava, 1969.

"Naive Art '70," Zagreb, 1970.

Because of frequent reference to them, these national exhibits should also be mentioned:

"Sinnvolles Laienschaffen," Recklinghausen, 1954.

"Naive Art in Yugoslavia," Belgrade, 1957.

"Yugoslav Modern Primitives," Edinburgh International Festival, 1962.

"Laienkunst im Ruhrgebiet," Recklinghausen, 1963.

"Von Rousseau bis heute," French Naive Art, Zagreb–Belgrade–Rijeka–Ljubljana, 1970.

ACEVEDO, Felicindo Iglesias y
Born 1898 in Orense, Galicia, Spain. Cloister school in France. Emigrated 1933 to Cuba. Importer of wine and spices. Took up painting 1939, while continuing his profession. Musician in a church in Havana, where he still lives.
Exhibits in Latin America, U.S.A., and Europe.

ASIRU (Asiru Olatunde)
Nigerian, from the Yoruba tribe. Blacksmith by profession. In his youth a ritual drummer. First made little copper figures of lions and elephants worn as brooches and earrings. Encouraged by the Austrian painter Susanne Wenger, began to make hammered reliefs on thin sheets of aluminum.
Represented in Bratislava, 1969.

BALAN, Maria
Born 1923 in the village of Uzdin, Banat, Yugoslavia. Peasant and housewife. Has woven, knitted, and embroidered designs for folk costumes. Began to paint in 1961.
Represented in exhibits in Yugoslavia, Switzerland, Bratislava (1966), Zurich, Frankfurt, Hannover, New York, Washington.

BALET, Jan
Born in 1913 in Bremen, Germany. Professional art schools in Munich and Berlin; art academy in Munich. Left Germany 1938 in protest. Lived in United States, doing graphics, paintings, illustrations for children's books. Returned 1965 to Munich.
Exhibits: Munich, 1966; Berlin, 1967; Lugano, 1969. Group shows. Museum purchases.

BARBEROV, Milček
Born 1950 in Hlebine, Croatia, Yugoslavia. Attended elementary school and school for applied arts. Began to paint 1968.
Exhibits since 1969 in Zagreb, Hlebine, and elsewhere. Represented in Brussels, Frankfurt, Geneva, and Zagreb, 1970.

BARKA, Nina
Born 1908 in Odessa, Russia. Naturalization in France. Milliner and seamstress.
First exhibit in the Galerie Antoinette, Paris, 1968. Second Prize at the international exhibit in Lugano. Represented in Bratislava, 1969.

BARTH, Andreas
Born 1916 in Basel, Switzerland. Professional gardener. Took up painting 1942. Encouraged by the painters Ernst Morgenthaler, René Auberjonois, Wilhelm Gimmi.
Represented in Bratislava, 1969.

BAUCHANT, Auguste-André
Born 1873 in Château-Renault, France. Professional gardener. Painted mythological compositions, landscapes, and flowers. Military service 1914–18. Map maker and surveyor 1917. Discovered by Ozenfant and Le Corbusier 1920. Died 1958 in Montoire.

First exhibit in the Salon d'Automne, Paris, 1921. Commissioned by Diaghilev to do decorations for Stravinsky's Apollon Musagète, 1927. Participated with Rousseau, Bombois, Vivin, and Séraphine in the exhibit "Maîtres populaires de la Réalité," Paris–Zurich, 1937, and New York–London, 1939. Represented also in Knokke-Le Zoute, 1958; Baden-Baden–Frankfurt–Hannover, 1961; Tokyo, 1964; Rotterdam–Paris, 1964; Bratislava, 1969.

BAZILE, Castera
Born 1924 or 1928 in Jacmel, Haiti. House servant in the art center in Port-au-Prince. Began to paint in 1945. Did three frescoes in the Episcopal church of Port-au-Prince in 1955. Contracted tuberculosis 1962 and stopped painting. Died 1966.
First prize in a Caribbean contest. Represented in Zagreb, 1970.

BENOÎT, Jacqueline
Born 1925 in Paris. Lives in Orléans. Comes from mercantile family and works in the firm.
First independent show in the Galerie Herbinet, Paris, 1964. Represented in Bratislava, 1966. First prize in an exhibit of the Galerie Latina, Stockholm, 1967. Represented in Zagreb–Belgrade–Rijeka–Ljubljana, 1970.

BENOÎT, Rigaud
Born 1911 in Port-au-Prince, Haiti. Cobbler by profession. Taxi driver and chauffeur for De Witt Peters and others. Painted common people and landscapes. Did a fresco of the birth of Christ in the Episcopal church of Port-au-Prince in 1951.
Represented in "Nineteen Haitian Painters" at the Palais des Beaux-Arts, Brussels, 1963, and "20th Century Latin American Naive Arts" in La Jolla, California, 1964.

BIGAUD, Wilson
Born 1931 in Port-au-Prince, Haiti. Follower of Hector Hyppolite and one of the founders of the Haitian School. Painted the *Wedding at Cana* in the Episcopal church of Port-au-Prince in 1946.
Represented in the exhibit "Peintres de l'Equateur, de Haiti et de Peru," UNESCO, Paris, 1947; in Knokke-Le Zoute, 1958; Baden-Baden–Frankfurt–Hannover, 1961; "Nineteen Haitian Painters," Palais des Beaux-Arts, Brussels, 1963; "20th Century Latin American Naive Art," La Jolla, California, 1964; Dortmund, 1969–70; Zagreb, 1970.

BIREŠ, Mihael
Born 1912 in Kovačica, Banat, Yugoslavia. Peasant and painter. One of the founders of the Kovačica school. Began to paint 1938.
Represented in the exhibit of naive artists in Belgrade, 1952, and in Bratislava, 1966. His paintings hang in the art gallery in Kovačica.

BLONDEL, Emile
Born 1893 in Le Havre. Cabin boy, sailor, and bus driver. Wholly dedicated to painting since retirement in 1950.
First exhibit in the Galerie Cambacérès, Paris. Represented in Knokke-Le Zoute, 1958; "Les Primitifs d'aujourd'hui" at the Galerie Charpentier, Paris, 1964; and Zagreb–Belgrade–Rijeka–Ljubljana, 1970.

BOEDEKER, Erich
Born 1906 in Recklinghausen. Former miner who spent thirty-five years working underground. Only began artistic activity after retirement. Modeled his first deer and lawn elfs in the fifties. Died 1971.
Sculpture prize in Bratislava, 1969. Prize for sculpture in Zagreb, 1970.

BOMBOIS, Camille
Born 1883 in Venarey-les-Laumes, Côte-d'Or, France. Childhood on a barge, later cabin boy, farmhand. Wrestler in a provincial circus 1903. From 1907 worked in Paris Métro, as a carrier, and on the night shift of a newspaper printing shop. Military service 1914. Became known after a sidewalk exhibit in Montmartre 1922.

Represented in the exhibit "Maîtres Populaires de la Réalité," Paris–Zurich, 1937, and New York–London, 1939; in Knokke-Le Zoute, 1958; Baden-Baden–Frankfurt–Hannover, 1961; Rotterdam–Paris, 1964; Bratislava, 1969.

BOUGUET, André
Born 1897 in La Varenne-Saint Hilaire, France. Apprenticed to a furnisher, then to a butcher. Foreman in an airplane factory in Paris. Military service 1914–18, and in 1919 in Indo-China. Discharged from service, sold meats in the market. Began to paint 1950.
First independent show in the Galerie de L'Institut, Paris, 1958. Represented in Knokke-Le Zoute, 1958, and "Les Primitifs d'aujourd'hui" at the Galerie Charpentier, Paris, 1964.

BOX, Eden (Mrs. Marston Fleming)
Born in London.
First exhibit in the Hanover Gallery, London, 1949. Represented in Rotterdam–Paris, 1964.

BOYADJIAN, Micheline
Born 1923 in Bruges. Secretary until her marriage. Began to paint 1954.

Represented in Knokke-Le Zoute, 1958, and Baden-Baden–Frankfurt–Hannover, 1961. Prize in Zagreb, 1970.

BRADLEY, John
Birth date unknown. Lived in New York. Painted portraits and miniatures dated 1937–45.

BRAREN, Oluf
Born 1787 on the North Sea island of Föhr, where he lived as a teacher. Nature study led him to painting. Earliest lay painter in Germany. Painted family pictures and portraits. Died 1839 of tuberculosis.

BRAŠIC, Janko
Born 1905 in the village of Oparić, Serbia. Lives in his birthplace as a peasant and painter. Began to draw while watching after sheep and cows. Apprenticed in 1933. Learned fresco technique while helping to build a church. Filled the Orthodox

church of his home town with frescoes. Visited and encouraged in 1936 by the Belgrade writer Siniša Paunović who purchased some of his paintings.
First showing of his paintings in the school of Oparić, 1937. Represented in the exhibit of naive Yugoslav painters in Belgrade, 1957; in Baden-Baden–Frankfurt–Hannover, 1961; Rotterdam–Paris, 1964; Bratislava, 1966; Zagreb, 1970. Most of his works are in the gallery of self-taught painters in Svetozarevo, Serbia.

BROWN, W. H.
Dates unknown. Painted around 1886 in Michigan, U.S.A.

BUKTENICA, Eugen
Born 1914 in Grohota on the island Šolta near Split, Yugoslavia. Lives there as a farmer, fisherman, and painter. Concentration camp 1941–44. Began to draw and paint in 1946. In 1950 met the Split artist Ante Kastelančić who helped him with techniques. Has since painted seascapes and scenes from the life of fishermen.

Represented in the exhibit of naive Yugoslav artists in Belgrade, 1957; in Knokke-Le Zoute, 1958; Edinburgh, 1962; Rotterdam–Paris, 1964; Bratislava, 1966 and 1969; Zagreb, 1970.

BUNJEVAČKI, Dragiša
Born 1932 in Pančevo, Yugoslavia. Four years grammar school, and four years secondary school. Laborer who has painted in his free time since 1945. Lives in Novi Bečej, and has collected about himself a group of painters and craftsmen called *"Selo"* ("the Village").

CASAS, J.
Cuban, and officer in the Cuban army. In 1914 was adjutant to a Colonel Gomez-Sicre, who commissioned him to paint his family farm. No other dates are known.

CHAMBERS, Thomas
Mentioned as a landscape painter in 1834. Lived in New York City. Painted in oils on canvas and wood, occasionally in water colors. His earliest signed picture is the *Sea Battle off Puerto Cabello, Venezuela* from 1835. Painted sea and harbor pictures 1838–40, referring to himself as a marine painter. Last signed picture from 1853, probably the year of his death.

CHESHER, A. W.
Born 1897 in Bedford, England, the son of a farmer. Forced to stop working after a serious accident in 1950. Began to build models of

early agricultural machines, but this proved slow and tedious so he began to paint. First did watercolors of machines, and later oils which include the historical country milieu.

CHEVAL, Fernand
Born 1836 in Charmes, France. Rural letter carrier who collected odd stones along his wanderings in the department of Drôme, and who

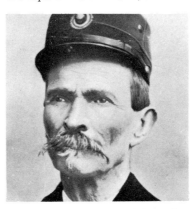

created over a period of forty-five years the monumental architectonic sculpture that became known as the *Palais Idéal.* Died 1924 in Hauterives, Drôme.

CSONTVARY-KOSZTKA, Tivadar
Born 1853 in Kisszeben, Hungary (modern Sabinov). Pharmacist who

later studied medicine. Began to draw in 1880. Gave up the pharmacy in 1894, made countless trips abroad, and dedicated himself wholly to painting. Died 1919 in Budapest.

DELATTRE, Louis (Louis de Laetre)
Born 1815 in Ghent. Mechanic, master painter, banker, photographer, and artist. Experimented with a flying machine 1865. Showed his work in stores and cafés. Died 1897 in Ghent.

DEMONCHY, André
Born 1914 in Paris. Brought up as a war orphan on a farm in the Yonne. Work as an apprentice locomotive engineer inspired him to do paintings of trains.
First exhibited in the Galerie de Berri, Paris, 1949, for whose catalogue a foreword was written by André Breton.

DIETRICH, Adolf
Born 1877 in Berlingen, Switzerland. Peasant origins. As a child drew in sand, scratched on rocks, formed figures of clay, and early began to experiment with paints and brushes. Earned his living as a woodsman, trainman, rope maker, and woodcutter. In 1903 the painter Völmy from Basel came to his village and urged him to paint. Published drawings 1916 in the *Book of Lake Constance* which were widely admired. Worked almost wholly as a painter from 1926. Died 1957.

Exhibited for the first time in Zurich in 1909. Represented in Constance, 1913; Winterthur Art Museum, 1926; Paris–Zurich, 1937; New York–London, 1939; Amsterdam, 1941; Kunsthaus, Zurich, 1942; Basel, Baden-Baden–Frankfurt–Hannover, 1961; Rotterdam–Paris, 1964; Bratislava, 1969. Purchases by countless museums and galleries.

DOCLEAN, Sofia
Born 1923 in the village of Uzdin, Banat, Yugoslavia. Peasant and housewife. Since 1962 a member of the group close to Anuica Maran. Onetime weaver. Paints landscapes and village life.

Exhibits in Uzdin, 1962; Belgrade, 1963; Zurich, 1965–66.

DOLAMA, Anuta
Born 1930 in Uzdin, Banat, Yugoslavia. Peasant and housewife. Likes to read, do handwork, spin, and weave. Makes her own patterns. Began to paint in 1962 and became one of the group close to Anuica Maran.
Exhibits in Belgrade, Zagreb, Zurich, and Frankfurt.

DUFFAUT, Préfète
Born 1923 in Jacmel, Haiti. Shipbuilder and carpenter in his home town. Once painted pictures of Erzulie, the voodoo goddess, but now generally a paradisical landscape similar to that of Jacmel. Did a fresco *The Temptation of the Lord* in the Episcopal church in Port-au-Prince in 1952.

ELLIS, Vivian
Born 1931 in New Orleans, Louisiana, U.S.A. Daughter of a Baptist preacher; studied nursing at B. S. Dillard University. Also studied languages at various colleges in the United States and Europe. Settled in Munich, and dabbles with painting when not working in a hospital. Has exhibited her work since 1964. Her themes have been either memories of her Louisiana childhood, biblical stories, or impressions from her present life in Europe.

EVE, Jean
Born 1900 in Somain/Douai, France, the son of a mining family. Apprenticeship in a machine shop. Used his first earnings to buy paints. Worked in a foundry, later as a trainman, surveyor, and customs official. Died 1968 in Meudon.
First exhibit in the Galerie Alice Manteau, Paris, 1930. Represented in Paris–Zurich, 1937, and New York–London, 1939; Knokke-Le Zoute, 1958; Rome, 1969; Zagreb and Belgrade, 1970.

FEJEŠ, Emerik
Born 1904 in Osijek, Croatia, Yugoslavia. Raised in poverty as the seventh of fourteen children. Learned to make buttons and combs. Lived in Novi Sad, where

he opened a second-hand store in 1945. Working as a turner and comb maker 1948. Began to paint his unique city-scapes in 1949. Died 1969 in Novi Sad.
First exhibits in Novi Sad and Dubrovnik, 1956. Represented in countless shows in Yugoslavia as well as in Knokke-Le Zoute, 1958; Baden-Baden–Frankfurt–Hannover, 1961; Edinburgh, 1962; Budapest and Vienna, 1962; Moscow–Leningrad, 1962–63; New York, 1963; Rotterdam–Paris, 1964. Memorial exhibits in Belgrade, 1969, and Hlebine, 1970.

FERRARA, Daniel
Born 1906 in Mers-El-Kebir, Algeria. Lay painter of fantastic, often biblical genre pictures. No further details known.

FIELD, Erasmus Salisbury
Born 1805 in Leverett, Massachusetts. Worked and studied for a few months in the studio of Samuel F. B. Morse, 1824. Lived 1842–48 in New York City, later in

Sunderland, Mass. Between 1859 and 1876 painted portraits and a series of fantastic paintings on biblical and mythological themes. Died at the age of ninety-five in Sunderland.

FILIPOVIĆ, Franjo
Born 1930 in Hlebine, Croatia, Yugoslavia. Peasant and painter. The master Ivan Generalić saw his drawings in 1945 and introduced him to painting.
Group show with other Hlebine peasant painters in Koprivnica, 1946. First one-man showing in Belgrade and Zagreb, 1959. Represented in Edinburgh, 1962; Moscow–Leningrad, 1962–63; Bratislava, 1969.

FOURÉ, ABBE (Adolphe Julien Fouere)
Born 1842 in Saint-Thoual, France. Died 1919, some say as early as 1910. Worked for some twenty-five years on the monumental naive sculptures which he carved into the cliffs at Rothéneuf near Saint-Malo.

FOUS, Jean
Born 1901 in Paris. Led a restless life. Dealer at the Paris Flea Market where he sold post cards, knickknacks, and picture frames he made himself. In 1944 he began to display for sale his own paintings as well.
First exhibit in the Galerie du Dragon, Paris. Represented in Knokke-Le Zoute, 1958, and Belgrade – Zagreb – Rijeka – Ljubljana, 1970.

GAJDOS, Janos
Born into a peasant family in Geszterede, Hungary. Cobbler's apprentice. No known dates.

GAŽI, Dragan
Born 1930 in Hlebine, Croatia, Yugoslavia. Began drawing as a child. Ivan Generalić saw his work in 1947 and showed him the technique of painting behind glass. Paints only in his free time after working in the fields.

First exhibit in Zagreb, 1952. Represented in Edinburgh, 1962; Bratislava, 1966; Zagreb, 1970.

GENERALIĆ, Ivan
Born 1914 in Hlebine, Croatia, Yugoslavia. Began to draw as a shepherd boy. Met the painter Krsto Hegedušić in 1930, and learned to paint from him. He still lives in Hlebine, and paints almost exclusively behind glass. The group of

peasant painters close to him is now known as the school of Hlebine.
First exhibited with the "Zemlja" group in 1931. First one-man show in the Salon Ulrich, Zagreb, 1938. Since the war countless shows and participation in exhibits—among others, in Paris, 1953; Sao Paulo, 1955; Knokke-Le Zoute, 1958; Zagreb–Belgrade, 1962; Moscow–Leningrad, 1962–63; Rotterdam–Paris, 1964; Dortmund and London, 1964; Zurich, 1965; Munich, 1966; Bratislava, 1966 and 1969; Zagreb, 1970.

GENERALIĆ, Josip
Born 1936 in Hlebine, the son of Ivan Generalić. Grammar school and secondary school 1943–51. Drawing teacher in Virje, then military service. Drawing teacher in Hlebine 1957–59. Study of pedagogy, training as a sports teacher, and simultaneous painting instruction in Zagreb 1960–62.
First independent show in Koprivnica, 1959. Exhibits in Zagreb, 1961; Rijeka, 1962; and together with Ivan Generalić in the Yugoslav pavilion at the Zagreb Fair, 1963. Represented at Bratislava, 1969, and Zagreb, 1970.

GENERALIĆ, Mato
Born 1920 in Hlebine, the brother of Ivan Generalić. Farmer with only grammar school education. Wood carver since 1950.
Represented in exhibits in Hlebine, 1965; Amsterdam, Groningen, Holland, Mexico, 1968; U.S.A., 1969; Bratislava, 1969; Zagreb, Belgrade, 1970.

GEORGES, Joseph
Born 1920 in Sion, Switzerland. Innkeeper and painter. Lives in Les Hauderes, Val d'Horens, Vallis. Rousseau Prize in competition at Sitten, Vallis, in 1961.

GERLACH, Friedrich
Born 1903 in Herten, Germany. Retired miner. Paints meditative and terror-filled dream compositions.
Represented in exhibits in Recklinghausen, 1958 and 1963; Bratislava, 1966 and 1969; Zagreb, 1970.

GOURGUE, Jean Enguérrand
Born 1930 in Port-au-Prince, Haiti, where he still lives. Began to paint quite early. Admitted into the Port-au-Prince art center 1947. Strong sense of tragedy, combining old customs and practices of the voodoo cult with his own magical rhythms.

GREFFE, Léon
Born 1881 in Charleroi, Belgium. Originally a miner, then a workman in Les Halles in Paris. Later porter in a building from which he could look down on Old Paris and paint it.

First showing in the Galerie du Dragon, Paris, 1945, with remarks in the catalogue by Anatole Jakovsky. He was given commissions, but began to drink. Died 1949 in Paris.

GUILLEN, Asilia
Born 1887 in Granada, Nicaragua. Lives in Managua. Used to do embroidery, and only recently began

to paint. Basically self-taught she had some training at the School of Fine Arts. Died 1964.
Exhibited in Washington, and in Rotterdam–Paris, 1964.

GUTTMANN, Robert
Born 1880 in Sušice, Czechoslovakia. Painter and globe-trotter. Early youth spent in Plana. Moved to Prague in 1895 where he attended business school. Took a

course in painting with L. Kirnig in 1900. Only from 1918 as a full-time painter. Deported into the Łódź ghetto 1941. Died in concentration camp 1942.
First exhibit in the Monopol Publishing House, Prague, 1928. Dr. Arthur Heller's biography of Guttman published 1932.

GYÖRI, Elek
Born 1906 in Tiszaladanyu, Hungary. Childhood in Tokaj. Blacksmith's apprentice. Right eye seriously wounded in 1919. Lived in Budapest during the thirties, working in the Goldberger plant, and sleeping in an old furniture van, later in a cellar room. Produced drawings for the newspaper "Vasarnap" 1931. From the mid-thirties on supported by "folk writers." Began to study painting in the forties. Died 1958 or 1959 in Tiszaladanyu.

Exhibited in Budapest, 1934; Amsterdam, 1938; Linz, 1964; Bratislava, 1966; Hungary, 1967–68.

HAGOORT, Pieter
Born 1887 in Grootebroeck, Holland. Retired race-track director. Already working on the Rotterdam trolley lines at the age of eight. Became a postal clerk in 1918, later a trolley official. Retired 1952. Began to paint in 1960 in order to record the old scenes of horse-drawn trolleys he so loved to remember.

HAYES, George A.
Painted around 1860. No other known dates.

HEFTI-STAMM, Anja
Born 1914 in Padua. Housewife and painter. Father .from Schaffhausen, mother from Venice. Attended high school in Venice. Married in Mannsdorf on Lake Zurich in 1934.
Represented in Bratislava, 1966 and 1969.

HICKS, Edward
Born 1780 in Attleborough, Pennsylvania. Orphaned early, was raised by a Negro woman. Apprenticed in 1793 to a cartwright and

painter. Opened his own shop as a wagon and house painter in 1800. Began to travel in 1810, traversing many states, and preaching the faith of the Quakers. He lived puritanically, worked hard to support his family, was a staunch enemy of alcohol, and thereby fell into disfavor with some of his own brethren. His business began to lag because of his frequent preaching, and he bought a farm. This attempt failed, however, and he went back to working as a craftsman. Painted in his free time, his favorite theme being the kingdom of peace in which the lion and the sheep lie side by side. Died 1849.

HIRSHFIELD, Morris
Born 1872 in a small town in Russian Poland. Liked to whittle as a boy, and made figures for the temple in his home town. Immigrated into the United States in 1890, where he became a tailor in a women's coat shop. Stayed in women's wear for twelve years,

then began a slipper factory. Retired after serious illness in 1936 and began to paint. Died 1946.

First showing in the Museum of Modern Art, New York, 1943. Also Sidney Janis Gallery, New York, 1949–50; Kunsthaus, Zurich, and Galerie Maeght, Paris, 1951. Represented in "Fifty Years of Modern Art" in Brussels, 1958; Knokke-Le Zoute, 1958; Baden-Baden–Frankfurt–Hannover, 1961; Rotterdam–Paris, 1964.

HOMONAI, Pal
Born 1922 in Irig, Yugoslavia. Has lived in Novi Sad since 1938. Learned cabinetmaking and did inlay work. Gave up his work altogether in 1964 to devote himself wholly to painting.
Participation in group shows. One-man shows in Novi Sad, Belgrade, and elsewhere.

HOUTMAN, Sipke Cornelis
Born 1871 in Dokkum, Holland. Worked as a baker's helper. Began to paint at sixty when he began to receive a pension. Occasionally wrote on the back of his pictures: "The Lord Jesus was my teacher." Died 1945 in a convalescent home in Amsterdam.

HYPPOLITE, Hector
Born 1894 in St. Marc, Haiti. House painter, cobbler, and voodoo priest. Founder of the naive school in Haiti. Encouraged by the Cuban painter Wifredo Lam and the Parisian writer André Breton. Died 1948 in Port-au-Prince.
Included in various Surrealist exhibits. His paintings in many collections, including that of the Museum of Modern Art, New York. Represented in Baden-Baden–Frankfurt–Hannover, 1961; Rotterdam–Paris, 1964; Zagreb, 1970.

ILIJA (Ilija Bosilj-Bašičević)
Born 1895 in Šid, Sirmia, Yugoslavia. Peasant and painter, with only grammar school education. Ninth child in the family, sent out with the sheep as a child. Remained a farmer in his birthplace. First drawings and gouaches in 1957. First oils 1958. Paints on wood, canvas, composition board,

and on salvaged pieces from furniture; also behind glass and with gold.
One-man shows in Belgrade, Zagreb, Genoa, and Frankfurt, 1963. Represented in Bratislava, 1966 and 1969, and Zagreb, 1970.

INVREA, Irene
Born in Langhe near Turin, Italy. Birth date unknown. Descended from a noble family. Began to paint after the death of her husband in order to conquer loneliness.
First independent exhibit in Turin, 1965. Exhibits in Rome, Biella, Enschede (Holland), Reggio Emilia, and elsewhere, 1967–70. Gold medal in Naples, 1968; gold medal in Lugano, 1969.

JASO, Luis
Born 1928 in Mexico City. Certified architect and self-taught painter.
First exhibit in the Centro de Arte Artesania, Mexico City, 1965. Shows in the Instituto de Cultura Hispanica in Madrid, Barcelona, and Valencia, 1967. Represented in Bratislava, 1969.

JEVTOVIĆ, Dušan
Born 1925 in Gornji Crnjani near Prokuplje, Serbia, the son of a peasant. As a child drew with charcoal on the walls of houses in the village, was thought to be bewitched, and was severely beaten. Began to learn blacksmithing. Joined the Partisans in 1941. Became an officer in 1945. During a long stay in a TB sanatorium began to paint. Draws from childhood impressions, tales told by his pious mother, and his experience of religious and secular traditions.
First showing in the library at Prokuplje, 1959, then in Sombor, 1966; Belgrade, 1965; Svetozarevo, 1965, 1966, and 1967. Represented in a traveling exhibit through Yugoslavia, 1964–66, and in the exhibits of Croatian naives at the Zagreb Fair, 1968–69. Shows in Paraguay, 1965; Italy, 1967; Switzerland and Sweden, 1967–68.

JONAS, Martin
Born 1924 in Kovačica, Yugoslavia, the son of a poor peasant who worked as a coachman. Grammar

school only. Loved to draw. After his father died, he began to paint. Helped found the artist colony and a gallery in Kovačica in 1952.
Represented in Bratislava, 1966 and 1969.

JOVANOVIĆ, Milosav
Born 1935 in Oparić, Serbia, Yugoslavia. Peasant and painter. Grammar school and four years of secondary school. Wanted to continue but needed to earn money. Reads avidly. Began to paint 1955. First only drawings of people and landscapes on paper, later came to oils.
One-man and group shows in Belgrade, Čačak, and Svetozarevo, 1960. Represented at Bratislava, 1966; Belgrade, 1970; Zemun, 1970.

JOVANOVIĆ, Peter
Born 1938 in Dolena Zetin near Škofja Loka, Slovenia, Yugoslavia. Peasant and sculptor. Lives and works in his birthplace.
Represented at the sculpture symposium "Forma Viva" in Kostanjevica an der Krka, Slovenia, 1968 and 1970.

JUROVATY, Ladislav
Born 1923 in Luky pod Makyton, Czechoslovakia. Foreman of a building materials depot. Makes wire sculpture in his leisure time. No further dates known.

KANE, John
Born 1860 in West Calder, Scotland. Emigrated to America 1879. Miner in Pittsburgh. Carpenter, steelworker, house painter, boxer. First oils 1900. Recognized in 1927 when he received a Carnegie Prize. Died 1934 in a Pittsburgh hospital.
Included in "Masters of Popular Painting" at the Museum of Modern Art, New York, 1938. Represented in Düsseldorf, 1953; Lucerne, 1954; Knokke-Le Zoute, 1958; Baden-Baden–Frankfurt–Hannover, 1961; Rotterdam–Paris, 1964.

KAOUAJI, Taieb
Folk artist in Tunis, Tunisia. Dates unknown.
Represented in Bratislava, 1969.

KASIALOS, Michael
Born in the village of Asbia on Cyprus. Folk artist and farmer. Also worked as a cobbler, and later set up an antique store in which he came to know a good deal about sculpture, ceramics, and copper and silverwork. Began his own work in 1960.
Sole representative from Cyprus in Bratislava, 1969.

KAZIMIERCZAK, Karl Eduard
Born 1894 in Helbra, Mansfelder Seekreis, Germany. Mechanic in the August-Thyssen works in Hamborn.

Only painted after his retirement. Died 1969 in Duisburg.
Represented in Recklinghausen, 1954 and 1958; Lille, 1961; Rotterdam–Paris, 1964; Bratislava, 1966; Lugano, 1969; Zagreb, 1970.

KEMKO, Josef
Born 1887 in Helpa, Czechoslovakia. Railroad worker. Began to whittle as a child, never learning a craft. Carved kitchen utensils and shepherd tools, also imaginative works based on motifs from popular sagas. Especially inspired by the hero Janošik. Died 1960 in Helpa.
Included in "Lay Art of Slovakia" in Prague, 1962; "Naive Art in Czechoslovakia," Prague–Brno–Bratislava–Ostrava, 1963–64; Bratislava Triennials, 1966 and 1969.

KERAK, Josef
Born 1891 in Velké Rovno, Czechoslovakia. Professional tinker. Hiked across Europe with his workshop on his back. Fashioned wire figures. Date of his death unknown.
Included in "Lay Art of Slovakia" in Prague, 1962; "Naive Art in Czechoslovakia," Prague–Brno–Bratislava–Ostrava, 1963–64.

KLEKAWKA, Franz
Born 1925 in Dortmund, Germany. Machinst for Hoesch A.G.
Represented in Recklinghausen, 1963; Bratislava, 1966; Zagreb, 1970.

KNEZ, Ivan Jurjević
Born 1920 in Lumbarda on the island of Korčula, Dalmatia, Yugoslavia. Fisherman and wine-grower. Wanted to become a sculptor, but had a large family to provide for.

Served with the Partisans in the liberation. Wounded during a sweep through a mine field in Postojna. Returned home as an invalid in 1945. In 1959 began to carve in stone on the rainy days when he couldn't fish. Has since turned to sculpture and has received commissions. Also paints in oils on composition board and makes stone mosaics.
Independent show at the War Invalids' Club, Belgrade, 1968.

More recently in Stockholm, Lumbarda, Dubrovnik, Orebić, and Korčula.

KNJAZOVIĆ, Jano
Born 1925 in Kovačica, Yugoslavia. Farmer. Began to paint in 1944, first watercolors then oils.
First exhibited in 1952. Included in Edinburgh, 1962; Rotterdam–Paris, 1964; Bratislava, 1966 and 1969.

KOVAČIĆ, Mijo
Born 1935 in the village of Gornja Suma near Hlebine, Croatia, Yugoslavia. Lives as a farmer and cattle herder, painting only in his free time. Began with watercolors in 1953. Taught painting behind glass and with oils by Ivan Generalić. First paintings on glass purchased by the Folk Museum in Koprivnica.
One-man and group exhibits in Zagreb, Zurich, London, Edinburgh, Vienna, Moscow, Leningrad, 1954–65. Represented in Bratislava, 1966, and Zagreb, 1970.

KREČA, Djordje
Born 1934 in Budimlić Japra near Banjaluka, Bosnia, Yugoslavia. Early orphaned as father killed in the war. Homeless until the liberation, then in home for war orphans. Grammar school and secondary school in Bihać; forestry school in

Split, where he wrote poetry and performed in the theater. Forester in Otočac, then worker in the "Rasadnik" plant in Split. Military service, various jobs, further study. Began to paint in 1964, and in the following year to do sculptures in wood.
First independent showing in Zagreb and Split, 1967. Represented in Dubrovnik and Zagreb, 1966; Amsterdam, Groningen, Mexico City, Wuppertal, Bremen, Kaiserslautern, and Milan, 1968; Bratislava, 1969; Zagreb, 1970.

KUDLA, Leon
Born 1879 in Swierze Gorne, Poland, the son of a farmer. Orphaned early. Laborer, then six years in the Russian army, during which he fought in the Russo-Japanese War. Had a small shop in Warsaw for a time, later postman. Moved back to his birthplace in 1930 and began to carve figures in wood. Died 1964.

Various post-war exhibits in Warsaw as well as other Polish cities. Makarczynski did a documentary film on him called "Cantata in Wood." Represented in Bratislava, 1966 and 1969.

LACKOVIĆ, Ivan
Born 1932 in the village of Batinska in the Podravina, Yugoslavia. Worked as a forester and gardener, 1943–52. Copied pictures of saints. Military service 1952–54. Drew with charcoals and pencil. Married and lived in Klostar Podravski, where he painted patron saint and other pictures on walls. Became

acquainted with Professor Dragutin Ančić and came into contact with the Gallery of Primitive Art, Zagreb. Moved to Zagreb 1957 and took a job in the post office. Contact 1962 with Professor Hegedušić and the journalist G. Ledić.
Included in exhibits in Čačak, Kostanjevica, and Zagreb, as well as twelve one-man shows. Represented in Bratislava, 1969, and Zagreb and Belgrade, 1970.

LAEMMLER, Bartholomäus
Born 1809 in Herisau, Switzerland. Most important of the peasant painters from Appenzell. Painted pictures of farms complete with families and cattle. Died 1865 in Unterach, Wolfhalden. His works in oil on wood are in the Art Museum in St. Gallen.

LAGRU, Domonique
Born 1873 in Perresy-les-Forges, Saône et Loire, France. Shepherd, miner, and, according to some, decorator. Began to paint at the age of seventy-six in 1949. Died 1960 in Paris.
First exhibit in the Galerie Romi, Paris, 1951. Represented in Knokke-Le Zoute, 1958, and Baden-Baden–Frankfurt–Hannover, 1961.

LAUKO, Juraj
Born 1894 in Szarvas, Hungary. Now lives in Bratislava, Czechoslovakia. Butcher by trade. Began to paint to amuse himself after his retirement.
Included in countless shows, including Prague, 1962; Brno, Bratislava, and Prague, 1963–64; Salz-

burg, Graz, and Linz, 1964; Bratislava, 1965. Represented at the international exhibits in Bratislava, 1966 and 1969, and Zagreb, 1970.

LEFRANC, Jules

Born 1887 in Laval, Mayenne, France, the birthplace of Henri Rousseau. Parents owned a hardware store. Encouraged by Claude Monet, began to paint in 1902. Bought wholesale hardware business in 1911 which operated until the First World War under the name "Drouot et Lefranc." Military service 1914–19. Met Aragon in 1920. Gave up profession entirely in 1928 to paint. Met Rimbert in the same year and they became close friends.

First independent show in the Galerie Carrefour, Paris, 1938, introduced by Jean Cassou. Met Lagru in 1951 and produced a show with him. Represented in Knokke-Le Zoute, 1958, and Rotterdam–Paris, 1964.

LENCZEWSKA, Maria

Born 1888 in Podoban, Poland. Worked as household help. Lost son and husband in Second World War, and began to paint patriotic and religious themes. Died 1967.
Represented in Bratislava, 1969.

LIAUTAUD, Georges

Born 1899 in Croix de Bouquets, Haiti. Sculptor. Professional blacksmith who produced iron farm tools and cemetery crosses. Unites Christian and voodoo symbolism. One of his crosses seen by De Witt Peters in 1953, and was encouraged by him to do purely artistic pieces.

Works represented in "Carnegie International" in Pittsburgh, 1958; "Fifth Biennial" at São Paulo, 1959; Baden-Baden–Frankfurt–Hannover, 1961; Bratislava, 1966.

LICKOVA, Anna

Born 1895 in Teschen, Czechoslovakia. Housewife. Began painting 1953.
Group shows from 1957 on. First one-man show in Žilina, 1965. Represented in Bratislava, 1966 and 1969.

LIGABUE, Antonio

Born 1899 in Zurich into an Italian emigrant family. Childhood in Switzerland, early orphaned. Return to Italy 1918. Military service. Lived in Gualtieri, Reggio Emilia. Restless life, often sick, suffered nervous breakdowns. Discovered 1930 by the sculptor Marino Mazzacurati. Best period of work 1935. Painted self-portraits and large paintings of woods and animals. Died 1965 in Gualtieri.
Included in Bratislava, 1969.

LLOYD, James

Born 1906 in Alsager, Cheshire, England. Farming family. Worked on the farm, as bus driver, factory employee, lamplighter, policeman, etc. Began to paint around 1945. Discovered by Sir Herbert Read.

First showing in the Gallery of Arthur Jeffress, London, 1958. Portal Gallery, London, 1961–68. One of his paintings hangs in the Tate Gallery, London. Purchases by other museums in Europe and U.S.A.

MAGYAR, Viktor

Born 1934 in the village of Motnik near Kamnik, Slovenia, Yugoslavia. Teacher. Lives in Čatež near Trabnje, and belongs to the group of naive painters in Croatia.
Participated in exhibits in Slovengradec, 1963; Klagenfurt, 1963; Innsbruck, 1965; Cologne, London, Genoa, Zurich, and Novarra, 1969; Philadelphia, 1968; Zagreb, 1970; Bled, 1970.

MARAN, Anuica

Born 1918 in Uzdin, Banat, Yugoslavia. Peasant and housewife. Used to weave and embroider folk costumes. Began to paint fabrics in 1956. The village teacher showed her and other women how to paint in oils.
Represented in exhibits in Belgrade, Zagreb, Washington, Frankfurt, Zurich, Lugano, and Stockholm. One-man shows in New York and Detroit.

MARINKOVIĆ, Miroslav

Born 1928 in Oparić, Serbia, Yugoslavia. Grammar school. Watched sheep, and worked in the fields. Military service 1948. Later began to draw. Showed his work to peasant painter Janko Brašić, and learned from him how to work with paints. Still paints only occasionally, exhibiting with other Serbian painters.

MARKOVA, Cecilie

Born 1911 in Kyjov, Mähren, Czechoslovakia. Graduated as a fashion designer 1930, then ran a hat shop in her home town. Began to paint 1938.
First showing in Kyjov, 1950. Included in "Naive Art of Czechoslovakia," Prague, Brno, Bratislava, and Ostrava, 1963–64.

MARUKI, Sumi

Born 1872 into a peasant family near Hiroshima, Japan. Had to work very hard even as a child. Never attended school, and could not write. Early married a farmer and had four children. One daughter, Iri Maruki, is a well-known

painter. Husband and brother killed, and one daughter badly wounded by the atom bomb in 1945. In her loneliness and sorrow she painted her first picture for her distant son when she was past sixty. Produced some fifty paintings. Died 1956 at the age of eighty-four.

MATAMOROS, Roberto Jay

Born 1912 in Santiago de Cuba. Accomplished in many trades; also worked as an elevator operator. Attended an art school briefly in Havana in 1937.
Represented in Bratislava, 1969.

MEHKEK, Martin

Born 1936 in the village of Novačka near Gola, Croatia, Yugoslavia. Peasant. Began to paint in 1953, mostly scenes from the life of the gypsies. Belongs to the school of Hlebine.
Represented in Belgrade, 1957; Edinburgh, 1962; Moscow, Leningrad, Budapest, and Vienna, 1962–63; Klagenfurt, 1964; London, 1965; Frankfurt, 1966; Zagreb, 1970.

MEIJER, Salomon

Born 1877 in Amsterdam, Holland. Worked as a diamond cutter. Began painting 1914. City scenes, landscapes, still lifes, animals. Lived in Blaricum. Died 1965 in Laren.

Exhibits in Laren, 1957, and in the State Museum, Amsterdam, 1958. Represented in Bratislava, 1969.

MEJO, Oscar de

Born 1911 in Trieste, Italy. Began drawing at sixteen. Started painting professionally in Los Angeles in 1949.

First exhibited in the Paylor Gallery in Beverly Hills. Exhibit in the Carlebach Gallery, New York, in 1950, organized by the critic Selden Rodman.

METELLI, Orneore

Born 1872 in Terni, Italy. Master shoemaker. Served on the jury at an international shoe exhibit in Paris 1911. Began painting at fifty to occupy his winter evenings. Loved music, and was a member of the city orchestra in Terni. Painted primarily scenes from the life of his

town and its architecture. Countless exhibits. Written about by important critics. Died 1938 in Terni.

MIDDELEER, Louis de
Belgian. Details unknown.

MIS, Johann
Born 1900 in Germany. Shaft foreman in the ERIN mines in Castrop-Rauxel. Sunday painter.

MONSIEL, Edmund
Born 1897 in Wozuczymie near Lublin, Poland. Son of a furniture maker. Grammar school and three years at a teachers school. Had a small shop which he lost in the Second World War. Hunted, but hid himself in a shed. Visions of terror and persecution complex; experienced conditions of ecstasy. Began to draw in 1943. Worked in a sugar factory after the war, living in a ruined mill. Some 500 drawings extant.
Exhibits in Krakow and Warsaw. Represented in Bratislava, 1969.

MORENO, Rafael
Born 1887 in Huelva, Spain. Spent his last thirty years in Cuba. Mason, farmer, bullfighter, shopkeeper, and owner of a shooting gallery. Began to paint frescoes in bars and cabarets in La Playa, a Havana suburb, in 1930. Died 1955.
Exhibits in Havana; Museum of Modern Art in New York; Port-au-Prince; Kansas City; and Galerie Pierre Loeb, Paris.

MORILL, D.
Naive American painter who lived in Connecticut. Painted genre pictures in oils around 1860.

MOSES, Anna Mary Robertson (Grandma Moses)
Born 1860 in Eagle Bridge, New York. Married Thomas Salmon Moses 1887. Operated a leased farm and had ten children, of whom only five lived. Started exhibiting pictures with her storekeeper. An art collector purchased her first efforts. Wrote her memoirs in 1952. Died 1961 in New York.

Countless exhibits at home and abroad, in New York, London,

Paris, etc. Represented at Knokke-Le Zoute, 1958; Salzburg, Rotterdam–Paris, 1969.

MOTOROJESCU, Marioara
Born 1928 in the village of Uzdin near Pančevo, Yugoslavia. Six years grammar school. Peasant and housewife. Began to paint with oils on canvas 1962. Loves flowers and their colors, and inspired by them to weave and paint. The village schoolteacher Doclean showed her and other women of Uzdin the technique of oil painting.
Has participated in exhibits in Belgrade, Pančevo, Zurich, et al.

MRAZ, Franjo
Born 1910 in Hlebine, Croatia, Yugoslavia. Farming family. At thirteen working in the fields and drawing animals and people. Met the painter Krsto Hegedušić 1930. Exhibited with Ivan Generalić in 1931 as guest of the *"Zemlja"* group in Zagreb. Paintings shown at Zagreb Fair in 1935–36, and in the Salon Ulrich in Zagreb. Participated in the liberation from 1941 on. Moved to Belgrade 1945, where he still lives as a painter.
Has taken part in all exhibits of naive Yugoslav painters. Represented in Third Biennial, São Paulo, 1955; Belgrade, 1957; Edinburgh, 1962; Moscow, Leningrad, Budapest and Vienna, 1962–63; Dortmund, 1964; "Naive Painting Behind Glass," Gutenberg Museum, Mainz, 1969.

NAUMOVSKI, Vangel
Born 1924 in Ohrid, Macedonia. Three years grammar school, and one year of art school in Skopje. Shepherd, butcher's apprentice, gardener, mason, mechanic, and wagon builder. Drawings exhibited 1948 in woodcarving studio, Ohrid. Began to paint in 1950.

First exhibited in Ohrid, Struga, and Skopje. Included in group shows in Yugoslavia, 1955–60. One-man show in Rome, 1965. Represented in Bratislava, 1966 and 1969, and in Zagreb, 1970.

NEERVOORT, Leonardus
Born 1908 in The Hague. Doorman. Spinal illness in 1957 left him more time for himself, and he began to paint.
Represented in Zagreb, 1970.

NEFF, Sibylle
Born 1929 in Appenzell, Switzerland. Family of craftsmen. Carries on the tradition of the old Appenzell dairy-farm painters.
Represented in Bratislava, 1966 and 1969.

NEGRETE, Ezequiel
Naive Mexican painter. Died 1961. No further details known.

NIKIFOR
Born around 1895 in Lemkowszeryzna, Poland, into a Russian Orthodox culture. Given the names Trifun and Nikifor, but also called himself Matejko. Mother a deaf and dumb beggar, probably Maria Derewniak. From childhood on the also deaf and dumb Nikifor wandered from village to village begging. Discovered as a naive

painter in 1930. First essay about him appeared in 1938. Elsa and Andrzej Banach met him in 1947 and organized his first showing in Warsaw. Later exhibited in Krakow, Zoppot, etc. Died 1968 in Krynica.
Represented in Knokke-Le Zoute, 1958; Baden-Baden–Frankfurt–Hannover, 1961; Rotterdam–Paris, 1964; Bratislava, 1966 and 1969; Zagreb, 1970.

OBIN, Antoine
Born 1930 in Cap Haitien, Haiti. Son of Philomé Obin, from whom he learned to paint. Lives in Cap Haitien.
Shows in England, 1968, and Dortmund and New York, 1969. Represented in Zagreb, 1970.

OBIN, Philomé
Born 1892 in Cap Haitien, Haiti, the son of a tailor. Worked as a bookseller, barber, coffee merchant, and painter in the Freemasons' temple. Belonged to the circle of Hector Hyppolite, and discovered by De Witt Peters. Founded an art school in Cap Haitien, where his brother Senèque and son Antoine

learned to paint.
Participation in exhibits in Germany, France, Holland, U.S.A., Latin America, and "Naive Art '70" in Zagreb, 1970.

OBIN, Senèque
Born around 1908 in Cap Haitien. Younger brother of Philomé Obin,

who was his teacher. Lives in Cap Haitien.
Exhibits with Antoine and Philomé.

O'BRADY (Gertrude MacBrady)
Born 1901 in Chicago. Uneventful life until Second World War. Began to paint in France in 1939. Concentration camp 1941–45 where she could only draw.
Included in "American Portraits" at the Galerie Georges Moratier, Paris, 1945. Also shown at Galerie Maeght, Paris, 1946, with a catalogue foreword by Jules Supervielle. Then stopped painting.

OCIEPKA, Teofil
Born 1891 in Silesian Janowie, Poland, the son of a miner. Machinst in electric plant, on the railroad, and in the mines. Began painting at thirty-six, in 1927. Reads avidly, especially on hypnosis and the occult. Paints in leisure time, usually fantastic motifs from prehistory, like Langou.

Represented in Knokke-Le Zoute, 1958; Krakow, Warsaw, London, Belgrade, Zagreb, Ljubljana, 1960–65; Bratislava, 1966 and 1969.

PALUŠKA, Martin
Born 1913 in Kovačica, near Pančevo, Yugoslavia. Lives there as a tractor repairman and chief machinist in the local mill. Began to paint in oils in 1938. Founded

group of lay painters in Kovačica together with the peasant painters Sokol and Bireš.
Included in Belgrade, 1957; Jeffers Gallery, London, 1961; Edinburgh, 1962; Moscow–Leningrad–Budapest–Vienna, 1962–63; Dortmund, 1964; Bratislava, 1966 and 1969.

PAPS, Maler (Dr. Waldemar Rusche)
Born 1882 in Naumburg, Germany. One of the most important ophthalmologists in North Germany; head doctor in the eye clinic of the St. Josef Stift in Bremen. Began to paint at seventy, in 1951; paints primarily memories of his many journeys as a young ship's doctor. Also painted theatrical impressions, flowers, harbor scenes. Died 1965 in Lilienthal near Bremen.

One-man shows in Bremen, 1959; Stuttgart, 1960; Constance, 1961; Lenbachhaus, Munich, 1963; Galerie Günther Franke, Munich, 1965; Galerie Emmy Widmann, Bremen, 1965; Gallery of Primitive Art, Zagreb, 1965; Goethe Institute, Paris, 1970.

PARK, Linton
Born 1826 in western Pennsylvania, U.S.A. Lived in Indiana County. Painted genre pictures, farm scenes, and loggers until 1870. Died 1906.

PASOTTI, Bernardo
Born 1910. Lives in Milan. Works in family's pharmaceutical factory and paints in leisure time.
Regular exhibits at the Galerie Wolfensberg, Zurich. Represented in Knokke-Le Zoute, 1958.

PATRICK (Patrick Byrne)
Born 1940 in Glasgow, Scotland. Attended art school briefly. Worked in a carpet factory. Paints things told him about his father's childhood.
Sent several pictures to the Portal Gallery in London in 1967, and has since had two showings there. Contributed to The Beatles' Illustrated Lyrics, London: 1969. Represented in Bratislava, 1969.

PETROV, Desanka
Born 1945 in Sefkerin, near Pančevo, Yugoslavia. Grammar school. Housewife. Began painting in 1964, joining Anuica Maran and the peasant painters of Uzdin. Married to a worker in Pančevo.
Has exhibited in Yugoslavia, Rumania, and Zurich.

PETROVIĆ, Arsenije
Born 1803 in Bela Crkva, Serbia, Yugoslavia. Painted chiefly portraits of children of the bourgeoisie. Died 1867.

PEYRONNET, Dominique-Paul
Born 1872 in Talence, near Bordeaux, France. Typographer. Began painting in 1920. Died 1943 in Paris.
Exhibits: Salon des Indépendants and Salon de l'École Française, Paris, 1932; Studio Waroline, Paris, 1939.

PHILIPPE-AUGUSTE, Salnave
Born 1908 in Port-au-Prince, Haiti. Retired judge. Spends all his time painting. Certain similarities to Henri Rousseau.

PICKETT, Joseph
Born 1848 in New Hope, Pennsylvania, where Edward Hicks lived. Traveled with a circus, worked as a carpenter at local fairs, and had his own shooting gallery in New Hope, for which he painted his own backdrops. Later owned a grocery store, painting in the storeroom. Made his own paints from berries collected in the woods, brushes from cat hair. Worked for months or even years on a picture. Only a few known. Died 1918 in New Hope.

PIERRE, André
Haitian voodoo painter. Birthplace and date unknown. Onetime farmer. Paints "when the gods call." Lives on the edge of Port-au-Prince in Croix-de-Missions in a hut near the voodoo temple. Used to paint gourds, then advanced to oil painting.
Exhibits in England, 1968–69; Dortmund, 1969–70; Zagreb, 1970.

PIERRE, Fernand
Haitian. Dates unknown. Once whittled little dogs which he sold as knickknacks to housewives, later began to paint. Shared in the painting of the Episcopal church St. Trinité in Port-au-Prince, commissioned by Bishop Vögeli.

PINÇON, Charles-Lucien
Born 1902 in Lamorlaye. Oise, France. Court official and justice of the peace in Mantes-la-Jolie, then mayor of Guerville in the *département* of Seine-et-Oise. Began to paint in memory of his mother, who

taught him to love nature. Paints chiefly landscapes.
Represented in Zagreb–Belgrade–Rijeka–Ljubljana, 1970.

PIPPIN, Horace
Born 1888 in West Chester, Pennsylvania. Eminent naive Negro painter. Began to paint religious scenes at ten. Left school in 1903. Porter, foundry worker, antique dealer. Went to France as soldier in the First World War. First oil painting in 1930. Until his death in 1947 painted pictures from the life of the American Negro, landscapes, war memories, religious compositions, and still lifes.

PIROSMANASHVILI, Niko (Nikolai Aslanovitch)
Born 1863 in the village of Mirzani in Kachetia, now in the Soviet Union. Father a gardener. Moved to Tiflis as a boy. Wanted to become an artist, but had to take a job with the railway. Later ran a dairy store. Became known as a painter in 1912. Self-taught. Painted the life of his people: festivals, feasts, episodes from the folk sagas. Also still lifes. Died 1919 in poverty.

PLEMELJ, Anton
Born 1923 in Selo, on Lake Bled, Yugoslavia. Trained as a shoemaker. Career officer. Began to paint intensively in 1961. Lives and works in Ljubljana.
First exhibit in Rijeka, 1966. Represented in Zagreb, 1970.

POELMAN, Willem
Born 1896 in Utrecht, Holland. Furrier by profession. Began to paint in 1965.
Exhibited in Utrecht. Represented in Bratislava, 1969, and Zagreb, 1970.

POKORNA, Ludmila
Born in Dresden, now living in Prague. Earlier a dancer, now housewife. Interested in architecture and music. Began painting in 1956 at the urging of her daughter.
Included in "Naive Art in Czechoslovakia" in Prague–Brno–Bratislava–Ostrava, 1963–64. Also shown in Bratislava, 1966.

POPA, Niculai
Born 1926 in Tirpesti-Neamt, Rumania. Cooperative farmer. Does sculpture in stone in free time. Folklore the point of departure for his imagination. Collects songs, costumes, masks, and folk sculpture. Assembles the local peasants for the traditional holidays and festivals. Constructs costumes and masks of great expressiveness, stages folklorist rituals, composes and writes poetry for these spectacles.
Included in Bratislava, 1969.

POSADA, José Guadalupe
Born 1851 in Aguascalientes, Mexico. Director of a school in Leon, Guanajusto, in 1873. Opened a graphics studio in Mexico City in 1878. Hired to do illustrations for the news of the day, for liturgical calendars, advertisements, songs, stories and prayers. Drew satires and caricatures full of social criticism for the opposition press. At his death in 1913 he left some 15,000 zinc etchings and lead and steel engravings. These rediscovered by the painter Jean Charlot in 1933, and became point of departure for modern graphics in Mexico.

POWELL, H. M. T.
American lay painter. Worked in California around 1850.

PRACHAZKOVA, Ludmila
Born 1903 in Herspice (Austerlitz) near Brno, Czechoslovakia. Married a postmaster in 1927, and is a housewife. Began to paint in 1941, while working as an ethnographer in East Mähren. Continued her work in Slavkov after 1945.

Included in exhibits relating to folk art since 1956. Started again to paint intensively in 1963. Represented in Prague–Brno–Bratislava–Ostrava, 1963–64, etc.

PRIOR, William Matthew
Born 1806 in Bath, Maine, U.S.A. Did a portrait of his neighbor even as a child. Traveling portraitist from the age of eighteen on. We have some of his advertisements from 1827. Referred to himself as a "limner" even in 1828, and was already getting relatively high prices for his work. Moved to Portland in 1834, where he worked as a portraitist with his brother-in-law. Moved his family to Boston around 1840. One of the followers of William Miller, who preached the reappearance of Christ in 1834. Died 1873.

RABUZIN, Ivan
Born 1919 in the village of Ključ, near Novi Marof, Croatia, Yugoslavia. Father a miner. One of nine children. Attended grammar school and an apprenticeship school. Be-

gan drawing figures and landscapes in 1944. Worked as a furniture maker while taking evening drawing courses in Zagreb, 1945–47. Worker and official in the furniture factory in the village of Novi Marof, 1950–61. Made contact with the Gallery of Primitive Art in Zagreb in 1958. Has painted as a professional since 1962.

Has exhibited since 1956. Received the Henri Rousseau Prize in Bratislava, 1969. Six one-man shows to date.

RAFFLER, Max

Born 1902 in Greifenberg am Ammersee in Bavaria, Germany. Son of the mayor. Operates a farm with his sisters. Paints imaginary landscapes, animals, and houses.
Exhibited in the Günther Franke Gallery, Munich, 1968. Two films have been made about him, and one calendar.

RAMHOLZ (Felix Muche)

Born 1868 in Querfurt, Germany. Overseer of a large estate from 1901. Father of the Bauhaus master George Muche. Began collecting paintings in 1916, among others Picasso, Chagall, Feininger, Franz Marc, and Paul Klee. Painted first picture in 1928. Died 1947 in Ramholz, Rhön.
Exhibited in Salzburg, 1964.

RAŠIĆ, Milan

Born 1931 in Donje Stiplje, near Svetozarevo, Serbia, Yugoslavia. Four years grammar school, then farm work. Helped build Zagreb–Belgrade highway. Two years military service. Began painting in 1960.

First showing in Yugoslavia, 1961. Represented in Belgrade, 1966; Bratislava, 1966 and 1969; Berlin, 1967; Zagreb, Amsterdam, West Germany, and Mexico, 1968; U.S.A. 1969–70; Venice, 1970.

RIEC-JESTIN, Raymond

Born 1905 in Landerneau, Finistère, France. Sailor, athlete, dishwasher, trolley conductor.
Represented in Bratislava, 1966 and 1969.

RIMBERT, René

Born 1896 in Paris. Postman like Vivin. Friend of Max Jacob and Marcel Gromaire.

First exhibit in the Galerie Percier, Paris, 1918. Represented in Paris–Zurich, 1937. Show at the Galerie Montmorency, Paris, 1956, with a catalogue introduction by Maximilien Gauthier. Also included in Knokke-Le Zoute, 1958; Rotterdam–Paris, 1964; Bratislava, 1966; Zagreb, 1970.

ROSAI, Ottone

Born 1895 in Florence. Professional painter. Contact with the Futurists before the First World War. Military service 1915–18. Adopted a kind of neoprimitive simplification in 1919. Teaches at the Art Academy in Florence.

ROUSSEAU, Henri

Born 1844 in Laval, Mayenne, France. Military service 1863–64. Played saxophone in regiment band. Married Clémence Boitard in 1868. Worked for the Paris customs office, 1869. Noncommissioned officer in the Franco-Prussian War, 1870–71. First known pictures by Rousseau from 1880. Lost first wife and asked to be retired in 1884.

First exhibited in the Salon des Champs Élysées, 1885. From 1886 exhibited regularly in the Société des Artistes Indépendants, with the exception of 1899–1900. Also from 1905 in the Salon d'Automne. Wrote a vaudeville play, "Visit to the World's Fair," in 1889. Came to know Gauguin, Redon, Seurat, Pissarro. Began to paint his exotic pictures in 1891. In 1889 married Joséphine Noury, who died 1903. Wrote drama, "The Revenge of a Russian Orphan." Became acquainted with Delaunay, Picasso, and Appollinaire in 1906. Met Wilhelm Uhde in 1907, and Uhde wrote the first monograph about him in 1911. Famous banquet for him in 1908 at Picasso's in the Bateau Lavoir. Died 1910 in the Necker Hospital, Paris.

ROVESTI, Bruno

Born 1907 in Gualtieri, Reggio Emilia, Italy. Served in the International Brigade in the Spanish Civil War, 1936–38. Fought in Africa and Greece, 1940–45, and was seriously wounded. Began to paint during long convalescence in a clinic, 1947. Returned as an invalid to Gualtieri. Paints only at night.
First exhibit in Rome, with introductory essay by the sculptor Marino Mazzurati, 1949. Included in "Mostra di pittura populare," Rome, 1955, and at Bratislava, 1969.

SALDIVAR, Jaime

Born 1921 in Tacubya, Mexico. Hotelkeeper and painter.
First shown in the Institute for Contemporary Art in Lima, Peru, 1961. One-man shows in Mexico City, 1962 and 1965. Group shows in Mexico City, 1965–66. Included in "The Primitives," Madrid-Barcelona-Valencia, 1967, and at Bratislava, 1968.

SAUTER, Aloys

Born 1875 in Stabroek, near Antwerp, Holland. Lived in seclusion in Montreil, near Paris, where he operated a cabinetmaking shop with his brother. His wife wrote verse. Painted only a few pictures of an unconscious and naive surrealism. Died 1952.
Represented in Knokke-Le Zoute, 1958, and Rotterdam–Paris, 1964.

SCHMIDTOVA, Natalie

Born 1895 in Vorova-Dobrinka, Russia. Worked as a chambermaid and governess in Rostov, Novorossisk, and at the Black Sea. From 1915 to 1919 lived in Prokuraovka, where she married a machinist and Austrian war prisoner, Rudolf Schmidt. Immigrated into Czechkoslovakia. Began to paint in 1943.

Exhibited since the war in Czechoslovakia, Austria, and Paris. Represented in Bratislava, 1966 and 1969, and in an exhibit of Czech naives in Reggio Emilia, Italy, 1969.

SCHRÖDER-SONNENSTERN, Friedrich

Born the son of a postal official in Lithuania, 1892. Childhood of extreme poverty. Isolated, and without playmates. Home for adolescents in 1906. Traveled as a laborer with a circus in 1910, playing small roles as a clown. Also employed as a gardener's helper, milker, letter carrier. Traveled as a spiritualist, preacher, smuggler, prophet, singer, etc. Military service at the front in both world wars. Deserted, was imprisoned, transferred to an asylum, and later lived in the ruins of Berlin. Suffering with a paralyzed leg, and depressed by his wretched living conditions, began to draw and paint in 1949. Came into contact with Professor Kubiczek who took an interest in his work.
Sold first pictures to the Springer Gallery, Berlin. Later exhibits in Hamburg, Basel, and Paris. Represented in the collection of André Breton, Edouard Roditi, Henry Miller, Jean Dubuffet, Hans Bellmer, etc.

SCHUBNEL, Jean

Born 1894 in Château-la-Vallière, France. Onetime tobacco seller. Lives in the Touraine. Paints old castles.
First exhibit in the Galerie Palmes, Paris, 1952. Represented in Knokke-Le Zoute, 1958; Bratislava, 1966 and 1969; Zagreb–Belgrade–Rijeka–Ljubljana, 1970.

SÉRAPHINE Louis (de Senlis)

Born 1864 in Arsy, Oise, France.

Childhood as a shepherdess. Moved to Senlis, and worked as a cleaning woman. Worked for Wilhelm Uhde, who discovered her work in 1912. Died 1942 in a home for the aged in Clermont.

First exhibits in the Galerie des Quatre Chemins, Paris, 1927, and in the Galerie Bernheim, Paris, 1932. Represented in Paris–Zurich, 1937, and New York–London, 1939. Also in "Cinq maîtres primitifs" at the Galerie Palmes, Paris, 1949; Berne, 1949; Dortmund, 1952; Knokke-Le Zoute, 1958; Rome, 1964; Rotterdam–Paris, 1964; Bratislava, 1969. Paintings in the collections of various museums.

SHALOM OF SAFED (Shalom Moskovitz)

Born around 1885 in Safed, Galilee, Israel, where he still lives. As a member of a Hassidic congregation, refuses to reveal particulars about his life. Has been a mason, silversmith, clockmaker. Began to paint in 1957. Inspired by movie posters and the picture books of his grandchildren.

One-man shows in New York, London, Zurich, Amsterdam, Brussels, Stockholm, Jerusalem, and Paris. Purchases by the Museum of Modern Art in New York, and Modern Art Museum in Paris. A documentary film about him made by Daniel Doron and Arnold Eagle.

SIJAKOVIĆ, Djordje

Born 1901 in Cetinje, Montenegro, Yugoslavia. Professional correspondent and librarian, now retired. Painting since 1962. Lives in Skopje, Macedonia.

Represented in Zagreb and Belgrade, 1970.

SKURJENI, Matija

Born 1898 in Veternica, Croatia, Yugoslavia. Peasant origin. One-time ditchdigger. Learned to work with paints as a railway employee. A workers' culture organization made it possible for him to take evening courses in drawing and painting. Retired in 1956. Lives in Zapreśće near Zagreb.

First exhibit in the cultural society "Vinko Jedjut," 1947. Included in exhibits in Belgrade, 1957; Bologna, 1958; Warsaw and Prague, 1959;

Zagreb, 1962; London, Rome, Munich, and São Paulo, 1961. Also Baden-Baden–Frankfurt–Hannover, 1961; Edinburgh, 1962; Zagreb, 1963; Moscow–Leningrad–Budapest–Vienna, 1962–63; Dortmund, 1964; Rotterdam–Paris, 1964; Zagreb, 1970.

SLOOT, Jentje van der

Born 1881 in Holland. Farmer, innkeeper, agent, painter. Died 1963.

SMAJIĆ, Petar

Born 1910 in Donji Dolac, near Split, Yugoslavia. Lives with his family in Ernestinovo, near Osijek. As a wagonmaker learned to work with wood, and began to carve heads for the one-stringed *gusles* which he made in his free time and sold. Art critics took notice of him and encouraged him in his artistic activity. Began to do extensive sculpture in wood in 1935.

Work displayed in the Yugoslav pavilion at the Brussels World's Fair, and in Zagreb, 1970.

SMITS, Johannes

Born 1916 in Amsterdam, into a working-class family. Waiter, bartender. Began to earn his living after only six years of schooling. Because he drank too much began to have family problems in 1962, and it was then that he started to paint.

Represented in Zagreb, 1970.

SOKOL, Jano

Born 1909 in Kovačica, near Pančevo, Yugoslavia. Grammar school. Farmer. Painting watercolors in 1923. In the local library came to know the peasant painter Martin Paluška who taught him oil painting. Group of peasant painters in

Kovačica founded in 1952. In 1953 the professional painter Trumić advised him to do scenes from peasant life instead of copying anymore.

Included in annual shows of the Kovačica group in Zagreb and Belgrade.

SPIELBICHLER, Franz

Born 1895 in Trübenbach, Lower Austria. Sunday painter. Laborer in 1913. Soldier 1917. On an island in the Black Sea in 1918, and learned to use water colors. Frequently unemployed, 1919–35. Learned filecutting. Military service and prisoner of war, 1939–45. Took a job in a file factory in Furthof, Austria, 1946. Paints in free time, mainly the surrounding landscape.

First showing in the Gallery of the Self-Taught, Vienna, 1968. Represented in Bratislava, 1966.

STANISAVLJEVIĆ, Dragiša

Born 1921 in Jabučje, near Lajkovac, Yugoslavia. Grammar school. Farmer. Began to do wood sculpture in 1958.

Exhibits with his son, Milan Stanisavljević, in the local school and in Belgrade, 1962, and in Lazarevac, Lajkovac, etc., 1964. Included in Zagreb, 1970.

STANISAVLJEVIĆ, Milan

Born 1944 in Jabučje, near Lajkovac, Yugoslavia, the son of Dragiša Stanisavljević. Six years grammar school. Began carving in wood at sixteen, and exhibits his work with his father's every year in their village.

Exhibits in the Cultural Center in Belgrade, 1962, and in Lazarevac and Lajkovac, 1967. Included in Bratislava, 1969, and Zagreb, 1970.

STEBERL, Ondrej

Born 1897 in Pezinok, Czechoslovakia. Lives in Bratislava as a letter carrier.

Shown in Reggio Emilia, Italy, 1959; Bratislava, 1966 and 1969; Zagreb, 1970.

STEFULA, Dorothea

Painter. Wife of György Stefula. No further details known.

STEFULA, György

Born 1913 in Hamburg. Father Hungarian; mother French.

Works first shown at the Great Exhibit in Munich, 1949. One-man shows at the Wolfsberg Gallery in Zurich, and the Museum am Ostwall, Dortmund, 1952. Included at Bratislava, 1966.

STERN, Emma

Born 1878 in Sankt Wendel, Saar. Well-to-do woman who died 1969 in Paris. No further details known.

Represented at Bratislava, 1969.

STOCK, Joseph Whiting

Born 1815 in Springfield, Massachusetts. Folk painter, chiefly of portraits. Severely injured on his eleventh birthday, and permanently lamed. After some years got a wheelchair in which he could sit up. Began to study art and to paint in 1832. Began a diary in 1842, in which he describes his life and work. Died 1855 in Springfield.

STRAKUŠEK, Jano

Born 1926 in Kovačica, near Pančevo, Yugoslavia. Worked as a farmhand for wealthy estate owners. Participated in the liberation. After the war a mason, later an independent contractor. Associated with the group of peasant painters in Kovačica, and exhibits with them.

STRYGEL, Hans

Born 1916 in Vienna. Furniture maker by profession. Began drawing as an apprentice. Unemployed, did silhouettes which he sold on the street. Fought as soldier in Poland, France, and Soviet Union, 1939–42. Prisoner of war, 1943–47. Painted as sole recreation.

Prize for a self-portrait in the exhibit "Talent Awakened—Discovered" of the Austrian Labor Union in Vienna, 1958.

SÜLI, András

Born 1897 in Algyö, Hungary. Six years grammar school, then farm work. Drawing since childhood. Soldier in Serbia, 1914. Returned to Algyö, 1918. Painted between 1933 and 1938. Some thirty-three pictures extant. Stopped painting when he did not receive an honorarium for pictures sent off to Budapest. Forgotten, and only rediscovered thirty years later. Died 1969.

Exhibited in Szeged, 1968. Represented in Bratislava, 1966 and 1969, and in Zagreb, 1970.

SZALMAS, Bela György

Born 1908 in Kaschau. Factory worker. Evening course at trade school in 1942. Holiday painter, 1945–49. Died 1961 in Budapest.

Complete exhibit, 1954. Memorial exhibit, 1964.

TISNIKAR, Jože
Born 1928 in Mislinj, near Slovenj Gradec, Slovenia, Yugoslavia, where he still lives today. Five years grammar school, then technical school. Worked in paper mill in Mislinj. Medical aide in the army in 1948, then began to work in home-town hospital. Loved to draw and paint even in grammar school. Started painting seriously in 1952. Supported and encouraged by the academic painter Karel Pečko.
Exhibits in Ljubljana, 1958 and 1966, and Slovenj Gradec, 1961, 1966, and 1969. Also in Belgrade, Maribor, Vienna, Hamburg, and Graz.

TORTI, Lavoslav
Born 1873 in Cavtat, near Dubrovnik, Yugoslavia. Was a sailor, harbor worker, house servant. Widely traveled. Long the cemetery custodian in his home town. Wrote poetry and music. Carved figures in pieces of stone and marble he found in the rubbish heaps of Cavtat villas. Exhibited his work in the cemetery, usually on the flat gravestones. Died 1942.

TRILLHAASE, Adalbert
Born 1859 in Erfurt, Germany. After training for a business career, he tried in vain to get ahead. Read a great deal, chiefly history and the Bible. Began to paint in 1918. Mother Ey, who owned a coffee house not far from the academy in Düsseldorf, and who later opened a small art shop, exhibited his earliest works. Died 1936 in Königswinter.
One-man shows in the Main Hall of the Gesolei exhibit in Düsseldorf, 1924, and in the Galerie G. Maratier, Paris, 1939. Represented in Bern, 1949; Dortmund, 1952; Recklinghausen, 1958; Baden-Baden–Frankfurt–Hannover, 1961; Rotterdam–Paris, 1964; Bratislava, 1969; Clemens Sels Museum, Neuss, 1968–69.

TYTGAT, Edgar
Born 1879 in Brussels, Belgium. Childhood and youth in Bruges. Learned the watchmaking trade and lithography. Emigrated to London in 1914, and worked as an illustrator. Returned to Belgium in 1920, where he lived first in Nivelles, and from 1923 in Woluwe–Saint-Lambert. Traveled in Bavaria, Austria, Switzerland, Italy, and Portugal. Died 1957 in Brussels.

URTEAGA, Mario
Born 1875 in Cajamarca, Peru. Details of private life and profession unknown. Died 1957.
First exhibited in 1934. In 1937 won first prize in an international competition at Vino del Mar, Chile. Honored by the Institute for Contemporary Art in Lima in 1955. One of his works in the Museum of Modern Art, New York.

VALÇIN, Gerard
Born 1925 in Port-au-Prince, Haiti, where he still lives. Tile worker by profession. Voodoo always present in his work. His brother Favrence is also a painter.
Exhibits in England, 1968–69; Dortmund, 1969; New York, 1970; Paris and Zagreb, 1970.

VAN HYFTE, Camille
Born 1886 in Ertvelde, Belgium. First a farmer, then horse slaughterer, then racer. Lived in a Paris suburb. Began to paint in 1951. Decorated the walls of his house, carved sculptures, decorated vases, and did paintings. Died 1966.
Exhibited in the Galerie de l'Institut, Paris, 1955. Included in Knokke-Le Zoute, 1958.

VANKOS, Margit
Born in Hungary. No further details known. Paintings resemble baptismal certificates.

VAN WEERT, Jan
Born 1871 in Hertogenbosch, Holland. Horse breeder, stable keeper, innkeeper, and equestrian in Paris, London, etc. Started painting in 1945. Lived in Düsseldorf, where he died in 1955.

VAN DER STEEN, Germain
Born 1897 in Versailles, where he spent his youth. Shopkeeper, drugstore operator in Paris. Poisoned by gas in World War I. Painting since 1938.
Regularly exhibited in Paris galleries, 1946–58. Also represented in Stuttgart, 1963; Zagreb, 1964; Basel, 1965; Paris, 1957 and 1960; Basel, 1961; Belgrade–Zagreb, 1963; Rome and Salzburg, 1965; Bratislava, 1966 and 1969; Zagreb–Belgrade–Rijeka–Ljubljana, 1970; Zagreb 1970.

VEČENAJ, Ivan
Born 1920 in the village of Gola in the Podravina, Yugoslavia. Four years grammar school. Farmer who lives and works in Gola. Began painting in 1952.
First exhibit in 1954. Shown frequently at home and abroad, among others in Zagreb, 1957; Belgrade, 1959; São Paulo, 1960; Basel, London, and Rio de Janeiro, 1961; Edinburgh, 1962; Moscow–Leningrad–Budapest–Vienna, 1962–63; New York, 1963; London, 1965; Frankfurt and Bratislava, 1966; Amsterdam, Mexico, Paris, Milan, and Geneva, 1969; Rome, Venice, and U.S.A. 1970.

VEČENAJ, Stjepan
Born 1928 in the village of Gola in the Podravina, Yugoslavia. Grammar school. Farmer in Gola. Started painting in 1957.
First exhibited in 1962. Shown in New York and Washington, 1963; New York, Klagenfurt, Pittsburgh, and Frankfurt, 1964; Vienna, 1967; Amsterdam, Mexico, Munich, and Milan, 1968; Germany and U.S.A., 1969–70.

VELASQUEZ, Antonio J.
Born 1908 in Caridad, Honduras. Tried several professions before he began to paint in 1933. Works as a barber in the Pan American School of Agriculture, near Tegucigalpa. Mayor of San Antonio de Oriente.
Exhibited frequently in the capital. First one-man show in Washington, D.C. Represented in Houston, 1954; Knokke-Le Zoute, 1958; Baden-Baden–Frankfurt–Hannover, 1961; Vienna, 1962; "20th Century Latin American Naive Art" in La Jolla, California, 1964; Rotterdam–Paris, 1964; Dortmund and Brussels, 1964; Stockholm, 1966; Second Biennial in Medillin, Colombia.

VENJARSKI, Jano
Born 1928 in Kovačica, near Pančevo, Yugoslavia. Grammar school. Military service. Started painting in 1950. Belongs to the group of Kovačica painters organized in 1952.
Exhibited in Yugoslavia since 1954. Represented in Frankfurt, London and Basel, 1961; Edinburgh, 1962; Moscow–Leningrad–Budapest–Vienna, 1962–63; Vienna and New York, 1963.

VENJARSKI, Ondrej
Born 1930 in Kovačica, near Pančevo, Yugoslavia. Brother of Jano Venjarski. Farmer. Grammar school. Began to paint while doing military service. Enclosed paintings of flowers in his letters to young girls. Bought his first paints in 1950 and did his first picture. Member of the Kovačica group.
Exhibited in Yugoslavia since 1959. Included in Basel, 1961; Edinburgh, 1962; Frankfurt and London. Also Moscow–Leningrad–Budapest–Vienna, 1962–63.

VIRAGHOVA, Zuzana
Born 1885 in Košice, Czechoslovakia. Housewife. Started painting in 1959.
Included in "Lay Painting" in Bratislava, 1960; "Lay Painting" in Prague, 1962; Prague–Brno–Bratislava–Ostrava, 1963; Graz–Linz–Salzburg, 1964; Paris, 1965; Bratislava, 1966 and 1969; Zagreb, 1970.

VIRIUS, Mirko
Born 1889 in Djelekovac, near Koprivnica, Croatia, Yugoslavia. Began to draw while imprisoned by the Russians in First World War. Became associated with Generalić and Mraz, the peasant painters of Hlebine, in 1936. Painted and exhibited with them. Observed and represented the peasant life and the drama of poverty. Died in concentration camp in Zemun, 1943.

Post-war exhibits included showings in Yugoslavia, 1950–54; São Paulo, 1955; Knokke-Le Zoute, 1958; Rome; 1960; Edinburgh, 1962; Moscow–Leningrad–Budapest–Vienna, 1962–63; Rotterdam–Paris, 1964; Bratislava, 1966; Zurich, 1967; Amsterdam and Mexico, 1968; U.S.A., 1969–70. Memorial exhibit in Koprivnica, 1970.

VIVANCOS, Miguel G.
Born 1895 in Mazarron, Andalusia, Spain. Moved to Barcelona. Chauffeur, longshoreman, painter, glazier, miner. Commandant of Puigcerdá during Spanish Civil War. Fled to France in 1938. In concentration camp during the German occupation. Went to Paris in 1944, where he copied paintings on silk, and began to paint on his own. André Bréton has written about him.

One-man shows in several Paris galleries: Mirador, 1956; Weil, 1957; Norval, 1958; Charpentier, 1964. Represented in Knokke-Le Zoute, 1959; Paris, 1960; Basel, 1961; Rome, Rotterdam–Paris, and "Le Panorama International de la Peinture Naive" in Rabat, 1964; Zagreb–Belgrade–Rijeka–Ljubljana, 1970.

VIVIN, Louis
Born 1861 in Hadol, Vogesen, Germany, the son of a teacher. Postal worker. Painted in his free time. First showed his work as a Sunday painter in an exhibit of postal employees in 1889. Began painting full time only after his retirement in 1922. In 1925 became acquainted with Wilhelm Uhde, who championed him. His right arm paralyzed during his last years. Died 1936 in Paris.

Represented at all the major exhibits of the naives: Paris–Zurich, 1937; New York–London, 1939; Amsterdam, 1941; Basel, 1956; Knokke-Le Zoute, 1958; Paris, 1960; Baden-Baden–Frankfurt–Hannover, 1961; Salzburg, 1964; Rome, Rotterdam–Paris, 1964; Rabat, 1964; Bratislava, 1966 and 1969; Zagreb–Belgrade–Rijeka–Ljubljana, 1970; Zagreb, 1970.

WALLIS, Alfred
Born 1885 in Devonport, England. Went to sea. Lived as a fisherman in St. Ives, Cornwall. Started to paint when he was over seventy. Encouraged by Christopher Wood and Ben Nicolson. Painted on old cardboard of irregular shape, and on boards. Died 1942 in poverty in St. Ives.

WAWRO, Jedrzej
Born 1864 in Gorzen Dolny, near Krakow, Poland. Son of a farmer. Miner, stonecutter, logger, junkdealer. Began carving figures of saints in wood in 1925. Died 1937. *Works have been shown in Paris, Brussels, Amsterdam, Rapperswil, Belgrade, Zagreb, Ljubljana, Maribor, etc.*

WILLSON, Mary Ann
Worked in America between 1810 and 1825.

WILSON, Scottie
Born 1890 in Glasgow, Scotland. Parents both workers. Military service in India. Lived for a time in Canada.
Exhibited in the Gimpel Gallery, London, 1947; Galerie Nina Dausset, Paris 1948; Galerie Hutter, Basel, 1950. Included in Knokke-Le Zoute, 1958, and Basel, 1961.

WITTLICH, Joseph
Born 1903 in Gladbach, near Neuwied, Germany. Grammar school. Worker in a ceramics factory. Has painted since childhood. Lives and works in Höhr-Grenzhausen.
Represented in Bratislava, 1969; Essen, 1969; Recklinghausen and Zagreb, 1970.

YAMASHITA, Kiyoshi
Born 1922 in Tokyo. Son of an alcoholic. Clear that he was mentally retarded from age nine. Lived separated from his mother from twelve on, either in the streets or in adolescent homes. Learned tech-

nique of *hari-e* collage, which he then perfected on his own. Worked as a farm hand, dishwasher, blacksmith's apprentice, fish seller. Slept in train stations. Kept extensive diaries. Work only appreciated after the war.

YCAZA, Adela Vargas de
Born 1910 in Granada, Nicaragua. Worked in a flower shop, then moved to León after her marriage to Luis A. Ycaza Reyes. Began to paint in 1967 at the urging of her son Alberto. The champion of naive art in Central and South America, José Gomez Sicre, became aware of her and arranged to have her work shown. Paints scenes from history, the Bible, and popular legend.

Exhibits in the National School of Fine Arts, 1967–69; the Rubén Dario National Theatre, 1970; Galeria Forma in San Salvador, 1968; São Paulo, 1969; Lima, 1970. Sharing an exhibit with her son in Washington, D.C., in the Organización de los Estados Americanos, 1971.

ZEGADIO, Adam
Born 1910 in Krzyžka, near Kielce, Poland. Son of a farmer who died early. Had to go to work in a factory. Carved wooden toys with his sons during the Second World War. Later began doing sculpture under the influence of his son Henryk.

Exhibits in Warsaw, 1965, and Kielce, 1966. Represented in Bratislava, 1966, and Rome, 1967.

ŽIVKOVIĆ, Bogosav
Born 1920 in Leskovac, Serbia, Yugoslavia. Son of poor peasants. Grammar school while helping in the fields. Joined the liberation forces in 1941, was captured and tortured. Spine wounded. Trained as furrier, but had to give up his profession to become a doorman in Belgrade. Began to carve figures in wood in 1957. The painter Mario Maskarelli heard of his work in 1960 and helped him arrange a show in Belgrade.

Many exhibits at home and abroad, including Moscow–Leningrad–Budapest–Vienna, 1962–63; New York, 1963; Zurich, 1965; Munich and Bratislava, 1966; Amsterdam, 1967; Bremen, Paris, and Mexico, 1968; U.S.A., 1969–70. One of his columns is in the National Museum of Modern Art in Paris.

ZOMER, Anna Maria
Born 1899 in Bunnik, Holland. Farmer's wife. Painting since 1954. *Exhibits in Vienna and Frankfurt, 1957, and Zagreb, 1968. Represented in Bratislava, 1969, and Zagreb, 1970.*

Bibliography

General Works:

Apollinaire, Guillaume, *Chroniques d'Art 1902–1918.* Gallimard, Paris, 1960.

Bihalji-Merin, Oto, *Das Naive Bild der Welt.* DuMont Schauberg, Cologne, 1959.

Cassou, Jean, "Les Maîtres Populaires de la Réalité." In: *Art Vivant,* Paris, August–September 1937.

Dasnoy, Albert, *Exegese de la Peinture Naive.* Laconti, Brussels, 1970.

Gamulin, Grgo, "Toward a Theory of Naive Art." In: *Kolo,* Zagreb, No. 5, 1965.

Goldwater, Robert J., *Primitivism in Modern Painting.* Harper & Brothers, New York–London, 1938.

Jakowsky, Anatole, *Peintres Naifs; Lexikon der Laienmalerei aus aller Welt.* Basilius Press, Basel, 1967.

Kandinsky, Wassiliy, "Über die Formfrage." In: *Der Blaue Reiter,* Munich, 1912, New edition: Piper Verlag, Munich, 1965.

Michailow, Nikola, "Zur Begriffsbestimmung der Laienmalerei." In: *Zeitschrift für Kunst und Geschichte,* Nos. 5–6, 1935.

Tkač, Stefan, *Insite Kunst der Welt.* Pallas Verlag, Bratislava, 1969.

Part One

Bader, Alfred, *Wunderwelt des Wahns.* With contributions by Jean Cocteau, Georg Schmidt, and Hans Stock. DuMont Schauberg, Cologne, 1961.

Bihalji-Merin, Oto, and Benac, Aloys, *Steine der Bogomilen.* Photographs by T. Dabac. Anton Schroll, Vienna, 1964.

Dubuffet, Jean, *L'Art Brut.* Paris, since 1964.

Elisofon, Eliot, *Die Afrikanische Plastik.* Contributions by Ralph Linton and William Fagg. DuMont Schauberg, Cologne, 1958.

Ford, Alice, *Pictorial Folk Art; New England to California.* Studio Publ., New York–London, 1949.

Hanhart, Rudolf, *Appenzeller Bauernmalerei.* Arthur Niggle, Teufen, 1970.

Irimie, Cornel, and Focşa, Marcela, *Rumanian Icons Behind Glass.* Meridiane, Bucharest, 1968.

Jackowski, Alexander, and Jarnuskiewiczova, Jadwiga, *Polnische Volkskunst.* Henschel Verlag, Berlin/ Arkady, Warsaw, 1968.

Jakab, Irene, *Drawings and Paintings of Mental Patients; Their Psychiatric and Artistic Analysis.* Hungarian Academy of Sciences, Budapest, 1956.

Janis, Sidney, *They Taught Themselves; American Primitive Painters of the 20th Century.* Dial Press, New York, 1942.

Lipman, Jean, and Winchester, Alice, *Primitive Painters in America, 1750–1950.* Dodd, Mead, New York, 1950.

Lommel, Andreas, *Vorgeschichte der Naturvölker.* Bertelsmann, Gutersloh, 1968.

Makarovič, Gorazd, *Poslikane panjske končnice.* Mladinska, Knjiga, Ljubljana, 1962.

Navratil, Leo, *Schizophrenie und Kunst; Ein Beitrag zur Psychologie des Gestaltens.* Deutscher Taschenbuch Verlag, Munich, 1965.

———, *Mutteridole eines Imbezillen; Psychopathologie und Bildnerischer Ausdruck.* Special Printing, Linz, 1969.

Noack, Liesel, and Holzhäuser, Wolfgang, *Bildnerisches Volksschaffen der Deutschen Demokratischen Republik.* Seemann, Leipzig, 1969.

Radin, Paul, and Sweeney, James Johnson, *African Folktales and Sculpture.* Bollingen Series XXXII, Pantheon, New York, 1952.

Read, Herbert, *Erziehung durch Kunst.* Droemer-Knaur, Munich, 1968.

Roh, Juliane, "Ich hab' wunderbare Hilf erlangt"; *Votivbilder.* F. Bruckmann, Munich, 1957.

Tischner, Herbert, *Oceanic Art.* Pantheon, New York, 1954.

Tomlinson, R. R., *Children as Artists.* King Penguin Books, London, 1944.

Part Two

Amiranashvili, C., *Niko Pirosmanashvili.* Sowjetski Chudoschnik, Moscow, 1967.

Bašičević, Dimitrije, *Ivan Generalić.* Art History Society, Zagreb, 1962.

Beier, Ulli, "Moderne Kunst in einer afrikanischen Stadt." In: *Tendenzen,* No. 32, Vol. 6.

———, "Populäre Kunst in Afrika." In: *Tendenzen,* Special Issue "Neue Kunst in Afrika," Munich, 1967.

Bihalji-Merin, Oto, *Ivan Generalić; Jugoslavische Pastorale.* Woldemar Klein, Baden-Baden, 1960.

———, *Bogosav Živković; Kollektiv-unbewusste Formen eines naiven Skulptors.* Photographs by Dragan Kažić. Woldemar Klein, Baden-Baden, 1962.

———, and Bihalji-Merin, Lise, *Henri Rousseau; Leben und Werk.* Verlag der Kunst, Dresden, 1971.

Bouret, Jean, *Henri Rousseau.* Editions Ides et Calendes, Neuchatel, 1961.

Damnitz, H. von, "Verhältnisse, Gesellschaft, Kunst." In: *Tendenzen,* Special Issue "Neue Kunst in Afrika," Munich, 1967.

Jakowsky, Anatole. *Dämonen und Wunder; Eine Darstellung der naiven Plastik.* DuMont Schauberg, Cologne, 1963.

Kelemen, Boris, *Naive Art in Yugoslavia.* City Gallery, Zagreb, 1969.

Perruchot, Henri, *Le douanier Rousseau.* Editions Témoins du XXe siècle, Paris, 1957.

Pohribny, Arsen, and Tkac, Stefan, *Naive Art in Czechoslovakia.* Artia, Prague, 1967.

Rodman, Selden, *Horace Pippin.* Quadrangle Press, New York, 1947.

Uhde, Wilhelm, *Henri Rousseau.* Editions Figuière, Paris, 1911.

———, *Fünf primitive Meister.* Atlantis, Zurich, 1947.

Vallier, Dora, *Henri Rousseau.* DuMont Schauberg, Cologne, 1961.

Williams, Shelden, *Voodoo and the Art of Haiti.* Morland Lee, Ltd., and Oxley Press, Ltd., Nottingham, n.d.

Zdanevitch, K. M., *Niko Pirosmanashvili.* Iskusstvo, Moscow, 1964.

Part Three

Bigiaretti, Libero, *Orneore Metelli* (Portfolio). Centro Culturale Olivetti, Invrea, 1964.

———, *Orneore Metelli.* Centro Cuturale Olivetti, Invrea, 1957.

Buccarelli, Palma, *Orneore Metelli.* L'Indipendente, Rome, 1946.

Buck, Hans, *Adolf Dietrich als Zeichner.* Rotapfel, Zurich–Stuttgart, 1964.

Courthion, Pierre, *Orneore Metelli, le peintre cordonnier (1872–1938).* With an essay by Aurelio de Felice and work register. Pierre Cailler, Geneva, 1951.

Doron, Daniel, *The Art of Shalom of Safed.* Catalogue of the exhibit in the Gallery of Israeli Art, New York, 1966.

Gorsen, Peter, *Friedrich Schröder-Sonnenstern; Eine Interpretation.* Heinrich von Sydow-Zifkwitz, Frankfurt/ Main, 1962.

———, *Das Prinzip Obszön; Pornographie und Gesellschaft.* Rowohlt, Hamburg, 1969.

———, *Das Bild Pygmalions; Kunstsoziologische Essays.* Rowohlt, Hamburg, 1969.

Hoenn, Karl, *Adolf Dietrich.* Huber & Co., Frauenfeld–Leipzig, 1942.

Jakowsky, Anatole, *Eros du Dimanche.* Editeur Jean-Jacques Pauvert, Paris, 1964.

Marcuse, Ludwig, *Obszön; Geschichte einer Entrüstung.* List, Munich, 1960.

Riess, Margot, *Der Maler und Holzfäller Adolf Dietrich.* Rascher, Zurich–Leipzig, 1927.

Roh, Juliane, *Adalbert Trillhaase.* Aurel Bongers, Recklinghausen, 1968.

Photo Credits

Index

Index of illustrations, by artist or source